THE STALIN CULT

A STUDY IN THE

ALCHEMY OF POWER

JAN PLAMPER

Hoover Institution
Stanford University
Stanford, California

Yale UNIVERSITY PRESS
New Haven and London

Published with assistance from the foundation established in memory of Amasa Stone Mather of
the Class of 1907, Yale College.

Yale University Press books may be purchased in quantity for educational, business, or promo-
tional use. For information, please e-mail sales.press@yale.edu (U.S. office) or sales@yaleup.
co.uk (U.K. office).

Set in Sabon type by Newgen North America, Inc. Printed in the United States of America.

Library of Congress Cataloging-in-Publication Data

Plamper, Jan, 1970–
 The Stalin cult : a study in the alchemy of power / Jan Plamper.
 p. cm. — (The Yale-Hoover series on Stalin, Stalinism, and the Cold War)
 Includes bibliographical references and index.
 ISBN 978-0-300-16952-2 (cloth : alk. paper) 1. Stalin, Joseph, 1879–1953—Influence.
2. Stalin, Joseph, 1879–1953—Public opinion. 3. Stalin, Joseph, 1879–1953—In mass
media. 4. Soviet Union—Politics and government—1917–1936. 5. Soviet Union—
Politics and government—1936–1953. 6. Cults—Political aspects—Soviet Union—History.
7. Political culture—Soviet Union—History. 8. Public opinion—Soviet Union—History.
9. Mass media—Political aspects—Soviet Union—History. I. Title.
 DK268.S8P535 2011
 947.084'2—dc23
 2011019576
A catalogue record for this book is available from the British Library.

This paper meets the requirements of ANSI/NISO Z39.48–1992 (Permanence of Paper).

10 9 8 7 6 5 4 3 2 1

In memory of
Veniamin Iofe (1938–2002)
and
Reginald Zelnik (1936–2004)

Contents

Plates follow page 74

Acknowledgments

This book has been in the making for years, and the list of debts to acknowledge has become quite long. It all started at Brandeis, where my undergraduate teacher, Gregory Freeze, assigned Michael Cherniavsky's *Tsar and People*. Cherniavsky's classic opened my eyes to the symbolic dimensions of power, Greg Freeze to the wonders of Russian history. Without Greg's example and mentorship I would have never become a historian of Russia. In 1992 I read Ian Kershaw's pioneering *The "Hitler Myth"* and began asking myself if there was something comparable on the Stalin cult. There wasn't. A year later, during eighteen months of social work (in lieu of my German military service) for the anti-Stalinist grassroots organization Memorial, St. Petersburg, I began looking for documentation on the Stalin cult and made first forays into the Party archives of St. Petersburg and Moscow, which had just opened. Ever since this first extended stay in Petersburg, the Scientific and Information Center Memorial has been my logistical, intellectual, and emotional base in Russia. I am very grateful to its current director, Irina Flige. The first dedication of this book is to the memory of its founding director, the late Veniamin Iofe, from whom I learned so much hands-on history.

In 1995 I entered graduate school at Berkeley and embarked on a dissertation on the Stalin cult under the guidance of a committee of unique scholars and human beings. Yuri Slezkine, my main adviser, was an astute and erudite reader, who offered excellent suggestions. He saved me from my own megalomania by convincing me early on to focus on selected aspects, saying that a *histoire totale* of the Stalin cult was about as realistic as a single-volume history of the cult of Jesus Christ. The late Reginald Zelnik was my second reader. Reggie's all-round qualities as teacher, scholar, mentor, *homo politicus,* and person were legendary long before I arrived at Berkeley; I feel extremely privileged to have experienced

them all first-hand and the book's second dedication is to his memory. Victoria Bonnell, one of my outside readers, gave crucial support at an early stage, and her book on Soviet political iconography has been an inspiration. A very special thanks must go to Irina Paperno, my other outside reader, who went beyond any call of duty in reading drafts and offering thorough, sharply intelligent criticism. When I got stuck in the process of revising the dissertation for publication, she gently prodded the book to completion. It is hard to put in words how much I value her intellectual and personal support over the years.

Thanks also to my other teachers at Berkeley, especially Carla Hesse, whose way of practicing history has left a deep imprint. And to my cohort of Berkeley graduate students, of whom I would like to single out Peter Blitstein, Chad Bryant, Victoria Frede, Brian Kassof, Ben Lazier, Zhenya Polissky, David Shneer, and Ilya Vinkovetsky. It was only after we all stopped being in one place that I realized how important informal communication with this group of people on a daily basis had been to me.

When I filed the Berkeley Ph.D. thesis in 2001 I was sure I would more likely end up teaching in Kamchatka than where I had gone to *Gymnasium*, Tübingen. But that was where I ended up. And for the better, it turned out. Dietrich Beyrau, the incomparable director of the Institut für Osteuropäische Geschichte and Landeskunde at the time, gave me all the freedom I needed. He was also very accommodating to my special challenge of trying to bridge two academic cultures, working on a *Habilitation* and teaching in Germany while at the same time publishing a first book in America. My wonderful colleagues and friends Klaus Gestwa, Katharina Kucher, and Ingrid Schierle deserve huge thanks. They had to witness at close distance the ups and downs of both the project and of a repatriate struggling to adapt to the German university system. I would further like to thank various Tübingen colleagues, some of them visiting professors or scholars, who helped in numerous ways: Michael Hochgeschwender, Oleg Khlevniuk, Yulia Khmelevskaia, Boris Kolonitskii, Anna Krylova, Aleksandr Kupriianov, Svetlana Malysheva, Christoph Mick, Oksana Nagornaia, Igor Narsky, Olga Nikonova, Natali Stegmann, Yelena Vishlenkova, and Elena Zubkova. Our Slavic librarian Zuzana Křížová was exceptionally forthcoming. What is more, at Tübingen I was blessed with stunningly capable research assistants, several of whom have gone on to careers as professional historians: Marc Elie, Luminiţa Gătejel, Mark Keck-Szajbel, Regine Kramer, Ulrike Lunow, Jens-Peter Müller, and Katharina Uhl. Jannis Panagiotidis and Alexa von Winning deserve to be singled out: they helped in the frantic final stages of manuscript preparation and proofreading.

Several people read portions of the manuscript and made very useful suggestions for improvement: Dmitrij Belkin, Michael David-Fox, Jacqueline Friedlander, Igal Halfin, Oleg Khlevniuk, Katharina Kucher, Sonja Luehrmann,

Susan Reid, Ilya Vinkovetsky, and Barbara Walker. Four people took it upon themselves to read an overlong version of the manuscript in its entirety and forced me to make cuts, to revise its structure, and to reframe some of its arguments: Olaf Bernau, Benno Ennker, Jochen Hellbeck, and Yuri Slezkine. I am enormously grateful to them.

A few extra words about Jochen Hellbeck are in order. Jochen took *shefstvo* over me at an early point and has been an exceptionally warm and good friend ever since. The dialogue with him has been essential to me, and I admire the boldness and sheer beauty of his own scholarship. Thank you, Jochen!

Jörg Baberowski, Oksana Bulgakowa, Laura Engelstein, Manfred Hildermeier, Peter Holquist, Catriona Kelly, Stephen Kotkin, and Karl Schlögel supported my work in various ways at one point or another. I received specific help from Ljudmilla Belkin and Sergiusz Michalski with art history; from Malte Rolf with Soviet holidays; from Julia Safronova with tsarist uniforms and decorations; from Irina Kremenetskaia with the graphs; from Nell Lundy with style editing; and from Irina Lukka of the Slavonic Division at Helsinki University Library with queries at the eleventh hour. I am grateful to them all.

The archivists at Moscow's Rossiiskii Gosudarstvennyi Arkhiv Sotsial'no-Politicheskoi Istorii (RGASPI), Rossiiskii Gosudarstvennyi Arkhiv Literatury i Iskusstva (RGALI), Rossiiskii Gosudarstvennyi Arkhiv Noveishei Istorii (RGANI), and Otdel Rukopisei Gosudarstvennaia Tret'iakovskaia Gallereia (OR GTG) as well as at St. Petersburg's Muzei-kvartira I. I. Brodskogo (MBr) have been of considerable assistance. Galina Gorskaia and Larissa Rogovaia of RGASPI as well as the Tretyakov's Lidia Iovleva, Tamara Kaftanova, and Irina Pronina must to be singled out for personal thanks.

I also wish to gratefully acknowledge the funding of research and writing by Berkeley's History Department, Institute for International Studies (through Bendix, Sharlin, and Simpson grants), and Center for German and European Studies; by the Mellon Foundation, the German Academic Exchange Service, and the Center for Comparative History of Europe at the Free University, Berlin.

My art historian friends kept telling me that obtaining illustrations and the attendant copyrights was tantamount to writing another book. I didn't believe them. They were right. Thanks to the Fritz Thyssen Foundation and the Universitätsbund Tübingen e.V. for offsetting the cost of reproductions. Thyssen also generously funded a two-month stay at Clare College, University of Cambridge, in 2004, where my friends Hubertus Jahn and Susan Morrissey took marvelous care of me.

I am very happy the book has found its home in the Yale-Hoover Series on Stalin, Stalinism, and the Cold War. Amir Weiner was pivotal in making this happen, and his sponsorship of my work first across San Francisco Bay, and later across the Atlantic, has been heartwarming. Thanks to series co-editor

Paul Gregory for his support and comments, to co-editor Jonathan Brent, and to Vadim Staklo, to Margaret Otzel for expertly shepherding the book through the acquisition and production process, and to Gavin Lewis for superb copy-editing. The final revisions were done at Ute Frevert's Center for the History of Emotions, Max Planck Institute for Human Development, Berlin, where I received first-class help from my research assistants Stefanie Gert and Eva Sperschneider. Karola Rockmann did a heroic job in preparing the index.

A few sentences of Chapters 2 and 4 appeared in "Georgian Koba or Soviet 'Father of Peoples'? The Stalin Cult and Ethnicity," in *The Leader Cult in Communist Dictatorships: Stalin and the Eastern Bloc,* ed. Balázs Apor et al. (Basingstoke: Palgrave, 2004), 123–140. Parts of Chapter 3 appeared in "The Spatial Poetics of the Personality Cult: Circles Around Stalin," in *The Landscape of Stalinism: The Art and Ideology of Soviet Space,* ed. Evgeny Dobrenko and Eric Naiman (Seattle: University of Washington Press, 2003), 19–50. I thank the publishers for permission to use this material here.

My mother Gudrun, my father Harald and his wife Evelyn, my brother Paul, my in-laws Victor and Yelena Mushkatin, and especially my mother-in-law Oxana Strizhevskaya jumped in at critical moments with childcare, money, and much more, for which I am very grateful. Finally, I should note that the writing of this book involved precious hours of pleasure, but also occasional suffering. The former I enjoyed in solitude, the latter I shared generously with my own family: Irina Kremenetskaia and our daughters Olga and Lisa. They deserve a public apology and my most heartfelt thanks.

Introduction

Sergei Kavtaradze, an Old Bolshevik who had known Stalin long before the Revolution, was fond of telling the following story. On his 1940 release after almost a decade in the Gulag, Beria and Stalin, to whom he owed his release, accompanied him to his Moscow apartment. As it turned out, parts of the Kavtaradze family's apartment were now occupied by a woman (also an Old Bolshevik) who had lost her own residence. The bell rang and the new tenant opened the door. When she saw Stalin, the woman staggered backward and fainted. Beria managed to catch her before she hit the floor. He shook her and asked what had scared her and why she was backing off from the "father of peoples." The woman replied: "I thought that a portrait of Stalin was moving towards me."[1]

Artyom Sergeev, Stalin's adopted son, was also fond of telling a story. He recalled a fight between Stalin and his biological son Vasily. After he found out that Vasily had used his famous last name to escape punishment for one of his drunken debauches, Stalin screamed at him. "'But I'm a Stalin too,' retorted Vasily. 'No, you're not,' said Stalin. 'You're not Stalin and I'm not Stalin. Stalin *is* Soviet power. Stalin is what he is in the newspapers and the portraits, not you, not even me!'"[2]

Kavtaradze's and Sergeev's stories are emblematic of the immense sway of the Stalin cult: in the collective imagination Stalin had become indistinguishable from his portrait. Stalin's portraits had saturated Soviet space, and through portraits Soviet citizens formed an image of their omnipresent leader. These portraits—and the many other manifestations of the cult—stirred the bodies and minds, the thoughts and feelings, of people from all walks of life in the Soviet Union (and leftists abroad) in ways difficult to fathom from today's perspective. Fearing the spiritual presence of the leader, a group of Moscow students,

including six World War II veterans, turned the Stalin poster on their dormitory wall around in order to feel free enough to talk openly about their experiences at the front; after the Mexican painter and former Trotskyist Frida Kahlo committed suicide in 1954, a Stalin portrait was found on her easel; the writer Boris Pasternak was "ecstatically" carried away when he saw his leader in vivo at a Komsomol Congress in 1936; in his youth, the future dissident Vladimir Bukovsky was haunted by dreams in which he failed to save Stalin from drinking a poisoned glass of water; ordinary people shed tears when Stalin died, and were trampled to death at his funeral; and others, among them victims of Stalin's terror, reacted so intensely to Stalin's death that they suffered heart attacks.[3]

A woman fainting when she saw Stalin, a writer working himself into a state of ecstasy when in physical proximity to Stalin, a future dissident suffering from nightmares about Stalin getting poisoned, victims of Stalin's violent policies dying of heart attacks when hearing about Stalin's death—these testimonies seem the stuff of mystery, magic, and transcendence. This book takes the transcendental effects of the Stalin cult very seriously, but it also claims that a story is hidden behind Stalin's portrait, the story of how the cult was actually made. The Stalin portraits, posters, drawings, statues, busts, films, plays, poems, and songs, which I collectively call "cult products," did not arise ex nihilo. They were created by specific people and institutions through concrete practices: as Clifford Geertz put it, "majesty is made, not born."[4] These practices—or the "cult production"—can be reconstructed. This book, then, is a history of the practices of Stalin portraiture. It ventures into the studios and peers over the shoulders of the painters, their Bolshevik patrons, the cultural functionaries, the censors, and many others, who produced the Stalin cult.[5]

What was the Stalin cult? The cult began on 21 December 1929, when on the occasion of his fiftieth birthday Stalin was glorified on a broad scale in various media—first and foremost in central newspapers like *Pravda*. This powerful beginning was followed by three and a half years of absence from the public stage, which is usually explained as Stalin's attempt to avoid any association with the catastrophic results of forced collectivization or as a result of his as yet unconsolidated power position in the Party.[6] In mid-1933 the cult took off in earnest and by the end of the 1930s his depiction in the various media had coalesced into a coherent system of signs—a canon—that was maintained from then on, even though it still evolved. The celebration of Stalin's sixtieth birthday in 1939 was one of the cult's high points, whereas the Second World War marked a hiatus. The cult picked up speed in early 1945, and Stalin's seventieth birthday in 1949 (also celebrated in the Eastern European "people's democracies") served as another apex. After Stalin's death on 5 March 1953 the cult was quietly yet noticeably phased out in the Soviet Union (but not in the satellite states). The real end of the state-sponsored Stalin cult came with Nikita Khrushchev's de-

Stalinization initiative in 1956, when the entire Soviet bloc embarked on an unprecedented iconoclastic campaign.

This book focuses on 1929–1953, the active period of the cult during Stalin's lifetime.[7] It also focuses on a specific place: Soviet Russia.[8] And while this study takes into account film, folklore, and poetry, its center of gravity is Stalin portraiture, specifically oil painting. All media were engaged in a continual competition for the status of the master medium. In the master medium the key images of Stalin—for example, as statesman, military commander, or coryphaeus of science—were first formulated and later canonized. Other media copied the master medium. Oil painting and photography were at the top of the hierarchy until they ceded this position to film in the second half of the 1930s. Mikhail Romm's *Lenin in October*, released in 1937, was the first movie starring an actor as Stalin, and from then on cinema became the master medium.

The Stalin cult was an overwhelmingly visual phenomenon, tailored to a population whose mental universe was shaped primarily by images, as opposed to written words. When the cult was inaugurated in 1929, the Soviet Union had just launched its effort to modernize at a breakneck pace through industrialization and the collectivization of agriculture. As part of this campaign the state stepped up efforts to promote literacy, a formidable task in a land where the 1926 census had revealed an illiteracy rate of 34.6 percent for males and 63.3 percent for females.[9] Many Soviet citizens could access Stalin only visually, and those who had just learned to read and write still perceived the world primarily through images. What is more, oil portraits of Stalin played a leading role in the making of the Stalin cult because certain other media were not available for this purpose. Socialist realist novels, for example, hardly ever featured Stalin as their main hero. These works followed the conventions of bildungsroman, in which the hero progresses along a linear path by overcoming obstacles, emerging, in the end, as a different and a better person—a Soviet "new man." Stalin, however, could not be shown in the process of becoming, for Stalin had long before completed his journey to a higher kind of personhood.[10] Stalin quite simply "was." He, an d only he, embodied the endpoint of the utopian timeline. As such he was beyond time and place.[11]

What is a personality cult? There are many definitions, and the first distinction I make is between the historical term "cult of personality" (*kul't lichnosti* in Russian) and the analytical term "personality cult." At its most basic level I take a personality cult to be the symbolic elevation of one person much above others. I circumscribe the range of personality cult objects by focusing on living or deceased real human persons, not allegorical beings ("Marianne" as the embodiment of the French nation, "Uncle Sam" as the United States of America, or "Hermann" and "Michel" as Germany), nor collectives of persons (the Japanese people), nor abstract ideas (reason).[12] These persons as cult objects are all

from the sphere of politics, not religion (the pope), literature (celebrated writers as national symbols), film (movie stars), music (pop stars), or sports (famous athletes). Through the process of elevation the person who is glorified in a cult comes to be endowed with something I will interchangeably call "sacrality" and "sacral aura."

My understanding of sacrality is indebted to the work of the sociologist Edward Shils. For Shils, it was axiomatic that "society has a center. There is a central zone in the structure of society." His second axiom holds that "the central zone partakes of the nature of the sacred."[13] Sacrality and authority are tautologically intertwined: "Authority enjoys appreciation because it arouses sentiments of sacredness. Sacredness by its nature is authoritative. Those persons, offices, or symbols endowed with it, however indirectly and remotely, are therewith endowed with some measure of authoritativeness."[14] I modify Shils's conception of sacredness in one important respect: sacrality need not exist a priori in every society; rather it is historically conditioned and culturally constructed in many different shapes and forms.[15]

While sacrality shares features of Max Weber's concept of "charisma," sacrality has a number of distinct advantages for an analysis of modern personality cults. One is its flexibility. For Weber, charisma remains locked in a grid of ideal types of authority.[16] An added advantage over Weber's charisma (and the anthropologist Victor Turner's "communitas") is that sacrality has stronger religious connotations and better conveys the echoes, traces, and rechanneling of religion in the modern, purportedly "disenchanted" world.[17] At the same time sacrality avoids the pitfalls associated with the direct transposition of religious categories into politics, which characterizes the notions of political religion or political theology that go back to the sociologist Émile Durkheim and the political theorist Erich Voegelin.[18]

Sacrality is a concept that does justice to both the premodern and the modern elements in the phenomenon of the Stalin cult.[19] Let me illustrate with Stalin portraits: scholars have often equated their social and emotional functions, their visual morphology, and their production with those of icons in the Byzantine, Russian Orthodox tradition. And indeed, Stalin portraits were sometimes hung in the "red corner," the place in a room formerly reserved for the icon. Stalin portraits were experienced not just as constative or mimetic images; but rather, like icons, they were perceived as performative images that enact a change in the viewer. Just as icons were often covered with a curtain during spousal arguments in order to block the saint's gaze (and avoid his punishment), so the Moscow students turned the Stalin portrait around because the energy pouring from the leader's image made it impossible to converse freely. The colors used in Stalin portraits sometimes suggested the symbolic valence of colors in Russian icons. During and after production painters and art critics described Stalin

portraits in terms that had long been used in discussions of icon-painting: For example, *zhivoi* (life-giving), which denotes the discharge of sacral energy, and *obraz* (image), which signifies a Russian Orthodox, nonmimetic, performative image.

One cannot simply equate icons and Stalin portraits, however. To do so is to gloss over other influences and qualities that are specific to Stalin portraiture. For example, the realist tradition, which drew upon both Western nineteenth-century portraiture and the Russian Wanderers (*Peredvizhniki*), is a key element of the portraits. Knowledge of icons will not explain the direction of Stalin's gaze, which was invariably directed at a focal point outside the picture; for Stalin was perceived as the embodiment of the linear, Marxist force of History. He, indeed, only he, could see the end of the utopian timeline: the future of communism. Finally, the concrete practices by which these images were produced obviously bore scant resemblance to the crafting of icons.

This book places the Stalin cult squarely within the rubric of modern political personality cults. The first cult of this kind was that of Louis-Napoleon Bonaparte, who was crowned Emperor Napoleon III in 1851. Five characteristics set modern personality cults apart from their premodern predecessors. First, all modern personality cults were the children of mass politics: they were directed at (and derived their legitimacy from) the entire population, the "masses," whereas monarchical cults were often directed at (and depended on the allegiance of) an elite group. Second, they all used modern mass media that allowed for the mass dissemination of cult products such as films and posters, whereas earlier cults had reached only a limited number of people. Furthermore, because of the spread of cultural techniques like reading and writing through such modern institutions as universal schooling and mass conscription, the cult artifacts disseminated were not only uniform, but also potentially readable by the entire population. Third, modern personality cults emerged only in closed societies. Closed societies have a highly circumscribed public space, making media-transmitted criticism of a leader cult or the introduction of a rival cult nearly impossible. In most closed societies the state exercises a high degree of violence, and the political personality cult is usually crucial in defining the relationship between ruler and ruled. Fourth, modern personality cults were invariably children of a secular age, one which had expelled God—however imperfectly—from society's metaphysical space.[20] By introducing a new political vocabulary of "nation" and "popular sovereignty" the French Revolution created other, secular sources of political legitimacy. The modern leader cults must be understood in the context of popular sovereignty: the modern leader's body now absorbs all of the sacral aura and serves as metaphor for everything, for all of (homogenized) society.[21] Before that, there were divisions of the king's body along the lines described by Ernst Kantorowicz, and the reference to

God was always included; the king's body was never a signifier for everything, but only for a part, while after the French Revolution the leader's body came to represent the totality of society.[22] Fifth and finally, the modern personality cult was an exclusively patricentric phenomenon: the objects of veneration in modern personality cults were men, whereas premodern cults had often celebrated queens, tsaritsas, and princesses.[23] The reason for this patricentrism lies in popular sovereignty as a source of legitimacy: since the cult object must somehow represent the population, and since power in this population is distributed unequally according to gender, the personality cult reflects this asymmetrical distribution and represents those members of society who are most powerful—men.[24]

Given this understanding of the modern personality cult, we must conclude that neither Franklin Delano Roosevelt, Charles de Gaulle, nor Ronald Reagan possessed one. And yet, despite all the differences, there are certain discomforting commonalities between modern personality cults and the image politics practiced in more open societies. Both employ the modern mass media in breathtakingly manipulative ways to project fabricated images of political leaders in an effort to muster the population's support. Both use similar techniques in measuring a politician's success at "marketing" himself to the population. Both began to assume their present form during the First World War, which in several different ways ushered in the age of mass politics—through the need to engage the entire population, often by blurring class and gender lines to promote the total war effort; by paying the postwar peace dividend by expanding the franchise; and by claiming legitimacy based on the support of the entire people, rather than one or another particular group.

For most of its history the Soviet Union officially condemned "personality cults." Marxism, after all, stresses collectives over individuals and material forces over individual agency, and then there was the fact that prerevolutionary Russia had celebrated the cult of the tsar. Even while Stalin was being glorified, inside the Soviet Union it was impossible to speak of a "personality cult." Instead, the Soviets wanted their citizens and the rest of the world to believe that the glorification of Stalin was the result of genuine democracy: the people spontaneously and naturally expressed their love for their leader, Stalin, who could only accept these expressions of love and grudgingly tolerate the cult. In seeking to reconstruct the cult's hidden history, then, the researcher must scour the sources for an object that, in official terms, did not—and could not—exist. Unlike Fascist Italy or Nazi Germany, both of which had no ideological qualms about their respective leader cults, the Soviet Union never generated straightforward records revealing how its cults were made. Hence documents pertaining to the Stalin cult that have emerged from the state and Party archives during perestroika and

especially after the collapse of the Soviet Union are not located in one or several clearly defined archival collections. For the Stalin cult there is nothing like, say, the files of the "commission for the immortalization of Lenin's memory" that was set up right after his death in 1924 and where all the documents to study Lenin's early posthumous cult can be found.[25] Instead, Soviet embarrassment over the existence of a Stalin cult obliges the historian to perform his detective work in an unusually wide range of sometimes unlikely sources from every corner of Soviet life.

Part One of this book examines the products of the Stalin cult, while Part Two treats their production. By products I mean not only the portraits and other cult artifacts themselves, but also the ways in which their meanings were created: the canonical patterns through which Stalin's image was projected; the changes in his image over time; and the ways in which people in different contexts made sense of these cult products. By production of the Stalin cult I mean the multilayered making of cult products: the mechanisms of their creation; the process of deciding who was to portray Stalin in what fashion; and Stalin's own influence on the way in which he was depicted. The line I have drawn between products and production is neither real nor analytically sustainable but rather a device used to shape the architecture of the book. In fact, this study presupposes that the modes of cult/ural production cannot be divorced from cult/ural products, that the meaning of a cult product is always constituted in a loop that includes the ways in which the cult product was made.

The book's prologue, Chapter 1, reconstructs the Russian and international historical pathways to the Stalin cult, from Napoleon III via the tsars, Mussolini, and Lenin. It shows how modern personality cults emerged "entangled" from the First World War. Chapter 2 tracks Stalin's visual representations in the central Soviet newspaper *Pravda* over time (1929–1953). It chronicles changes in the visual portrayal of Stalin over the course of the cult's existence and spotlights some of the visual strategies used to elevate him above his comrades-in-arms during the cult's ascendancy. Chapter 3, the book's most "art-historical," interprets Aleksandr Gerasimov's painting *Stalin and Voroshilov in the Kremlin,* focusing on the work's spatial organization. This interpretive effort is set within additional contextual webs, including those of the painting's making.

In Part Two, Chapter 4 concentrates on the role of individual actors in the production of the Stalin cult. It begins at the apex of the polity, with Stalin himself, and shows that while affecting humble resistance to the construction of his cult, he in reality wanted and played an important role in it. I then turn to Kliment Voroshilov, the main patron of visual artists, including Stalin's portraitists, and examine the connections between patronage and personalized power. Chapter 5 looks at the institutional actors central to the production of the Stalin cult, including the visual artists' union, the publishing houses, and the

censorship board. I conclude that there never was anything like a "Stalin cult ministry" but instead a multitude of personal and institutional actors vied for influence in cult-making. Stalin's position alone was never in question; he was the ultimate arbiter who could cut across all established lines of command and he was the final filter for a lot of cult products. Chapter 6 focuses on the visitor comment books (*knigi otzyvov*) that were put out for the public at Stalin exhibits. In analyzing visitors' actual comments, the chapter grapples with the knotty matter of the cult's "reception."

In telling the story behind Stalin's portraits, I have sought to demystify and historicize the Stalin cult. And yet, no matter how hard I tried to historicize it, I feel that I often arrived at the limits of what we can know about the cult, about any cult. The more I focused my lens, the harder it became to see my specimen. How are we to understand a woman who faints on seeing Stalin, a writer deemed an anti-Stalinist who works himself into a state of ecstasy on coming close to Stalin's physical body, a future dissident who suffers nightmares about Stalin being poisoned, victims of Stalin's violent policies who die of heart attack on hearing of Stalin's death? In short, what really went on between ruler and ruled?

In many respects the Stalin cult worked like alchemy. Alchemy begins with a careful choice of discrete elements. These elements are then combined. They interact and the result is a sum total that is more than and different from the original elements. If alchemy is the endeavor to transmute base metals into gold, then the alchemy of power was such a process of transmutation. The net result was a Stalin who seemed larger than—indeed different from—real life. The alchemical process is what we are about to step into.

1 Paths to the Stalin Cult

CRITICISM OF STALIN'S rule has centered on the Stalin cult since the cult's inception. The disjuncture between the Stalin cult and an ideology that propagated collectivism and professed to have radically broken with the past, including the cult of the tsar, appeared so outrageous that simply describing the lionization of Stalin in some detail seemed entirely sufficient. As Stalin's archrival Leon Trotsky complained in January 1935, "The Stalinist bureaucracy has created a revolting cult of leaders (*kul't vozhdei*), endowing them with divine attributes."[1] The habit of describing, not analyzing, the cult as sufficient evidence for the depravity of Stalinism continued in the West after the onset of the Cold War, even if the Stalin cult now symbolized Soviet-style communism and Marxism as a whole. As a result, in writings about the Stalin cult there is an imbalance between description and analysis, with the scales tilted in favor of the former.

Where scholarship has moved beyond description and analyzed the Stalin cult, this analysis has focused on the cult's genesis, functions, and products. Its production or making have barely been discussed, and the second part of this book seeks to remedy this, while the first part adds to the analysis of the visual cult products.[2] As for the genesis of the Stalin cult and the closely related question of its functions, some scholars have interpreted the cult as a peculiarly Russian phenomenon, viewing it as a relapse into eternal Russian mysticism-cum-authoritarianism, embodied in the twin institutions of the monarchy and the Russian Orthodox Church.[3] Quite a few have located the origins of the cult in the dictator himself, seeing the cult as the outgrowth of Stalin's (psychopathological) personality.[4] Other scholars find the question of Stalin's personality irrelevant since a private cult of self-aggrandizement that is not disseminated to the populace would be futile. Instead they have pointed to the power dynamics

of Stalin's entourage, his closest comrades-in-arms, as the locus from which the cult sprang forth.[5] In a similar vein, some have traced the origins of the cult to intra-Party "political culture."[6] Several authors see a wider society responsible for the beginning of the cult, viewing it as a concession to the peasant mentality of the social upstarts (*vydvizhentsy*) brought to power by Stalin. The cult was the price the Bolsheviks paid for social integration.[7] Some believe the cult to be a constitutive and inescapable feature of all totalitarian movements, including Italian Fascism, Nazism, and Stalinism.[8] Others view the cult as the product of cultural and ideational trends: the result of Nietzsche's influence and his philosophy of voluntarism embodied in the superman, or as a specifically Stalinist aesthetic structure or ideal type called "culture number two" (*kul'tura dva*).[9] And yet others think that Bolshevism was a kind of political religion and the Stalin cult just one aspect of this religion.[10]

This book seeks to add to these explanations of the cult's roots above all by situating the cult in history, more precisely, in the context of modern personality cults.[11] The historical paths that led to the Stalin cult were tangled and many. The sacralization of the human person in the wake of the Enlightenment and the French Revolution, the concept of popular sovereignty first put into practice in the French Revolution, modern personality cults outside Russia, and the tradition of the cult of the tsar were all important signposts. The leader-centered circles (*kruzhki*) where so many young Bolsheviks were schooled constituted another crucial way station. Taken together, these paths offer a compelling answer to the question how Stalin's alchemy of power could have started in the first place.

THE FIRST MODERN PERSONALITY CULT: NAPOLEON III

In the middle of the nineteenth century the acceleration of the desacralizing dynamic of monarchs ushered in an age from which on we can speak of personality cults as modern. During the rule of Tsar Alexander II the case of France's Emperor Napoleon III introduced a new form of leader representation that not only became a model for his Russian counterpart but also—surprisingly—became the first modern personality cult (Fig. 1.1).[12] Louis-Napoleon Bonaparte came to power as president of the Second Republic through an election after the introduction of universal adult male suffrage in the revolution of 1848. After a coup d'état in 1851 he was proclaimed emperor in 1852 and ruled until 1870. Thanks largely to the *fête impériale*, i.e. the ensemble of spectacles, parades, myths, and symbols, he "dazzled and seduced the French populace."[13] What allows us to speak of him as the world's first "democratic despot" with a modern personality cult?

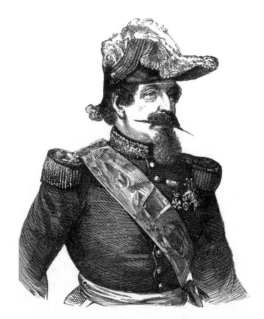

Figure 1.1. Napoleon III, object of the first modern personality cult. This etching shows him uniformed and with his insignia of power (the medals); no special skills are needed to decipher these—the image is addressed at the entire population. Source: Israel Smith Clare, *Illustrated Universal History* (Philadelphia: J. C. McCurdy and Co., 1878). Retrieved with permission 1 June 2007, from http://etc.usf .edu/clipart/200/278/napoleon3_1.tif

The source for Louis-Napoleon's legitimacy was the people and the plebiscites through which they had expressed the general will. It was not a "cosmology of divine right and a rule that transcended his physical body."[14] When Napoleon III, like his uncle Napoleon I, went on a royal tour throughout the Empire, he gave different meaning to a form pioneered by the old divine right monarchs, as "the chief signs of Napoleon III's dominance were the massive crowds that turned out to welcome him in every corner of the Empire."[15] He presented himself as being close to the people by using, for instance, a populist, pro-worker tone in his speeches, whenever and wherever politically expedient. He used charity in what Matthew Truesdell has felicitously called a "politics of sincerity." In propaganda, he exploited his marriage to a minor noblewoman— not a royal personage—as an emblem for his down-to-earth nature.[16] Unlike a medieval king, Napoleon III was not represented as a magic healer in possession of mystical healing powers, and unlike Napoleon I, his nephew never made use of the coronation's *sacre* (the mystico-monarchical ceremony going back to prerevolutionary France) and emphasized economic development rather than foreign wars.[17] Napoleon III claimed to represent the nation and its history, i.e. its—invented, to be sure—continuity with the past.[18] Like Mussolini and Hitler after him, he was a "modern democratic dictator"—he presented himself as being of the people yet towering "above politics and petty party squabbles."[19]

Moreover, Napoleon III made use of the modern mass media more fully and persistently than anyone before him. Spectacles were produced in proto-capitalist

fashion with open bidding, in which different decoration companies vied for contracts to stage, for example, the *fête nationale* (as the celebration of Napoleon I's birthday had come to be called).[20] In these royal spectacles, the staging of mass participation and approval was crucial; there were even "paid cheerers" and "official shouters."[21] In a fascinating adumbration of twentieth-century personality cults, the "government paid very close attention to the popular response to the August 15 celebrations. Officials sometimes systematically went through the newspaper reports, and prosecutors and prefects both reported on how the celebrations had been received in their districts, after getting reports from their subordinates."[22] The signs that represented the emperor were a hybrid drawn from ancient and modern sources. Thus the overwhelming success of Louis-Napoleon in the 1851 plebiscite was celebrated in the following way: "At ten o'clock, the Invalides cannon marked the beginning of the celebration by slowly booming out seventy-five times—ten times for each million 'yes' votes in the plebiscite."[23] The press was the leading medium used to represent the live spectacles to members of the nation beyond the participating masses. In the early years of Louis-Napoleon's rule, opposing accounts of the popular response to the spectacles still appeared, but later the "regime maintained a virtual monopoly on public discourse" through censorship and other measures.[24]

The features that allow us to qualify Napoleon III's personality cult as modern did not arise from a vacuum. The ingredients of his cult predated his reign, but Louis-Napoleon was the first to combine them to create Bonapartism, a monarchy supported by mass elections. The most momentous shift had occurred with the French Revolution, which marked an enormous acceleration of the desacralizing dynamic that began in the early eighteenth century. It affected all European monarchs and their cults (Russia was no exception). The revolution injected into the political sphere the new terms of "nation" and "popular sovereignty," thus supplying nonmonarchic sources of political legitimacy. Modern personality cults like that of Napoleon III reflect the instability of popular sovereignty: the modern leader's body now absorbed all sacral aura and served as metaphor for everything, all of (homogenized) society. Premodern personality cults differed in that the reference to God was always inscribed on the king's body; the king's body was never a signifier for everything, but only for a part, while the postrevolutionary monarch's or leader's body came to represent the totality of society. From the concept of popular sovereignty something else followed: the cult object had to be male, because the new kind of sovereignty reflected social inequalities, including the rule of men. Clearly, also, the cult of Napoleon III was directed at the entire French population, not, for instance, just the nobility. And because it was directed at the entire population, it used the newly available mass media for its dissemination. The cult products spread via these mass media were no longer, say, unique single copies of a painting, but

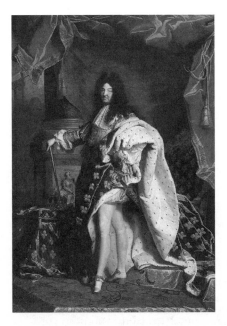

Figure 1.2. Hyacinthe Rigaud, *Portrait of Louis XIV* (1701). Only a small part of the population would have been able to understand that the bottom of the column shows the allegorical figure of justice. This is a painting of a premodern personality cult. Oil on canvas, 279 × 190 cm. Original at Musée du Louvre, Paris.

mass-produced uniform products like posters aimed at the entire population. This population had increasingly been subject to modern schooling and the modern army and had thus been inculcated with the cultural techniques necessary for a potentially uniform reception of the cult products—unlike a premodern population that might assign highly group-specific meanings to a cult product.[25] Thus Hyacinthe Rigaud's portrait of Louis XIV was interpreted in one way by those equipped with the cultural techniques necessary to decipher its classical allegory and in another way by those who lacked these techniques (Fig. 1.2).[26] Finally, the public arena under Napoleon III was sufficiently closed to prohibit, for example, the introduction of a competing political figure with a cult. The cult of Napoleon III for the first time encapsulated all these five characteristics that typify a modern personality cult: the secularism and the new basis on popular sovereignty; the patricentrism; the targeting at the masses; the use of mass media and uniform, mass-produced cult products; and the limitation to closed societies.[27]

HOW THE CULT OF THE TSAR FAILED AT BECOMING MODERN

The changes in Western European monarchic representations affected the Russian tsars as well. Alexander III, who ruled from 1881 to 1894, felt that educated society had thoroughly discredited itself during the reform era of his predecessor Alexander II (ruled 1855–1881). Increasingly, Alexander III became both a Slavophile and a Germanophobe. The emperor's representations came to be

directed at a mysticized, Russian—not multinational—"people." The concept of the "people" (*narod*) now included the peasants, with whom Alexander III was connected through bonds of nationality (Russianness) and religion (Orthodoxy). For the first time, a tsar made use of the mass-circulation press to project his image. Published by the Ministry of the Interior, the newspaper *Village Messenger (Sel'skii Vestnik)* was targeted at the peasants, and "by 1905 its circulation reached 150,000."[28] The monarch's image always included the empress and the imperial family.[29] It stressed their piety and portrayed them as "sympathetic human beings, recognizable to the common people."[30] At the coronation and under conditions of tightened censorship, both domestic and foreign news reports were skillfully manipulated to demonstrate the popular support for Alexander III. Overall, the court was viewed as discredited, and the rituals of the emperor's cult were played out on different stages. Apart from the print media, the cult disseminated its message through several channels: ceremonies that took place outside the court, and realist portraiture, including works by Ilya Repin, a member of the "Wanderers" movement in painting.[31] Given such successful "propaganda," the government and the tsar himself imagined that he had bonded with the people, particularly with the peasants. The rulers believed the myth they themselves had created.

After Alexander III's early death in 1894, Nicholas II continued the national scenario, further devaluing the court as an arena for monarchic symbolism. If Alexander III had looked upon parts of the court with suspicion, Nicholas II distrusted all officials and regular administration. He sought direct spiritual bonds with the people and greatly expanded the pious, religious component introduced by Alexander III. This was most dramatically and famously symbolized by Rasputin, and was manifested in general by the "charismatic holy men from the people" via whom the tsar and his wife sought a connection to their God, bypassing priests, rites, and institutions.[32] It was also manifested in the coronation ceremonies, as Richard Wortman has explicated: "In 1881 the national myth shifted focus from the consecration of the monarchy to a consecration of autocratic power as a sacrosanct as well as historical Russian tradition. Nicholas II's reign took this a step further: the coronation bestowed consecration not on the monarchy but on the monarch himself as the chosen of the Lord."[33]

As the old regime drifted towards revolution, Russia was characterized by two increasingly diverging developments: while ever more segments of society sought enlarged political participation, Nicholas II reverted to an ideal of "a pure autocracy where a tsar drew personal authority from God and the people, unencumbered by institutions of state."[34] Even the revolution of 1905 and the introduction of a parliament (the Duma) were perceived by Nicholas II not as a crack in his bond with the people, but rather as the work of "enemies"—

allegedly Jews and revolutionaries—who had directed his "good" people away from the right path.

The tsar cult's means of communication changed dramatically under Nicholas II. To begin with, three historical celebrations—the bicentenary of the Battle of Poltava in 1909, the centenary of the Battle of Borodino in 1912, and the tercentenary of the Romanov dynasty in 1913—were modeled on festivities of Victorian England, shifting the site of ceremony outside the palace, making monarchs "objects of mass popular love and acclaim, attracting attention to their *persons* rather than the office of the sovereign, and connecting the monarchy with a national, popular past."[35] Still more important, after 1905 Nicholas began to compete with the Duma in the same sphere, trying to win mass support. This was the most dramatic development of the Russian monarchy at the century's beginning. Ultimately, it proved self-destructive, for playing the game of mass politics stripped monarchy of its elevated qualities. For instance, in order to reach the masses, the government introduced (for the first time) postage stamps bearing the emperor's portrait. Many postal officials, however, refused to cancel these stamps, because they were afraid to defile the image of the tsar (Fig. 1.3). Nicholas's likeness had been turned into a mass, everyday image and had lost its magic in the eyes of ordinary people who were steeped in a premodern representational culture. Among the other new modes of representation were the theater (following the lifting of an 1837 ban against the representation of tsars on stage), documentary cinema, the first-ever biography of a living tsar (by Elchaninov, 1913), kitschy mass-produced tercentenary souvenirs, and other print media.[36] The qualities of the different media had a strong impact on ruler representations. Photography of the tsar, for example, was perceived as a more mimetic medium, showing the tsar with greater verisimilitude than any other. Photographs of the tsar were, however, perceived as lacking in luster, compared to the painted images with which the public was familiar. Thus Nicholas attempted to become the first modern tsar, addressing his myth to the masses and

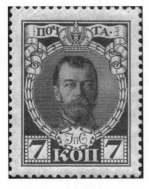

Figure 1.3. On 1 January 1913 for the first time in Russian history the government issued postage stamps depicting the tsar. This is the seven-kopek stamp that officials were loath to cancel, fearing desacralization of their emperor, Nicholas II. Retrieved with permission 1 June 2007 from Evert Klaseboer's online classical stamp catalogue.

employing the latest technical means to do so. Nicholas II "vied with the Duma and in so doing relinquished the Olympian superiority to politics fundamental to the imperial myth."[37] This was but one of the many symbolic dilemmas that beset Russian monarchic ceremony, but one that contributed significantly to bringing the Russian monarchy to its fall in 1917.[38]

As much as the Bolsheviks tried to distance themselves, the tradition of the cult of the tsar, itself a part of the wider European context of monarchical cults, weighed upon them. The sum of the specific ways in which the Bolsheviks took this tradition into account is something one might call a "tsarist carryover."[39] Occasionally this perception entered the self-reflections of the Bolsheviks, as in Stalin's statements: "the people need a tsar" and "don't forget that we are living in Russia, the land of the tsars . . . the Russian people like it when one person stands at the head of the state."[40] Yet the Stalin cult was not a simple relapse into the cult of the tsar. The "revenge of Muscovy" thesis cannot capture the multiple and different ingredients that combined to produce the Stalin cult.[41] The tsarist ingredients were but part of this hybrid phenomenon.

Given the existence of a tsarist carryover, it is important to examine the specificity of the tsar cult. Russian monarchy had always borrowed from either the Western or the Byzantine traditions. Byzantium had been the main source of inspiration until Peter I. From Peter I until Alexander II, Russian imperial symbolism relied on Western models, mostly classical, but beginning with the nineteenth century, also on recent Western models such as that of King Frederick the Great of Prussia. In 1881, Alexander III reversed this appropriation of the Western tradition and returned to an invented Russian, Muscovite tradition. The systems of representation used by Alexander III and Nicholas II were "national" in their use of signs. The "nation" likewise came to play a huge role for the intended audiences of the tsar cult. The cults of eighteenth-century tsars were still directed exclusively at the noble elite of Russian society. This changed as the ripple effects of the French Revolution introduced Russia to the concept of "nation." Alexander I became the first emperor to include parts of the *narod* in his ceremonies, if only at the coronation, and if only from estates other than the peasantry. In the wake of the Decembrist rebellion, Nicholas I had for the first time consciously excluded a part of the elite (parts of educated society, of whom he had become suspicious) from his cult, and instead emphasized more emphatically his connection to the people. Nicholas I's son, Alexander II, had reversed his father's course and appealed to all parts of society, including educated society, in his symbolic program in order to garner support for his reforms, such as the emancipation of the peasants in 1861. Alexander III, in turn, embarked upon a radicalized Nicholaevan symbolic itinerary and tried to exclude all of educated society and most of the nobility, especially its non-Russian parts, from his cult. Nicholas II took this course even further, bypass-

ing not just the elites, but regular administration altogether, and returning to an archaic notion of direct, religiously colored, and mystically inclined politics that based itself on an imagined timeless bond with the *narod*. For him the *narod* now meant the masses, that is, the peasantry. It was now an age of mass politics, which Russia had entered willy-nilly with the 1905 revolution and the introduction of the Duma. Thus a narrative of the intended audience of the cult of the tsar might well look like a linear progression, of shifting downward to the large base of the social pyramid. The story starts with a tiny elite group, and at empire's twilight encompasses nearly all of society, including the peasants, but excluding the elite.

Similarly, the range of signs and methods used to elevate the monarch also widened over the centuries. This was partly due to technological developments, and partly to the intention to project the tsar's image to ever-wider segments of the population. It seems that much of what Soviet historians called "naïve monarchism" and Daniel Field called "peasant monarchism"—the unfaltering belief of the peasants in "father-tsar" (*batiushka-tsar'*)—was rapidly eroding as the old regime drifted toward revolution. Before, when anything went amiss, the peasants would typically blame the people surrounding the tsar, but not the tsar himself. Now this was changing too.[42] The botched military command of the Imperial Army in World War I only amplified this development. Nicholas II (much like Napoleon III in France before him) tried to compete with the Duma in the open field of democratic politics by projecting his image on objects of everyday life and in greater numbers than ever before. He failed miserably, and ultimately had to face the desacralization of the monarch's persona. As for sacrality, we can observe the enormous impact of the French Revolution, which rechanneled the sacral to the popular sovereign—the nation—and did much to erase the higher, metaphysical legitimizing power of God. From then on, Russian monarchy had to compete with this novel concept of sacrality. Such was the situation as Russia in 1914 entered what became known as the Great War, as the old regime drifted towards revolution, as Lenin made plans to return to his homeland from exile, and as Stalin plotted to escape from his Siberian exile.

WORLD WAR I AND THE AGE OF MASS POLITICS

Like the French Revolution or the reign of Napoleon III, the Great War was another one of those events that rapidly accelerated a continuum of change. The masses had entered the political scene with the French Revolution, but it was the war that signaled the beginning of a new age of mass politics.[43] As the first total war, World War I required the mobilization of both the home and war fronts. Unprecedented numbers of men from all social classes entered the

fighting forces and unprecedented numbers of women entered the workforce on the home front. This development created expectations of increased political participation once the war was over. The most extreme form of fulfilling these expectations was the parliamentary, representative democracy with universal suffrage of such countries as Great Britain and France. From war's end onward, any polity anywhere had to reckon with this kind of political participation as an Archimedean point of reference—whether it liked it or not.

Consumerism, accelerated by the war, further involved the masses in different ways. Mass-produced consumer goods should be made available for sale to as many people as possible, erasing differences of class, gender, and race. Modern techniques of marketing these goods were developed. Paradoxically, the more uniformly the masses emerged from these historical and economic processes, the greater the value of individual personality. It was one of the antinomies of modernity that elevation above the anonymous masses became one of the most rare and most coveted items. The more everyone seemed alike, the greater the value of being different. In America, advice literature began to de-emphasize typical character traits and to promote the nurturing of individual personality.[44] The valorization of individual personality had a strong influence on the political sphere. In Britain, France, and the United States, politicians highlighted two states of being; at the same time that of being like everyone (one of the masses) and yet also that of being different from everyone (individuals above the masses). To communicate their complex message of universalism-cum-individualism, they increasingly used the modern marketing techniques pioneered by the advertising industry. Soviet Russia was not isolated from these developments precipitated by the Great War.

RUSSIA: PERSONALITY CULTS BETWEEN TSAR AND LENIN

After more than three centuries of Romanov rule, the monarchy imploded in the February Revolution of 1917. As the tsar was disposed of, so was his public cult. As in any revolution since 1789, the February Revolution involved both caricature of the old system and iconoclasm, much of it directed at the tangible manifestations of the cult of the monarch, who had embodied the system for so long. Yet amidst the rubble of the toppled tsar statues and torn-down portraits of Nicholas, the revolutionaries immediately began to build cults around new political and military figures like Aleksandr Kerensky and Lavr Kornilov. The British ambassador to Russia, George Buchanan, recorded a soldier telling him: "Yes, we need a republic, but at its head there should be a good tsar!"[45] A Menshevik deputy of the Moscow Soviet, who had traveled in March for agitational purposes to a regiment's meeting near the town of Vladimir, reported the reac-

tion of a soldier who enthusiastically responded to his eulogy of revolution and the republic by saying, "We want to elect you as tsar," to the raucous applause of his fellow soldiers. "I refused the Romanov crown," recalled the Menshevik, "and went away with a heavy feeling of how easy it would be for any adventurer or demagogue to become the master of this simple and naïve people."[46]

Kerensky became this new tsar and the object of an elaborate cult (Fig. 1.4). His status was raised to that of a cult figure right after February, due to his theatrical capabilities and because he was the only politician who belonged both to the Duma committee and the Soviet executive committee. In other words, he was the only one who managed to bridge a gap, representing the liberal elite and the people at the same time.[47] During the coup in July 1917, the rebellious general Lavr Kornilov was likewise celebrated in a cult.[48] Yet these first post-tsarist cults of political or military leaders in Russia were small-scale, short-lived, and limited in their reach when compared with those of their tsarist predecessors and Soviet successors. They do not qualify as modern personality cults according to this book's definition.

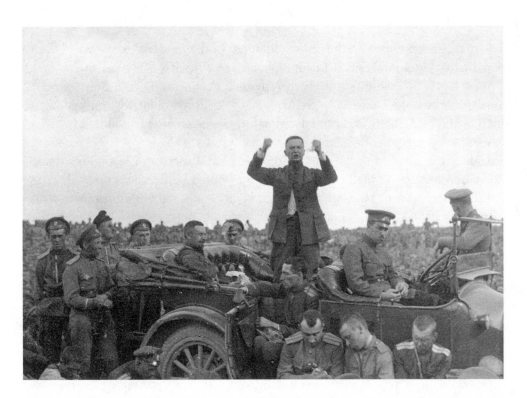

Figure 1.4. Alexander Kerensky giving a speech at the front, spring 1917. © Bakhmeteff Archive, Columbia University, New York.

Both Kerensky's and Kornilov's cults failed to reach, or be accepted by, all segments of the population. In contrast, the cults of the tsars since Alexander II (at the latest) and the Lenin and Stalin cults all achieved wide popularity. Kornilov's coup collapsed quickly and Kerensky was ousted in the October Revolution. Russia soon slid into the Civil War, which was characterized by what Boris Kolonitskii has called "polytheism," that is, multiple smaller personality cults among all fighting parties, the Reds included.[49] In fact, many of the long-lasting patronage relationships between Bolshevik Civil War military commanders and painters were forged in the crucible of the Civil War. Civil War heroes like Voroshilov, Stalin's commissar of war, began commissioning portraits from painters and reciprocated by handing out resources (brushes, money, food) that were especially scarce in time of war. Patron-client relations were formed and took on a specific shape that was to prevail throughout the Stalin period, as we will learn in Chapter 4. Patronage, a form of personalized power, and the personality cult, a form of symbolic politics, entered into a strong marriage that turned rocky only after Stalin's death.

OUTSIDE RUSSIA: PERSONALITY CULTS BETWEEN THE WARS

The first countrywide and the most influential of the modern, post–World War I personality cults in Western Europe was that of Benito Mussolini, who ruled 1922–1945.[50] Mussolini's cult both redefined the meaning of a quintessential modern personality cult and provided a stock of symbolically charged signs, such as the black shirt and the Fascist salute, to be creatively adapted by other twentieth-century dictators, most infamously Hitler (Fig. 1.5).

Italian fascism's greatest bête noire was liberal, democratic politics. It abhorred nothing more than efforts to sort out political differences through rational discourse in a public sphere and arrive at democratic compromises. Mussolini once called parliamentary debates "a boring masturbation."[51] Thus it was only after the Great War that fascism could become a viable movement. Only the war induced the changes that put liberal democracy with universal franchise on the map as the yardstick of politics. Fascism offered a chance to overcome the factionalism and lackluster aesthetics of liberal democracy through, among other things, the cult of Mussolini. In essence, it proposed an aesthetic counteroffensive to what it perceived as the grayness of liberal democracy. Mussolini was Romanticism's godlike "artist-creator" transposed from the sphere of the arts to the arena of politics. Like the Romantic artist, he absorbed huge amounts of sacral capital set free by the ousting of God from society's metaphysical space. As in the vision of the late nineteenth-century crowd theorist Gustave Le Bon, Mussolini filled his role of artist-creator in a highly specific, highly

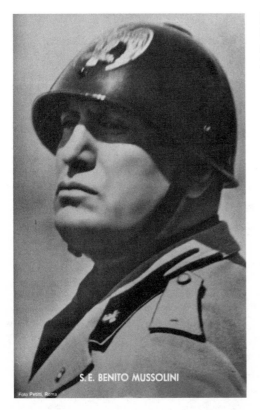

S. E. BENITO MUSSOLINI

Foto Petiti, Roma

Figure 1.5. Benito Mussolini photographed by Pettiti (1937). Black and white photograph on cardboard, 9 × 14 cm. © Deutsches Historisches Museum—Bildarchiv, Berlin.

hybridized modern inflection.[52] It was the virile *Duce* who, in sculptor's fashion, molded the anaesthetized, hypnotized, female-coded masses into a work of art; who, in an act of violent creation reminiscent always of the violence of the trenches of the war, produced out of the masses the modern, harmonious, aesthetically beautiful body national. In so doing, Mussolini overcame all of the dichotomies that threaten to tear apart the modern person—male/female, rational/emotional, mind/body, and so on. Once the harmonious body national was created, violence and disharmony shifted to the international scene, where warfare became the prized modus operandi.

The target audience of the Mussolini cult was undoubtedly the masses, the totality of society. The means employed to disseminate Mussolini's images were the modern mass media—posters, films, books, mass spectacles in sports arenas, and national holiday festivals. Technological advances allowed for an unprecedented omnipresence of *il Duce* so that he truly ended up being everywhere. The signs with which he was represented were highly amalgamated. They included so many overtly Christian religious references that the cult has been viewed as a paradigm for the (re)sacralization of politics in the modern, secular age.[53]

The Mussolini cult was highly influential because it was the first of the post-war dictator cults to be put into practice in political life. But it was never sui generis. Rather, the Mussolini cult was one variant of a common answer to the dilemmas of modernity that beset all developed nations in the postwar political order: anonymity amidst ever-growing social interaction beyond the confines of small-scale social units (family, village) through the universalizing institutions of school and army and with the help of modern communications (roads, railroads, as well as the telegraph, the telephone, and the radio); and a memory both of *Gemeinschaft* and the person-centered symbolic politics of the prewar monarchies. With the rise of liberal democracy, fascism, and Bolshevik-style socialism there were more political options available than ever before. Each of these "systems" and their attendant ideologies had universalist aspirations, which engendered a global climate of competition between differing political ways of life. Two blatant examples are the imagined competition of height between Moscow's (never-built) Palace of Soviets and New York's Empire State Building, and the real competition (at the 1937 Paris World's Fair) between the German eagle on the Nazi pavilion and the hammer and sickle carried by Vera Mukhina's *Worker and Female Kolkhoz Farmer* sculpture on top of the Soviet pavilion. Likewise, the developed nations exhibited an unprecedented degree of economic interdependency, which became patently and fatally obvious as they drifted into a downward spiral of depression after the crash of the stock market on Black Friday in 1929.

These conditions created fertile ground for leader cults, and also an as yet unheard-of interconnectedness between these leader cults once put into practice. Monarchic cults, to be sure, had also attempted to impress competing monarchs with a dazzling display of royal grandeur while copying and influencing one another. The symbolic rivalry between the "Sun King" Louis XIV and his Habsburg contender Leopold I is a famous case in point.[54] Yet the speed of this process multiplied thanks to the modern mass media. With the development of the radio, theoretically any place in the world with a receiver could be subjected to a live broadcast of Mussolini's, Hitler's, Roosevelt's, or Stalin's voice. While monarchs had been in agreement about the political order they represented, the battle of symbolic politics between the cults of Hitler, Roosevelt, and Stalin was also always a deadly standoff between the systems of National Socialism, liberal democracy, and communism respectively. Mutual dictator-watching was a natural consequence of these developments. The post–World War I leader cult ended up being entangled in new ways, by defining itself in contradistinction to another cult and the system it represented. We will revisit specific cases in the chapters to come, but let us note here that in all likelihood Stalin's pipe, stuffed with cheap cigarette tobacco, was deliberately set off against the bourgeois cigar

in general, and eventually against Churchill's cigar in particular (Figs. 1.6, 1.7; also see Fig. 3.3, p. 96). Roosevelt's optimistic, white-toothed smile, representing his belief in capitalism's superior ability to overcome economic crisis, was in deliberate contrast to Hitler's brooding, Gothic countenance (Fig. 1.8, 1.9). Hitler's eyes, as one historian has suggested, were deliberately presented as more magnetic, exemplifying the antirationalist element of National Socialism as opposed to the Soviet Enlightenment project, embodied in Stalin's eyes.[55] The modern personality cult, in other words, emerged from the Great War in the company of an "Other." It is a prime example of "entangled modernities."[56]

New symbolic "double" and "triple alliances" developed. Both Stalin and Hitler were presented—and perceived—as incarnations of viable solutions to the economic crises that struck the capitalist nations of Western Europe and the United States. Fewer Western intellectuals would have fallen prey to Stalin's cult if the Soviet Union had not celebrated its breakneck industrialization and collectivization as a resounding success against the depression in the West. In the case of Weimar Germany, with its fragile democratic tradition and its street warfare between political extremists, surely the longing for a monarchical or modern *Führer* was strong and perhaps indeed created what Hans-Ulrich Wehler has identified as an overdetermined "charismatic situation."[57] This situation was not limited to Western, Southern, and Central Europe; it extended to the East European states as well, such as Poland with its cult of Joseph Piłsudski.[58]

Unlike Germany, Italy, Poland, or Russia, the political culture of the United States had a strong tradition of elections. In the presidential elections of the nineteenth century, candidates still embodied a residual aristocratic distance and traditionally stayed out of the fray of campaigning. It was the party functionaries who communed with the mob and praised the candidate in countless speeches (nineteenth-century campaigning was primarily public speaking). In the late nineteenth century technological advances (photography) and the rapid expansion of commercial advertising necessitated that traditional political culture adopt these mass media, public relations techniques. The 1896 electoral campaign of William McKinley is considered the first time a candidate actively joined in campaigning and beat his main competitor, William Jennings Bryan, through deft usage of the mass media. Bryan had tirelessly traveled the country and reached about five million people directly, but McKinley mounted about 100 million posters.[59] This period in 1910–1911 constituted a landslide shift from program to posing. An entire photo series showed Theodore Roosevelt posed while speechmaking.[60] In many ways, the medium had (already) become the message and persona ruled over program. The American combination of commercial advertising techniques and modern personalized politics was a

Figure 1.6. Personality cults became relational during World War I. Eventually, Stalin's proletarian pipe (stuffed with cheap cigarette tobacco) symbolized communism and was juxtaposed to Churchill's cigar, which stood for bourgeois capitalism. *Pravda*, 1 January 1936, 1.

Figure 1.7. Source: Imperial War Museum, London, IWM Collections Online, Photograph H 2646.

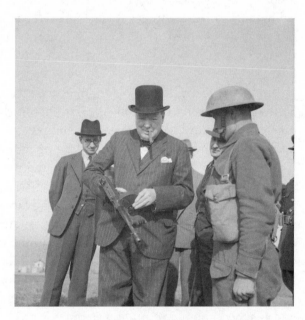

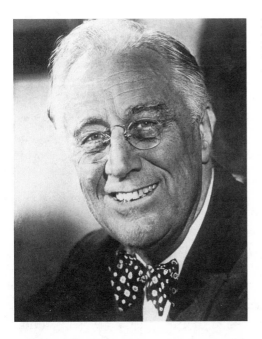

Figure 1.8. Smiling, optimistic Roosevelt . . . Retrieved 1 June 2007, from http://www.fdr library.marist.edu/images/photodb/09–1892a .gif

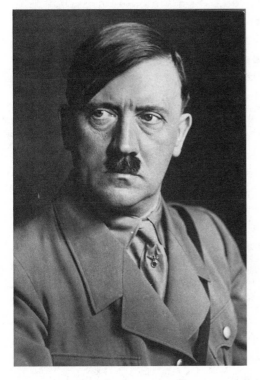

Figure 1.9. . . . and brooding Hitler, photographed by Heinrich Hoffmann (February-March 1933). Black and white photograph on cardboard, 12.3 × 8.3 cm. © Deutsches Historisches Museum—Bildarchiv, Berlin.

trendsetting and inspiring example. There are grounds to believe that Heinrich Hoffmann, Hitler's court photographer, copied the depiction of Hitler as a nonelevated "man of the people"—shaking hands, smiling, and reading a newspaper—from presidential representations produced by Woodrow Wilson's public relations machine. In 1930, Joseph Goebbels explicitly vowed to "exploit the most modern advertising techniques for our movement."[61] Thus new political, democratic concepts, anchored in the ideal of universal suffrage, encroached upon symbolic representations of the leader anywhere in the world. The politician as "man of the masses" was born.

Franklin Delano Roosevelt (president from 1933 to 1945) manipulated the mass media in unheard-of ways and managed to create a heroic image during his first hundred days in office; thereafter the image showed only cosmetic changes.[62] Roosevelt started an "offensive of smiling" to exude optimism in times of economic crisis, but his main medium was the radio.[63] Roosevelt's famous weekly public radio addresses, the "fireside chats," reached 60–70 million out of 130 million citizens. The press was his secondary medium. Roosevelt's presentation was, interestingly, less visual than that of others. It was his sonorous, calm, and confident radio voice that assured him his following. The public relations sector expanded enormously under Roosevelt. During the New Deal almost all U.S. government institutions acquired staff in positions such as "director of information," "publicity director," "chief of public relations," "press officer," "secretary of press relations," and "editorial assistant." These aides produced press conferences and a steady stream of press releases and flyers.[64] Roosevelt, who had journalistic experience himself, chose men with a press background as his secretaries. Louis Howe and Stephen Early, the former an Albany newspaperman, the latter an erstwhile reporter for the Associated Press, were media pros par excellence. They choreographed the relationship between the media and the president they served. They supplied news releases and personalized human stories about Roosevelt to the media. And they achieved the remarkable feat of hiding the effects of Roosevelt's polio from the public. This was due to the voluntary "self-obligation" of the press, rather than outright censorship, and was supported by subtle pressures—for example, journalists who failed to adhere to this gentlemen's agreement were kept away from photo opportunities and press conferences.

Between the modern, post–World War I cults of dictatorial and democratic leaders there were numerous commonalities but also differences, both of which become visible upon comparison. All cults made use of different yet related signs to portray their leaders. All made use of the same technology, though they weighted these media differently. All were targeted at the masses. The respective relationships to sacrality were quite different. Mussolini and Hitler did not shy away from comparing themselves with God and Jesus, while atheist Marx-

ism avoided such analogies. Hitler and Mussolini did not fabricate images of modesty but openly justified their cults ideologically, while the Stalin cult was presented as an oxymoron, a cult *malgré soi*. What is more, as far as we know Hitler's cult was orchestrated from a single institution, Goebbels's propaganda ministry, while Stalin's cult had no such central directorate. Many of the techniques used for the cults were inspired by American commercial advertising. Yet representations of this interdependency were entirely different: what the United States in its own country called "mass communications" and elevated to an academic discipline, it scorned as "propaganda" in Germany, Italy, Japan, and Soviet Russia.[65] Nonetheless, Roosevelt's America managed to suppress his wheelchair. To be sure, Western image politics had achieved what has been called the "semantic occupation of the public sphere" by different, and less repressive means than authoritarian regimes.[66] Indeed it is crucial to remember that dictatorial image politics developed against the background of states that made use of terror and physical force on an unprecedented scale. In the West, there was neither censorship nor the monopoly of one newspaper or media conglomerate. Instead there was competition, but in reality this competition achieved similar results. Ultimately the New Deal marginalized pluralistic political parties and greatly strengthened the executive powers of the president, a necessary precondition for the buildup of the welfare state. As a result, politics became more personalized.[67]

BOLSHEVIK PERSONALITY CULTS

The Bolsheviks were of course Marxists, and Marxism started as a movement around cult figures, Marx and Engels, no matter how much the founding fathers themselves derided personality cults. What is more, Bolshevik ideology was less collectivist than is often believed. There was Lev Kleinbort's positive tradition of the "cult of man" in Russian Marxism and Georgy Plekhanov's dialectical justification of the supreme role of the individual in history.[68] Bolshevik-style Russian Marxism also contained many Nietzsche-inspired voluntarist and individualist elements—the socialist new man as superman.[69] And there were the Bolshevik concepts of the Party vanguard (*avangard*) and the Party leader (*vozhd'*). Both set Bolshevik ideology—and practices—apart from the emphasis on Party soviets and cells of the Mensheviks, Socialist Revolutionaries, and other parties of the Left.[70]

But there is more. Most Bolsheviks were from the radical intelligentsia. Most intelligentsia members, as Barbara Walker has shown, took part in a social circle (*kruzhok*), in which they read poetry, discussed Marx, fought over politics, or critiqued one another's paintings.[71] And most intelligentsia circles were organized around a leader. As one participant remembered her circle leader, "his knowledge was unlimited. I believed that, were there only a few more like him,

one could already begin the revolution."[72] The circle and its leader provided the members with material resources (housing, food, publication opportunities) and psychological resources (praise or what we today would call "positive reinforcement," harmony, a sense of belonging). As a member of Maximilian Voloshin's Koktebel circle during the 1920s recalled in 1945, "Voloshin was the center to [which] all were drawn. . . . He was a subtle psychologist. Whomever he met, he always found those words, those thoughts, which enabled him to approach his interlocutor more intimately and entice him into a long conversation, at the end of which it turned out that they were, unexpectedly to both, close friends."[73] In return, the circle members glorified their circle leader during his lifetime in poems and songs, with paintings and sculptures, and after his death in obituaries and memoirs. The circle members, in short, built a cult around their leader. Most Bolsheviks, no matter how much their Marxism stressed the importance of collectives over individuals, were socialized in these *kruzhki* and brought a culture of leader veneration with them. Glorifying a leader was a formative experience for these Bolsheviks, and many could not but continue to act accordingly once in power, despite all professions of contempt for personality cults in their ideological rhetoric.

Up to the early nineteenth century, the single source of limited resources for cultural producers was the tsarist court, and the single person to be glorified was the tsar.[74] The intelligentsia emerged only after a parting of ways; a small part of the Russian nobility distanced itself from the monarchy in the late eighteenth and early nineteenth centuries. Later came the development of the intelligentsia circles around circle leaders.[75] With the emergence of the intelligentsia, there appeared new resources for cultural producers, separate from the monarch; and consequently new people to be glorified, also separate from the monarch.[76] Of course the tacit exchange relationship between circle leader and cultural producers, in which the cultural producers extolled their circle leader with cult products in return for resources, mirrored the exchange relationship between other cultural producers and the tsar. Slavicists and cultural historians Gregory Freidin, Harsha Ram, and Viktor Zhivov are among those who have followed with painstaking care the discursive traces that the dominant institutions of emperor and Orthodox Church left on the language of those who sought to overcome these institutions, beginning with the Decembrists.[77] As Alexander Zholkovsky summed up this tradition (which began in the late eighteenth century and ended only in 1991) for the twentieth-century poet Anna Akhmatova, she "stands out as an ultimate paradox of resistance-cum-replication."[78] By continuing the circle tradition of the oppositional intelligentsia, the Bolsheviks therefore not only violated the Marxist principle of collectivism but also unwittingly slipped into a century-old tradition of replicating the reciprocal relationship between the loathed tsar and his eulogists who also received resources in exchange for cult products.

It is instructive to take a look at Bolshevik biographies in the light of the circle experience. Vladimir Lenin joined his first revolutionary circle at age nineteen, when he entered Nikolai Fedoseev's illegal proto-Marxist *kruzhok* in Kazan in 1889.[79] Many more circles followed, and Lenin moved from circle participant to circle leader. Lavrenty Beria in 1915 at age sixteen helped found a clandestine Marxist study circle at the Baku Polytechnic School for Mechanical Construction. He served as its treasurer.[80] Anastas Mikoian took part in the organization of his first Marxist circle as a seventeen-year-old in 1912 at the ecclesiastical seminary of the Armenian Church in Tbilisi.[81] Sergo Ordzhonikidze as a fifteen-year-old began studying at a school for male nurses in Tbilisi, where he joined his first Marxist circles, culminating in his entrance to the Russian Social Democratic Workers' Party at age seventeen.[82] Yemelian Yaroslavsky (born 1878) was introduced to his first underground circle as a fifteen-year-old through his elder sister. A long circle career followed, working together with exiles, Gymnasium students, and teachers, mostly in his native East Siberian town of Chita, where his father, a Jew, had been exiled after refusing to serve in the tsarist army for religious reasons.[83] Viacheslav Molotov joined the Bolshevik Party in Kazan at age sixteen and was in charge of the revolutionary circles at the educational institutions in town.[84] Kliment Voroshilov started his circle life in a theater circle at age fifteen at the Donetsk-Yuriev metallurgical factory in Alchevsk, after he was forced to quit school to earn money. In 1898, at age seventeen, he joined the factory's "illegal group of workers, an embryonic Social Democratic circle."[85] In 1903 he joined a full-fledged Social Democratic circle at the Hartman locomotive factory in Lugansk and devoted three eulogistic pages of his autobiography to the leaders of this circle, V. A. Shelgunov and K. M. Norinsky.[86] Stalin himself (in 1931) claimed to have joined his first Marxist circle at age fifteen while still a seminarian in Tbilisi (about 1894): "I joined the revolutionary movement when fifteen years old, when I became connected with underground groups of Russian Marxists then living in Transcaucasia."[87] By all accounts, he indeed joined a secret socialist study *kruzhok* at the seminary together with his friend Iosif Iremashvili. According to Robert Tucker,

> As he entered upon his rebel career through the young socialists' study circle that he and Iremashvili joined, he took it for granted that he belonged at the head of the movement. The circle elected as its leader an older student named Devdariani, who drew up for the new boys a six-year reading program designed to make them educated Social Democrats by the time they graduated from the seminary. Before long, however, Djugashvili [Stalin] was organizing one or more new study circles of which he himself was the mentor.[88]

For Stalin and all of these Bolsheviks, circle activity started in their formative years. For all of them, too, it was their debut as members of political organizations. For most, their first circle was the beginning of a revolutionary circle

career. And for most, it was the beginning of an upward path from circle participant to circle leader. Thus, I propose that while these Bolsheviks might ridicule and profess their contempt for the cult of the tsar, they all internalized the principle of personality cult because they all were socialized in the microsocial institution of the circle during their formative years. Once they came to power and had the opportunity to set the rules of the macrosocial game, many were compelled to follow the logic of their microsocial *kruzhok* education.

THE LENIN CULT

Considering all these factors, it is not surprising that there were nascent cults of generals and politicians among the Reds in the Civil War. It is also not surprising that Lenin in his 1918 "Decree on the Removal of Monuments Erected to the Tsars and Their Servants and the Projecting of Monuments of the Russian Socialist Revolution" linked iconoclasm toward the old regime with the building of new statues honoring founding fathers of the Left, from Babeuf and Robespierre to Marx and Engels.[89] And it is not surprising that the first full-blown personality cult of a Party leader, albeit a dead one, was constructed around Lenin.

During Lenin's lifetime there was no modern political personality cult around him, even allowing for the accolades that did exist. Lenin died on 21 January 1924. While a part of the Bolshevik command might have been influenced by the philosopher Nikolai Fedorov's belief in the ability of science to achieve physical immortality, the decision to embalm the corpse and build a mausoleum around it was above all determined by an unexpectedly large public interest in Lenin's dead body.[90] In order to accommodate the masses who wanted to file by and catch a glimpse of the dead Lenin, the natural decomposition of the corpse needed to be halted. To coordinate these efforts a "Commission for the Immortalization of Lenin's Memory" was put together from members of the Party Central Committee and Politburo. Initially led by Felix Dzerzhinsky, and later by Leonid Krasin, this commission faced opposition from figures like Lenin's widow Nadezhda Krupskaia, and Voroshilov, who saw the analogies of Russian Orthodox canonizations and tsars' burials as looming too large in the public imagination. But the faction that favored permanently embalming the corpse fabricated evidence of popular support and eventually defeated its opponents.[91]

Later a variety of media—film, photography, paintings, posters, sculptures, and poetry—was employed in creating what came to be called "Leniniana." Sculptor Sergei Merkurov, for example, produced a death mask that served as the blueprint for a group of sculptors commissioned to produce works of art (Fig. 1.10). Two out of fifty-five were then chosen for mass reproduction.[92]

Figure 1.10. Lenin's death mask amidst others by the sculptor Sergei Merkurov (1981 photograph). © State Tretyakov Gallery, Moscow.

During the Stalin era some of these sculptors published memoiristic accounts of their heightened sense of responsibility for fixing the Soviet leader's image for mankind and history. The sculptor Ivan Shadr remembered how he was overcome by "panic and fear" when approaching the corpse, and Merkurov himself wrote about his death mask: "The mask is a historical document of immense importance. I [had] to preserve [Lenin's] traits on his deathbed and pass them down to the centuries!"[93] Soon mountains and towns, factories and kindergartens, airplanes and ships were getting named after Lenin. A famous outside observer, Walter Benjamin, in 1927 used the German word *Kultus* to

describe Lenin's posthumous public veneration: "Already today the cult (*Kultus*) of his [Lenin's] image is reaching unexpected proportions. . . . Moreover, it is slowly beginning to generate canonical forms. The widely known picture of the speaker is the most common of these. More touching and probably more characteristic is another: Lenin at his desk, leaning over an issue of *Pravda*."[94]

Stalin played a peripheral role in the Lenin cult and did not mastermind it, as has often been asserted.[95] Nor was he featured in the Lenin cult before the onset of his own cult. But the existing Lenin cult surely served as a model for his own cult. And Voroshilov, the main patron of the visual arts and mastermind of the Stalin cult in painting, had been part of the initial Lenin commission. Once Stalin's cult began, he was portrayed as Lenin's best disciple and successor. At the time, the introduction of this quasi-dynastic succession principle in the semiotics of a modern personality cult was a novelty.[96] Later in the century it was topped by genuine kinship-based dynastic successions in a communist leader cult, in North Korea where Kim Jong Il succeeded his father Kim Il Sung; and in a Ba'athist leader cult, in Syria where Bashar al-Asad succeeded his father Hafiz al-Asad.

Multiple paths, then, led to the Stalin cult. The larger context of modern personality cults was decisive. This context, of which Russia was part, gained its specific shape primarily due to the rechanneling of sacral aura from the religious sphere—a process that has inadequately been termed secularization—into other spheres, that of politics included. Crudely put, the death of God was the precondition for the deification of man and the types of modern personality cults to which the Stalin cult belongs. Rulers after the Enlightenment and the French Revolution received their legitimacy not from the killed God, but from (parts of) the people. The sacral energy set free by God's assassination floated throughout society until it attached itself to their persons, giving rise to the secular personality cult. This personality cult became modern for the first time in France during the reign of Napoleon III. His cult was based on popular sovereignty; it was patricentric and targeted at the masses; it made use of mass media and uniform, mass-produced cult products; and it could flourish only because it took place in a sufficiently closed society. Even allowing for much overlap and nonlinear historical development, these five characteristics were so novel that they require us to draw a line between personality cults in the sphere of politics before and after the world's first "democratic despot." Beginning with Napoleon III, personality cults are best classified as modern.

The Russian tsar cults were not isolated from the developments in Western European monarchical symbolic politics. Russia produced its own, highly specific inflection of monarchical cults before the Revolution, even if the cult of the tsar failed at becoming fully modern. The cult of the tsar was a tradition that

bore heavily upon postrevolutionary rulers and ruled, a tradition they had great difficulty breaking or ignoring, even if they tried as hard as the Bolsheviks did. This path to the Stalin cult might be called the "tsarist carryover."

After Napoleon III's rule, World War I was the next event that triggered momentous changes in political personality cults. Mass conscription and the influx of large numbers of women into the workforce widened the horizon of expectation. The war made "one person, one vote" the benchmark of popular sovereignty. Every country somehow had to reckon with this new standard, even if it fell short of it. Now there was no way back from mass politics. Mass consumption followed in due course and further blurred class and gender lines. All cults around political leaders presented their *Duce, Führer,* or *vozhd'* as men who came from the masses, yet at the same time transcended the masses. These leader cults were interrelated in more ways than the cults of monarchs had ever been. While monarchical cults had been in basic agreement about the political order—monarchy—they represented, every leader embodied a modern political "system" with world-hegemonic aspirations. Stalin stood for communism, Mussolini and Hitler each stood for a variant of fascism. In addition, because of the development of the radio, in theory the entire world could now hear Stalin's, Hitler's, or Mussolini's voice in real time. This tectonic shift had an impact on how these leaders were represented in their cults. The representation of Stalin as calm and unmoving was deliberately juxtaposed to Hitler's wild, "hysterical" body language. Stalin's pipe or cigarette was intended to signify the proletarian nature of the Soviet Union; it was one pole of a binary, with Churchill's bourgeois cigar figuring as the opposing pole. Thus the semiotics of the modern personality cult became relational or entangled.

Finally, there was the Marxist path and the ideology and practices of Bolshevism. The wider movement of Marxism had featured personality cults; and Bolshevik ideology, with its emphasis on the Party vanguard and Plekhanov's dialectical justification of individuals as a historical driving force, was not as immune to personality cults as it claimed. What is more, the official tsar cult was accompanied by a microsocial underside of patronage-cum-cults anchored in the countergovernmental institution of the intelligentsia circle. The members of these circles glorified their leaders with their cultural products and received material and psychological resources in return. Nearly all Bolsheviks were socialized in intelligentsia circles. Socialization is meta-intentional, and whether they liked it or not, once they came to political power many could not but act as they were taught in their circles, despite Marxism's profession of collectivism.

Taken on its own, each of these paths only partly explains the genesis of the Stalin cult. Taken together, they give a fresh answer to the question why the alchemy of power, why the Stalin cult, got started.

I
CULT PRODUCTS

2 Stalin's Image in Time

THE STALIN CULT burst upon the public scene with a big bang late in 1929 and was followed by three and a half years of near silence. On 21 December 1929 Stalin turned fifty years old. The eight pages of *Pravda* on that date were filled with laudatory articles by fellow Party bosses extolling Stalin's role in the history of the Party as well as his various functions of general secretary, mastermind of the Soviet industrialization drive, organizer of the USSR, and theoretician of Leninism; congratulatory telegrams by the Communist Party leaderships from Italy to Indonesia and by factory committees and trade unions from all over the Soviet Union; and photographs, with a photo portrait adorning the front page (Fig. 2.1).[1] Other newspapers followed suit and featured similar greetings and visual representations, suggesting that the beginning of the Stalin cult was orchestrated and centralized.[2] This glorifying salvo in multiple papers must have seemed startling to readers, for throughout the 1920s, Stalin in public representations had paled in comparison to other high-ranking Bolsheviks such as Lenin, Trotsky, and Kalinin. Because Stalin controlled the media since at least 1927, there can be no doubt that he acquiesced to this gambit of minimizing his cult.[3]

This chapter charts Stalin's image in *Pravda* from the beginning of the cult in December 1929 until early 1954, a year after his death. It provides a sense of continuity and change in the depiction of Stalin. Its focus is on visual representations—mostly photographs—but it includes some verbal ones as well. It is based on a reading of every page (amounting to a total of about forty thousand) of the newspaper, which for most of the period was six pages long.[4] Visual representations of Stalin are broadly defined as, inter alia, photographs, reproductions of paintings, depictions on book covers, and portrayals in plays

Figure 2.1. Stalin on his fiftieth birthday. *Pravda*, 21 December 1929, 1.

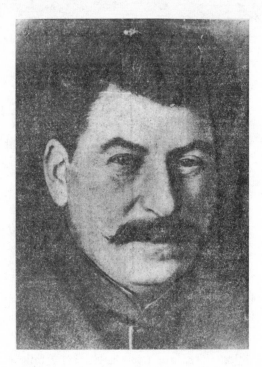

or movies. Statistics of these visual representations are in an appendix at the end of the book.[5]

Why *Pravda*? *Pravda* was much more than the first socialist state's premier newspaper: it was both a mirror of the Soviet political, social, and cultural landscape and an invaluable compass used to navigate through this rugged terrain. The Party official in a Karelian village read *Pravda* behind his desk at the kolkhoz soviet in order to stay in tune with the contorted Party line. The history teacher in Kazakhstan could not explain current affairs to her steppe nomad students without the most recent issue of the paper. The agitprop activist stationed with a Red Army unit in the Soviet Far East feared for his life if he overlooked *Pravda*'s exposé on an "enemy of the people"—the same highly decorated general whom he had just praised in front of his soldiers. Stalin's place in the topography of *Pravda* was central. The painters discussed in this book all read *Pravda* to trace the zigzag Party line. "Don't you read the papers?," shouted "a voice in the audience" at the speaker during a Moscow Artists' Union meeting in 1938.[6] More importantly, the painters also read *Pravda* to get inspiration for a portrait from a new, usually photographic, visual representation of their leader (such as was soon to be distributed among them as a template in the upcoming Stalin portrait competition); to get inspiration from a new verbal source, as in an idea propounded in a Stalin quote; to get cues about shifts in art politics, as from a comment by the art critic Osip Beskin; or

to survey their own status in the art world, shown by the number of their paintings that were reproduced in the premier newspaper (Figs. 2.2, 2.3, 2.4). Stalin's portrayal in *Pravda,* then, was both a microcosm of the total of the Stalin cult and an influential medium of the Stalin cult. Photographs of Stalin—most of them first publicly circulated via *Pravda*—were, until the appearance of the first Stalin movie in 1937, the master medium of the Stalin cult insofar as they canonized his image. They provided the expressive language of his depiction, which was then followed by other media.

STALIN'S CONTROL OF *PRAVDA*

Pravda was founded in tsarist Russia in 1912 as a workers' daily and remained one of the few operating newspapers after the Bolsheviks closed down private and heterodox socialist papers following the October Revolution. In early Soviet Russia, both *Pravda,* the Party organ, and *Izvestia,* the newspaper representing the state, were considered elite. Both were read mostly by Party activists of intelligentsia background. In the early 1920s, the Bolsheviks founded mass-

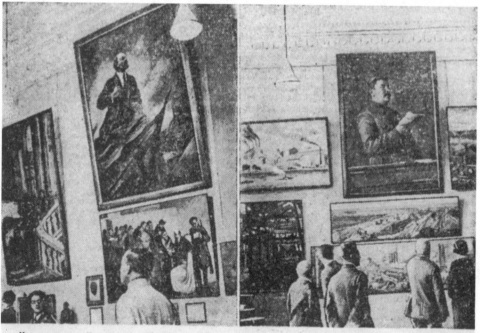

На выставке «Художники РСФСР за 15 лет»: слева—в зале Ленина, справа—в зале Сталина.

Figure 2.2. Photographs like this one indicated to the Stalin painters who, and which style, was fashionable. The caption says: "At the exhibition 'Artists of the RSFSR over the Past Fifteen Years': left: the Lenin room, right: the Stalin room." *Pravda,* 28 June 1933, 4.

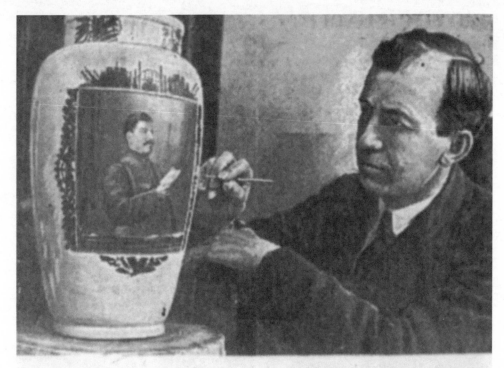

На Государственном фарфоровом заводе им. Ломоносова (Ленинград) художник А. А. Скворцов заканчивает художественную роспись вазы с портретом тов. Сталина (с картины худ. Бродского).

Figure 2.3. "At the Lomonosov State Porcelain Factory (Leningrad) the artist A. A. Skvortsov finishes painting a vase with a portrait of Comrade Stalin (from a painting by artist Brodsky)." *Pravda,* 19 April 1935, 4.

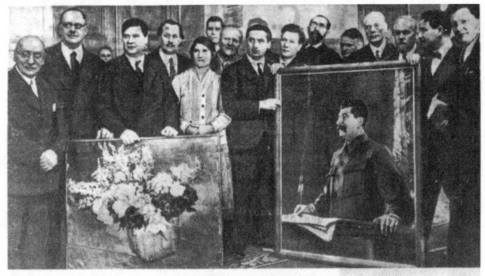

Делегация художников и скульпторов, приветствовавшая С'езд Советов. Делегация поднесла С'езду портрет товарища Сталина работы художника А. Герасимова и картину «Букет цветов» работы художника Кончаловского.

Figure 2.4. "A delegation of artists and sculptors after greeting the Congress of Soviets. The delegation presented the Congress with a portrait of Comrade Stalin by the artist A. Gerasimov and artist Konchalovsky's painting *Flower Bouquet." Pravda,* 6 February 1935, 4.

circulation newspapers targeted at specific audiences—for example, *Krestian-skaia gazeta* at the peasants, *Rabochaia gazeta* at the workers, *Rabochaia Moskva* at Moscow workers, and *Bednota* at rural activists and officials. Most of these papers were discontinued in the second half of the 1930s, since literacy had increased as a result of the Soviet leap into industrial modernity during the Great Break (1928–1932), and the principle of targeting such specific audiences had been abandoned. Consequently, *Pravda* increased in stature, circulation, and reach.[7]

Pravda and a number of other newspapers were the main medium through which the original Stalin cult was launched on Stalin's fiftieth birthday in December 1929. At that time the audience of *Pravda* had expanded to include the engineers and workers on the construction sites of the First Five-Year Plan and the kolkhoz accountants in the villages. The circulation was one million copies in early 1930.[8] The Bolshevik leadership used *Pravda* to push certain themes, and other papers followed suit by producing articles on agenda points first set in the leading news outlet. Stalin effectively coopted *Pravda* much earlier, in 1924, when he entered into a coalition with the main editor, Nikolai Bukharin, during the struggle over the Party leadership after Lenin's death.[9] In the same year, the photographic depiction of Party leaders was centralized and placed under the control of the secret police.[10] Stalin and Bukharin split in 1927, and the latter was ostracized as part of the "Right Opposition." In consequence, Stalin staffed the editorial board of *Pravda* with supporters who continued to ensure his control.[11] Stalin's editorial control was largely informal and based on oral communication—the editor of *Izvestia*, Ivan Gronsky, recalled regular telephone conversations with Stalin in 1928–1929 during the final battle against the Right Opposition.[12] Starting in 1930 with Lev Mekhlis, Stalin began appointing his own men as editors in chief of *Pravda*. At the time, few people were closer to Stalin than Mekhlis: he had been Stalin's secretary and personal assistant, functions that on paper sounded routine but in fact were equivalent to ministerial posts in a shadow cabinet. Mekhlis was one of the few gateways to the dictator, and thus one of the most powerful men in the Soviet Union.[13]

After the ousting of Bukharin and the appointment of Mekhlis, the smoothly working control mechanism of *Pravda* (through Stalin and his secretariat) most likely operated as follows. All articles that remotely had to do with Stalin's person were sent to his secretariat for approval. For instance, on 17 August 1938 *Pravda* editor Lev Rovinsky sent to Stalin's head secretary, Poskryobyshev, galleys of an article that contained passages about a meeting with Stalin and accompanied this article with the following note: "For Aviation Day Comrade Kokkinaki wrote an article for *Pravda*. . . . Since there are references to meetings and conversations with Comrade Stalin, I am enclosing two copies of the article and ask you to authorize the publication of these parts of the article. The parts

are marked in red pencil on one of the copies."[14] On 13 April 1939 the editor of
Komsomol'skaia Pravda, a certain Poletaev, sent an article entitled "I Remem-
ber the Young Leader," by G. Yelisabedashvili, to Poskryobyshev along with the
following letter: "The editorial board of the newspaper *Komsomol'skaia Pravda*
asks that you look through the memoir of Comrade Stalin's youth which we
plan to publish in the next issue of our newspaper. The material is verified and
authorized (*zavizirovan*) by the Tbilisi branch of the IMEL [Marx-Engels-Lenin
Institute] at the Party Central Committee." Stalin wrote across the letter: "I am
against the publication. Among other things, the author shamelessly told lies.
J. Stalin."[15]

Photographs were sanctioned in a very similar way. On 24 February 1934
the deputy editor of the Russian version of the journal *USSR in Construction*
(*SSSR na stroike*) wrote to Stalin's secretariat: "To Comrade Poskryobyshev.
The editorial board sends you an unpublished portrait of Comrade Stalin (the
photograph was shot at the seventeenth Party Congress) and asks that you give
permission to publish it in the next issue of our journal. The photograph has
yet to be retouched." Poskryobyshev noted: "The photograph ought to be re-
touched and shown[.] Poskryobyshev. Likely there will be no objections against
this photograph."[16] Sometimes Stalin—via his secretariat—was given a choice
of which portrait to publish, as on 4 December 1943 when "major general, edi-
tor in chief N. Talensky" on behalf of the editorial board of *Krasnaia Zvezda*
wrote to Poskryobyshev, "I ask for permission to publish in *Krasnaia Zvezda*
in an issue devoted to the Day of the Constitution one of the herewith enclosed
portraits of Comrade Stalin," attaching two 1943 Boris Karpov drawings of
Stalin, one without a hat, the second with a hat.[17] And of course canonizing a
photograph by publishing it for the first time was a more sensitive undertaking
than republishing a previously approved photo: "Dear Comrade Poskryoby-
shev! I am attaching an offprint from a plate that we want to publish in the
December issue of our journal. This photograph has never been published. I
implore you to allow us to publish it."[18]

There is evidence that Stalin looked at the photographs himself and actively
took part in the decision to publish them or not. On 16 June 1935 Lev Mekhlis
wrote in curt terms (implying close familiarity) to the man who presently filled
the position in Stalin's secretariat that he once held: "Comrade Poskryobyshev!
The 17th marks the fifth anniversary of the opening of the Stalingrad trac-
tor engine [factory]. I want to publish a photo of Ordzhonikidze and Stalin.
Show it, please! (*Pokazhi, pozhaluista!*)." "Show it, please!" most likely meant:
"show it to Stalin, please!" Across the note there is the handwritten phrase:
"Not worth publishing (*Ne stoit pomeshchat'*)."[19] An even clearer example is
a note that Poskryobyshev received from someone on the editorial board of
Izvestia on 17 June 1937: "Dear Comrade Poskryobyshev! I ask that you allow

Izvestia to publish the enclosed photo in the 18th June issue, which is dedicated to Gorky." Written across this note I found, "Comrade Stalin objects (*t. Stalin protiv*)."[20] How regularized and permanent was this kind of direct control by Stalin and his secretariat? We cannot know. But we do know for sure that the dictator's control over the country's leading newspaper was one of intervention when he saw fit.

PRAVDA, 1929–1953: REPRESENTING THE LEADER

Only a diachronic analysis can shed light on the changes that took place in Stalin's representation. At the beginning of the period studied, the first sign that Stalin's birthday was approaching came on 18 December 1929 when a first batch of congratulatory anniversary telegrams was published on page three. A day later a second batch was published, again on the third page. On 20 December, Stalin's representation had climbed up to page two, with a poem by Demian Bedny, while the rest of page two and page three again featured congratulatory telegrams. The Stalin presented in the 21 December birthday issue, finally, was an overwhelmingly verbal, not visual construct. There were three kinds of verbal contributions. First, there were multicolumn articles by his fellow Bolshevik luminaries, extolling his specific qualities (Ordzhonikidze's article "A Staunch Bolshevik"), stressing a particular function of Stalin (Manuilsky's article "Stalin as the Leader of the Comintern"), or highlighting stations in his revolutionary hagiography (the article "Tsaritsyn"). Second, there appeared short telegrams and congratulatory greetings from Communist organizations or other collectives from the Soviet Union (the All-Union Central Council of Trade Unions or the "workers of the Tbilisi shoe factory") and abroad (from the "Central Committee of the North American United States"). Third, there were article-length or poetic tributes by figures of the literary establishment (Demian Bedny's poem "I am certain" ["*Ia uveren*"]). Generally all verbal representations kept distance and refrained from terms of endearment or excessive metaphoric or other figurative descriptions of Stalin. In the 117 greetings Stalin was designated as "leader" most frequently with the terms *rukovoditel'*, matter-of-factly signifying his function (76 of 201 times), and *vozhd'*, connoting more heroic, charismatic qualities (49 of 201 times). The most typical designations were "leader of the Party" (both *rukovoditel'* and *vozhd'*).[21] Later in the 1930s the charismatic and sacral *vozhd'* (with linguistic roots going back to Old Church Slavonic) came first to surpass and then completely eclipse the newer and more sober term *rukovoditel'*.

If a *Pravda* reader on that December day had any inkling that the eight pages gave but a foretaste of a full-blown Stalin cult, the reader would have certainly thought that this phenomenon was going to be verbal, not visual. The quality of

the pictures that did appear was poor, but this was a general technical problem with *Pravda*. On the front page there was a photographic portrait of Stalin's face, occupying about one-sixteenth of the page, a fraction of the size of later front-page Stalin photographs (see Fig. 2.1). Stalin was shown fairly young, with jet black, full and quite unruly hair, not yet combed backward in the style he would later adopt. The photo must have been shot at least one year earlier, because Isaak Brodsky's 1928 Stalin painting was clearly modeled on the same picture. Stalin gazed directly at the onlooker, not into the distance, as was typical of later images. The second page featured the later canonical January 21 photograph of Stalin and Lenin in Gorki, with Stalin sitting in the foreground in his white uniform. On page three, in connection with articles on Stalin and the Red Army, there was a small and poor-quality photograph of Stalin with Budyonny, walking in his characteristic army boots and riding pants. Pages four and five showcased even lower-quality photographs—of Stalin and Kalinin, with Stalin's hand in his field jacket in Napoleonic fashion, and Stalin and Molotov respectively. Finally page seven had a tiny frontal photo portrait of Stalin, Lenin, and Kalinin.

After the birthday, throughout 1930, Stalin's appearances were quite rare and limited to specific dates, such as Party congresses and holidays like the Day of the October Revolution. There was a strong sense of openness and indeterminacy. So much so that the headline of an article in early January 1930 could read "The Stalin faction (*Stalinshchina*) is fighting for leadership in the Donbass," using the pejorative suffix -*shchina*.[22] At the beginning, the genre of visual representation too was less fixed, ranging from caricature-like drawings by Viktor Deni, to constructivist montaged photographs by Gustav Klutsis, to retouched photographs. And within these genres, there were surprises, as with an image in which Stalin suddenly seemed much older than in the other pictorial representations that had circulated so far. At this time, Stalin still appeared in advertisements, as in an ad for the printed version of his April 1929 speech, "On the Rightist Deviation in the VKP(b) (O Pravom uklone v VKP(b))."[23] Stalin quotes printed across the upper right corner of *Pravda*, the place reserved for the slogan of the day, or visualized as slogans on banners, became more common and occupied increasing space in the newspaper. So did the greetings, congratulations, and self-commitments to Stalin. To begin with, Stalin sometimes replied to these utterances, as in his own public congratulatory three-line greeting on the occasion of the tenth anniversary of the Comrade Stalin Cavalry Brigade: "A heartfelt greeting to the Special Cavalry Brigade on its tenth anniversary. I hope it remains a model for our heroic cavalry units. J. Stalin."[24]

But again, 21 December 1929 was not the beginning of a continuous process of showcasing Stalin. It was followed by silence. Between 1930 and mid-1933, Stalin made only rare appearances on the pages of *Pravda*. When he did, he

was shown together with other Party functionaries and was not marked as outstanding or seen on socialist holiday occasions. This hiatus has been attributed either to a deliberate attempt to avoid linking the person of Stalin with the upheavals of collectivization, or to vestiges of opposition to his single power in the Party. Not surprisingly, there were no greetings from kolkhoz farmers on 21 December 1929.[25] Whatever the case, in mid-1933 the public Stalin cult took off in multiple media.

Of course Stalin's personality cult—even when on hold from 1930 to mid-1933—was accompanied by a new emphasis on "the individual" or "personality" (*lichnost'*), as evidenced in such phenomena as the beginning star system of movie actors (in contrast to Eisenstein's and Vertov's anonymous actors); the cults of other Party magnates, as with the *Pravda* celebration of Voroshilov's fiftieth birthday on 5 February 1931; and the cults of the heroes of the First Five-Year Plan, for example in a full-page *Pravda* article featuring images of some of them (accompanied by short summaries of their achievements) and adding, "The country ought to know its heroes. The outstanding shock worker, the inventor, the rationalizer (*ratsionalizator*) who has mastered production technology—this is the hero of the land of socialism under construction."[26]

With the take-off of the Stalin cult in mid-1933, the genres of representation also became more fixed. Deni caricatures and photomontages gave way to (retouched) photographs, sculptures (in late 1934), and the first reproductions of socialist realist paintings, as with Mikhail Avilov's picture *The Arrival of Comrade Stalin at the First Cavalry in 1919*, taken from the exhibition "Twenty-five Years of the Red Army," or Aleksandr Gerasimov's 1934 painting *Comrade Stalin Gives His Report to the Seventeenth Party Congress on the Work of the Central Committee of the VKP(b), 1934*.[27] At the same time in verbal representations, words derived from or connected with Stalin's name became more common, as in Kirov's dictum, "For the success of the Second Five-Year Plan we must work Stalin-like (*po-stalinski*),"[28] and as in an article on the Day of the Soviet Air Force about "steel birds and people of steel (*stal'nye ptitsy i stal'nye liudi*)," where "steel" (*stal*) derived from Joseph Dzhugashvili's pseudonym "Stalin."[29] The letters "S-T-A-L-I-N" sometimes became an emblem of his cult. Airplanes flew in formation to spell them out (Fig. 2.24, p. 71); or they were embodied by people, as in a 1933 Physical Culture parade at which the athletes formed up to spell the words "Hello Stalin (*Privet Stalin*)" when viewed from above.[30] Verbal representations, however, during the take-off period of the Stalin cult (after mid-1933) were often still quite literal, as, for instance, in Beria's 1934 article, "We Owe Our Successes to Comrade Stalin."[31]

From the moment of the Stalin cult's take-off in mid-1933 until the late 1930s *Pravda* was busy marking Stalin as the supreme leader, ultimately furnishing a canon of stock images or *obrazy*. First of all and most obvious, marking Stalin

involved showing him alone and suppressing representations of other leaders. Just as it became clear in real politics around this time that Stalin could monopolize power if he wished, the newspaper drove home the point that Stalin could monopolize leader representations if he wished. To give an example, different articles in August and November on collectivization were accompanied by the same photograph of the Lenin's Way collective farm's "meeting of the individual peasant-farmers (*edinolichniki*) regarding their entry into the kolkhoz," as the caption announced. But in August 1930 the wall in the background showed portraits of both Kalinin and Stalin, whereas by November only the Stalin portrait remained.[32] The formation of a canon also involved distinguishing Stalin from other Party leaders in pictorial representations of groups, say in a photograph of a presidium on the stage of the Bolshoi Theater. Such strategies of visual distinction revolved around Stalin's size, his place in the picture, the color of his clothing, his arm movements, and the fact that his hands never touched his face whereas others rested their heads on their arms or held earphones to their ears. For example, in photographs of the presidium of a Party meeting, Stalin was often placed in the center.[33] What is more, in photographs of the Seventeenth Party Congress of February 1934, Stalin was the only Party leader with a light-colored uniform, thus standing out from his comrades Molotov, Ordzhonikidze, Kirov, et al.[34] A picture of Stalin and his Party cronies with the leader of the epic Arctic expedition of the ship *Chelyuskin*, Otto Shmidt, likewise illustrates the point (Fig. 2.5). The coloring of his uniform was likely achieved by retouching, or even by gluing an entire picture of him into an existing photograph, because his appearance was very unnatural in these pictures. At other times Stalin's dark clothing set him apart from the light clothing of others.[35] Furthermore Stalin was sometimes the only top Party member with his arm raised higher than that of others, say, in greetings to a Physical Culture parade marching across Red Square.[36] Or, in a February 1934 photograph of Kaganovich giving a speech in the presidium of the Seventeenth Party Congress, "The Congress of Victors," Ordzhonikidze, Voroshilov, and Molotov rested their heads on their hands, while Stalin was the sole Party boss whose hands did not touch his face.[37]

The direction of Stalin's gaze was another sign of distinction. While others looked at each other, at their leader Stalin, at an object, or at the viewer, Stalin's own gaze was directed at a point outside the picture. This visual strategy was time-tested.[38] In Soviet Russia it acquired a new ideological-temporal dimension and came to signify the leader's embodiment of the utopian timeline, with the leader gazing into utopia—the future of socialism or communism. In depictions of the young Stalin, the gaze was mostly pointed directly at the camera, not outside the picture: thus in a 1915 picture showing him with fellow revolutionary Suren Spandarian in their Turukhansk exile, Stalin gazes directly into

the camera.[39] Apparently it was only the crucible of the Revolution and the inheritance of the Party leadership from Lenin in 1924 that turned Stalin into the embodiment of materialist history, of the force that could propel humanity to utopia.

Stalin's distinction was further marked by his portrayal as motionless, whereas the bodies of others were shown in a state of movement. Motionlessness in general became one of the key themes in representations of Stalin, and the word "calm" (*spokoinyi*) proliferated in reference to him. Objects of everyday life in Stalin's immediate proximity—the pipe in his hand, a map, a newspaper or book—also set him apart from others. His closeness in the picture to the figure of Lenin or an image of Lenin—a poster or painting on the wall—was another distinguishing marker.

Moving outside the intrinsic features of the picture itself, the text accompanying pictures also marked Stalin as special. In the captions below group pictures Stalin was often mentioned first, no matter where he stood in the picture (Fig. 2.5).[40] To further underscore his prominence, his name was often

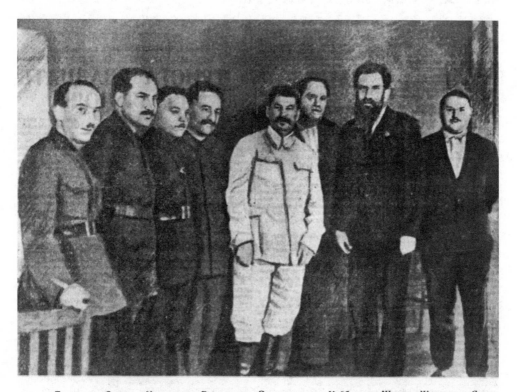

Товарищи Сталин, Каганович, Ворошилов, Орджоникидзе, Куйбышев, Шмидт, Жданов и Ягода.

Figure 2.5. Distinguishing Stalin from others by his place in the picture and color of clothing. In addition, the caption lists Stalin first. *Pravda*, 6 June 1934, 1.

capitalized while the names of others were not. Later in the 1930s, however, *Pravda* turned to enumerating all those standing in the picture by position and refrained from giving Stalin's name in capital letters.[41] The placement of his picture also played a role. For a long time, it was never placed at the foot of a page. The page itself was divided into different zones with different levels of prominence. The upper-left quarter of the page right beneath the masthead was especially sacred: here decrees and the most important announcements were often printed.

Raising Stalin's profile involved not only images but also words. In late 1932 and early 1933, a new monumentalism of published Stalin articles—now on the front page and sometimes taking up all of it—predated the take-off of the visual Stalin cult in *Pravda*.[42] Yet at this early point Stalin's legitimacy was still identified as derived from Lenin and his leadership of the Party.[43] Later *Pravda* turned to citing the size of print runs and the number of translations into foreign languages of his writings as an indicator of Stalin's greatness.[44]

These were the main visual and verbal strategies of making Stalin stand out that were used from mid-1933 to the late 1930s. Then how did his depiction change over time? Starting in 1934 Stalin began appearing in connection with the expeditions and flights of Arctic explorers and aviators, all of whom were presented as heroes and embodiments of the Soviet new man.[45] Famously, Otto Shmidt and his fellow sailors from the ship *Chelyuskin* arrived at the Belorussian train station in Moscow and were later greeted by Stalin personally.[46] Even more famously, two years later the aviator Valery Chkalov flew to the Soviet Far East in record time. Moscow greeted Chkalov and his crew with a ticker tape parade reminiscent of the welcome for Charles Lindbergh upon his return to New York from the first cross-Atlantic flight in 1927. Stalin personally greeted Chkalov and the second pilot in the crew, Georgy Baidukov, with a fatherly kiss; and a *Pravda* article read, "It was Stalin who raised these brave men."[47] The same year Stalin appeared with a new hero, Viktor Levchenko, one of the pilots who had flown from Los Angeles to Moscow.[48] Perhaps most famously of all, Ivan Papanin and his crew of Arctic explorers purportedly gathered at the North Pole around a radio receiver to listen to their leader's address. An article, "Warmed by Stalin-like Care," read: "North Pole, 24 May, 7 P.M. (RADIO). Yesterday evening there was the extraordinary picture of a meeting of the thirty members of the leading unit of the expedition on the ice at the pole, listening to the reading of a telegram of greetings from the leaders of the Party and government. They gathered under the open sky, in a snowstorm, but felt no cold because the bright words and the anxious care of the great Stalin warmed them and they sensed the glowing breath of their beloved homeland."[49]

These new hero cults were part of the Stalinist Second Five-Year Plan tradition of celebrating socialist heroes like the Stakhanovites, named after Aleksei Stakhanov who during a single six-hour shift in August 1935 allegedly surpassed his norm fourteen times by hewing 102 tons of coal. Invariably these hero cults were in dialogue with the Stalin cult and entailed what one might call sacral double-charge.[50] The glorification of other outstanding personalities in conjunction with Stalin's personality engendered greater sacral charge both for Stalin and the other celebrated person. Thus in 1936 the widow of just-deceased physiologist Ivan Pavlov in a *Pravda* "letter to Comrade Stalin" thanked the leader for all the attention her husband got during his lifetime.[51]

Generally speaking, as soon as it had become clear—by the mid-1930s—that Stalin was the supreme leader, the phenomenon of the personality cult began spreading to others, not only Party bosses in and outside Moscow, but also cultural figures. Alongside the Stalin cult in April 1935, for example, the cult of the Ukrainian national poet Taras Shevchenko appeared, a cult that was to serve as an example for many other writer cults, especially the vast cult of Pushkin on the occasion of the hundredth anniversary of his death in 1937, a cult that was intricately tied with the Stalin cult with a Stalinized Pushkin reinforcing Stalin's power and a Pushkinized Stalin reinforcing literature's power.[52] In pictorial representations this was true literally with Pushkin appearing in Stalin's overcoat.[53] Likewise on the occasion of the centenary of Gogol's death in 1952, the sculptor Nikolai Tomsky produced a Stalinized Gogol bust.[54]

When Stalin and Lenin were shown together, Lenin was usually to the viewer's left, Stalin to the right. In much of symbology, the left signifies beginning and the female, the right the end and maleness. It was unthinkable, for instance, that Stalin's portrait be hung to the left of Lenin's on the façade of the main department store GUM for a parade on Red Square; Lenin was always to the left of Stalin. In general the iconography of Lenin-Stalin seems to have been projected back onto Marx-Engels. The movement from left to right in depictions of the tetrad of Communist patriarchs, Marx-Engels-Lenin-Stalin, was to be perfected after the war. On the occasion of the hundredth anniversary of the first publication of the *Communist Manifesto* (27 February 1948), a bas-relief showed all four heads looking to the right, with facial hair getting progressively shorter from Engels to Stalin (Fig. 2.6). Likewise on the occasion of the 125th birthday of Nikolai Ogarev, *Pravda* refracted the Herzen-Ogarev relationship through a Marx-Engels, Lenin-Stalin lens, pronouncing that "bourgeois historians of literature have depicted Nikolai Platonovich Ogarev, Herzen's friend and comrade-in-arms, as 'a pale companion to the bright star.' In actuality Herzen was right, who said that he and Ogarev were 'separated volumes of a single poem.'"[55] As time went by, to be sure, the artistic genres of joint Lenin-Stalin

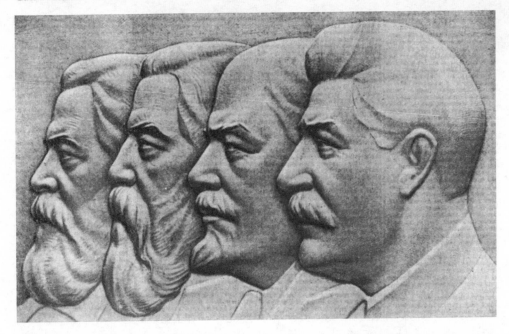

Figure 2.6. Left to right movement from Marx to Stalin. *Pravda*, 28 February 1948, 1.

depictions evolved. The bas-relief, showing white plaster Lenin and Stalin heads on a dark background in a usually round frame, appeared as a new genre of Stalin cult visual art as cult products turned more classicist.[56] Interestingly, some of the other Party leaders were always shown with the same pictures. Molotov, for example, throughout the early 1930s was shown in a single image, sometimes rendered as a photograph, sometimes as a drawing.[57]

The popular Leningrad Party boss Sergei Kirov was murdered on 1 December 1934. A few days later Stalin appeared as a pallbearer at Kirov's funeral, one of his many appearances as pallbearer, totaling fourteen (Figs. 2.7, 2.8).[58] Did images like these establish an uncanny link between Stalin and (violent) death, as in the purges that followed the Kirov murder? Did this link stay in collective memory, ready to be reactivated during mass terror as in 1937? And did it thus counter the strategy of scaling back Stalin's appearances in *Pravda* in times of trouble in order to avoid negative associations?

After the Kirov murder *Pravda* began a feature on Stalin's involvement in the struggle for Tsaritsyn early in the Russian Civil War, further establishing this event as a key moment in the founding history of the Soviet Union, signifying the first defensive victory of the new country born in Red October. In early 1935 the first pictures of Stalin without a caption began appearing, testifying to a perception among the makers of *Pravda* that by now its readers were Stalin-literate

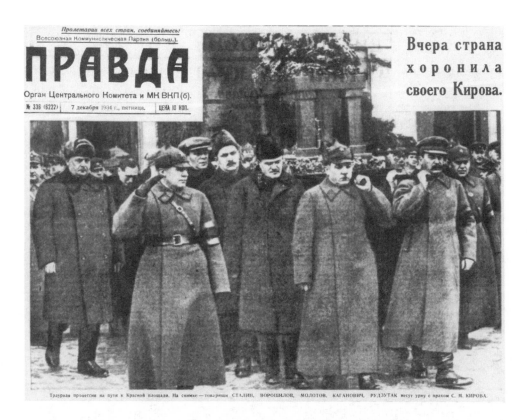

Figure 2.7. Stalin as pallbearer at Kirov's funeral. *Pravda*, 7 December 1934, 1.

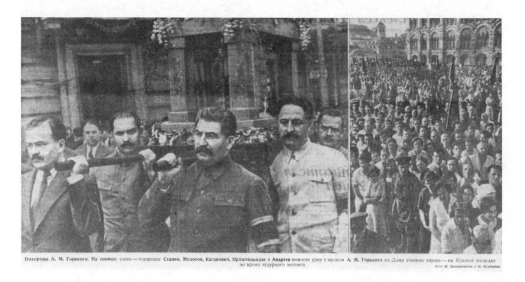

Figure 2.8. Stalin as pallbearer at Gorky's funeral. *Pravda*, 21 June 1936, 1.

enough to recognize their *vozhd'* at first sight, without verbal explanations. At the same time reproductions of paintings became more numerous, larger in size, and more monumental in appearance, set in baroque gold frames when shown in the background.[59] In the spring of 1935 representations of abundance and fertility burst upon the scene, symbolized by smiling Central Asians carrying exotic fruits or a newborn.[60] There was also a sudden explosion of flowers, lakes, and nature, of nature metaphors as in a description of young athletes as a "blossoming generation" and an article by a young Pioneer, "I Gave a Bouquet to Stalin." Such pastoral idylls pointed to the new sense of arrival, of nearing socialism, to an end of the emphasis on machines and heavy industry of the First Five-Year Plan, to an end of the hardships of building socialism.[61] This was in conformity with the shift from machine to garden metaphors in socialist realist novels, as Katerina Clark has shown (Figs. 2.9, 2.10, 2.11).[62]

Smiles proliferated, and on the tribune of the Lenin Mausoleum even the Party leaders, including Stalin, smiled while applauding the parade on Red Square

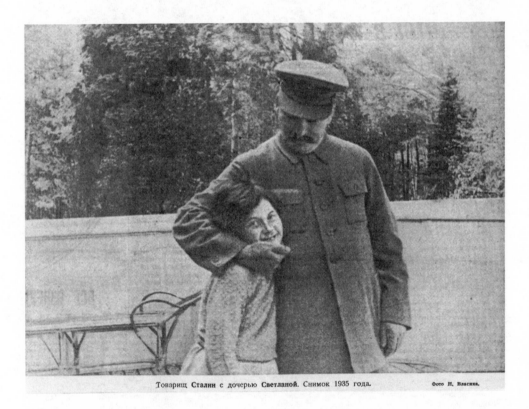

Товарищ Сталин с дочерью Светланой. Снимок 1935 года. Фото Н. Власика.

Figure 2.9. *Pravda*'s only photo of Stalin with a biological child, Svetlana. Conforming to Stalin's image of "father of peoples," hereafter he was only shown with non-biological children. The image was credited to Nikolai Vlasik, Stalin's bodyguard, tutor of his children, and majordomo after his wife Nadezhda Allilueva's death in 1932. *Pravda,* 3 August 1935, 3.

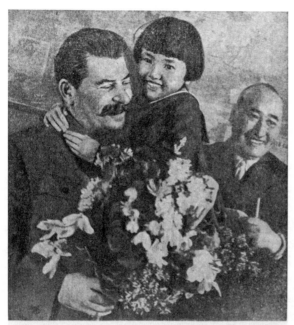

Figure 2.10. Stalin with Gelia Marki-
zova, a Buriat Mongol girl. *Pravda*,
30 January 1936, 1.

Товарищ Сталин с шестилетней **Гелей Маркизовой**, преподнесшей ему букет цветов — подарок
делегации Бурят-Монгольской Автономной Советской Социалистической Республики. Справа на
снимке — секретарь Бурят-Монгольского обкома ВКП(б) тов. **Ербанов.**
Снимок сделан в Кремле 27 января 1936 года. Фото М. Калашникова.

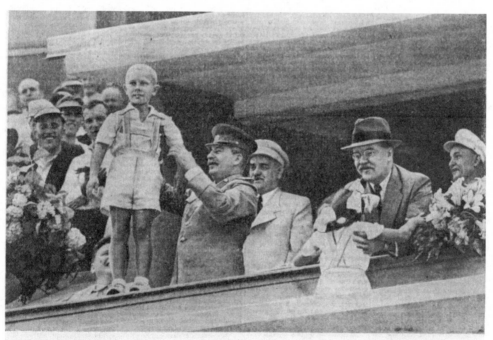

Всесоюзный парад физкультурников в Москве на стадионе «Динамо». На снимке: И. В. Сталин и В. М. Молотов принимают цветы от детей
Фото Е. Халдея. (ТАСС).

Figure 2.11. Stalin with a blond boy at a Physical Culture parade at Moscow's Dynamo stadium.
Note the shift to ethnic Russian children. *Pravda*, 22 July 1946, 1.

during the annual Day of the October Revolution.[63] All this was encapsulated in the 1935 Stalin dictum, "Life has become more joyous, comrades, life has become easier!" Newspapers creatively adapted this formula, fashioning a binary opposition with life in the dark, capitalist West constituting the negative pole. Consider, for example, London correspondent N. Maiorsky's headline, "Life Has Become Harder and Sadder."[64] 1935, the year that had begun with the first wave of purges following the December 1934 Kirov murder, ended with the first picture of a New Year's tree in *Pravda*.

Socialism arrived in the mid-1930s, officially first proclaimed with the Stalin Constitution of 1936. On a formal level, this change meant that horizontality triumphed over verticality. Beginning in 1930 *Pravda* had turned to statistics, graphically represented with steep upward curves, as well as photographs and drawings of the developing socialist cathedrals—blast furnaces, smokestacks, oil rigs, and electricity poles—likewise pointing upward. These were the representations of the building of socialism, of an acceleration on the utopian timeline. The mid-1930s marked the arrival at a plateau, an arrival that was expressed with horizontal representations, such as panoramic views of new socialist towns like Magnitogorsk, of gardens, or bird's-eye-view maps.

Similarly, in late 1935 the ethnic minorities of the Soviet Union began crowding the pages of *Pravda*. During the Moscow-based "week of national art" (*dekada natsional'nogo iskusstva*) of a specific minority, Stalin often made an appearance and was sometimes shown in appropriate national costume.[65] How, then, was Stalin's own ethnicity presented? The answer is surprising, but first warrants a look at the complex Soviet concept of ethnicity. The Soviet Union was not a nation-state but a federation composed of territories delimited according to ethnolinguistic criteria. Apart from citizenship of this federative Soviet Union, every Soviet citizen was ascribed a nationality, which matched (with some exceptions) one of the ethnoterritorial units. This nationality was recorded in such documents as the internal passport. Rogers Brubaker has described this bifurcated Soviet conception of ethnicity, which was to a large extent formulated by and under Stalin, with the terms "ethnoterritorial federalism" and "personal nationality."[66] Stalin was from Georgia, his personal nationality was Georgian, and in real life he bore many markers of Georgianness, starting with his thick Georgian accent and ending with his habit of appointing a toastmaster (in Georgian, *tamada*) at his late-night drinking banquets with his cronies in the Kremlin. At a dinner in his close circle after the 1937 Day of the October Revolution parade, with tongue in cheek he even told the Bulgarian head of the Comintern, "Comrade Dimitrov, I apologize for interrupting you, but I am no European, I am a Russified Georgian-Asian (*obrusevshii gruzin-aziat*)."[67] Yet Stalin was never depicted as a Georgian. As a critique of a draft copy of a heavily illustrated album of Lenin and Stalin put it, "The majority of

the pictures . . . belongs to artists from Georgia. This creates the impression of Stalin as the leader only of the Georgian people, not of all peoples of the Soviet Union. This political flaw must be eliminated."[68] As "father of peoples" (*otets narodov*), one of his central images, Stalin, to use Brubaker's terms, represented the "ethnoterritorial federation" of the Soviet Union, not his Georgian "personal nationality." His representations were supranational and consisted of an amalgam of Bolshevik Party culture, Civil War traditions, and other sources. If Georgia (or any other personal nationality) appeared in his official depictions at all, then at most as a kind of wallpaper during the Georgian *dekada*, which started on 19 March 1936, that is, as folkloric background.[69] Personal nationality did appear as a vestige of the representational techniques of a specific artistic culture, meaning that Stalin in a portrait produced by an Uzbek artist often looked slightly Uzbek with "Asiatic," "slanted" eyes. Likewise, after 1945 and the enlargement of the Soviet space through the annexation of Eastern European countries, Stalin portrayed in a portrait by a Romanian artist appeared slightly "Romanian."[70] Later, during the rise of "Soviet patriotism" (considered by many a barely disguised version of Russian nationalism) at the end of the 1930s, especially during the war, Stalin's image was Russified. For example, the main film actor starring as Stalin changed. Previously Stalin had been portrayed mostly by Mikhail Gelovani, a fellow Georgian with a heavy Georgian accent and a physical appearance startlingly like Stalin's. Beginning with the 1948 movie *The Third Blow*, a new Stalin actor was introduced, Aleksei Diky, an ethnic Russian without an accent. Nonetheless, the Russification of Stalin's image only went to a certain point. In fact, it mirrored precisely the proportion of Russian space compared to the many other ethnoterritories in the sum of the federative Soviet Union. But an excursus on Stalin and ethnicity would be incomplete without mentioning the potential danger posed by less official representations of his Georgian personal nationality. Suffice it to say that there is a long series of identifications of Stalin as Eastern, Asiatic "Other"—including such high points as Stalin's "broad Ossetian's chest" (*shirokaia grud' osetina*) in Osip Mandelstam's 1933 epigram and Karl Wittfogel's 1957 study *Oriental Despotism*.[71]

As far as genres of Stalin representations were concerned, in early 1936 there was a marked move away from photomontages toward reproductions of socialist realist paintings. On 12 June 1936 a draft of the constitution that one month later became known as the Stalin Constitution was published in *Pravda*. It engendered a new performance of quasi-democracy, with citizens discussing the constitution and sending to *Pravda* letters addressed to Stalin.[72] Soon thereafter *Pravda* served as a platform for initiatives to open Stalin museums.[73] In early August 1936, the theme of Stalin in danger was developed in preparation for the first Moscow show trial of Kamenev and Zinoviev. Articles with titles

like "Take Care of and Guard Comrade Stalin" and "Take Care of Your Leaders Like a Military Banner" were launched.[74] Generally in *Pravda* the increase in violence in politics during the show trial was accompanied by an increase in love and tenderness for Stalin.

Early 1937 indeed showed a precipitous drop in Stalin pictures, likely to avoid linking him with the purges. During 1937 the flowers, gardens, fruits, and smiling Central Asians disappeared, together with the pictorialized Stalin. If smiles made a comeback at all during the year of the Great Terror, it was on the faces of ethnic Russian blonde Komsomol members and schoolchildren, in connection with the beginning of the new school year and Komsomol Day during the fall.[75] The year 1937, one of the bloodiest years in Soviet history, drew to a close with an article on 30 December entitled "We Owe Our Happiness to Comrade Stalin."[76]

Between January and May 1938 there again was much less Stalin representation than usual in *Pravda*, confirming the thesis that Stalin's cult diminished during cataclysms like the Terror. Again, possibly to avoid negative associations, Stalin was kept out of the pictorial representations of the Soviet-German Nonaggression Pact.[77] In the fall of 1938 the Terror was stopped, and the cult picked up again. Letters to Stalin by meetings of scientists, Party units, a congress of Soviet surgeons, the Third Congress of Leading Livestock Breeders of Kazakhstan, trade unions, and kolkhozes also came back with a vengeance. The first still pictures from movies with actors playing the role of Stalin began appearing in *Pravda* (Fig. 2.12).[78] At the dawn of the 1940s the representation of Stalin's age was conflicting. In some pictures he was shown as old, in others as young. In the course of three weeks in 1941 Stalin appeared first as aged with graying hair, then again as young, with his "Georgian" haircut, "Georgian" moustache (the ends pointed downward), and with hardly a single gray hair.[79] This was a period of flux in which Stalin changed to a new paradigm—the image of the postwar generalissimo with deep wrinkles, an aging chin, graying hair, a Russian haircut, and a Wilhelmine moustache (with upward-pointing ends like Kaiser Wilhelm II).

The year 1939 ended with the greatest manifestation so far of the cult in *Pravda*, and any other medium for that matter—Stalin's sixtieth birthday celebration (Fig. 2.13). For all high Soviet Party functionaries only round-number birthdays were celebrated in public;[80] in fact, for Stalin there were normative documents expressly restricting birthday celebrations to these. The normative documents were a reaction to attempts to celebrate his fifty-fifth birthday.[81] In this respect the Soviet festive cycle differed from that of Hitler's Germany, where 20 April was always the holiday of *Führers Geburtstag*.

Pravda's 21 December 1939 issue numbered twelve pages (in contrast to the regular six pages and the expanded eight pages of the 21 December 1929 issue),

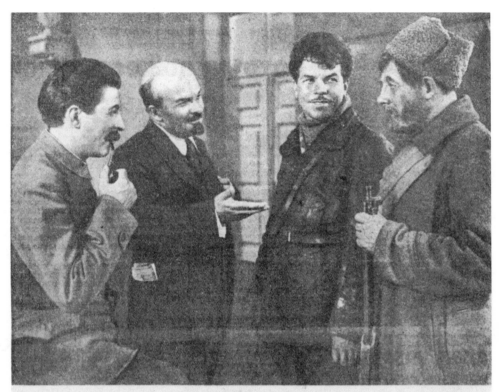

Кадр из фильма «Человек с ружьем». Товарищи **В. И. Ленин** (заслуженный артист республики М. Штраух) и **И. В. Сталин** (артист М. Геловани) беседуют с солдатом **Иваном Шадриным** (артист Б. Тенин) и красногвардейцем **Чибисовым** (артист В. Лукин).

Figure 2.12. The first still picture from movies with actors playing the role of Stalin: Mikhail Gelovani as Stalin in *Man with a Rifle* (1938). *Pravda,* 3 October 1938, 4.

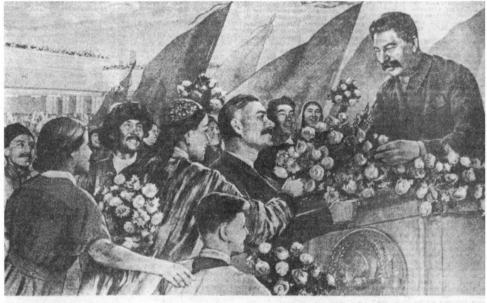

Композиция художника В. Корецкого.

Figure 2.13. Stalin's sixtieth birthday. Note the emphasis on ethnic minorities, women, and children, who reinforce Stalin's "father of peoples" image. *Pravda,* 22 December 1939, 1.

which itself is an indicator of the gigantism of the birthday celebrations. The number of visual representations during the birthday month of December overshadowed any other month (see Graphs 2.1, 2.2, and 2.3). A photograph of Stalin sitting at his desk with a pencil in his hand and several sheets of paper in front of him took up at least one-third of the front-page; let us recall here that in 1929 the photograph in the birthday issue occupied no more than one sixteenth of the front-page. Stalin was shown smiling benevolently, his hair neatly combed back, and his gaze directed to the right at a point outside the picture, not at the onlooker as in 1929. The long and anonymous lead article is entitled "Dear Stalin (*Rodnoi Stalin*)," carrying the kinship connotation that goes along with *rodnoi*. The upper right part of the front-page held a decree by the Presidium of the USSR Supreme Soviet that bestowed upon Stalin the order of Hero of Socialist Labor. Below this decree there is an article signed by the Party Central Committee, "To the Great Continuer of Lenin's Task—Comrade Stalin."

Compared with 1929, *Pravda*'s 1939 celebration of Stalin's sixtieth birthday was a more visual event. Again compared with 1929, photographs were not greater in number but larger in size and better in quality. They accompanied texts and showed, for example, in the middle of a full-page article by Molotov on "Stalin as the Continuer of Lenin's Task," an image of Stalin with Molotov. Further articles were written by Voroshilov, Kaganovich, Mikoian, Kalinin, Andreev, Khrushchev, Beria, Malenkov, Shvernik, Shkiriatov, Poskryobyshev

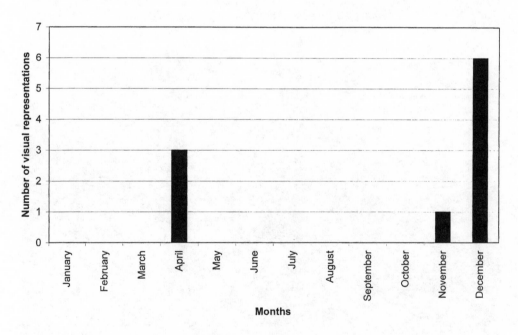

Graph 2.1. Visual Representations of Stalin in *Pravda,* 1929

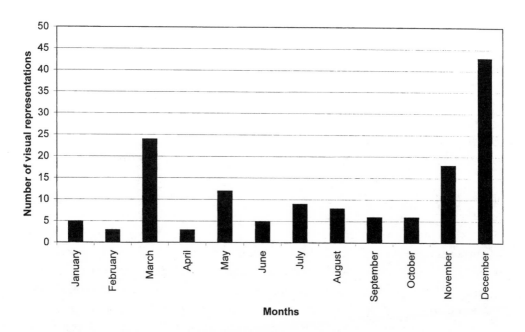

Graph 2.2. Visual Representations of Stalin in *Pravda*, 1939

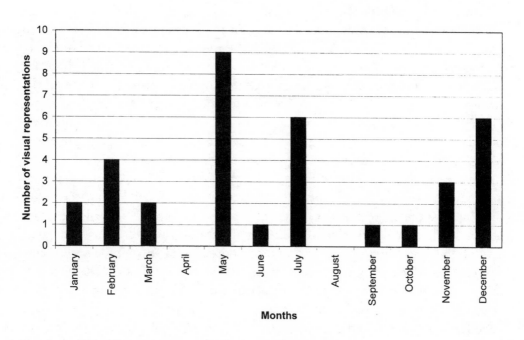

Graph 2.3. Visual Representations of Stalin in *Pravda*, 1949

and Dvinsky, and Dimitrov. Typically the author would treat Stalin's achievements in the sphere he represented, Voroshilov writing about "Stalin and the Buildup of the Red Army" and Dimitrov about "Stalin and the International Proletariat." Compared with 1929, new topics included the agrarian sector, the title of Andreev's article reading "Stalin and the Great Kolkhoz Movement," and the nationalities issue, the title of Khrushchev's article reading "Stalin and the Great Friendship of Peoples." As in 1929, there was a small place reserved for "real news." In 1929 this space was still half of the penultimate page seven, while in 1939 this area had been reduced to the rightmost, last slim column on page twelve. On 21 December 1949 news was completely effaced from the country's main newspaper.

For the entire month of January 1940, every issue of the newspaper carried a rubric on page two, three, or four entitled "Torrent of Greetings to Comrade Stalin in Connection with His Sixtieth Birthday," with lists of individuals and organizations extending their congratulations to the leader. On 9 March 1940 and the surrounding days the newspaper celebrated Molotov's fiftieth birthday, also with a rubric of congratulatory greetings, although under a different title ("From All Ends of the Country"), fewer in number, and shorter in duration. Of course in the representations of Molotov's birthday, Stalin often appeared together with his close "comrade-in-arms."

In February 1941 came the celebrations of Voroshilov's sixtieth birthday, in which Stalin, as usual, played a huge role, amplifying Voroshilov's status and his own.[82] Everything changed on 22 June 1941, the day of the German attack on the Soviet Union. Smiles, which had been reappearing, even on Uzbeks and Tadzhiks at the All-Union Agricultural Exhibition in Moscow, were suddenly wiped off all faces. One day after the attack, on 23 June, *Pravda* featured a large photograph of Stalin occupying the entire upper right-hand quarter of the front-page. Stalin looked leftward, his nose very pointed, his moustache already faintly Wilhelmine. There were small crow's feet in the corners around his eyes, but his hair had not yet turned gray. The slogan at the top of the page presented Stalin as the pivot of the Soviet Union, around whom all were supposed to rally: "Fascist Germany has rapaciously attacked the Soviet Union. Our heroic army and navy and brave falcons of the Soviet aviation will carry out a crushing blow against the aggressor. The government calls upon the citizens of the Soviet Union to close ranks even more tightly around our glorious Bolshevik Party, around the Soviet government, around our great leader—Comrade Stalin. Our cause is just. The enemy will be defeated. Victory will be ours."[83] The next day this point was driven home pictorially. A photo on the second page showed a large gathering at Moscow's Stalin car factory with a Stalin bust in the center. Page four pictured a soldier holding the 23 June issue of *Pravda* with Stalin's image in the "waiting room of the Oktiabrsky district draft center," as the cap-

tion explained, and a Stalin bust in the background. Evidently to boost morale, in mid-December *Pravda* featured a still from a film of Stalin's speech on Red Square on 7 November, the Day of the October Revolution. The caption identified Stalin as "Chairman of the State Defense Committee." Typically, Stalin's many Party, state, and military titles were deployed according to the situation. On 15 February 1942 there appeared a Stalin whose forehead now showed a deepening wrinkle.[84] There was a new seriousness and decisiveness about him and his gaze into the distance now also signified his visionary premonition of the outcome of the war, of victory. As to clothing, the general's cap with the Red Star appeared.[85] In late March *Pravda* announced a new movie, *The Defense of Tsaritsyn*, whose story placed the old founding myth of Stalin's defense of Tsaritsyn against domestic enemies during the Civil War in the new context of the Soviet Union against the foreign enemy during World War II. Interestingly, even though the film was set in 1919, the actor starring as Stalin—Gelovani—had changed his physical appearance to conform to Stalin's emerging wartime and postwar image: his hair was graying, the moustache was Wilhelmine.[86] Overall, however, there was a decline in visual representations of Stalin during the war. In fact the newspaper became more text based, with the exception of caricatures by the Kukryniksy, the artist trio Mikhail Kupriianov, Porfiry Krylov, and Nikolai Sokolov. Their drawings portrayed recent political events or protested against Hitler and the fascists, depicting them as cannibals, pigs, monkeys, and vultures.[87] In *Pravda*, the visual image–based Stalin cult only really gained in profile near the end of the war, when victory was certain.

A heavily retouched photo showed a soldier single-handedly producing a self-made front newspaper called *Fighting Newsletter* (*Boevoi listok*), with a pencil in his hand filling the page right below the Stalin portrait he himself has supposedly just drawn—but such pictures remained an exception.[88] The by now canonical representation of some of the major public holidays was suspended, and there was no picture of a May Day parade on Red Square. Instead on 1 May 1942 the front page featured a Stalin decree and a recent drawing of Stalin by Boris Karpov, executed with bold strokes and showing the leader as army commander with his general's cap, in profile, looking left, with deep wrinkles on his forehead and around his eyes, and wearing a very Wilhelmine moustache. Instead of parade pictures on the following days, *Pravda* on 3 May showed a small photograph of a meeting of soldiers in the woods with several officers and a Stalin portrait on a makeshift tribune.[89] Everything was now connected with the war. If a Stalin portrait at a worker meeting in a factory was shown, it was a defense industry factory. If a Stalin portrait at a concert was shown, it was a concert of the Red Army choir. If Stalin was shown with foreign dignitaries, they were generals or politicians of the Allied forces.[90]

In 1942, the Day of the October Revolution was another milestone on the road toward Stalin's postwar pictorial representations. From now on he often appeared not in his customary army riding pants with high boots but rather in parade trousers, decorated with stripes on the side, and low parade shoes. The new image soon made its way into secondary representations, as in a painting in the background of a picture of the opening of a new Moscow metro line, where Stalin is shown in his generalissimo's greatcoat and the new Supreme Commander in Chief's cap. This image developed further: the gray started at his forehead and temples and later moved to the top of his hair, and spread to his moustache. Epaulettes and elaborate buttons appeared on his uniform. The pockets on the once simple gray military uniform were now stylized and pointed, and the collar became a high one.[91] Bodily attributes of Soviet leaders turned into loaded signs and came to stand in for the whole person: think only of Stalin's moustache, Khrushchev's bald head, Brezhnev's eyebrows, and Gorbachev's birthmark. A turning point in the gradual move toward the postwar style of representations of Stalin as generalissimo came on 7 November 1943, when he was shown on the front page in a drawing by Pavel Vasiliev in his ornate military uniform. Stalin was looking right, his hair graying, his moustache Wilhelmine, much oakleaf decoration on his dark uniform. The caption read: "Decree of the Presidium of the USSR Supreme Soviet on the award to Marshal of the Soviet Union, Joseph Vissarionovich Stalin, of the Order of Suvorov." Two pages further on, Stalin was shown speaking at Mossovet, the Moscow City Soviet, on 6 November, and here too his hair was gray.

Soviet Russia was not the only country where the bodily features of leaders became iconic signs. Italian writer Italo Calvino remembers from his youth the shift of depictions of Mussolini "from the frontal image to the side image, which was much exploited from that point on, in that it enhanced his perfectly spherical cranium (without which the great transformation of the dictator into a graphic object would not have been possible), the strength of his jaw (which was emphasized also in the three-quarters pose), the continuous line from the back of his head to his neck, and the over-all Romanness of the whole," all prompted by the appearance in the early 1930s of a new equestrian monument at a stadium in Bologna. Mussolini's physique infiltrated everyday behavior of the Italian population and inspired concrete practices. "In one of the affectionate games that people used to play at the time with children of one or two years," Calvino recalls, "the adult would say, 'Do Mussolini's face,' and the child would furrow his brow and stick out angry lips. In a word, Italians of my generation carried the portrait of Mussolini within themselves, even before they were of an age to recognize it on the walls. . . ."[92] Mussolini's protruding chin, his balding head, the often bare-chested torso, the clean-shaven face (vs. the moustached or bearded countenances of his Italian predecessors or his

European rival statesmen)—none of these were neutral or insignificant. All of these corporeal features were powerfully signifying loci, and many of them had a latent antipode in Roosevelt, Hitler, or Stalin.

A new setting for photo opportunities also appeared in late 1942: increasingly Stalin was shown with foreign prime ministers and other high-ranking dignitaries in a dark wood-paneled Kremlin room, standing with his hands behind his back behind a table where either the dignitary or Molotov was signing a treaty, for example, that on "Friendship, Mutual Help, and Postwar Cooperation between the Soviet Union and the Czechoslovak Republic."[93] In these ceremonies a benevolent smile sometimes returned to Stalin's face—after a near-total absence during the first years of the war. Also towards the end of the war, there appeared photos of Stalin at peace conferences meeting the other two members of the "Big Three," first at Tehran in 1943, then at Yalta and Potsdam in 1945. S. Gurary's famous Yalta photograph was published on *Pravda*'s front page on 13 February 1945 and depicted Churchill sitting on the left (seeming physically frail and disgruntled), Roosevelt in the middle, and Stalin on the right. Roosevelt was holding a cigarette (apparently retouched), Churchill was smoking a cigar, only Stalin was not smoking. He was smiling, dressed in his marshal's greatcoat and general's cap, and appeared to be the tallest of the three statesmen. In the spring of 1945, *Pravda* readers could get further visual cues that the end of the war was nearing. Stalin again reappeared in the background of photographs, as in a picture of the "management board of the Stalin *artel*, Ramensky district, Moscow region" shown "discussing the production plan of the kolkhoz for 1945." Plans for the future, if only plans of a kolkhoz, were back, as were happy faces of the kolkhoz peasants.[94]

A majestic Stalin appeared in a 1945 picture by Boris Karpov on the front page of 1 May 1945, just a little over a week before the German capitulation (Fig. 2.14).[95] This image shows Stalin in a dark marshal's uniform with nine medals, his thumb between two buttons of his jacket in a semi-Napoleonic gesture, wearing long trousers and parade shoes, and with graying hair and moustache. In the background (presumably his office) behind him is a chimney-like contraption, and on the upper right-hand side of the wall is a canonical picture of Lenin reading a newspaper. The entire rest of the page was taken up by a Stalin text, a "decree of the Supreme Commander in Chief (*Verkhovnyi Glavnokomanduiushchii*)" to "give a twenty-gun salute" in the capitals of the union republics to honor the bravery of the Soviet nation on the war and home fronts and on the occasion of the May holiday. All the Stalin decrees appearing in *Pravda* towards the very end of the war either singled out specific generals, soldiers, or army units for praise or—symbolically—"ordered" them to do something, such as conquer Berlin. During the early phase of the war, there seems to have been a deliberate effort not to enmesh Stalin's name with failures

Figure 2.14. War's end is imminent and Stalin is back in *Pravda*. By Boris Karpov. *Pravda*, 1 May 1945, 1.

and defeats. At the victorious end, *Pravda* deliberately linked his name with the glorious deeds. On 2 May 1945, after a three-year gap (1942–1944) and for the first time since the beginning of the war, *Pravda* published a picture of a May Day parade with fifteen leaders on the tribune of the Lenin Mausoleum, with Stalin standing third from the left, between Budyonny and Falaleev. Many were in uniforms with numerous medals; Stalin was dressed more simply, in his marshal's greatcoat. Several leaders including Stalin were saluting the parade with their right arms. On the same front page was a typical picture of Beria, Stalin, Malenkov, Kaganovich, Kalinin, Mikoian, Shvernik, Voroshilov, and Voznesensky "walking to Red Square" from the Kremlin.

On the day of the German capitulation, 9 May, soon to join the canon of holidays as Victory Day (*Den pobedy*), *Pravda* showcased on page three a drawing by V. Andreev that depicted a beaming soldier with an automatic rifle, holding

a flag with a Stalin portrait, with the Kremlin tower in the background and fireworks in the sky. The slogan of the day reads: "Long live our victory!" One day later two-thirds of the front page were occupied by an image of Stalin by V. Bulgakov.[96] This image shows a graying Stalin in his marshal's uniform with the single Hero of Socialist Labor medal, holding a pipe in his left hand and papers in his right hand. On the lower left part of the page is a picture of Stalin, Truman, and Churchill. The rest of the right-hand front page is taken up by an "Address of Comrade J. V. Stalin to the People" on the German capitulation (Fig. 2.15).

On 13 May 1945 Stalin and his magnates were again staged on the mausoleum tribune, this time at A. S. Shcherbakov's funeral. According to the caption, the photo showed "The funeral of A. S. Shcherbakov, Comrades Aleksandrov, Shvernik, Gorkin, Golikov, Stalin, Voroshilov, Malenkov, Beria, Andreev, Kaganovich, Voznesensky, and Budyonny on the tribune of the mausoleum during the funeral procession (*traurnyi miting*). Comrade Popov is making a speech."[97] By this time at the latest both domestic and foreign observers (Kremlinologists) were trying to obtain cues about the current hierarchy of the Party leadership below Stalin by studying the grouping of men around him and, discounting the military men Voroshilov and Filipp Golikov, they would have figured that Malenkov and Beria both had good chances, being placed close to Stalin. In these *Pravda* representations during May, "the high point of the authority of Stalin" (Elena Zubkova), proximity to Stalin can be read as an indication of high status, even as a pole position in the struggle for succession that was bound to erupt some time in the future.[98]

The war was over, and so was the heightened seriousness maintained in the country's leading newspaper. Images of soccer, cows, and the Dnieper hydroelectric power station all returned to *Pravda*. As if to make up for his low profile during the war years, during the summer of 1945 Stalin was all over the newspaper. The official victory parade on Red Square on 24 June was duly celebrated in *Pravda* one day later. On 27 June the front page announced that Stalin had received the title Hero of the Soviet Union. On 28 June *Pravda*'s front page carried a repeat portrait by V. Bulgakov on the occasion of the presentation to Stalin of "the highest military rank—Generalissimo of the Soviet Union (*vysshego voinskogo zvaniia—Generalissimus Sovetskogo Soiuza*)," and on page two, an image showing a soldier reading aloud this decree to his happy comrades. The postwar generalissimo image of Stalin, which had been gestating since at least early 1941, now reached its fullest expression.[99] Stalin's hair and moustache had definitively turned gray, he looked weathered by the war, his skin appeared older, his entire face somewhat puffy, his chin unmistakably double. He was habitually dressed in his marshal's uniform and greatcoat, with the single pentagram-shaped Soviet Hero of Socialist Labor medal, often with his hands behind his back. On 1 August Stalin made his first appearance in his

Пролетарии всех стран, соединяйтесь!

Всесоюзная Коммунистическая Партия (больш.).

ПРАВДА

Орган Центрального Комитета и МК ВКП(б).

№ 111 (9882) Четверг, 10 мая 1945 г. ЦЕНА 20 КОП.

Вчера наш великий народ, народ-победитель праздновал день полного торжества своего правого дела.

Да здравствует великий организатор и вдохновитель исторической победы советского народа над германским империализмом—наш любимый вождь и учитель товарищ Сталин!

И. В. Сталин.

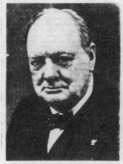

Премьер-министр Великобритании У. Черчилль.

Президент США Г. Трумэн.

Обращение тов. И. В. Сталина к народу

Товарищи! Соотечественники и соотечественницы!

Наступил великий день победы над Германией. Фашистская Германия, поставленная на колени Красной Армией и войсками наших союзников, признала себя побежденной и об'явила безоговорочную капитуляцию.

7 мая был подписан в городе Реймсе предварительный протокол капитуляции. 8 мая представители немецкого главнокомандования в присутствии представителей Верховного Командования союзных войск и Верховного Главнокомандования советских войск подписали в Берлине окончательный акт капитуляции, исполнение которого началось с 24 часов 8 мая.

Зная волчью повадку немецких заправил, считающих договора и соглашения пустой бумажкой, мы не имеем основания верить им на слово. Однако сегодня с утра немецкие войска во исполнение акта капитуляции стали в массовом порядке складывать оружие и сдаваться в плен нашим войскам. Это уже не пустая бумажка. Это—действительная капитуляция вооруженных сил Германии. Правда, одна группа немецких войск в районе Чехословакии все еще уклоняется от капитуляции. Но я надеюсь, что Красной Армии удастся привести ее в чувство.

Теперь мы можем с полным основанием заявить, что наступил исторический день окончательного разгрома Германии, день великой победы нашего народа над германским империализмом.

Великие жертвы, принесенные нами во имя свободы и независимости нашей Родины, неисчислимые лишения и страдания, пережитые нашим народом в ходе войны, напряженный труд в тылу и на фронте, отданный на алтарь отечества, — не прошли даром и увенчались полной победой над врагом. Вековая борьба славянских народов за свое существование и свою независимость окончилась победой над немецкими захватчиками и немецкой тиранией.

Отныне над Европой будет развеваться великое знамя свободы народов и мира между народами.

Три года назад Гитлер всенародно заявил, что в его задачи входит расчленение Советского Союза и отрыв от него Кавказа, Украины, Белоруссии, Прибалтики и других областей. Он прямо заявил: «Мы уничтожим Россию, чтобы она больше никогда не смогла подняться». Это было три года назад. Но сумасбродным идеям Гитлера не суждено было сбыться, — ход войны развеял их в прах. На деле получилось нечто прямо противоположное тому, о чем бредили гитлеровцы. Германия разбита наголову. Германские войска капитулируют. Советский Союз торжествует победу, хотя он и не собирается ни расчленять, ни уничтожать Германию.

Товарищи! Великая Отечественная война завершилась нашей полной победой. Период войны в Европе кончился. Начался период мирного развития.

С победой вас, мои дорогие соотечественники и соотечественницы!

СЛАВА НАШЕЙ ГЕРОИЧЕСКОЙ КРАСНОЙ АРМИИ, ОТСТОЯВШЕЙ НЕЗАВИСИМОСТЬ НАШЕЙ РОДИНЫ И ЗАВОЕВАВШЕЙ ПОБЕДУ НАД ВРАГОМ!

СЛАВА НАШЕМУ ВЕЛИКОМУ НАРОДУ, НАРОДУ-ПОБЕДИТЕЛЮ!

ВЕЧНАЯ СЛАВА ГЕРОЯМ, ПАВШИМ В БОЯХ С ВРАГОМ И ОТДАВШИМ СВОЮ ЖИЗНЬ ЗА СВОБОДУ И СЧАСТЬЕ НАШЕГО НАРОДА!

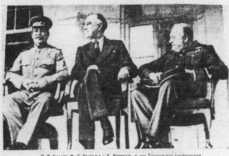

И. В. Сталин, Ф. Д. Рузвельт и У. Черчилль в дни Тегеранской конференции.

Figure 2.15. Front page the day after Germany's capitulation. *Pravda*, 10 May 1945, 1.

white generalissimo uniform with five golden buttons and epaulettes.[100] The occasion was the Potsdam Conference. In this picture (and in two more photographs of the conference) the white color of his uniform and his position in the picture set Stalin apart from his Western counterparts, Harry Truman, Winston Churchill, and Clement Attlee.[101] In an August 1945 picture of the Soviet leadership with General Eisenhower and Averell Harriman on the tribune of the Lenin Mausoleum during a Physical Culture parade, for the first time the white uniform spread from Stalin to other Party luminaries.[102] In pictures of various Party or Supreme Soviet congresses, Stalin was now often seated all by himself, appearing aloof, sometimes in a corner of the auditorium.[103]

It was only a small step from this aloofness to complete absence. Thus in the photograph of the tribune of the Lenin Mausoleum during the Day of the October Revolution 1945, Stalin was missing among his cronies for the first time in years.[104] Thereafter he made one last appearance, in 1952. There might have been real-life explanations for this change, such as his frail health. However, to *Pravda* readers this change announced a shift toward absent representations, as in Chiaureli's movie *The Oath* (1946), where in a famous scene Lenin's spirit was transferred to Stalin at a park bench in Gorki;[105] or as in Pavel Sokolov-Skalia's painting, *The Voice of the Leader*, which showed a group of soldiers and others grouped around a radio listening to a Stalin speech. Another example was Dmitry Mochalsky's 1949 picture, *After the Demonstration (They Saw Stalin)*, which depicted a group of children and others returning from a parade with shining faces—the presence of Stalin in the picture was manifest on the faces of the children and in the title, yet there was no direct representation of him (Fig. 3.12, p. 114). Around the same time in Poland, Party meetings adopted the ritual of electing Stalin to an imaginary honorary presidium and then leaving a chair empty for his spiritual presence.[106] Practices such as this one reconnected with premodern (and Byzantine) tradition, for example of using an *effigie* in France as an ersatz monarch, or of the *Rat* who in 1791 genuflected in front of an imperial portrait.[107] Stalin's absence hence was an absence that implied presence—"in the spirit," as an allusion, as a metaphor. Put differently, by being absent, Stalin became more present than ever (for the first—1937— absent representation of Stalin see Fig. 2.16).

In *Pravda*'s representations of Stalin, the concept of presence-in-absence went hand in hand with the rise of the radio. In conjunction with the 1947 elections to the Supreme Soviet of the USSR, not only was Stalin shown at a rostrum with microphones on the stage of the Bolshoi Theater, but an article described enraptured audiences gathered around radio receivers, listening to their leader's voice emanating from Moscow, the center of the vast Soviet Union.[108] Likewise, the representation of the election results was strictly hierarchical: the announcement of winning deputies listed the Russian Republic first, next the city

Figure 2.16. The first absent representation of Stalin. "... together with his family I. I. Chernyshev is listening to a radio speech of J. V. Stalin from the Bolshoi Theater. ..." On the same page there was a series of reports from various union republic capitals under the headline "The Whole Country Listened to Stalin." *Pravda*, 12 December 1937, 3.

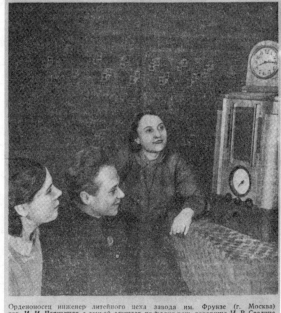

Орденоносец инженер литейного цеха завода им. Фрунзе (г. Москва) тов. **И. И. Чернышев** с семьей слушает по радио речь товарища И. В. Сталина из Большого театра Союза ССР.
Фото Л. Дорецкого.

of Moscow, then the election district named "Stalin," and finally the winner—Joseph Vissarionovich Stalin.

One year after the end of the war, 9 May had become part of the holiday cycle and *Pravda* featured on the front page a photograph of Stalin in marshal's uniform in a wood-paneled room, his left hand behind his back, and his right hand between the buttons of his jacket in the Napoleonic fashion that had become popular in depictions of Party leaders in the early 1930s and had trickled down to smaller authority figures in factories, mines, and kolkhozes (Figs. 2.17, 2.18). In general, after the war the Stalin pictures in *Pravda* became more repetitive and more closely associated with specific holidays.

PRAVDA 1947: ONE YEAR IN THE LIFE OF JOSEPH VISSARIONOVICH

Now has come the moment for a closer look at the more cyclical, ritualized, and synchronic quality of Stalin's representation: the elements that were repeated year after year. It is best to explore one year to follow Stalin's appearance in the premier Soviet newspaper—1947. This was one of the gray years in the pages of *Pravda*. By January 1948 the country would get a foretaste of the 1949 anti-Semitic campaign against "rootless cosmopolitanism," as it learned of the "accidental" death (in fact, the murder by the secret police) of Solomon

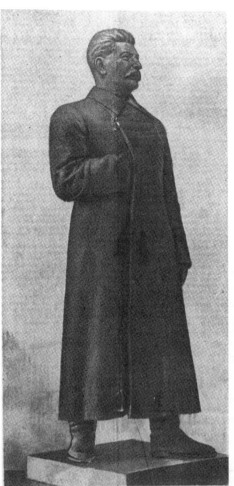

И. В. СТАЛИН. Новая скульптура харьковского художника
М. А. Новосельского.

Figure 2.17. Stalin sculpture by M. A. Novoselsky. The Napoleonic hand inside the coat goes back at least to photographs of Marx, whose bourgeois period had domesticated the French Emperor's gesture. *Pravda*, 10 June 1936, 1.

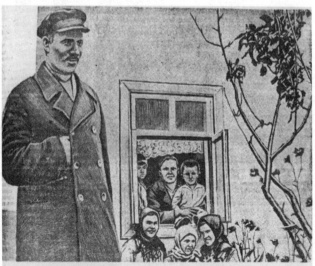

Иван Федосеевич у своего дома. Из окна смотрят его жена, дети, вся семья.

Figure 2.18. This is one of several examples of the dissemination of the Napoleonic hand gesture to the new Stalinist heroes, in this case a kolkhoz activist. *Pravda*, 22 October 1933, 3.

Mikhoels, director of Moscow's State Jewish Theater and president of the Jewish Antifascist Committee. True, in 1947 there was a famine in the Ukraine and in the central and southern parts of the Soviet Union, but needless to say, this calamity never made it onto the pages of the newspapers. And yes, the Cold War and the *Zhdanovshchina* (the era of Zhdanov, of ideological and cultural persecution) with its tireless campaign against Western cultural influences had all begun a year earlier, but 1947 was a year without noisy scandals like the 1946 attacks against Anna Akhmatova, Mikhail Zoshchenko, and the journals *Zvezda* and *Leningrad*. The year 1947, as far as *Pravda* was concerned, was an atypically typical year, no *annus mirabilis* or *annus horribilis* but rather a thoroughly quotidian year.

There were 42 visual representations of Stalin in *Pravda* during 1947, compared with 53 representations in 1945, 39 in 1946, 35 in 1948, and 35 in 1949 (Graph 2.4). This was a far cry both from the prewar all-time high of 142 Stalin pictures in 1939 or a still-impressive 92 in 1937 at the height of the Great Terror, a time when the public Stalin cult was supposedly scaled back, and from the wartime lows of, say, 21 in 1942. Precisely because of its grayness and typical qualities, 1947 is a good year to peer across a *Pravda* reader's shoulder, navigating through the newspaper.

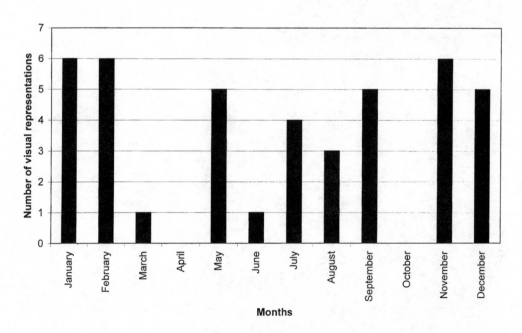

Graph 2.4. Visual Representations of Stalin in *Pravda*, 1947

The lead article on Wednesday, 1 January 1947, was headed simply "1947" and began with the words, "At midnight the Kremlin's Spassky Tower clock announced the end of one year and the beginning of another. The hearts of the Soviet people were filled with a feeling of calm confidence at the sound of the Kremlin chimes. Time is working for us!"[109] In the rest of the article there was a lot of talk about Stalin and how the Soviet Union, under his guidance, was catching up after the wartime devastation. The same was true for the remainder of the paper, but there was no picture of Stalin. The only pictures were photographs of the Dnieper hydroelectric station and the restored S. M. Kirov mill, destroyed during the German occupation, in the town of Makeevka in the Ukraine's Stalin oblast in the Don Basin, accompanied by an article by *Pravda*'s Stalino-based correspondent. Consider the use of "Stalin oblast" and "Stalino"—just as movement through Soviet space had become impossible without encountering Stalin coordinates, movement through the leading Soviet newspaper had become impossible without encountering Stalin's name. But there was no picture of Stalin published on this first day of the year 1947.

This too was typical. Usually neither the 31 December issue nor the 1 January issue featured an image of Stalin. On December 31 there might be seen a picture of a New Year's tree and on the first of the year a photograph of Moscow's illuminated Red Square and the Kremlin's Spassky Tower headed "Moscow on New Year's Eve." In general by 1947, in fact by 1939 at the latest, there was much less of a sense of flux as a canon of Stalin images and a schedule of their appearances had been formed. His representations in *Pravda* adhered to a certain rhythm, which more or less followed the calendar of Soviet holidays. Year after year Stalin appeared on the same occasions and the same holidays—often with the same pictures. Apart from these representations at the high points of the Soviet festive calendar, Stalin appeared on other occasions such as in a photo with a visiting a foreign dignitary, or at an extraordinary Party congress, or of one of the many Soviet election rituals. But what remained stable, what structured Soviet time, what lifted the kairotic above the chronological, were Stalin's ritualized holiday appearances.[110] It was around these holidays that the year revolved.

Most often Stalin made his first appearance of the year on 21 January, in the issue devoted to the anniversary of Lenin's death.[111] Here he was shown with Lenin in a classic 1922 photograph at the government country estate in Gorki. Lenin was ailing after his first stroke of late May 1922. In the photo, Stalin is dressed in a white army overcoat and sitting in a vigorous-looking pose with his legs apart, while Lenin is somewhat in the background, dressed in a gray army overcoat, his hands folded and his legs crossed.[112] The picture suggests one man, Stalin, about to leap, ready for action, while another is sitting back.[113] In 1947, instead of this photograph, *Pravda* featured a drawing

of Lenin by Pavel Vasiliev in the upper left-hand quarter of the first page and a drawing (also by Vasiliev) of Stalin and Lenin in the upper left-hand quarter of page two. The drawing showed Lenin and Stalin seated at a table with a newspaper, Lenin in three-quarter view further back and ambiguously gazing both at a point outside the picture and at Stalin. In the foreground is Stalin in side view, looking down at the newspaper (Fig. 2.19). As so often, the theme was that of Stalin as Lenin's legitimate heir, of Stalin as the follower of Lenin's ideas. In 1947, a merely ritualistic invocation of this theme was necessary, since Stalin had long ago become self-referential and no longer needed to refer to Lenin as a source of legitimacy. A long article entitled "The Great Friendship" ends by citing a piece of Soviet folklore: "The banner that Lenin raised above us,/Neither years nor centuries will shake./Time marches firmly like a trusted horse,/The years go by and we move forward./Along those paths that Lenin bequeathed to us,/Dear Comrade Stalin leads us."[114] The article ended by proclaiming, "This is what the Soviet people say in their epic. They see the embodiment of the Leninist ideas, of the Leninist beginning in his worthy pupil and comrade-in-arms, in the great continuer of his cause. 'Stalin is the Lenin of today,' they say."[115] Other photographs, drawings, or reproductions of paintings might also be shown on this day. Sometimes there were facsimile reproductions of "new" archival documents linking Lenin to Stalin, such as a Lenin telegram or letter addressed to his onetime disciple.[116] The resounding message in all representations on this day was encapsulated in the classic slogan, "Stalin is the Lenin of today." The 22 January picture of the Party leadership at the Lenin commemoration—on the stage of the Bolshoi Theater with a huge Lenin portrait

Figure 2.19. The anniversary of Lenin's death and Stalin's first visual appearance in the annual holiday cycle. Drawing by Pavel Vasilev. *Pravda*, 21 January 1947, 2.

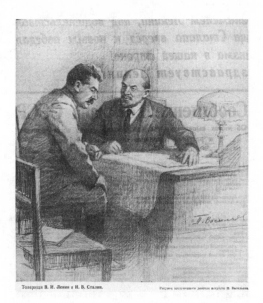

in the background—drove home the same message: despite the entire Party leadership's presence, Lenin's gaze again was directed both into the distance and at Stalin, whose gray generalissimo's uniform distinguished him from his black-clad magnates.

Stalin's next holiday appearance was on 23 February, the Holiday of the Red Army (later Day of the Soviet Army), an important occasion celebrating the founding of the Red Army in 1918. It was important, but not as holy a day as the two highest holidays, International Workers' Day on 1 May and Day of the October Revolution on 7 November.[117] On 23 February 1947 a quarter-page photograph showed Stalin in his parade greatcoat with a fur collar and his parade cap with a (probably gold-colored) cord and single Soviet star button. He peered attentively and pensively both at and past our imaginary *Pravda* reader (Fig. 2.20). His gaze seemed as if he was spotting new military foes of the state he embodied, or pondering the future that he—as the embodiment of history— was able to foresee. To the left of his picture was a long decree that consisted mostly of a summary of the Soviet Army's achievements but closed with the following words:

> In commemoration of the twenty-ninth anniversary of the Soviet Army I decree: Fire a twenty-gun salute in the capital of our motherland, Moscow, in the capitals of the union republics, in Kaliningrad, Lvov, Khabarovsk, Vladivostok, Port Arthur, and in

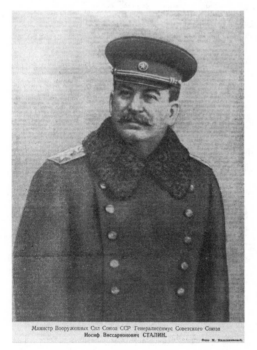

Министр Вооруженных Сил Союза ССР Генералиссимус Советского Союза
Иосиф Виссарионович СТАЛИН.

Figure 2.20. Stalin on the "Holiday of the Red Army." The caption describes him as "Minister of the Armed Forces of the USSR and Generalissimo of the Soviet Union." *Pravda*, 23 February 1947, 1.

the hero-cities Leningrad, Stalingrad, Sevastopol, and Odessa. Long live the Soviet Army and Navy! Long live our Soviet government! Long live our Communist Party! Long live our great Soviet people! Long live our powerful motherland!

The decree was signed "The Minister of the Armed Forces of the USSR, Generalissimo of the Soviet Union J. STALIN."[118] Often on this day *Pravda* featured a picture of Stalin on the tribune of the Lenin Mausoleum taking the salute at a parade of soldiers and heavy military equipment on Red Square. Frequently he was joined by Voroshilov. The message on this day was one of Soviet military might, of preparedness to fend off any outside attack, and of Stalin's embodiment of the Soviet Army. This was a new role he had assumed during World War II. Before then Stalin embodied the state only, and Voroshilov the Red Army, which in turn protected Stalin. But with the war, Stalin had assumed this new double role, embodying both state and army, thus superseding whoever was commissar of war.

In March, Stalin might only make an appearance on the eighth, International Women's Day. But this was not one of the regular "Stalin holidays," and he rarely appeared on this day. In 1947 the Women's Day issue of *Pravda* was pictureless altogether. April was a month without a major holiday, but in late April began the preparation for International Workers' Day on 1 May, with articles like "On the Eve of the Great Holiday." Readers encountered ritualized self-commitments to higher plan targets or greetings, both addressed to Stalin personally, by Yakut reindeer herders, Estonian collective farmers, and Abkhaz lemon growers. May Day was the second holiest of all Soviet celebrations. The festivities always included a military parade on Red Square followed by a civilian. Stalin presided over both of these ceremonies, and stood with other leaders on the tribune of the Lenin Mausoleum. (The tribune was in fact much lower than one might assume based on the *Pravda* pictures, and hence guaranteed less elevation of the leaders than the media representations portrayed.) Not surprisingly, the 1 May 1947 issue of *Pravda* did not include any Stalin pictures. To be sure, page one (and all other pages, for that matter) were full of references to Stalin, including a decree by the Minister of the Armed Forces of the USSR, Nikolai Bulganin, who had succeeded Stalin in this function on 3 March 1947. Bulganin ordered a twenty-gun salute on the occasion of 1 May and closed with almost the same slogans as Stalin on 23 February—with one difference: the last slogan now read, "Long live the Great Stalin!"[119] One day later Stalin made his appearance in the customary photograph of the leaders on the tribune of the mausoleum. On this 2 May 1947, our imaginary *Pravda* reader would have looked at a front-page with the usual paratextual matter occupying the masthead—the *Pravda* title on the left and a prolix slogan on the right.[120] It said: "The Soviet people celebrated 1 May with enormous enthusiasm. The

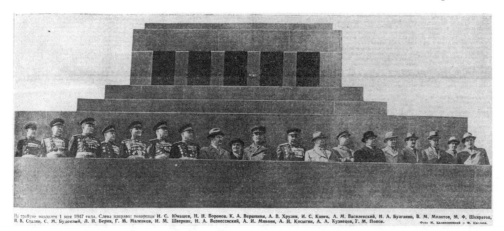

На трибуне мавзолея 1 мая 1947 года. Слева направо: товарищи И. С. Юмашев, Н. Н. Воронов, К. А. Вершинин, А. В. Хрулев, И. С. Конев, А. М. Василевский, Н. А. Булганин, В. М. Молотов, М. Ф. Шкирятов, И. В. Сталин, С. М. Буденный, Л. П. Берия, Г. М. Маленков, Н. М. Шверник, Н. А. Вознесенский, А. И. Микоян, А. Н. Косыгин, А. А. Кузнецов, Г. М. Попов. Фото М. Калашникова и Ф. Кислова.

Figure 2.21. Stalin and the Bolshevik leadership on the tribune of the Lenin Mausoleum at the May Day parade on Red Square. *Pravda*, 2 May 1947, 1.

May First holiday was a powerful demonstration of the love and dedication of the Soviet people to the Socialist motherland, the Bolshevik Party, the great teacher and leader Stalin." The masthead was separated from the rest of the front page by a thick black line. Right below that was a full-size photograph, which occupied at least two-sevenths of the page and showed the leading Party luminaries on the tribune of the Lenin Mausoleum (Fig. 2.21). The space of the photograph was organized in a pyramid shape; Stalin occupied the central place on the tribune, which formed the broad base for the stepped-back roof of the mausoleum. From the viewpoint of the onlooker, to Stalin's left were two Party magnates in plainclothes, M. F. Shkiriatov and Molotov, and further left a number of high-ranking, uniformed, and highly decorated military generals, including marshals Ivan Konev and Aleksandr Vasilevsky. Immediately to Stalin's right was Budyonny in uniform with medals, and further right a series of Party leaders in civilian clothes: Beria, Malenkov, Shvernik, Voznesensky, Mikoian, Kosygin, Kuznetsov, and Popov (in that order). Everyone looked toward the right, obviously at the parade, while Budyonny and (slightly backgrounded) Shkiriatov looked downward and to the left respectively. Stalin alone gazed straight ahead into the camera—making eye contact with our imaginary reader. The caption below the picture listed the names of the leaders strictly in order of position from left to right. This too was a departure from the early to late 1930s, when the media were still busy establishing Stalin as alpha in the collective imagination and would often mention him ahead of others, regardless of his position in the photo. Page two of *Pravda* had photographs of the parade, with huge Lenin and Stalin posters (separated only by a banner with slogans) peering from the Red Square façade of the department store GUM.

In one photograph the view of the parade included airplanes flying above, and sometimes in earlier and later years the airplanes would form the letters "S-T-A-L-I-N."[121] Page three had a photograph of a motley crowd of laughing and joyous people on Red Square, with a Stalin poster, Stalin slogans on banners, and a small girl on a soldier's shoulder smiling and waving up to an invisible person—Stalin, needless to say—on the tribune of the Lenin Mausoleum. Often more pictures followed May Day, showing, for example in 1940, the leaders (Molotov, Mikoian, Kalinin, Andreev, Stalin, Kaganovich, Beria, and Shvernik, listed in that order in the caption) striding on their way from the Kremlin on foot to the parade, with Stalin taking care of the Soviet Union's "elder," Kalinin, who walked with a cane.[122]

Shortly after 1 May followed the Day of the Bolshevik Press (5 May), a second-tier festivity. This day was important to newspapers and media professionals. Invariably *Pravda* featured—usually on its first page—a reproduction of a 1938 drawing by Pavel Vasiliev of Lenin, Stalin, and Molotov at the newspaper's editorial office in July 1917. Here we see Stalin in the foreground, sitting in side view in his simple army coat with thick, black hair and holding papers, obviously from an article for *Pravda*. To his right, at the table we see a three-quarter view of Lenin in a three-piece suit, holding a pencil in his hand and speaking to Stalin. In the background we see in frontal perspective a more lightly penciled and bespectacled Molotov, pensively gazing into the distance, a look that is underlined by his hand at his chin in thinker's pose. The table also has an inkstand and in the background we see a telegraph. The message is clear: Stalin formulates, adds to, and executes what Lenin thinks; Molotov's function is that of a prop at best.

Next in the calendar, on 9 May, came Victory Day, which lost its holiday status from 1948 to 1965, a fact that many historians have seen as a sign that the regime deemed it too unruly and too "from below."[123] In *Pravda*, however, this day in later years became one of the most important, as highly significant as the Day of the October Revolution and May Day. In 1947, Victory Day had yet to achieve this level, but it was well on its way. The front page featured a large, high-quality photograph of Stalin in three-quarter perspective (Fig. 2.22). It showed the magisterial generalissimo on two-thirds of the right-hand half of the page. Stalin's hair was gray, his moustache almost Wilhelmine (the whiskers pointed less upward than those of Wilhelm II), his gaze heavy, introverted, and suspicious. He wore a gray generalissimo's parade uniform with epaulettes, the pointed collar decorated with an extra rectangular ornament and large buttons. On his jacket was a single medal, the Gold Star Hammer and Sickle Hero of Socialist Labor medal, a pentagram with a hammer and sickle in the center. Stalin also wore his marshal's hat with cord and Soviet Star button, with his hands behind his back.[124] The caption in modernist typeface beneath the picture

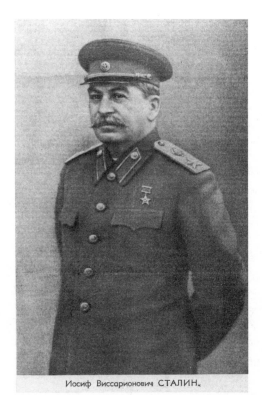

Figure 2.22. Stalin on Victory Day. *Pravda*, 9 May 1947, 1.

Иосиф Виссарионович СТАЛИН.

read simply: "Joseph Vissarionovich STALIN." To his left there was another de-
cree by Bulganin ordering a thirty-gun salute—ten more than on any other
holiday our *Pravda* reader would have encountered so far in 1947—on the oc-
casion of "the holiday of the victory over fascist Germany." Later May Day and
Victory Day would often be lumped together as the "May holidays" (*maiskie
prazdniki*).

June would have passed with no major holiday and only one picture of Sta-
lin, this time sitting in the last row of the presidium of the Supreme Soviet of
the RSFSR during its session on 21 June. To be sure, on 7 June there started to
appear masses of pictures of the annual Stalin Prize winners—but never Stalin
himself. This was to change in late July. One day after the All-Union Physical
Culture Day on 20 July the front page used a photograph of the Party leader-
ship in the "government box," as the caption explained, of Moscow's Dynamo
Stadium.[125] This was a curious photograph, for it looks as if it was one of the—
several and abortive—attempts to build up a successor to Stalin in the sphere
of symbolic politics.[126] Stalin appeared at the far left of the Party functionaries,
shown in nondescript fashion. Two of his magnates stood out. Malenkov, who
occupied the central place, wore clothing retouched to look white, and gazed left
into the distance, usually Stalin's pose. Bulganin, at far right, was also dressed

Figure 2.23. Stalin with ethnic Russian, nonminority children at the All-Union Physical Culture Day at Moscow's Dynamo Stadium. *Pravda*, 21 July 1947, 1.

Всесоюзный парад физкультурников в Москве, на стадионе «Динамо». На снимке: И. В. Сталин и В. М. Молотов принимают цветы от детей. Фото М. Калашниковой.

in retouched white and also gazed left into the distance. Further down the front page, in the right corner, was a large photograph of a foreground Stalin in side view, as if about to lift up a small girl with braids onto the tribune. Behind Stalin was Molotov receiving flowers from a small blond boy (Fig. 2.23). As from the start of the Stalin cult, Stalin continued to be shown with girls—when he was shown with children at all. More than boys, girls marked the distance to the leader: the further away from him by virtue of their gender and age, the more they heightened Stalin's elevation above the people. But one thing had changed: in 1947 the children shown with the leaders were no longer from the ethnic minorities. Rather they were quintessentially Russian—a girl with braids and a blond boy, both dressed in white. This change testifies to the wartime shift towards "Soviet patriotism," a catch phrase many historians interpret as thinly veiled Russocentric nationalism.[127] As our imaginary reader leafed through the newspaper there would have been more encounters with Stalin on pages two and three, shown on large posters in the stadium during the parade of white-dressed athletes. The Physical Culture parade was a showcase of Soviet parade symmetry.

The next canonical day in the festive calendar followed soon after, on 27 July, the Day of the Soviet Navy. On this day, another second-tier holiday like the Day of the Soviet Army on 23 February, *Pravda* carried another decree by Bulganin, ordering twenty-gun salutes by "warships in Leningrad, Kronstadt, Tallin, Baltiisk, Sevastopol, Odessa, Poliarny, Baku, Khabarovsk, Vladivostok, Port Arthur, in the Soviet Gavan and in Petropavlovsk on Kamchatka . . . Long live

the Soviet Navy! . . . Long live our leader, the Great Stalin!"[128] A day later the newspaper featured a photograph of something like a Black Sea parade on water, of Soviet sailors (*massovy zvezdnyi zaplyv moriakov,* in the words of the caption beneath the picture) swimming close to their warships with posters and banners montaged in, one depicting Stalin in his generalissimo's uniform, entwined laurel branches adorning the bottom of the picture, and further below a banner with the slogan "Honor to the Great Stalin!"[129]

Within two weeks, on 3 August, came a third second-tier military holiday, the Day of the Soviet Air Force. All three military holidays were second to the most sacred holidays, May First and the Day of the October Revolution. And within these second-tier military holidays, the Day of the Soviet Air Force was eclipsed by the Day of the Soviet Army but more important than the Day of the Soviet Navy. Second-tier holidays were not fixed to a specific date and could be moved to weekends in order to avoid a loss of labor productivity.[130] Often *Pravda* did not show Stalin on the holiday itself (instead printing another Bulganin decree ordering a twenty-gun salute), but carried his picture on the following day. Here our imaginary reader would have seen the Party leaders on the tribune-like balcony of the Tushino airfield in a photograph that occupied the entire upper third of the page right below the masthead. Stalin again was not particularly marked. He was shown slightly off-center between Voroshilov and Bulganin in a gray uniform, with at least four leaders in white uniforms: Kaganovich, I. S. Yumashev, I. S. Konev, and K. A. Vershinin. The lead article beneath the photograph, however, was oriented entirely towards Stalin. After a long buildup it described the scene. At three o'clock in the airfield's "government box appears Comrade J. V. Stalin" and his lieutenants. "Comrade Stalin!—the words spread through the rows. Hundreds of thousands of people greet the great leader of the Soviet people with extraordinary enthusiasm. Their stormy applause expresses the love and gratitude of the workers for the organizer of all the victories of the Soviet people, for the wise teacher, the leader and friend, the founder of the mighty Soviet air force. With the name of Stalin the entire country built its air fleet. With the name of Stalin the Soviet pilots mercilessly smashed the enemy in the air and on the ground. With the name of Stalin the glorious aviators yesterday began the splendid show of their mastery."[131] Page two then showed a photograph of a stunned crowd watching a group of airplanes forming both a Soviet star and the letters "S-T-A-L-I-N" (Fig. 2.24).

September, an uneventful month without a major holiday, began as *Pravda* readers returned home from their dachas where they had spent the summer months, and sent their children back to school on the first of the month. During some years—in 1946, for instance—the 8 September issue featured a stock image of Stalin as a military leader on the occasion of the Day of Tankmen. In 1947 there was the extraordinary event of Moscow's eight hundredth anniversary,

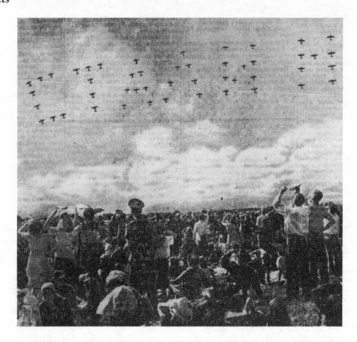

Figure 2.24. A second-tier holiday, the Day of the Soviet Air Force. *Pravda,* 3 August 1947, 2.

and in this connection, several pictures of Stalin made their way onto the pages of *Pravda* on 7 and 8 September.

If September stood out at all, then it was as prologue to the annual climax of sacredness, the Day of the October Revolution on 7 November, the founding event of the state that Stalin embodied. In 1947 this date was especially special, for it marked the thirtieth anniversary of the Revolution (Fig. 2.25). The front page of *Pravda* starred a photograph showing Lenin on the left and Stalin on the right. Together they took up half the page. Lenin was shown in nearly frontal view and in his three-piece suit with a tie, while Stalin was in true three-quarter perspective and in his gray generalissimo's uniform as in his Victory Day photo. His hair and moustache were graying and he radiated confidence, not suspiciousness, as on the military holidays. The eyes of both Lenin and Stalin were directed to the left, that is, back at the founding event of the Revolution, back at utopian point zero, yet at the same time forward into the bright future—the future of communism, a major theme on this day. Lenin was portrayed as the embodiment of the Revolution and the beginning of the eschatological timeline, Stalin as its follower and completer, leading the country from socialism to a new utopian goal, communism. This was the visual and verbal theme of the front page. In the masthead above the photographs we read the slogan for the day: "Long live the thirtieth anniversary of the Great October Socialist Revolution! Under the banner of Lenin, under the leadership of Stalin, forward to the victory of communism!" The spatial arrangement of the photographs reinforces

this very theme. Lenin, as always, is at left and thus in the place marked as beginning; Stalin is at his right from the viewpoint of our imaginary reader, the place of ending, of openness. Thus Stalin represents Lenin and at the same time, together with Lenin, the larger entities of, among other things, the Party, the state, and historical agency in a Marxist linear sense.[132] Most of the remainder of the paper was taken up by a speech Molotov had given at a "ceremonial meeting of the Moscow Soviet" on the day before. Page two was pictureless, page three showcased the 6 November meeting of the Moscow Soviet with a large photograph on top, showing the presidium in front of an enormous picture with Stalin in the foreground, Lenin in the background, the dates 1917 and 1947 to left and right respectively, and the slogan "Long live the thirtieth anniversary of the Great Socialist October Revolution!" above the heads of the leaders. In the foreground at far left was Molotov at a rostrum giving his speech; Stalin himself did not belong to the Moscow presidium.

A day later, on 8 November, our reader would have encountered, on the first page, all Bolshevik leaders and a number of high-ranking military officers on the tribune of the Lenin Mausoleum greeting the parade on Red Square, all except Stalin. Molotov had his central place in the middle of the tribune, looking directly at the camera and raising his arm. For the first time in *Pravda*'s pictorial representations of the Day of the October Revolution on Red Square, our reader would have seen the letters "LENIN" on the granite of the mausoleum below the tribune, and for the first time she would have seen the Kremlin's Senate Tower in the background right above the roof of the mausoleum—shown perhaps to demonstrate the link with Stalin who had merged with the Kremlin.

Figure 2.25. Front page on the Day of the October Revolution, holiest of holidays. *Pravda*, 7 November 1947, 1.

On the next page, the reader would have found Stalin, although represented indirectly, on the usual poster to the right of Lenin on the Red Square façade of GUM, and in another photograph on a poster above a group of demonstrators. For the rest of November there were only inconspicuous appearances of Stalin in images, most of them connected with elections to local bodies of Soviet power—oblast, city, and district soviets.[133]

On 5 December came the last Stalin holiday of the year, the Day of the Stalin Constitution, a day that, as we can see, was intimately tied semantically to an adjectivized Stalin. On this day, year after year, the same photograph appeared in the upper left-hand corner of the page. It showed, as the caption explained, "Comrade J. V. Stalin on the tribune of the extraordinary Eighth All-Union Congress of Soviets, 5 December 1936" (Fig. 2.26). Stalin is seen in nearly, but not quite side view looking rightward, his right hand raised as if to underline a point. This was very unusual, for he was typically static and his hands were never shown gesturing, in deliberate contradistinction to Hitler (see Chapter 3). Stalin's mouth is slightly open as he speaks, and his eyes gaze into the far distance. His hair is still almost black with only sparse streaks of gray, his uniform

Figure 2.26. Day of the Stalin Constitution, the last holiday of the year. *Pravda,* 5 December 1947, 1.

Товарищ И. В. Сталин на трибуне Чрезвычайного VIII Всесоюзного с'езда Советов, 5 декабря 1936 года.

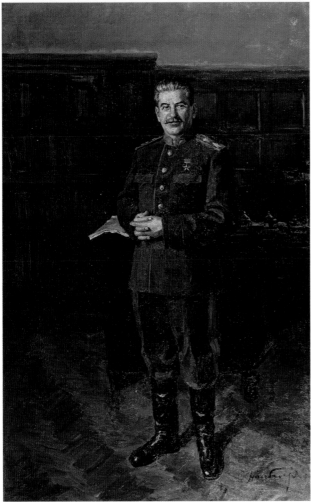

Plate 1. Isaak Brodsky, *Lenin at the Smolny* (1930). Oil on canvas, 190 × 287 cm. © State Historical Museum, Moscow.

Plate 2. Dmitry Nalbandian, *Portrait of J. V. Stalin* (1945). Oil on canvas, 221 × 144 cm. © State Tretyakov Gallery, Moscow.

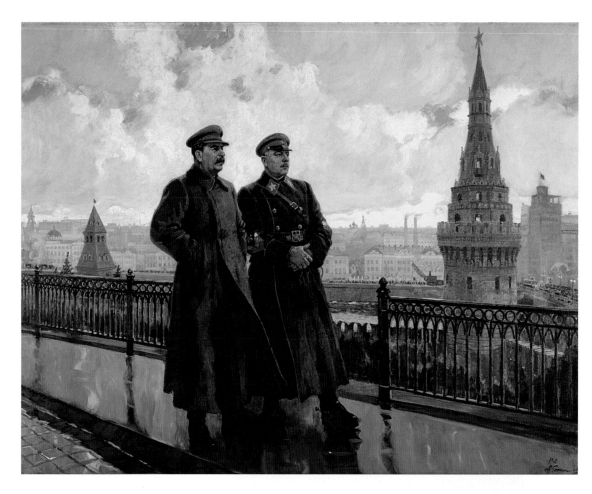

Plate 3. Aleksandr Gerasimov, *Stalin and Voroshilov in the Kremlin* (1938). Oil on canvas, 296 × 386 cm. © State Tretyakov Gallery, Moscow.

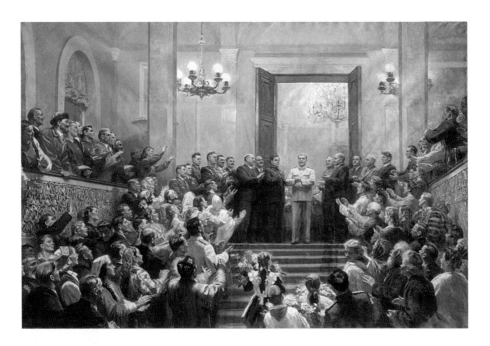

Plate 4. Iury Kugach, Vasily Nechitailo, and Viktor Tsyplakov, *"Glory to the Great Stalin!"* (1950). Oil on canvas, 351 × 525 cm. © 2007, State Russian Museum, St. Petersburg.

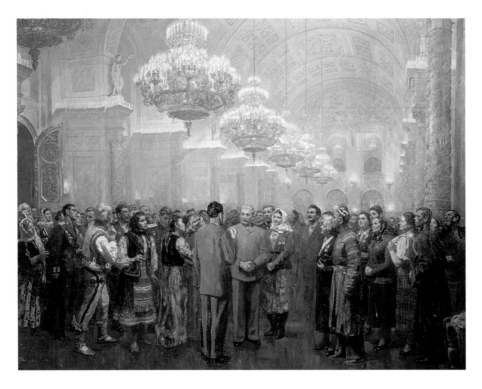

Plate 5. Boris Ioganson, Leonid Tanklevsky, and Aleksandr Khomenko, *J. V. Stalin among the People in the Kremlin (Our Wise Leader, Dear Teacher.)* (1952). Oil on canvas, 410 × 530 cm. © 2007, State Russian Museum, St. Petersburg.

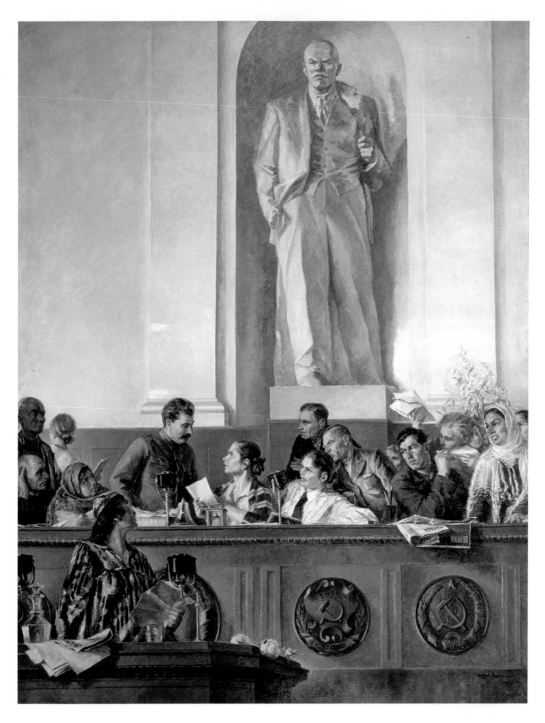

Plate 6. Grigory Shegal, *Leader, Teacher, and Friend (J. V. Stalin in the Presidium of the Second Congress of Kolkhoz Farmer–Shock Workers in February 1935).* (1936–1937). Oil on canvas, 340 × 260 cm. © 2007, State Russian Museum, St. Petersburg.

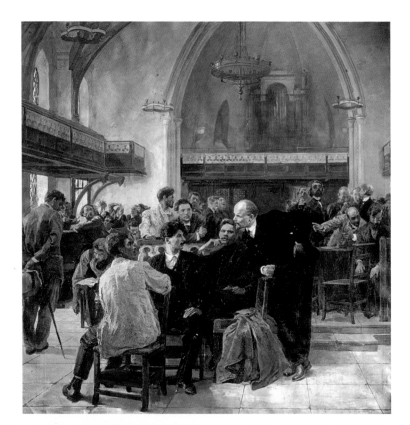

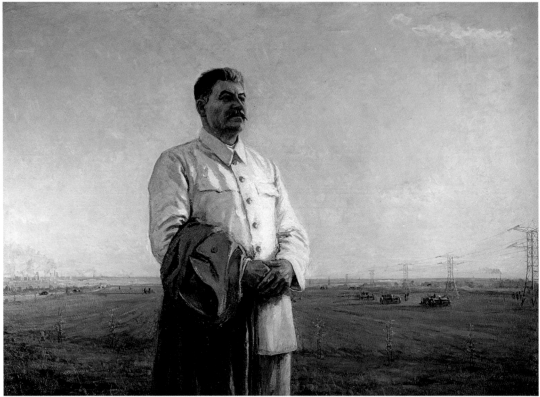

Plate 9. Stalin portrait by Nikolai Andreev, dated
1 April 1922. Likely because it showed his pockmarks,
Stalin wrote in red pencil across the portrait: "This ear
shows that the artist doesn't know anatomy. J. Stalin.
The ear screams, is a gross offense against anatomy.
J. St." And yet, though it would have been easy for
Stalin to censor the drawing, one version (without
comments) was exhibited at the Tretyakov Gallery
throughout the Stalin period. Pencil and crayon on
paper, 32 × 24.5 cm. © David King Collection,
London.

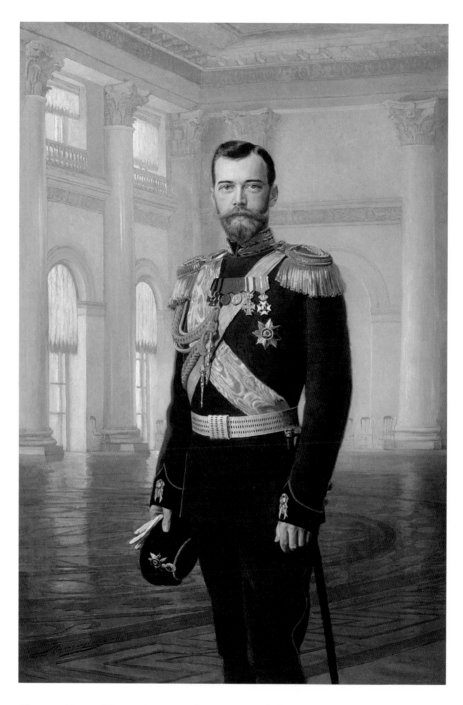

Plate 10. Ernest Lipgart, *Portrait of Emperor Nicholas II of Russia* (1900). Oil on canvas, 165 × 110 cm. Original at Tsarskoe Selo Museum.

Plate 11. An example of a modernist Stalin portrait: Pavel Filonov, *Portrait of J. V. Stalin* (1936). Oil on canvas, 99 × 67 cm. © 2007, State Russian Museum, St. Petersburg.

Plate 12. Isaak Brodsky, *Portrait of J. V. Stalin* (1937). Oil on canvas, 210 × 143 cm. © 2007, State Russian Museum, St. Petersburg.

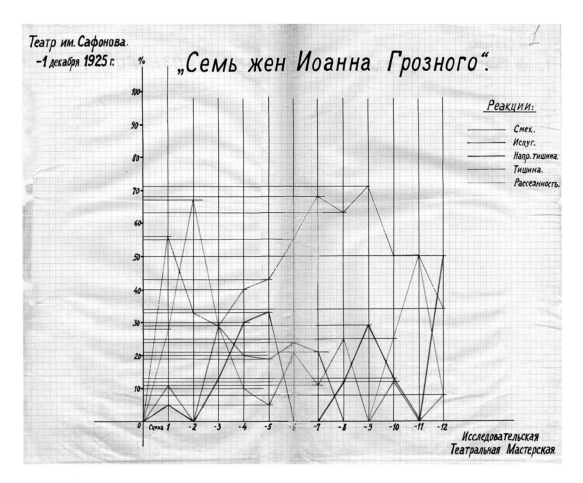

Plate 13. An example of NEP-era "scientific" viewer studies: graph of viewer reactions during the play *The Seven Wives of Ivan the Terrible* at the Safonov Theater, 1 December 1925. Source: RGALI, f. 645, op. 1, d. 312, l. 1. © RGALI.

Plate 14. Cover of comment book, "15 Years of Soviet Art" exhibition at Tretyakov Gallery, 1933. Source: OR GTG, f. 8.II, d. 513. © State Tretyakov Gallery, Moscow.

Plate 15. Inside cover of comment book, "15 Years of Soviet Art" exhibition. "Comrades visitors! Write your comments about the sculpture exhibition in this book. State Museum of Visual Arts, July 1933." Source: OR GTG, f. 8.II, d. 513. © State Tretyakov Gallery, Moscow.

Plate 16. Inside pages in comment book, "15 Years of Soviet Art" exhibitions. Note the spontaneity of this early comment book with visitors using the margins to comment on comments. Source: OR GTG, f. 8.II, d. 513, ll. 60b.-7. © State Tretyakov Gallery, Moscow.

Plate 17. An example of Stalin-era reception as performance: leather-bound comment book, "Art of the Georgian SSR" exhibition at the Tretyakov Gallery, 1937–1938. Source: OR GTG, f. 8.II, d. 770. © State Tretyakov Gallery, Moscow.

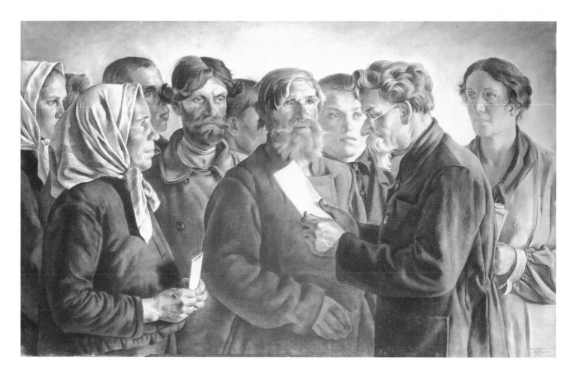

Plate 18. Evgeny Katsman, *Visitors with Kalinin* (1927). Charcoal and pastel, 92 × 146 cm. © 2007, State Russian Museum, St. Petersburg.

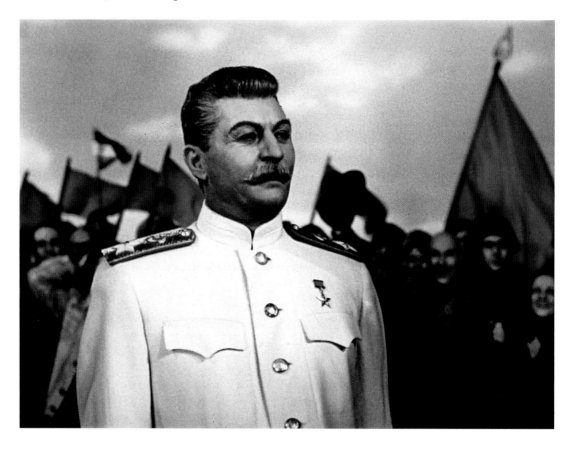

Plate 19. Actor Mikhail Gelovani as Stalin in the movie *The Fall of Berlin* (1949–1950). Photograph Filmmuseum München.

Plate 20. An anonymous note on scrap paper passed to the stage at Alexei Diky's celebrity evening. "Please tell us, have you met with comrade Stalin to prepare for your role?" Source: RGALI, f. 2376, op. 1, d. 197, l. 40. © RGALI.

Plate 21. Another anonymous note: "Tell us why you speak <u>without</u> the characteristic accent, when you play J. V. Stalin." Source: RGALI, f. 2376, op. 1, d. 197, l. 34. © RGALI.

simple and prewar, the black moustache still quite Georgian. This picture served as a template for numerous paintings of Stalin. Right beneath the photograph there was a lead article, "Under the Banner of the Stalin Constitution," ascribing all merit of the constitution to Stalin, who appeared in adjectival form (*stalinskaia konstitutsia*) in almost every sentence.

With this day the Soviet festive calendar reached its end point. Thus the annual cycle was punctuated by ten holidays that were intimately tied with Stalin's image. The holiest of holidays were International Workers' Day on 1 May and the Day of the October Revolution on 7 November. After 1945, Victory Day (on 9 May) joined this group of principal holidays. The second-tier holidays included the day of Lenin's death on 21 January, the Day of the Soviet Army on 23 February, and the Day of the Stalin Constitution on 5 December. Further down the hierarchy were the Day of the Bolshevik Press on 5 May, the Physical Culture Day (usually in late July), and the three additional military days (the Day of the Soviet Navy on 27 July, the Day of the Soviet Air Force on 3 August or later, and the Day of Tankmen on 8 September).

ANOTHER BIRTHDAY AND A FUNERAL: STALIN'S SWAN SONG

In December 1949 the preparations for Stalin's seventieth birthday on the twenty-first surfaced on the pages of *Pravda*. Articles with titles like "We Shall Mark Comrade J. V. Stalin's Seventieth Birthday with New Industrial Successes" or "Socialist Competition in Honor of Stalin's Seventieth Birthday Is Expanding" announced the beginning of a major campaign leading up to the birthday, some of which were "socialist commitments" to overfulfill the plan.[134] The campaign's intensity mounted and its reach expanded, a point that was driven home by the slogan "The people-wide socialist competition in honor of Stalin's seventieth birthday is widening."[135] Reports about birthday preparations in Poland, Czechoslovakia, Hungary, Romania, and even France, followed in due course. So did an article, "The People's Love: In the Rooms with Gifts for J. V. Stalin," on an exhibition of gifts for Stalin, which gave readers a foretaste of the display.[136] Archival sources reveal that the exhibition divided a total of 1,398 gifts into those "from workers from capitalist countries," "from workers in countries of people's democracy," and "from the peoples of the USSR."[137] The gifts included: from Australia, a "Bowl-shaped tobacco box. The bowl was carved out 100 years ago by one of the first settlers in Australia. From Neili Kinning. 1945";[138] from the United States, a "Headdress of an Indian war leader. Awarded by the meeting of Indian tribes from the U.S.A. and Canada. 'To the greatest warrior J. V. Stalin.' The headdress is made of eagle feathers. On 20 February 1942 in Brooklyn, New York, the traditional meeting of twenty-seven Indian tribes from the U.S.A. and Canada took place, at which J. V. Stalin was elected hon-

orary leader (*vozhd'*)";[139] from "Palestine," as it called present-day Israel: "A Book. K. Marx, 'Capital.' In Ancient Hebrew. From the Central Committee of the Labor Party of Palestine. 1947";[140] from France: a "Neolithic ax, found in Moustier. From Mrs. Sere. 1945";[141] and from Moscow, going back to 1932: a "Portrait of J. V. Stalin. Branded in wood. For 1 May 1932. From the communist workers and invalid Red Army soldiers of the Moscow Military Hospital."[142]

Included in the exhibition was a painting of three weavers holding a Stalin portrait as a template, in the process of producing a gift for Stalin in the form of a tapestry (Fig. 2.27). The painting was also to be shown at a 1949 art exhibition on the occasion of Stalin's birthday. Thus the borders between photography, popular folk art, and academic oil paintings, between "high" and "low," were erased: the folk artists weaving a Stalin tapestry based on a printed (mass

Подарок товарищу Сталину

Картина худ. Н. Чебакова Всесоюзная художественная выставка 1949 года

Figure 2.27. "A gift for Comrade Stalin": painting for Stalin's birthday of weavers producing a Stalin tapestry from a Stalin portrait for Stalin's birthday. Painting by N. Chebakov. *Pravda*, 12 December 1949, 2.

media) photo were shown in an easel painting, which in turn was reproduced in the print mass medium *Pravda*.[143] On 17 December Mao Zedong was shown arriving in Moscow; the birthday was now called "the great date (*velikaia data*)," and articles reported on the "Preparation for the Great Date in China" and the Czech people's "Feelings of Sincere Love" for Stalin.[144]

Finally the "great date" arrived. On Wednesday, 21 December 1949, a news-free and double-length (twelve pages instead of six) issue of *Pravda* featured a photo of Stalin that took up four-fifths of the left-hand page. Stalin is shown standing in his office in his marshal's uniform with a round-tipped collar, the single Hero of Socialist Labor medal on his jacket, hands folded in front, wearing black shoes. The room has parquet flooring, in the background is his desk (with a globe), and on the wall is a picture of Lenin reading *Pravda*. The picture was in fact a variation of an image by M. Kalashnikova that, despite its drawing-like feeling, had been designated a "photograph" and had originally appeared on 7 November 1948. There were differences: in the 1948 version, Stalin's hands were behind his back; in 1948 there were five buttons in his uniform while in 1949 there were four, his hands covered the fifth; and the 1948 picture was cropped at his knees while the 1949 version was full-length (Fig. 2.28). Beneath the photo of Stalin a caption read: "Decree of the Presidium of the USSR Supreme Soviet on the award to Comrade Joseph Vissarionovich Stalin of the Order of Lenin." Each of the following pages was filled with full-page articles by Stalin's "closest comrades-in-arms" about his multiple roles (most of which corresponded to stock visual images). Malenkov wrote of "Comrade Stalin—the Leader of Progressive Mankind," Molotov on "Stalin and the Stalin Leadership," Beria on "The Great Inspirer and Organizer of the Victories of Communism," Bulganin on "Stalin and the Soviet Armed Forces," Khrushchev of "The Stalin Friendship of Peoples—a Guarantee of the Invincibility of Our Homeland," and so on. This issue was overwhelmingly textual. The fact that the only other picture of Stalin (apart from the front page) was a photo taken after the beginning of the war, on 7 November 1941, showing Stalin at the rostrum with a microphone, testifies once more to the key place this event had come to occupy in both the Stalin cult and Soviet culture at large.[145] On 22 December, covering the upper third of the first page was a photograph of Stalin standing in the front row between Mao Zedong and Walter Ulbricht with an international group of Communist leaders on the stage of the Bolshoi. Stalin was also present in an oversized, gold-framed portrait standing in front of the curtain as well as on flags and in the slogan on the curtain: "Long live the great leader and teacher of the Communist Party and the Soviet people Comrade J. V. Stalin!" The caption listed all the luminaries of the Soviet bloc from left to right, regardless of rows: Palmiro Togliatti, A. N. Kosygin, L. M. Kaganovich, Mao Zedong, N. A. Bulganin, J. V. Stalin, W. Ulbricht, Yu.

Figure 2.28. Photo on the front page of the seventieth birthday issue. *Pravda*, 21 December 1949, 1.

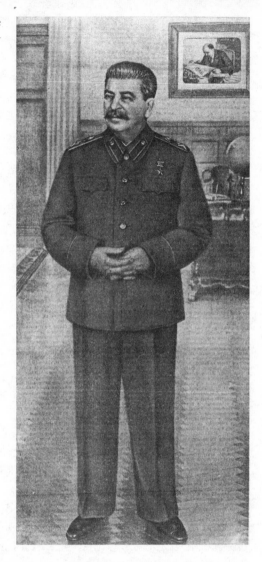

Tsedenbal, N. S. Khrushchev, I. Koplenig, Dolores Ibarruri, G. Gheorghiu-Dej, M. A. Suslov, N. M. Shvernik, V. Chervenkov, G. M. Malenkov, V. Široký, L. P. Beria, K. E. Voroshilov, V. M. Molotov, A. I. Mikoian, Mátyás Rákosi. Everyone was standing and applauding, including Stalin himself. In the same issue there was a photograph of Stalin shaking hands with children.[146] From this day on— for almost two years until early October 1951—nearly every issue of *Pravda* (usually on page two) showcased a rubric, "A Torrent of Greetings," with congratulatory telegrams and letters from individuals and organizations from all over the Soviet Union.[147]

In 1950 Stalin (as played by Gelovani) with his pipe and behind his desk made an extraordinary appearance when on 25 January *Pravda* published stills from a Kremlin office scene in Chiaureli's centerpiece of Stalin cinematography,

The Fall of Berlin. Beside articles on the film, the reader was offered a spectrum of enthusiastic comments by moviegoers, among them the sculptor Vera Mukhina.[148] From early February 1950 onward there was a sense of preparation in images and texts for the upcoming elections to the Supreme Soviet. Every day on the front page some assembly of a factory or organization in the Soviet Union nominated Stalin as their number one candidate for deputy in the Supreme Soviet. Election day on 13 March was a dazzling display of what the lead article touted as the "triumph of Soviet democracy." An unreal Stalin, who looked as if he was being played by a double, was shown placing his ballot into a flower-decorated ballot box, ostentatiously sealed to represent Soviet democracy. The other pictures of voters putting their ballots into ballot boxes all featured large Stalin portraits or plaster busts in the background.[149] Two days later Stalin appeared in a photo in his gray marshal's uniform next to the election results—a near-perfect victory for him, needless to say.[150] Thus in 1950 *Pravda* still staged elaborate performances of Soviet pseudo-democracy.

On May Day there was a front-page photo of Stalin in his marshal's uniform. A day later the newspaper's first page showed the Communist leadership saluting the May Day parade on the tribune of the mausoleum, Stalin standing in the center, Bulganin to his left and Malenkov to his right from the viewer's angle. To Stalin's left almost everyone wore military uniforms and numerous medals, to his right everyone wore coats and dark suits without medals. Late Stalinism did not mean that campaigns to mobilize the population for a certain cause disappeared entirely. In early May, for example, *Pravda* showed workers at Moscow's Vladimir Ilyich factory signing up for a new state loan with a Stalin portrait in the background.[151] Pseudo-democracy was sometimes seen in ethnically adapted images of Stalin, as in a huge portrait of an Azerbaijanized Stalin hanging on the wall behind a Baku husband and wife putting their ballots in the box.[152] Thus *Pravda* continued to serve as an agitational platform for state projects that demanded the involvement of the population and Stalin's image continued to serve as symbol to rally the population in these campaigns. Nor did High Stalinism mean that all representations of the leader became allegorical or metaphorical. Sometimes he was involved very concretely, as in an article, "Thanks to the Leader," which credited Stalin with the building of the postwar "great constructions of communism," notably hydroelectric stations and canals.[153]

The Day of the October Revolution in 1950 introduced a new photograph of Stalin, in which Stalin's upper torso was shown behind a balustrade (likely on the mausoleum tribune) in his gray marshal's uniform with his single medal, wearing a black marshal's cap with a single Soviet star on the front, with gray hair and a gray moustache but hardly any extra chin, which strangely made him appear both younger and older at the same time (Fig. 2.29). His face was directed toward the camera lens yet his gaze was pointed left, into the distance. His body was, quite unusually, turned ninety degrees, thus creating a more

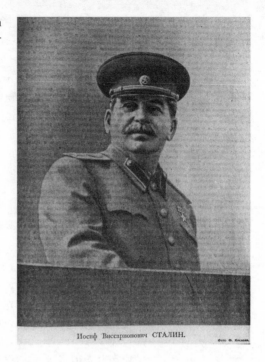

Figure 2.29. Day of the October Revolution 1950—one of the last new photographs of Stalin. *Pravda*, 7 November 1950, 1.

dynamic, less static image. The photos of the actual parade on Red Square featured Stalin indirectly, in a poster on the façade of GUM, not in person.[154] He was to appear only one last time on this holiday, in 1952.

In the habitual photograph of the 21 January 1951 meeting at the Bolshoi on the occasion of Lenin's death, Stalin was the only Party leader holding his hands folded in front. Malenkov was to his left and his uniform was the lightest of all. If there was any effort to make someone beside Stalin stand out, this time it was concentrated on Malenkov.[155] On May Day itself, in a reprinted photograph, Stalin appeared in his gray marshal's uniform, a day later he appeared indirectly, on posters showing him on the mausoleum tribune between Malenkov and Bulganin, carried by a motley and seemingly very happy crowd on Red Square.[156] On 3 May there was another—and extraordinary—photo of the May Day parade, showing Bulganin on the left on the tribune, a space, then a blonde Russian Pioneer girl, then Stalin holding her arm and smiling or speaking with the girl. To present-day Anglo-American eyes, Stalin's gaze seems lecherous, while the girl looks up to him respectfully. Stalin was in a new greatcoat with a collar he had never worn before and in a new cap with new ornamentation. In the picture caption's words, the "first-grader Ira Melnikova of school no. 131 presented Joseph Vissarionovich Stalin with a bouquet in the name of the Pioneers of Moscow."[157] The picture is unusual both in its rare depiction of Stalin with a child, and in its specific type of representation.

The rest of the year was much like previous ones and 1952 in *Pravda* again began like a routine year of depicting Stalin. On 9 March and 19 April, readers witnessed the export of round-number birthday celebrations of leaders from the Soviet Union to its satellite states, with the treatment of Hungary's Mátyás Rákosi's sixtieth birthday and Poland's Bolesław Bierut's sixtieth birthday respectively.[158] As in the year before, on 3 May Stalin appeared on the tribune of the Lenin Mausoleum in a rather unusual photograph with yet another blonde Russian schoolgirl, this year hugging and kissing him, as Malenkov looked on. The caption explained: "First-grader Vera Kondakova of Moscow school no. 612 warmly greets Joseph Vissarionovich Stalin after he has received a bouquet."[159] In October Stalin appeared at a Party gathering for the last two times before his death, more precisely, at the Nineteenth Party Congress. The depiction of Stalin in the presidium was much as it had been in recent years—as Malenkov spoke at the rostrum, Stalin sat in the row behind the rostrum alone and aloof, looking gray and old, even holding his chin and, unusually, with his hand touching his face.[160] A week later he was shown on the far left at the rostrum giving his speech at the "final meeting of the Nineteenth Party Congress."[161] A day after the Revolution Day parade he was shown for the last time on the tribune of the Lenin Mausoleum, standing in the left center between Bulganin and Timoshenko, and as usual, a day later people were shown carrying Stalin posters at 7 November demonstrations in Baku and Stalingrad.[162] The 5 December 1952 issue carried the habitual Stalin Constitution Day photo of 1936 for the last time; the customary 1922 photograph of Lenin and Stalin in Gorki was shown for the last time on 21 January 1953.[163]

The 5 March issue signaled the beginning of the end of the *vozhd'*. It featured a "bulletin on the health condition of J. V. Stalin at 2 o'clock on 5 March 1953" in the upper left hand of the newspaper's front page. That day, of course, Stalin died, and the next day the entire front page was framed in thick black and featured a canonical photograph of a living Stalin, looking left, his right hand in his marshal's uniform (Fig. 2.30). On 7 March pages two through six were devoted to Stalin's death, and on 8 March the topic occupied every single page of the newspaper (on this day the death of the leader eclipsed the traditional International Women's Day). The issue of 9 March was exactly like that of 8 March. The comparison of the photographs of Stalin on the first days after his death, from 6 March to 9 March, is telling: on 6 March Stalin was alive in a standard photograph every Soviet citizen was likely to have seen in some form, at some point. On 7 March Stalin was shown lying in his coffin; he was in the foreground, in the right corner, while leading Party bosses, among them his potential heirs, stood in the background, appearing relatively small (Fig. 2.31). On 8 March the position was reversed: Stalin's followers now stood in two columns left and right of the coffin, which was now in the center background.

Figure 2.30. Stalin is dead. *Pravda*, 6 March 1953, 1.

Shown at left, from Stalin's head toward the viewer, were first Malenkov, then Beria, and next Khrushchev. At right, from Stalin's feet toward the viewer, were Bulganin, Voroshilov, and Kaganovich. On 9 March Stalin in his coffin faded even further into the background (Fig. 2.32). Again there were two columns to the left and right of the centered coffin. Closest to Stalin's head and feet stood two soldiers. Right next to them on the left were Malenkov, then Beria, next Voroshilov, and finally Molotov. To his right there were Bulganin, Khrushchev, Kaganovich, and Mikoian. In these photographs of 7–9 March it is as if the visual-spatial succession of images of Stalin's dead body is meant to re-present the *vozhd*'s fading from power. At the same time, this succession indicates the dawning of a new era and the coming of a new leader. In the first photograph (7 March), the heirs are shown in one row and thus on a relatively equal plane. The photographs on the following two days, by contrast, create the impression of individual competitors standing opposed to one another, as if about to start a fight. In both photographs Malenkov is closest to Stalin's head in the left row. In both rows the old guard—Voroshilov, Molotov, Kaganovich, and Mikoian—is reduced to outer ornamentation. Paradoxically, these old comrades-in-arms of Stalin may have lost their power but are seen larger, because they occupy the immediate foreground, closest to the viewer. And paradoxically too, between 7 and 9 March Stalin moves from foreground to background, yet still forms the sacral center of the picture from which power, here the power to succeed him, emanates. In other words, our imaginary *Pravda* reader witnessed a double movement of Stalin's dead body in the photographs during these three days in March 1953: by moving into the background it in fact moved into the foreground; or, by moving backward it reversed the spatial valence of background and foreground. It is as if, when new forces were slowly and gradually trying to dim the sacral aura of the dead demiurge, Stalin retaliated by simply moving this aura along with his body, radiating it more glowingly than ever to compensate for the unbefitting position in the picture. The visual representation of Stalin's dead body on 7, 8, and 9 March, then, served as an emblem of the uncannily difficult tasks of putting a modern, nondynastic dictator, surrounded by a personality cult, to rest and of building up a new leader.

Insofar as these *Pravda* photographs announced a new leader, it was Malenkov. On 8 and 9 March Malenkov was depicted closest to Stalin's head, the most sacrally charged part of the dead *vozhd*'s prostrate body in the coffin; on 8 March the second page showed a jet black–haired Malenkov giving a speech at the rostrum at the Nineteenth Party Congress in 1952 with an almost white-haired Stalin looking on from above; on the front page of 10 March he was shown between other Party luminaries and foreign communists behind microphones, giving a speech on the tribune of the Lenin Mausoleum ("STALIN" in capital letters had been added to "LENIN" on the façade beneath the tribune). Right beneath this picture the text of his speech was printed, taking up almost

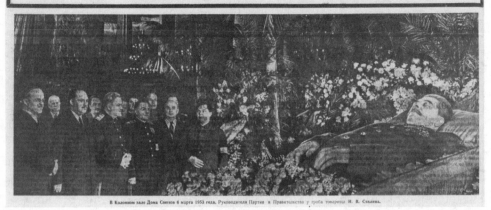

Figure 2.31. Dead Stalin in the foreground, his heirs in the background. "In the Hall of Columns of the House of Soviets on 6 March 1953. The leaders of Party and government at Comrade J. V. Stalin's coffin." *Pravda*, 7 March 1953, 2.

half the page; finally, on the 10 March third page Malenkov was shown in a 14 February 1950 photograph with Mao and Stalin, the latter two in the background, their hands behind their backs, while Malenkov was in the right foreground, in three-quarter view, his hand in Napoleonic fashion in his jacket. This photograph contributed much to Malenkov's undoing and his loss of position to Khrushchev: Malenkov was scolded by other Central Committee members for this photograph, and went on the offensive later that day, being the first post-Stalin Party elite member to attack the "cult of personality," though not yet the person, of Stalin.

All other pages of the 10 March issue were again devoted to Stalin. On 11 and 12 March, the entire newspaper was about Stalin, much of it reporting on meetings on public squares and other reactions in faraway corners of the Soviet empire. Starting with 11 March non-Stalin news returned to the paper, at first in a single, slim column on the last page. This column became larger every day, and from 15 March onward news not related to Stalin's death returned to the front page. The coverage of Stalin and his death continually decreased so that by 20 March, *Pravda* did not feature a single headline devoted to the *vozhd'*.

Shortly after Stalin's death began the silent phase of de-Stalinization. This tectonic, if underground, shift was lost on no one. No even partially discerning *Pravda* reader could have missed it. During the entire remainder of 1953, Stalin appeared in pictures a mere five times: once in a poster on the May Day demonstration, once (on 30 July) in the well-worn photograph with Lenin in Gorki on the occasion of the fiftieth anniversary of the Bolshevik Party's founding, and three times on posters in the background at the Day of the October Revolution

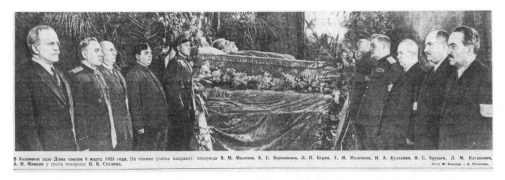

В Колонном зале Дома союзов 8 марта 1953 года. На снимке (слева направо): товарищи В. М. Молотов, К. Е. Ворошилов, Л. П. Берия, Г. М. Маленков, Н. А. Булганин, Н. С. Хрущев, Л. М. Каганович, А. И. Микоян у гроба товарища И. В. Сталина. Фото Ф. Кислова и А. Устинова.

Figure 2.32. Dead Stalin in the background, his heirs in the foreground. *Pravda*, 9 March 1953, 1.

celebrations (twice with Lenin, once by himself). There were no Stalin posters or portraits in the photographs of the Physical Culture parade or the Day of the Navy.[164] On the Day of the Soviet Air Force at the Tushino airfield, airplanes formed "glory to the USSR (*S-L-A-V-A S-S-S-R*)," not "glory to Stalin."[165] On the Day of the October Revolution, the crowds on Red Square carried a Stalin portrait that was smaller than that of Lenin.[166] And while Stalin had prohibited the celebration of any but the round-number birthdays during his lifetime, nothing spoke against remembering his 21 December birthday in the year he died. But this did not happen: on 21 December 1953 the front-page of *Pravda* carried articles (with accompanying pictures) on the winners of the Stalin Prizes "For the Strengthening of Peace between the Peoples," which had been handed out on 12 December, but there was no mention of Stalin's birthday anywhere in the entire paper. True, a *Pravda* reader could have had the impression that there was at least a halfhearted effort to continue the spirit of the "Lenin Days" tradition on (and surrounding) the founding father's death on 21 January and to establish 5 March as a Soviet holiday: on 5 March 1954 there was a full Stalin portrait on the front page. But this portrait was highly ambiguous: on one hand it showed Stalin dressed in an atypically (for his later generalissimo years) dark, simple army uniform, perhaps to signify his passing; and it introduced an unusual source of light in the upper left corner of the photograph, which looked like a transcendent illumination. Some of this light even radiated around Stalin's neck. On the other hand, all the verbal utterances degraded Stalin to the formula "Stalin is the Lenin of Today"—for example, the lead article read: "J. V. Stalin—the Great Continuer of Lenin's Cause"—a role, and a source of legitimacy, he had long shaken off when still alive.

A diachronic look at the representations of Stalin has allowed us to explore the changes in Stalin's image. But such a diachronic look does not catch the syn-

chronic, repetitive quality of the cult. Therefore we scrutinized a typical, most ordinary postwar year of the cult—1947. Taken together, these two approaches provide a working knowledge of the evolution of Stalin's image from the inception of the cult to its very end.

To reiterate the contours of this evolution, when seen quantitatively, the first surprising fact about visual representations of Stalin in *Pravda* is that they did not occur on every day on every page. In sum, the statistical story of these representations is one of sudden outbreak, hiatus, expansion, hiatus, high plateau, hiatus, lower plateau. They burst upon the public scene on 21 December 1929, the beginning of the public Stalin cult, and faded away until mid-1933. From then on they expanded enormously, because the stock images were canonized for the first time and because Stalin had to be implanted in the collective imagination as the number one leader via processes of visual distinction vis-à-vis other leaders. The expansion ended in 1937, a Terror-related hiatus of sorts, but then continued and gained momentum until reaching its apex in December 1939 with Stalin's sixtieth birthday. During the war the representations shrank to a minimum, but picked up in early 1945 as soon as victory was certain. In the postwar period the numbers of representations hovered quite stably around a lower plateau. This contraction was due, among other things, to the suffusion of society with Stalin images.

As for the development of the actual image, the most serious break came during the war: the appearance on 7 November 1943 of Pavel Vasiliev's drawing of Stalin in an ornate uniform, with graying hair and a Wilhelmine moustache, constituted the single greatest acceleration of a continual move toward the canonical postwar image. Thus the overarching narrative emerging from an analysis of the visual content of Stalin's image would divide the twenty-four years of the existing public cult into two large blocs: prewar and postwar. Before the war the following changes took place. From the beginning in mid-1933 until about 1935, Stalin was depicted as being more serious. His image was involved in competition with the image of other leaders. In 1935 and 1936, he appeared more joyous, smiling, with children, women, national minorities, and the new Soviet heroes (Stakhanovites, Arctic explorers, aviators). During the war, Stalin's image acquired a new serious and anxious note. The military leader *obraz*—later in its generalissimo incarnation—was added and played a major role during the entire postwar period. Toward the very end, a last innovation was introduced: absent representations, as in allusions, metaphors, or as in an appearance in "the spirit" on the shining faces of radio listeners. Such is the picture of the evolution of Stalin's visual image in *Pravda* across time during the entire period of the public Stalin cult. Let us keep it in mind as we turn to the paintings and their meanings.

3 Stalin's Image in Space

IMAGINE, FOR A moment, a citizen living in the mid-twentieth century, under postwar Stalinism. Further imagine that, perhaps as a reward for overfulfilling the production quota at a local coal mine, this citizen gets to take a trip from the Soviet provinces to Moscow. After visiting the major landmarks such as the Lenin Mausoleum and the Kremlin, and after taking a ride on the magnificent metro, our visitor from the Russian provinces might sign up for an excursion to the Tretyakov Gallery. There the visitor will likely be offered a guided tour that focuses on artistic representations of Lenin and Stalin. The museum guide may have graduated from a crash course based on the 1947 essay "Methodical Elaboration of Excursions in the State Tretyakov Gallery on the Subject: 'The Images of Lenin and Stalin in the Soviet Fine Arts'" by Vladimir Sadoven. And this being the Soviet Union, the guide will probably follow the Sadoven pamphlet quite closely. It teaches that the subject of Lenin and Stalin in Soviet art "is of great, exciting interest for every Soviet person." The depiction of Lenin and Stalin embodies "the best features of the Bolshevik-revolutionary and the builder of socialism and [therefore] the tour has a great moral-political, educational goal." It goes on to explain that "by invoking through the artistic images of Lenin and Stalin . . . different stages in the history of the Party and the Soviet state, the tour also has great political and historical edifying value." "Because of these goals," Sadoven warns, "the tour must be conducted in an accessible, politically accurate, and emotional manner."[1]

The tour will probably start with a short introductory lecture, followed by a powerful visual salvo of two emblematic paintings, Isaak Brodsky's *Lenin at the Smolny* (1930) and Dmitry Nalbandian's *Portrait of J. V. Stalin* (1945) (Plates 1, 2). Then visitors will pass through rooms displaying a series of drawings and sculptures of Lenin by Nikolai Andreev. Adulatory quotes about Lenin

and Stalin from the poetry of Mayakovsky, Lunacharsky, and the Kazakh folk-lore performer Dzhambul (Dzhambul Dzhabaev) will be interspersed through-out the entire tour. To "sustain the mounting impressive impact on the viewer from the images of the 'Leniniana,'" the tour will probably then gloss over a number of paintings and hurry to "subtheme Stalin"—specifically, a room exhibiting Aleksandr Gerasimov's monumental *Stalin and Voroshilov in the Kremlin* (1938).[2] There, visitors will hear the tour's lengthiest exegesis:

> The picture shows Comrades Stalin and Voroshilov during a walk in the Kremlin against the backdrop of the wide panorama of Moscow. The figures of Stalin and Voroshilov are given in full size in the foreground. On the second plane are the ancient towers of the Kremlin; on the third is Moscow under reconstruction. Stalin and Voroshilov are looking into the distance. They are walking along the pavement, which is still wet from the rain that has just fallen, and their figures are distinctly recognizable against the backdrop of the city and the cloudy sky with blue break-ing through here and there. The subject of the picture is very simple and taken, as it were, from everyday life, from a genre painting. But the picture captivates the spectator with a feeling of elation and importance. The artist managed to create this impression both with his composition and with the harmonious uplifting colors; he successfully used the motif of the weather, when everything seems illuminated by the recent rain, and even the color gray looks cheerful. Likewise, the artist has attained a unity of pictorial tone that enables the wholeness and compelling sublimity of the impression. In the appearance of Stalin and Voroshilov one can sense calm strength and vigilance. The result is an unpretentious and majestic image of the leader of the Soviet people and his closest comrade-in-arms, the People's Commissar of Defense, against the background of the great city, the capital of a new world, Moscow. They are standing in the ancient Kremlin, the heart of the city and the world, are guarding this new world, and are vigilantly looking into the distance.[3]

Clearly, the guide's miniature lecture was replete with corporeal-spatial meta-phors—the Kremlin as "the heart of the city" and "the heart of the new world," Stalin and Voroshilov gazing "into the distance." All of these metaphors are bound up with centrality.

In the Soviet Union there was a connection between centrality and sacrality: no place was more sacrally charged than society's center. The closer a person was to the center of society, the more sacred was that person. The person placed closest to the center of society embodied the sacred most powerfully.[4] As we have seen, it was during the Great Break that Stalin successfully maneuvered himself into the center of Soviet society and firmly established a system of sin-gle, dictatorial rule that was to last until his death. This principle of power came to encompass all spheres of society; in the words of Katerina Clark, "the entire country in all its many aspects—political, social, symbolical, and cultural—

became unambiguously centripetal and hierarchical in its organization."[5] On the level of symbolic representations too, Stalin was moved into the center. Cult products accorded Stalin center stage and other persons and objects began to be assembled around Stalin, the center, in circles.

If throughout its history the Russian state was usually centered on a single person, then this pattern extended to the micro level as well. The institution of the intelligentsia circle (*kruzhok*) is a case in point. As we saw in Chapter 1, most Bolsheviks had been members or leaders of Marxist study circles (*kruzhki*), each grouped around a single leader. During the Stalinist 1930s, textual cultural representations of the Communist Party unabashedly placed the circle at the beginning of the Party's genealogy. Organized Russian Marxism started as a *kruzhok* and ended up as the Party, according to the *Short Course:* "The VKP(b) formed on the basis of the workers' movement in prerevolutionary Russia out of Marxist circles and groups, which connected with the workers' movement and brought Socialist consciousness to it."[6] Lenin himself had begun as the leader of a circle: "Lenin entered a Marxist circle, organized by Fedoseev, in Kazan. After Lenin's move to Samara, the first circle of Samara Marxists soon formed around him."[7] Later, in St. Petersburg, Lenin reshaped many smaller circles into a single larger circle, an embryonic party: "In 1895 Lenin united all Marxist worker circles (already about twenty) in Petersburg into one 'Union of the Struggle for the Liberation of the Working Class.' Hereby he prepared the foundation of a revolutionary Marxist workers' party."[8] But the reconfiguration of circles turned out to be more difficult than expected and demanded superhuman efforts from the shapers, Lenin and Stalin: "The rise of the workers' movement and the manifest closeness of revolution demanded the foundation of a single, centralized party of the working class, capable of guiding the revolutionary movement. But the state of the local party organs, the local committees, groups, and circles was so poor, and their organizational disunity and ideological differences so great, that the creation of such a party posed incredible difficulties."[9]

Bolshevik textual self-presentation, as in the *Short Course,* is one thing, visual representation another. In searching for a starting point in visual genealogy for the sacralizing of the *khruzhok,* the court portrait (*paradnyi portret*) would probably be a good choice. The quintessential court or ruler portrait (German, *Herrscherbild*) was centered on the courtly person or sovereign.[10] Anton von Werner's painting of the proclamation of the German Empire on 21 January 1871 in the Hall of Mirrors at Versailles illustrates this point—with an interesting twist: it famously places Bismarck, in his white uniform, in the center of the picture, despite the presence of King Wilhelm I and other members of the Prussian royal family in the painting (Fig. 3.1). The artist, according to the

Figure 3.1. Anton von Werner, *The Proclamation of the German Empire* (1877). Bismarck (in white uniform), not Kaiser Wilhelm I (to the left on the dais), is placed in the center. According to the common interpretation, the artist centered Bismarck to express that he, not the Kaiser, deserved the credit for founding the German Empire. Original at Bismarck-Museum, Friedrichsruh.

common interpretation, centered the picture on Bismarck to suggest that the statesman, rather than the monarch, deserved credit for the foundation of a German Empire.

These principles of spatial arrangement applied to cities as well. Moscow can be seen as always having been governed by a circular spatial order rather than an axial or linear order, because it was organized in ring roads around the Kremlin. This was further reinforced in the "general plan" for the reconstruction of Moscow in 1935. By contrast, St. Petersburg–Petrograd-Leningrad was

organized around the axis of Nevsky Prospekt, pointing toward the Neva River, which, as the "window onto Europe," leads to the Neva delta and out to the Baltic Sea and the world. Similar to its place of origin, the Revolution itself was always represented as linear, forward movement.

Thus the pictorial representations centering on Stalin were but a late addition to a long visual genealogy. Just as the Russian state had always been centered on a single leader, images of the Russian state, its rulers, and its religion had usually been organized in concentric circles. The years of the Revolution and the period of the New Economic Policy (1921–1928) were the exception rather than the rule. This is not to suggest that linear movement was banished altogether from the genre of the Stalin portrait. Stalin quite simply monopolized linear movement: his gaze came to figure as the only axis pointing outside the circular pictorial patterns. Stalin's gaze at a focal point outside the picture became a distinguishing feature of visual representations of the *vozhd'*. It is worth recalling that this representational strategy was anything but new. The novelty of socialist realism was to frame the gaze of Stalin—linear, materialist history personified—as the apprehension of the dawning of the future, a future of communism that the Soviet Union would soon enter.

STALIN AND HIS METAPHORS IN FOLKLORE AND ARTIST RHETORIC

The late 1920s saw the eclipse of the Russian avant-garde and the rise of realist art. Within realism changes took place as well. For our purposes it is important to remember that a reordering of the hierarchy of artistic genres was taking place: the portrait was established as the primary genre, and all other genres (landscape, still life) were devalued. This was a necessary condition that led to the development of the Stalin portrait genre. Stalin began to occupy center stage in other fields of cultural production, too. He engendered uncountable metaphors and became a metaphor himself. Indeed, Stalin and the Soviet Union—its nature, its topography—were locked in a loop of mutual signification. If Stalin's physical body functioned as a signifier for nature (the gaze directed into no-time and no-place—utopia), then nature functioned as a signifier for Stalin. Stalin's coming to power ushered in a toponymical revolution. Villages and cities, canals and roads, mountains and islands began to bear his name. It became impossible to move through Soviet space without encountering Stalin coordinates.

At the same time, Stalin was consistently likened to nature in the work of writers, poets, and artists. His biographer, Henri Barbusse, wrote: "Here he is, the greatest and most important of our contemporaries. . . . In his full size he towers over Europe and over Asia, over the past and over the present. He is the most famous and yet almost the least known man in the world."[11] In the

aftermath of Stalin's and Voroshilov's famous meeting with three artists, Isaak Brodsky, Aleksandr Gerasimov, and Evgeny Katsman, on 6 July 1933 at Stalin's dacha, Katsman wrote to Voroshilov:

> Stalin has enchanted us all. What a colossal man! To me he seems as huge and beautiful as nature. I was on the top of Mount Tupik (*na verkhnem Tupike*) in Dagestan at sunset. The mountains radiated like bright gems, I couldn't take my eyes off this, and wanted to remember everything for the rest of my life. Stalin is just like that: I looked at him, wanted to look at him forever and couldn't. I wanted to remember Stalin and couldn't. He very much resembles nature—the oceans, the mountains, the forests, the clouds. You wonder and are amazed and fascinated, but you know that this is nature. But Stalin is the peak of nature—Stalin is the oceans, mountains, forests, clouds, coupled with a powerful mind for the leadership of humanity.[12]

In 1937 *Pravda* framed the flight to America via the North Pole by a team of explorer-aviators (so popular at the time) as a voyage from the center to the periphery and back to the center, placing Stalin in "the heart of Moscow," the Kremlin. Such trips to the periphery were indispensable in recharging and reinforcing the notion of the center:

ALL OUR THOUGHTS ARE OF STALIN

> Forty-two days ago we left our native Moscow. After taking off from the Shchelkovsky aerodrome our airplane set course for the North Pole. From that moment on all our thoughts constantly centered on Moscow. When making every effort to overcome the difficulties of our flight, we thought about Stalin who works in the heart of Moscow, in the Kremlin. . . . Now, during the final hours of our way to Moscow, all our thoughts are about Stalin, about the motherland. It is the greatest of all joys to return to one's native land with the feeling of an accomplished duty, so that we can report to our beloved teacher and leader Comrade Stalin: The mission you entrusted to us is accomplished![13]

Pravda also featured articles about a group of mountaineers who climbed the Soviet Union's second-highest mountain, Mount Lenin in the Pamir Mountains of Tadzhikistan, and then the country's highest mountain, also in the Pamirs, Mount Stalin:[14]

CLIMBING MOUNT STALIN

> Soviet mountaineers on top of the USSR's highest mountain. According to information from Moscow, on 13 September at 5:30 P.M. a detachment of the mountaineering expedition of Comrades Aristov, Barkhash, Beletsky, Gusak, Kirkorov, and the physician Fedorkov reached the top of Mount Stalin in the Pamir Mountains. On the northwestern rocky ridge of the USSR's highest mountain, at a height of 7,495 meters above sea level, they emplaced a bust of Comrade Stalin. Thus the objective of the expedition—to conquer the highest peaks of the USSR: Mount Korzhenevskaia, Mount Lenin, and Mount Stalin—has been attained.[15]

Figure 3.2. "Recently, after the harvest fifty-one combine operators and tractor drivers from the Azov–Black Sea Territory climbed to the peak Mount Kazbek. On the hillside leading to the peak the combine operator–mountaineers placed themselves in rows that formed the name 'Stalin,' which was shot by our photo reporter." *Pravda*, 5 October 1935, 6.

From now on the highest Soviet elevation not only carried Stalin's name but also featured a Stalin bust. Shortly following these articles *Pravda* ran a photograph of Mount Kazbek's snow-covered peak in the Caucasus. "On the hillside of Kazbek's peak," elaborated the caption, "fifty-one combine operators and tractor drivers from the Azov–Black Sea Territory" had "placed themselves in rows that formed the name 'Stalin'" (Fig. 3.2).[16] Yet Stalin had to occupy all of the globe's extremities, not just the highest mountain, but also the northernmost pole. In 1940 *Pravda* depicted two sailors from the icebreaker ship *Sedov*, raising two flags on an ice floe, one with hammer and sickle, the other with Stalin painted on it.[17]

Another typical nature trope (with roots going as far back as to Russia's first court poet, Simeon Polotsky [1628–1680]), was that of Stalin as light or the sun.[18] From Stalin's personal library we know that he drew a red circle around the word "sun" and wrote in the margin "Good!" next to this passage in a book about Napoleon I: "Had Napoleon been forced to choose a religion, he would have chosen to worship the sun, which fertilizes everything and is the true god of the earth."[19] As for metaphors of Stalin as sun: if the earth revolves around the sun, then the Soviet Union revolved around Stalin. Looking at Stalin therefore required a celestial, upward gaze. The quintessentially central trope of Stalin as light or sun was especially prominent in Soviet folklore.[20] According to a quantitative analysis, an Armenian collection for Stalin's sixtieth birthday, *Stalin in the Works of the Armenian People*, contains 151 appellations of "great," 119 of "father," and 116 of "sun."[21] And Dzhambul sang:

> Stalin, my sun, in Moscow I realized
> That the heart of wise Lenin beats in you:
> On a day that shone like turquoise,
> I was in the Kremlin among a circle of friends.
> My eyes saw
> The greatest of men.
> You, whose name has reached the stars,

With the glory of the first wise man,
Were attentive, affectionate, simple,
And dearer to me than my own father.
For the joyous, fatherly reception in the Kremlin
Stalin, my sun, I thank you.[22]

Likewise the last stanza of A. Bezymensky's "March of Parachutists" resounded:

And if in our favorite outpost
Appear hordes of vicious enemies,
We beat with a landing of unheard-of glory
The skulls of the enemy's fascist regiments.
We will fly where no one has flown before us.

We will finish what we must finish.
 Long live the sun! Long live Stalin!
 Long live the people of the Soviet land! *(repeat)*[23]

And a "fakelore" poem, "Stalin—Our Golden Sun," "recorded" (supposedly by ethnographers) in Kabardino-Balkaria, as *Pravda* explicated, read:

Stalin—our golden sun.
The word is deadly for our enemies:
 "Stalin."
Having chased away the thunderclouds,
You opened sunny expanses for us.
. .
Among the soldiers before the battle,
Tall and majestic,
Sparkles in his military outfit
Voroshilov—the famous warrior.
Never vanquished in battle,
He is dressed in armor of strongest
 steel,
This brave soldier, enlightened
 By the sun . . .
This is the golden sun—Stalin. . . . [24]

Yiddish folklore also eulogized Stalin: "He has raised the great shining sun / Over the earth, / Has turned our land / Into a blossoming garden."[25] The topos of Stalin-sun further came up in letters to Stalin, as in that of the Moscow professor who in January 1945 introduced his suggestion that a documentary film be made about the *vozhd'* during his lifetime with the words, "You are our SUN, you are our PRIDE."[26] Or in a compilation of popular suggestions for celebrating Stalin's seventieth birthday: these included the idea to "make from

sun-colored metal a sun with an engraved image of Stalin in its middle and the words around the sun—'Stalin is our sun,' and to write to the left of the image '1879' and to the right '1949.'"[27] Artists too echoed the metaphor of Stalin as light or sun. In Katsman's words after the 1933 meeting of artists with Stalin: "It was as if the life of everyone of us was illuminated with a specially life-giving light (*kak by osvetilos' osobo zhivitel'nym svetom*)."[28] Light here might have had Christian connotations, but there is also the modern transmutation (of the old Christian luminary motif) of the role of light in enlightened modernity.[29] Finally, a Yiddish ditty (*chastushka*) posed the question of metaphor itself: "Stalin, what can we compare you with? You cannot be compared with anything." The conclusion of Stalin's incomparability is reached, of course, only after attempting to liken him to each of the elements of nature—sun, clouds, winds, ocean, fire, and water, in that order.[30] Here we have a trace of the long tradition in Western culture of denigrating attempts to depict the divine with human hands. "The common cry throughout is that gods cannot be represented by dead objects of wood and stone, worked by human hands—let alone be present in them and worshiped," as David Freedberg has summarized the aniconic tradition.[31]

STALIN AND VOROSHILOV IN THE KREMLIN (1938)

As banal as it may sound, Stalin was not born into the Kremlin or destined by right of birth to inhabit the center of the Soviet Union's cultural representations. He had to be actively placed there. In the case of pictorial representations, this involved concrete visual strategies, directed at distinguishing Stalin from other Party leaders. To remind us of a few such strategies from the preceding chapter, they revolved around his place in the picture, his relative size, and the color of his clothing. Stalin's distinction was further marked by portraying him as motionless whereas others were shown in a state of movement.[32] Stability in general became one of the key tropes in representations of Stalin, and the words "calm" (*spokoinyi*) and "confident" (*uverennyi*) proliferated. Objects of everyday life in Stalin's immediate proximity—the pipe in his hand, a map, a newspaper or book—also set him apart from others. And the proximity of Stalin to the figure of Lenin or an image of Lenin—a poster or painting on a wall—was another distinguishing marker.

The sense of Stalin's uniqueness was enhanced by setting him off against others, to whom were ascribed the negative sides of culturally latent binary pairs. For example, the male-female gender code, to use Joan Scott's term, evoked a series of other binaries, such as strong-weak, mind-body, and reason-emotion.[33] This principle of binary definition was later extrapolated outside of the Soviet context. The pipe stuffed with cigarette tobacco (*Gertsegovina Flor* was allegedly his favorite brand) came to signify Stalin, whereas the cigar—together with

Figure 3.3. "Peace pipes." Caricature by Deni. *Pravda,* 17 April 1935, 1.

the top hat—acquired the status of the pipe's bourgeois Other. No picture illustrates this better than a 1935 Deni caricature of Stalin with his "peace pipe" and a bulldog-faced Western capitalist (perhaps reminiscent of Churchill?) wearing a bowler hat, with a phallic, cannon-shaped cigar pointing from his mouth, spewing bullets (Fig. 3.3).[34] In Russia Stalin's pipe is an abiding cultural myth producing legends, reiterations, and new adaptations.[35]

Stalin's male-coded composure was juxtaposed against Hitler's female-coded hysterical fits.[36] And Stalin's unpretentiousness as a speaker was contrasted with Hitler's inflated rhetorical fireworks—"he has never made use of that tumultuous force of eloquence which is the great asset of upstart tyrants," as Stalin's hagiographer Henri Barbusse put it in 1935.[37] Conversely, for Hitler too cigars and cigarettes were loaded signs, though with a different twist. After the forging of the Hitler-Stalin Pact in 1939, Hitler prohibited the publication of photographs of Stalin with a cigarette, reasoning, according to his photographer Heinrich Hoffmann, that among the German population such images would threaten the respectable status of the statesman with whom the *Führer* had struck a deal: "'But a cigarette-smoking Stalin is exactly typical of the man,' I objected. But Hitler wouldn't have it. The German people, he asserted, would take offence. 'The signing of a Pact is a solemn act,' he said, 'which one does not approach with a cigarette dangling from one's lips. Such a photograph smacks of levity! See if you can paint out the cigarettes, before you release the pictures to the press.'" The cigarette in Stalin's mouth was duly retouched away.[38] Hitler further tried keeping Göring from smoking cigars in public, arguing that whoever had been turned into a monument should not be shown "with a cigar in one's mouth."[39]

Artists spoke openly about placing Stalin in the center of their paintings. Aleksandr Gerasimov stressed, for example, on one hand the historical accuracy of his *Tehran Conference,* painted on the premises of the 1943 meeting of the Allied powers. On the other hand, he told his audience unabashedly "it was important that the necessary person be the center of attention. In my case

Figure 3.4. Aleksandr Gerasimov, *Hymn to October* (1942). Oil on canvas, 406 × 710 cm. © 2007, State Russian Museum, St. Petersburg.

Stalin."[40] And about his monumental 1942 *Hymn to October*—406 by 710 centimeters in size—Gerasimov told his listeners: "This is a huge picture. Yet I must say with confidence here that, regardless of its size, regardless of the fact that the chandeliers and golden loges shine there—the attention still falls on Comrade Stalin."[41] (Fig. 3.4). Gerasimov achieved this effect by pointing a spotlight at the comparatively small figure of Stalin, who stands at a rostrum at the Bolshoi Theater off to the left of center stage, and by pointing the heads of the entire audience in Stalin's direction. Moreover, a silhouette of Stalin towers on the Bolshoi's curtain above a large Lenin sculpture. The silhouette is topped only by the Roman numerals XXV, which signify the twenty-fifth anniversary of the October Revolution.

By about 1935, after Stalin had been firmly established in the center of visual culture, pictures of various kinds changed their strategies. After 1936, Stalin was shown by himself (rather than in groups) more frequently, and often he was merely invoked through a Stalin image or sculpture in the background. Again, concentric circles became the dominating pattern of spatial organization.[42]

Perhaps no other painting illustrates this pattern better than Aleksandr Gerasimov's *Stalin and Voroshilov in the Kremlin,* and perhaps no other painting in the Soviet Union ever attained more fame (Plate 3).[43] Stalin and Voroshilov are shown walking along the sidewalk of the inner Kremlin with a Kremlin tower in the immediate background. The Moscow River and the city of Moscow lie in the more distant background. The spatial arrangement of this

painting is predicated on concentric circles grouped around Stalin, the center. Technically speaking, even though Voroshilov's folded hands (or more precisely, his army greatcoat cuff) occupy the picture's geometric center Stalin takes center stage in every other respect. In perspective, he is closer to the viewer and therefore painted as the taller figure. Immediately next to him, in the closest circle, is his closest guard, Voroshilov—a member, incidentally, of the coterie around Stalin also known as his "inner circle" (*blizhnyi krug*). The subsequent concentric zones are occupied by the Kremlin tower, then the Kremlin wall, followed by the Moscow River and the masses crowding along the embankment right behind it. Finally we see the city sprawl of Moscow. The new Moscow, reconstructed according to Stalin's general plan, is signified by the House of the Government (*Dom pravitelstva*), the newly built Great Stone Bridge (*Bolshoi kamennyi most*) across the Moscow River to the far right, and the smokestacks beyond. The old Moscow, symbolized by the three cupolas of a Russian Orthodox Church, has moved to the background. The old Russia, as it were, had been overcome. The House of the Government was specifically moved into the picture, as Gerasimov admitted, perhaps to imply that the Party and intelligentsia elites who resided there were ideologically close to Stalin.[44]

The circle was the seminal Stalinist shape used to structure space. In the case of Gerasimov's painting, Stalin is the sacral center of the Soviet cosmos. Following an observation from Walter Benjamin's *Moscow Diary*, Mikhail Yampolsky noted the absence of an anthropomorphic monument inside the walls of the Kremlin.[45] Thus the sacral center of the Kremlin was uniquely freed for Stalin.[46] Stalin (and Gerasimov) did not have to fear sacral doubling that might be caused by the proximity of a monument, nor would the monument be threatened with sacral overcharge from Stalin's proximity. Stalin's sacrality is underlined by his size, by the immobility of his body—a center, by definition, does not move—and by his lack of ornamentation. Whereas Voroshilov bears the full insignia of a high representative of the Soviet army (a star-shaped cap, collar badges, a belt buckle, an officer's chest belt, and badges on his sleeves), Stalin does not need these, because he is already firmly established in the collective imaginary as the country's sacral center.[47] Stalin is dressed in nothing but his simple gray greatcoat, his cap, and army boots. This central circle containing Stalin and Voroshilov remains open toward the viewer, who is drawn into the picture and merges with the leader.

If Stalin embodies the Soviet body politic, then Voroshilov embodies the Red Army. Thus the Soviet people, incarnated in Stalin, are protected by their army, incarnated in Voroshilov. The railing is a further symbol of defense. It is broken, jarringly and incongruously, at only one place, right behind Voroshilov, in order to show the Moscow River in more detail and, more importantly, the masses on the embankment. The gap in the railing permits the creation of a visual axis

Figure 3.5. 1—Kremlin. 2—Palace of Soviets. 3—Gorky Park. 4—Monument of the Stalin Constitution. Map on inside front cover, *General Plan for the Reconstruction of Moscow* (Moscow: Union of Soviet Architects, 1935).

between Voroshilov and the people on the Moscow River embankment. The motif of the connection between the leader, Voroshilov, and the masses is thus unmistakably present in the painting.[48] But the main theme is one of defense against outside aggression, against fascist encirclement, a theme that also finds symbolic expression in the smokestacks that represent the preparation of Soviet industry against outside attack.

Other readings of the picture are possible. In 1939, one year after the appearance of the painting, one critic suggested that Stalin's gaze was directed at a specific focal point: "Stalin and Voroshilov are standing on the Kremlin mountain, gazing to the place where a majestic monument in honor of V. I. Lenin is being erected—the Palace of Soviets."[49] Indeed, the winning design by Boris Iofan et al. of the 1931 architectural competition for the Palace of Soviets (415 meters high) had included an eighty-meter-high Lenin statue on its apex (2 in Fig. 3.5). The building was to be the world's largest and tallest—topping the Empire State Building completed in 1931—and was to be erected at the site of the Cathedral of Christ the Redeemer, Russia's largest church, located five hundred meters southwest of the Kremlin (1 in Fig. 3.5) on the Moscow River bank. The destruction of the cathedral was duly finished by December 1931, the foundation poured, and the nearby metro stop was named Palace of Soviets station. But the building never got off the ground. Water filled the foundation pit, and after numerous redesigns the building ended up as a white elephant,

eventually opening as the Soviet Union's (the world's, it was often suggested) largest open-air swimming pool.[50] The Lenin statue on top of the Palace of Soviets had raised doubts from the beginning and in March–April 1934, visitors to an exhibition of the Iofan model at the Pushkin Fine Arts Museum remarked in the comment book that the "significance of the leader of the masses, ascending into the clouds far from the people, is utterly lost here. What is more, Lenin is depicted in the pose of a provincial actor. Unbelievably inflated and banal."[51] Other critics of the Lenin statue worried that parts of it would be covered by the clouds, creating unintended meanings, if, say, only his genital region were visible. Yet the axis between the Kremlin and the Lenin statue on top of the Palace of Soviets had been intentional, as a 1934 decree—published in *Pravda*, thereby testifying to the centrality of this building to the state—goes to show: "The Lenin sculpture and the building's main façade are oriented toward the Kremlin, from whose side a wide, monumental staircase leads which can also serve as a tribune for the reception of demonstrations."[52] How, then, are we to understand this version? One reading would view Lenin as the beginner of communism, Stalin as the completer and living incarnation; therefore the Lenin statue on the Palace of Soviets points to the living center of power: Stalin in the Kremlin. Another reading would see Stalin looking at Lenin and thus into the embodied beginning of the utopian timeline, for beginning and end are equally timeless and thus ultimately interchangeable. The Adamistic ur-moment, Lenin, is as utopian as the eschaton of "the bright future."[53] An absolute beginning of time and an absolute end are both literally and equally inconceivable, unthinkable—in a word: utopian.

Yet there are more examples. Other Moscow construction projects were also reoriented toward the planned Palace of Soviets. In 1928, construction began on Gorky Park, officially termed the "Central Culture and Recreation Park" (3 in Fig. 3.5). Since the 1931 architecture contest for the Palace of Soviets, Gorky Park was supposed to create an axis from its location (between the banks of the Moscow River, Krymsky Val, and the Lenin Hills, formerly the Sparrow Hills) to the location of the palace diagonally across the river at the former site of the Cathedral of Christ the Redeemer. The axis of the Palace of Soviets–Lenin Hills "was supposed to direct the masses from the Kremlin, the center of power, to their site of political representation (the Palace of Soviets) along places of ideology and knowledge (the Institute of Red Professors, Komakademia) to 'bread and circuses' at Gorky Park."[54] Further along the embankment of the Moscow River, away from the Kremlin, was the proposed site of the Monument of the Stalin Constitution (4 in Fig. 3.5). It was supposed to be built on the top of the Lenin Hills, which today are topped by the Moscow State University skyscraper. There was going to be a huge "staircase of the peoples of the USSR," each step representing one people or republic. Most importantly, there was

the intention to create an axis from the Kremlin to the Palace of Soviets to the Monument of the Stalin Constitution.[55] Therefore it is also possible to interpret Stalin's gaze in the Gerasimov painting as being directed not only at Lenin on top of the Palace of Soviets, but also at his own work, the 1936 Constitution. Seen this way, Stalin's gaze became self-referential and circular.

On the other hand, perhaps the Palace of Soviets was never built because no second, competing center to the Kremlin, and to Stalin within its walls, was supposed to exist. The Kremlin, ideally suited because it was without monuments, was to be filled by Stalin's body and serve as the single center. At least the appearance of a competing center to Stalin was what a letter writer named Ganna Begicheva, a self-described "simple ordinary laborer (*prostoi riadovoi truzhenik*)," worried about in a 1945 epistle to Beria that was forwarded to Malenkov and to Molotov, into whose archive it found its way:

> Do not punish me for this bold letter; this boldness comes from the miraculous secret of the new life which allows the man in the street (*malen'komu cheloveku*) to address the very greatest people with the word "comrade" and to muse about the fate of our mother country. . . . I HAVE IN MIND THE CONSTRUCTION OF THE PALACE OF SOVIETS. The intended site for its construction is not sound for the following reasons: . . . First, given its size the grandiose building of the Palace in the very center of town kills, squashes the architectural ensemble of the Kremlin. . . . The Moscow River will seem like an insignificant rivulet, not to mention St. Basil's Cathedral and the Mausoleum, which will look like mere toys. This monster will destroy the wonderful appearance of historical Moscow with its streets extending like sun rays from the heart of the city—the Kremlin. It will destroy the remarkable intention of the construction of the Kremlin—of the sun city, gazing in all four directions (*na vse chetyre storony*) and embodying Great Ivan's ideal of Moscow as the Third Rome. . . . The Palace will profit from some distance to the center of town, say, at least on the Sparrow Hills where it will "rise above" the old Moscow, especially considering that the LENIN monument will be covered by clouds half the year long.

Begicheva then went on to formulate her own, quite concrete, proposals for new buildings in Moscow. She suggested building a "Palace of Glory" with "reliquaries of the victories of 1812 and 1945" and tombs for the heroes. Enter Stalin:

> Maybe this is excessive Ukrainian lyricism speaking, but when I go to Ekaterina DZHUGASHVILI's tomb in Tbilisi I think with great tenderness and love about the woman who gave the world a magnificent son—the man of all men, and I mourn her like my own mother. Gravestones always touch the heart, through them you feel the interconnectedness of the ages (*sviaz' vremen*). No monument speaks more to the heart than the shrine of LENIN, than the tombs of TOLSTOY, PUSHKIN, KUTUZOV, and others, only getting close to Gorky's grave is impossible. Be patient, Comrade BERIA, do not take my words as an idle fantasy.

Begicheva then returned to the subject of the Palace of Soviets and cast herself as a simple woman of the people, daring to say what everyone was thinking. All of Moscow, she contended, was afraid that the Palace of Soviets would dwarf the old town and that one would have to "raise one's head to look at this monster like at a nice elephant who wandered into a room."[56]

THE MAKING OF *STALIN AND VOROSHILOV IN THE KREMLIN*

Gerasimov spoke about his picture in public on at least three occasions: in November 1938, in 1947, and in December 1949. Each time the occasion was an evening at Moscow's Central House of Art Workers (TsDRI), a club-like establishment where members of the artistic intelligentsia, especially actors and artists, gathered to watch plays, listen to lectures, and socialize.[57] At the first meeting Gerasimov began by pointing out that *Stalin and Voroshilov in the Kremlin* was originally his entry in a 1937 Stalin portrait competition:[58]

> I painted this picture for the IZOGIZ [Visual Arts Publishing House] competition "Portraits of our Leaders." I could have painted Stalin . . . and other leaders with Comrade Stalin, but I chose Stalin and Voroshilov because it is impossible to paint portraits from photographs, without seeing the people; it is impossible, the photograph does not render the face exactly. You have to know a person well so that he is in your visual memory as though alive. Then the photograph will help you preserve the proportion, form, and everything else you must give from yourself. I had the high honor of being at Comrade Stalin's several times. I was at Comrade Voroshilov's many times. He posed for me.[59]

From a letter to another painter, Isaak Brodsky, inviting him to participate in the competition, we can place Gerasimov's description in context and trace the conditions of the contest—and ultimately the construction and constructedness of the picture—more fully.[60] The competition was actually called the "IZOGIZ Competition for the Best Portrait of Comrade Stalin and His Closest Comrades-in-Arms."[61] Although some portrait competitions were public and open to all, in this one only fifty select artists were invited to participate. Portraits were acceptable "in any technique—oil, watercolor, gouache, drawing, lithography, linoleum cut, etching." The painting was supposed to have a size of fifty by sixty centimeters and had to "satisfy the demands of reproduction for mass printing."[62] Upon signing a contract, the artists each received fifteen hundred rubles for their expenses and were allotted about half a year to finish their entries, so that the winners could be presented at an exhibition during the celebrations of the October Revolution. The jury included the members of the Party elite and of the artistic and literary intelligentsia, among them Aleksei Stetsky, Platon Kerzhentsev, Dmitry Moor, and Aleksei Tolstoy. Stalin's own influence was guaranteed through the presence of a member of his personal

Central Committee secretariat, Lev Mekhlis. The themes for the paintings were in fact more scripted than Gerasimov would have us believe. They included the "portrait/bust" of Stalin and images of Stalin "on the tribune of the Extraordinary Congress of Soviets," "on the tribune of the mausoleum," "with a raised arm/at the evening of the opening of the metro or at the Congress of Soviets 'Forward to New Victories,'" "on the Moscow-Volga Canal," "among children, aviators, heroes of the Soviet Union," and "in the Gorky Park of Culture and Recreation." The organizers further suggested a number of high Party figures with whom Stalin might be portrayed: Molotov, Kaganovich, Voroshilov, Kalinin, Mikoian, and Yezhov.[63]

Gerasimov's statement about the disadvantage of painting from photographic examples and the importance of live posing was a hint at the distribution of photographic and cinematic templates among the artists—an issue that was usually taboo in public discourse about art. "The publishing house is providing each participant of the competition with all the photographic records on the designated themes from its archive and is organizing the screening of the necessary films," in the words of the invitation letter for the competition.[64] During the 1930s, Stalin never posed for Soviet artists, and their sources for portraits of him were photographs, movies, the existing iconography, and—in the case of a privileged few—sketches drawn on occasions when Stalin spoke publicly and the artists were permitted to attend. Indeed, Gerasimov's *Stalin and Voroshilov in the Kremlin* was possibly inspired by a *Pravda* photograph by A. Kalashnikov, showing Stalin and Molotov walking inside the Kremlin (Fig. 3.6).

Nonetheless, Gerasimov would have us believe that the subject of his painting was the product of his artistic inspiration alone: "I began to think about this theme and decided that they must be painted as incarnations of the Red Army and of all peoples. And yet, in poses that convey firmness (*nepokolebimost'*) and confidence (*uverennost'*). These poses are supposed to express that the peoples and the Red Army are the same, are one monolith." Here, Gerasimov perpetuated the Romantic myth of autonomous artistic inspiration. He also unwittingly perpetuated the tensions that typically accompanied the continuity of this myth in Soviet Russia, where art was created according to plan, copied, and mass-produced.

Gerasimov further said about his painting: "I liked the silvery gamut [of colors]. And suddenly I thought: what could be easier than to paint them in front of the Kremlin Palace, in which government meetings take place. I remember this sidewalk well. They might have come out, stood there, waited for a car, or looked at Moscow. As far as the idea was concerned, it was decided. I had to do a whole number of sketches because the silvery gamut was hard for me—I am used to cheerful colors, and the gray tone is awfully difficult. There are such a great number of nuances in it that I struggled with this painting for a long time."[65]

Figure 3.6. "Comrades Stalin and Molotov in the Kremlin on 14 May 1935." *Pravda*, 5 June 1935, 1.

Товарищи **Сталин** и **Молотов** в Кремле 14 мая 1935 года.
Фото М. Калашникова.

After the war, Gerasimov gave a different gloss to his painting and claimed that he had sensed, in 1937, that the war was approaching. In his own words at a 1947 meeting at the Central House of Art Workers: "I painted Stalin several times, and I began the last portrait when war was already threatening on the horizon. . . . Earlier I called this painting *Guarding Peace* (*Na strazhe mira*). . . . The clouds appear to sense what is about to happen. It is clear that there will be a spring thunderstorm, but the clouds will pass, it is not going to be terrible and the clear day will return. The premonition was supposed to come to a good end." He continued, "And so I ended up at the Kremlin and saw a standing person at the railing and understood at that point that this was what I was looking for. The painting went fast. The next day I had completed a sketch of the Kremlin. The Kremlin is not only the heart of Moscow but the hope of all of humanity."[66] This 1947 interpretation and the detail of the thunderstorm must have led Vladimir Sadoven, the author of the course for Tretyakov

Figure 3.7. Viktor Vasnetsov, *Three Warriors* (1898). Oil on canvas, 321 × 222 cm. Original at State Russian Museum, St. Petersburg.

Gallery excursion guides, to conclude that the pavement on which Stalin and Voroshilov were walking was "still wet from the rain that has just fallen."[67] And this interpretation must have laid the groundwork for the popular tongue-in-cheek rhymed epithet viewers later gave to the painting, "Dva vozhdia posle dozhdia" ("Two leaders after the rain").[68]

In 1949, Gerasimov added an interesting new detail. He asserted that Viktor Vasnetsov's *Three Warriors* (1898) had been his inspiration for the painting (Fig. 3.7). After applauding the anti-Impressionism of Vasnetsov, Gerasimov said: "I admit that this picture was constantly before my eyes; there are three warriors there, and here stand two warriors—our Soviet ones."[69] Vasnetsov (1848–1916), a preeminent Wanderer, repeatedly produced illustrations of the ancient Russian oral epic poems (*bylini*) about heroic Russian warriors. *Three Warriors* shows three mythical medieval Russian knights—Dobrynia, Ilya Muromets, and Alyosha Popovich—in full armor on horses in a mountainous countryside. The two at left are looking into the distance, as if to spot the enemy. The third knight is set back somewhat and gazes in a different direction. Unlike in Gerasimov's painting, all three figures are portrayed flatly rather than in three-quarter view, and the two main knights look toward the viewer's left, whereas Gerasimov's Stalin and Voroshilov look to the right. Thus the gaze of the three *bylina* heroes is meant to depict the defense of the Russian land, whereas the gaze of Stalin and Voroshilov holds the dual connotation of vigilance against exterior enemies and the embodiment of history—the gaze into the socialist future.

Let us now return to the circle, which serves as an organizing theme in many other paintings. One example is Vasily Yefanov's *An Unforgettable Meeting*

Figure 3.8. Vasily Efanov, *An Unforgettable Meeting* (1936–37). Oil on canvas, 270 × 391 cm. © State Tretyakov Gallery, Moscow.

(1936–37), which foregrounds a triangle of three figures arranged in circular movement: Stalin, a woman, and Molotov (Fig. 3.8). The three heads indeed create the immediate visual impression of a triangle, but there are in fact more points: the three heads, the arms of Stalin and the woman, joined in a warm handshake (Stalin envelops the woman's hands). Together these points create a circle in the center of the picture. The remaining Party luminaries, with flowers and microphones, create a second circle around the central one. Other paintings that are arranged in circles around Stalin include Yury Kugach et al.'s *"Glory to the Great Stalin!"* (1950),[70] Boris Ioganson et al.'s *J. V. Stalin Among the People in the Kremlin (Our Wise Leader, Dear Teacher.)* (1952), and Grigory Shegal's *Leader, Teacher, and Friend (J. V. Stalin in the Presidium of the Second Congress of Kolkhoz Farmer–Shock Workers in February 1935)* (1936–1937) (Plates 4, 5, 6),[71] as well as David Gabitashvili et al.'s *Youth of the World—for Peace* (1951), in which Stalin is shown on a poster carried in the center of a crowd of people at a procession.[72]

The circular arrangement held wherever Stalin was, even if the painting concerned a scene from the distant past. For example, Iosif Serebriany's *At the Fifth (London) Congress of the RSDRP (April–May 1907)* (1947), which shows the

young Stalin and the already older, balding Lenin, is arranged circularly around the young Stalin (Plate 7). Sometimes the circular arrangement was projected back onto other spheres of society, without Stalin's presence. This practice was particularly true of the artistic intelligentsia. For example, Vasily Yefanov's picture of the theater director Konstantin Stanislavsky shows him in the center of a circle of people.[73]

Fedor Shurpin's 1949 *Morning of Our Motherland* shows Stalin standing in the Soviet countryside in his white postwar generalissimo's uniform, carrying his greatcoat (Plate 8). His hands are folded, his hair is gray, the wrinkle on his forehead has deepened. This is the canonical postwar Stalin, seasoned by a world war and the loss of millions of people. The exact geometric center is the place where Stalin's heart would be beneath his uniform; this is also the lightest spot in the picture. Here Stalin is the immobile center of the picture. The land is already transformed and moving in no larger, metaphysical direction, only in its self-referential circles (consider the smoke of the smokestacks in the far background, the tractors, the little trees planted symmetrically behind Stalin and expected to grow to a certain height but no higher).[74] The agents of transformation are collectivization and industrialization, as is visible from the tractors and the smokestacks. There are overtones of Christian transcendence: the green behind Stalin symbolizes fertility; the white of his uniform, godlike creation. The only linear movement—Stalin's gaze—is directed outward, with a vanishing point outside the picture. While the land is "utopia become real," Stalin's gaze is directed toward an even brighter future.

Soviet art criticism itself noted the direction of Stalin's gaze. The newspaper *Sovetskoe Iskusstvo*, for example, wrote that "the gaze of the great leader and military commander" in an 18.5-meter-high Stalin sculpture to be erected at the White Sea–Baltic (Belomor) Canal "is directed into the distance."[75] At times the gaze into the "bright future" became so overpowering that it overshadowed conventional strategies of pictorial composition. In Peisakh Rozin's picture *V. I. Lenin and J. V. Stalin at the Bay* (1950), Lenin and Stalin are saying farewell and should be looking at each other. Instead, their gazes do not meet and are both directed into the distance.[76]

This interpretation of Stalin's gaze also entered public discourse. Witness a 1946 *Pravda* article by the Tretyakov Gallery's director, Aleksandr Zamoshkin, about a "New Portrait of J. V. Stalin" by "the master embroideress Comrade Tselman from Sudzha, Kursk oblast." Zamoshkin began formulaically by summarizing Stalin's place in the folk arts: "Comrade J. V. Stalin's image, already engraved in many works of Soviet artists, invariably catches the attention of folk arts masters. Their eyes are fixed on the man who led our motherland to power and prosperity. In artistic embroideries, in bone-carving, in artistic rugs,

in lacquer painting the masters of folk arts realize the image of Comrade Stalin, in whom the people sees the embodiment of its achievements and victories." After this preliminary paragraph Zamoshkin turned to the embroidery by Tselman of "Generalissimo of the Soviet Union J. V. Stalin," thus indicating the *obraz* genre—Stalin as military commander (not statesman, not father of peoples, nor Marxist theoretician).[77] "This portrait," he continued, "executed in colored silks, is the most important work of a number of works created earlier by folk masters and is a valuable contribution to our art. This talented artist has managed to express boundless love for the leader of peoples in her great work." Zamoshkin went on to offer as analytical an interpretation of the artwork as socialist realist art criticism—in a central newspaper—was able to offer. In doing so he expressly described Stalin's face as the surface onto which utopia was inscribed:

> In the austere purity of Comrade Stalin's face the artist has managed to express the proud creature of victory, an immense inner power. Comrade Stalin's gaze is directed into the distance. It is as if our bright future is reflected in his face, illuminated by deep thought (*V litse, ozarennom glubokoi mysl'iu, kak by otrazheno nashe svetloe budushchee*). The artist has convincingly conveyed all this in the expression of the eyes, which are full of life, and in the position of the head, which is lifted and slightly turned back.[78]

COMPARING GAZES, COMPARING BODIES

For heuristic purposes, it is worth contrasting Shurpin's painting of Stalin with paintings reflecting the Lenin iconography and, more jarringly and productively, with nineteenth-century American landscape painting. We begin with the second comparison and return to the first.

Albert Boime has identified "the magisterial gaze" in American landscape painting during the period of Manifest Destiny, circa 1830–1865, as an "elevated viewpoint of the onlooker" that "traced a visual trajectory from the uplands to a scenic panorama below."[79] The assumption of this viewpoint, the "Olympian bearing," is deeply ideological and constitutes the discursive expression of an underlying structural disposition for key tenets of the national American pioneer spirit: the subjugation of the wilderness and the concomitant destruction of the Native Americans who inhabited this wilderness, as well as the expectation of continued westward movement into a utopian paradise on earth. Boime convincingly juxtaposes the peculiarly American "magisterial gaze" with the nearly contemporaneous Romantic German "reverential gaze" of a Caspar David Friedrich. In Friedrich's paintings, "his point of view moves upward from the lower picture plane and culminates on or near a distant mountain peak." According to Boime, "the reverential gaze signified the striving of vision toward a celestial goal in the heavens, starting from a wide, panoramic base."[80] It is perhaps best to further illustrate the American pioneer stance with one of Boime's

Figure 3.9. Thomas Cole, *River in the Catskills* (1843). Oil on canvas, 69.85 × 102.55 cm. Original at Museum of Fine Arts, Boston.

readings of a specific picture. Of Thomas Cole's *River in the Catskills* (1843; Fig. 3.9) he writes:

> A young farmer standing in for the spectator leans on his axe and gazes from a hilltop foreground across the wide vista below. The foreground is strewn with thickets and storm-blasted trees symbolizing the undomesticated landscape that the farmer prepares to clear. We follow his gaze from the boundary of the wilderness across the river to the cultivated middleground zone and the farm dwellings. Moving perpendicularly to the youth's line of vision is a train in the middle distance crossing a bridge. The line of vision extends into the remotest distance where smoke arises from scarcely seen manufactories on the horizon. Cole's picture tells us that the future lies over the horizon, with time here given a spatial location. . . . Of course, in actuality, the farmer would be facing in the opposite direction, away from the boundary of civilization toward the forest wilderness to be cleared. I see this reversal, however, as a metaphorical mirror of the pioneer's vision of the future prospects awaiting him. In looking backward, the farmer declares from the edge between wilderness and savagery on the one hand, civilization and order on the other, that progress moves along a timeline of the landscape.[81]

Shurpin's *Morning of Our Motherland,* by contrast, features a fundamentally different arrangement and perspective. The onlooker does not assume the

place of Stalin and follow his gaze, but rather looks at Stalin face-on. Whereas the viewer of Cole's *River in the Catskills* is proffered, by following the gaze of the young farmer—whose face remains invisible—a pictorialized idea of the utopian future lying ahead, our only hint at the Soviet future is Stalin himself and his gaze. In the American case landscape itself embodies utopia, whereas in the Soviet case Stalin embodies the bright future.[82] As obvious as this may seem, in the American case we are ultimately dealing with a liberal-democratic society, whereas in the Soviet case we have a person-centered dictatorship. The comparative perspective opens up yet another vista on the inner logic of the cult surrounding its dictator.

Moreover, Boime writes of Asher Durand's *Progress* (1853) that "the diagonal line of sight is synonymous with the magisterial gaze, taking us rapidly from an elevated geographical zone to another below and from one temporal zone to another, locating progress synchronically in time and space. Within this fantasy of domain and empire gained from looking out and down over broad expanses is the subtext of metaphorical forecast of the future. The future is given a spatial location in which vast territories are brought under visual and symbolic control" (Fig. 3.10).[83] One reading of *Morning of Our Motherland* might likewise

Figure 3.10. Asher Durand, *Progress* (1853). Oil on canvas, 121.92 × 182.72 cm. Original at The Warner Collection, Gulf States Paper Corporation, Tuscaloosa, Alabama.

Figure 3.11. Viktor Tsyplakov, *V. I. Lenin (Lenin at the Smolny)* (1947). Oil on canvas, 270 × 210 cm. © State Historical Museum, Moscow.

posit an encoding of the temporal line—progress—in the painting via the tractors moving in the background, the trees growing, and the rising smoke of the factories. But another reading is possible: the dominant encoding of progress in this painting is via Stalin's gaze, which is placed in the foreground; the tractors, trees, and smokestacks are marked by cyclical movement in self-referential circles. They are but the background achievements of the foreground Stalin, who can claim these as his very own achievements, as lying "behind" himself. If, in the iconography of industrial construction during the First Five-Year Plan, progress was inscribed in the portrayal of construction itself, then during the postwar era Stalin has consummated a monopolization of progress.

Turning to a comparison of Shurpin's image of Stalin with the Lenin iconography, it is noticeable that the latter features a Lenin who is entirely in motion. In Viktor Tsyplakov's *V. I. Lenin (Lenin at the Smolny)* (1947), for example, Lenin's gaze into the future is echoed not only by his body, which is in dynamic motion, but also by the bayonets of the soldiers around him and by the bodies of these soldiers as well (Fig. 3.11). Gerasimov, a painter who created pictorial representations both of Lenin and Stalin, spoke of his differential approach to

movement and immobility with regard to the two leaders. "The Gorky Museum commissioned a large watercolor portrait [of Stalin] with outstretched arm," he recounted:

> I wanted to convey the loving face of Joseph Vissarionovich [Stalin], this gesture of reaching out to the audience. There is no audience in the picture, because I had been ordered to paint a portrait only. Here all my methods are opposed to the technique I used when I did a portrait of Comrade Lenin. There we have an impetuous pose, the expression of the face matches [the pose], there's the cry of the Revolution, the cry for the Revolution. Here in all my pictures the image of Joseph Vissarionovich is calm confidence (*spokoinaia uverennost'*) in the position of the cause that he leads, complete trust in his powers (*polnaia uverennost' v svoi sily*), nothing harsh, and calm, convincing speech (*nichego rezkogo, spokoinaia, ubeditel'naia rech'*).[84]

At another point Gerasimov asked rhetorically, "Why is V. I. [Lenin] shown talking in this portrait? Because," he answered, "this was the moment of the Revolution." By contrast, in his portraits of Stalin he wanted to show "in his poses and gestures a different stage of the Revolution. Then there was struggle, but here we have construction—not without struggle, to be sure, but nonetheless, this is not the kind of struggle when the fate of the Revolution was still up in the air." Finally, for Gerasimov, Stalin "embodies calm, certain power," hence "the always calm gesture, the calm and utterly convincing manner of speaking."[85]

STALIN: A FACE FULL OF MEANINGS

The topography of Stalin's face furthermore doubled the topography of the Soviet Union. Consider the poem by Aleksandr Karachunsky, a lyrically inclined sixteen-year-old from Aleksandria, Kirovograd oblast, in *Pravda*:

> PORTRAIT OF THE LEADER
> I know the lines of all wrinkles
> All sparkles of his attentive gaze;
> In him there is so much wonderful, dear
> Unpretentiousness!
> In him is the will of the people, in him are our dreams,
> In him is a boundless ocean of dreams.
>
> And every fine wrinkle on his forehead
> Tells tales of difficult years.
> About the prisons of Siberia, about fighting the enemy,
> About the workers' platoons marching victoriously
> In fire and smoke.
>
> About how factories rose in the desert,
> How in the tundra flowers blossomed,

How we survived hunger and frost,
Survived and got powerful.
We all know his dear greatcoat,
The silver smoke from his pipe . . .
And I see the bread of the Ukrainian steppes,
The Caucasian oil, heat from Donbass coals,
The bridges of battleships.
I see how hundreds of heroes of labor,
Are warmed by your care,
They build factories, palaces, towns . . .
Inspired poets compose.
Pilots—the heroes of the air—
Conquer fog and darkness,
And thousands of our Soviet children
Bring glory to the name of the leader.[86]

The central features of Stalin's face are usually his eyes (with Lenin, by contrast, the head itself was more signifying than the face).[87] Artists continually focused on the eyes in their discussions and descriptions of Stalin. At the 1933 "Fifteen Years of the Red Army" exhibition, Stalin, Voroshilov, Molotov, and Ordzhonikidze (all in all, about fifteen Politburo members and other luminaries) came to visit. A crowd of artists (Bogorodsky, Brodsky, A. Gerasimov, Lvov, Merkurov, Modorov, Perelman, Shegal, the art historian Mashkovtsev, and others) moved behind the Politburo. "Everyone carefully studies Stalin. Everyone noticed the beauty of Stalin's face, the harmony of proportions, the beautiful posture, the calmness, the courage, the self-control, the eyes of amber (*piva*) color with dark outlines, around the eyes his wrinkles of kindness and laughter, which run downward from the eyes and upward on his forehead. That is a very characteristic trait of Stalin's. A rather small, medium nose, and pleasant, tanned hands."[88] After Stalin's July 1933 dacha meeting with Gerasimov, Brodsky, and Katsman, the latter wrote about Stalin's eyes: "During lunch we came to talk about Lenin, and Stalin said with a warm and tender look on his face: 'He is unique, after all (*On ved' u nas edinstvennyi*).' In my mind I painted Comrade Stalin's portrait, admiring his eyes, in which his entire genius is expressed, and I felt his expressive and strong look on me."[89]

The eyes were also the point of origin for connecting axes between the leader and his people. The sculptor Nikolai Tomsky said of a meeting of Stakhanovites with Stalin that

when one of Leningrad's best Stakhanovites spoke—a metalworker of the Kirov Factory—I had the fortune to watch Joseph Vissarionovich very closely, and as an artist I naturally tried to capture every gesture, every expression of his face. And when the metalworker Kardashov, if I remember his name correctly, began to speak

about the achievements of the factory, about the new people of the factory, the eyes of Joseph Vissarionovich began to shine with some inexpressible light. It seemed to me, thanks to the fact that his eyes are very close to one another—I am saying this as an artist—that a single radiant star shone through the entire room. At that point I understood what kind of living power, what continuous threads connect our worker, our man, with Comrade Stalin (*kakie nepreryvnye niti sviazi mezhdu rabochim, mezhdu nashim chelovekom i tovarishchem Stalinym*).[90]

In his sculpture *Stalin's Oath,* Tomsky "wanted to find in this oath the uninterrupted bond of the Soviet people with its great leader." The gaze between Stalin and his people is mutual. Tomsky also professed to see his objective in "finding the closest bond of our people, the bond of the peoples, whose looks are fixed on Comrade Stalin."[91] Conversely, whoever had seen Stalin acquired the ability to "see" both literally and figuratively, progressing to a higher level of ideological clairvoyance.[92] Consider this final example of a person who took Stalin's portrait off the wall and turned to his leader's countenance for advice: "I approached Stalin's portrait, took it off the wall, placed it on the table and, resting my head on my hands, I gazed and meditated. What should I do? The Leader's face, as always so serene, his eyes so clear-sighted, they penetrate into the distance. It seems that his penetrating look pierces my little room and goes out to embrace the entire globe. I do not know how I would appear to anyone looking at me at this moment. But with my every fibre, every nerve, every drop of my blood I felt that, at this moment, nothing exists in this entire world but this dear and beloved face. What should I do?"[93]

In the early 1930s, visual culture was preoccupied with establishing Stalin as the center of representation. By 1948 his apotheosis had reached such proportions that he was sometimes represented indirectly. Stalin is present, for example, only on the attentive faces of the people clustered around the radio in Pavel Sokolov-Skalia's *The Voice of the Leader,*[94] and only in the joyful faces of the boys in Dmitry Mochalsky's *After the Demonstration (They Saw Stalin)* (1949; Fig. 3.12). Likewise, in Robert Sturua's *She Saw Stalin* (1950) a woman has returned from a meeting with Stalin to her native Caucasus village. She is entirely self-engrossed, and wears an entranced, "knowing" look that veers off to the left-hand lower corner. She tries to speak, to describe the meeting, but obviously cannot: Stalin is too great for words. Enraptured, the villagers look at her and seem to be daydreaming about their leader.[95]

Like the Stalin cult, socialist realism itself was expansive and sought to break down borders in order to fill space totally and completely. This striving for ubiquity did not stop short of the viewer, not even the viewing critic, who was to lose distance and be drawn into the art. Nor did these totalizing ambitions

Figure 3.12. Dmitry Mochalsky, *After the Demonstration (They Saw Stalin)* (1949). Oil on canvas, 69.5 × 132 cm. © State Tretyakov Gallery, Moscow.

allow for the existence of art criticism as a separate field; consequently art-critical treatises became indistinguishable from the comments workers entered in an exhibition's comment books. Seen from this angle, socialist realism implied the end of art criticism and art history as we know it. Considering the absence of conventional art-historical or visual studies exegeses of socialist realist painting today it would seem that socialist realism successfully deployed its empire-building ambitions.[96] As Boris Groys put it, socialist realist art "presents a rare example in today's cultural context—in a world where otherwise 'anything goes'—of a truly irreducible other."[97]

Within the realm of socialist realist leader portraits, there may be more historical continuity to socialist realism's usurpation of art criticism than is discernible at first sight. Professional art history has squared poorly with ruler portraits since the Enlightenment. As soon as the metaphysical legitimizing source for the ruler crumbled, his (in a few cases, her) representations too were subjected to the same formal-aesthetic criteria to which a rapidly professionalizing scholarly discipline had begun subjecting all artwork—in the egalitarian, universalist fashion so typical of the bourgeois age. Crudely put, while criticism of a baroque portrait of an absolutist monarch amounted to lese majesty, a critical comment on a nineteenth-century monarchical portrait could claim to be a sign of connoisseurship.[98] "How is it," wondered the French critic Théophile Étienne Joseph Thoré in 1861, "that contemporary art has become incapable ... of producing depictions of personalities who rule over nations?"[99] Contemporary art

had not, one could argue then, become incapable of producing such depictions, nor had "the nation" become incapable of deriving sacral aura from these pictorial representations of rulers; instead, contemporary art history had become incapable of interpreting them because its analytical instruments stopped short of nothing, not even a portrait that was to be revered rather than analyzed.

II
CULT PRODUCTION

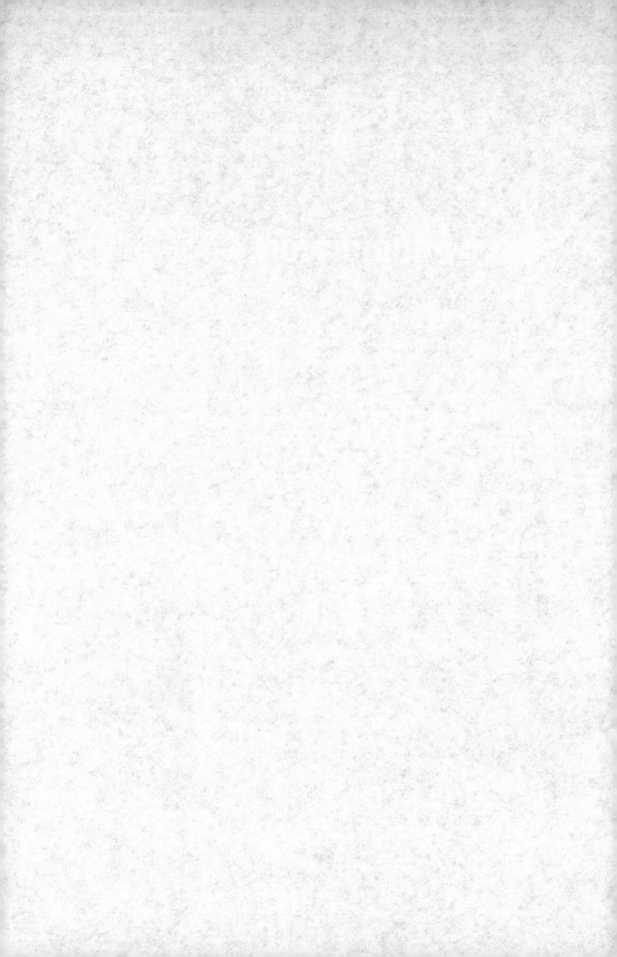

4 The Political Is Personal,
Art Is Political
Stalin, the Cult, and Patronage

THE SPECIAL ISSUE of *Pravda* on 21 December 1929, Stalin's fiftieth birthday and the beginning of his cult, featured a poem, "I am certain" ("Ya uveren"), by then-undisputed court poet Demian Bedny:

Suddenly from *Pravda* a loudly resonant
Telephone crackling:
—"Demian!"
 —"I can't hear you! I turned deaf!"
—"Stop joking!"
 —"No, I won't!"
—"There's panic in the editorial office:
Heaps and piles of telegrams! . . .
On the occasion of Stalin's fiftieth birthday!
Never mind that Stalin
Gets mad and thunders,
Pravda can no longer
 Remain silent.
Write about Stalin without delay.
The Stalin issue will go to press
On the twentieth of December without fail. . . . [1]

Bedny's poem is a striking cultural artifact. By describing the deadline of December 20 for the "Stalin issue (*Stalinskii nomer*)" of *Pravda,* its author gave away more about the production process of the cult's foundation moment than any other publicly available information. The poem allows a glimpse into the constructed and concerted production of the birthday celebration. What is more, Bedny's poem more explicitly than any other document to date articulated a key component of the cult, namely Stalin's alleged opposition to (and grudging

acquiescence in) his own cult; for the cult was the expression of democratic, popular will, and the Soviet Union the world's first true popular-democratic state. "On the occasion of Stalin's fiftieth birthday!," Bedny composed, "Never mind that Stalin/Gets mad and thunders." Bedny then proceeded to reiterate this thesis in a prose article beneath his poem, in case the lyrical did not make the point obvious to everyone: "I know: to write intimately about Stalin means to sacrifice oneself. Stalin will awfully scold you."

The sovereign's rejection of praise had been part and parcel of the glorification of Russian rulers since enlightened absolutism at the latest. Catherine the Great, for example, personally initiated and managed the Legislative Commission, yet in 1767 rejected the bestowal of the title "Catherine the Great, Mother of the Fatherland." She reasoned that the verdict on her reign belonged to posterity, while she had been merely doing her duty out of love for her people and her country.[2] Likewise, wordy professions of the inability to find words sufficient to extol the sovereign had been part of tsar panegyrics during the reign of Nicholas I in particular and of European sentimentalism in general.[3] Bedny's poem achieved more than that: it voiced an entire structure of Stalin eulogy that was to be used until Stalin's end, and the very end of his cult. This structure was dialectical in nature and consisted of extolling Stalin, in particular his modesty, while including his resistance to the very act of extolling as a further sign of his modesty. This first chapter on the production of the Stalin cult scrutinizes this dialectics of the cult. It looks at the role of personal actors in the production of the cult, above all Stalin himself, but also the main patron of the visual arts, Kliment Voroshilov. The varieties of patronage, a supreme form of personalized power, will figure prominently here.

STALIN'S MODESTY

Official Soviet representations featured a whole array of superlatives for Stalin. Among them was the description of Stalin as the "most modest of men." Thus Stalin appeared to be in outright opposition to his own cult or at most tolerated it grudgingly; for this cult was the expression of popular love, and Stalin was of the people and ruled for the people. "Comrade Stalin always combines the belief in the masses with great love for the people, for the creators of the new life, and with enormous modesty, which characterizes him as the greatest leader of the popular masses," pronounced a jubilee album published on the occasion of his sixtieth birthday in 1939.[4] Official rhetoric further depicted Lenin as having handed over power to Stalin. The leitmotif, "Stalin is the Lenin of today," expressed the idea of Lenin as another source of Stalin's legitimacy. By synechdochic extension, Lenin's character traits—chief among them modesty—were

ascribed to Stalin as well.[5] The Soviet people, in turn, were to emulate Stalin: "His example teaches us great modesty and moral purity."[6]

Memoirists and observers of the Soviet scene contributed much to this image of Stalin. According to the memoirs of Vladimir Alliluev (whose mother was Stalin's sister-in-law) Stalin displayed his typical modesty when inspecting a model by sculptor Evgeny Vuchetich for the memorial in Berlin's Treptow Park in honor of the Soviet victory in World War II. "Listen, Vuchetich, aren't you tired of the guy with the moustache?" supposedly asked Stalin. He proceeded to replace a statue of himself in the center of the model with a statue of a Soviet soldier, carrying a little girl in his arms.[7] Foreign observers perpetuated the official image of Stalin's modesty and grudging acceptance of his cult. One of the foreigners to equate person with persona was Lion Feuchtwanger, the German communist writer in Californian exile, who wrote of Stalin: "He shrugs his shoulders at the vulgarity of the immoderate worship of his person. He excuses his peasants and workers on the grounds that they have had too much to do to be able to acquire good taste as well, and laughs a little at the hundreds of thousands of portraits of a man with a moustache which dance before his eyes at demonstrations."[8] Another was the Swiss journalist Emil Ludwig, who interviewed Stalin on 13 December 1931 and a decade later characterized him as "Stalin simplex" and "a healthy, moderate man who in twenty years of rule has never shown a sign of megalomania, even if he unfortunately gave in to his glorification."[9] A third was the Hungarian writer Ervin Sinkó, who recounted a story the writer Isaac Babel allegedly told him: "Babel and Gorky were visiting Stalin. Stalin's daughter, Svetlana, came in. Stalin said to her: 'Tell the father of peoples, the leader of the world proletariat, what you learned in school today?'"[10]

At first glance, some archival sources confirm the image of modesty as one of Stalin's character traits.[11] In a 1933 reply to the playwright Aleksandr Afinogenov, Stalin wrote: "You talk about the 'vozhd'' in vain. This is not good and, I suppose, not proper. Things do not depend on the 'vozhd',' but the collective leader—the Central Committee."[12] Also in 1933 the publishing house Stary Bolshevik sent a note to Poskryobyshev, asking for Stalin's permission to publish a dedication to Stalin in a book by a certain Baron Bibineishvili. Reciting the dedication aloud would have required a deep breath:

> To the man who first inspired Kamo to his selfless and heroic revolutionary struggle, who first called him by the name "Kamo," who with his hand of steel forged the Bolshevik organizations of Georgia and the Transcaucasus, who, together with Lenin, the international proletariat's leader of genius, led the liberation struggle of the proletariat and the victory of Great October, who after the death of the great Lenin continues and develops the teaching of Marx and Lenin, the theory and practice

of the founders of Marxism-Leninism, the strategy and tactics of the revolutionary proletarian struggle, under whose direct guidance the Party is realizing the great task of building a classless socialist society on one-sixth of the globe. To the great leader of the Leninist Communist Party and the Comintern, to the ingenious organizer and strategist of the international proletarian revolution, to Comrade STALIN the author B. Bibineishvili dedicates this book."[13]

Stalin answered: "I am against 'dedications.' I am generally against hymns as 'dedications.' I am all the more against the suggested text of the 'dedication,' since it twists the facts and is full of pseudoclassical eulogistic pathos (*lozhnoklassicheskogo pafosa vospevaniia*)."[14] In 1934 the Politburo accepted Stalin's proposal to rename "the Stalin Institute under construction in Tbilisi" into a mere branch of the Marx-Engels-Lenin Institute without carrying his name in its title.[15] In 1935 Yemelian Yaroslavsky wrote asking Stalin's personal intervention to release all required documents at the Marx-Engels-Lenin Institute through so that he could write Stalin's biography. Stalin replied in handwriting diagonally across Yaroslavsky's letter: "I am against the idea of my biography. Maxim Gorky has a plan analogous to yours . . . but he and I have given up this affair. I think the time for 'Stalin's biography' has not come yet!!"[16] In 1936 Stalin crossed out his own name in a proposal by Platon Kerzhentsev to organize a competition for the best theater play and movie script on the "role of Lenin and Stalin in the preparation and conduct of the October Revolution."[17] One year later, in 1937, Stalin remarked on a screenplay by Fridrikh Ermler for the movie *The Great Citizen*, "I agree that it is undoubtedly politically literate. Also, it undoubtedly has literary virtues. However, there are some errors. . . . The reference to Stalin must be excluded. Instead of Stalin the Central Committee of the Party must be mentioned."[18] Also in 1937 at a dinner following the Red Square demonstration on October Revolution Day, the Comintern chief Georgy Dimitrov proposed a toast to Stalin: "When I was imprisoned in Germany I saw the greatness of Lenin, and since Lenin's death the name of Comrade Stalin is inseparably connected with Lenin; it is the fortune of the history of the human struggle that after the death of the great Lenin Stalin took his place. To the health of Comrade Stalin!" But Stalin would not let this pass: "Comrade Dimitrov is wrong even from the perspective of Marxist methodology. Personalities always appear when the cause that promoted them is good (*ne gibloe*)." Foreshadowing his famous 23 February 1942 dictum, "The Hitlers come and go, but the German people, the German state stays," he went on: "Personalities come and go, the people stay (*lichnosti poiavliaiutsia i ukhodiat, narod ostaetsia vsegda*), and when the cause is good, a personality will appear." Recapitulating the intra-Party struggles of the 1920s, he added: "They knew me, Stalin, but not like Trotsky, be brave and don't invent things that aren't true. . . . Don't be afraid to face the facts. Trotsky, Kamenev, Zinoviev, Tomsky, Bukharin, and

Rykov were well-known. Who was on our side? Well, I did organizational work in the Central Committee. But who was I in comparison with Ilyich? A nobody (*zamukhryshka*). There were Comrades Molotov, Kalinin, Kaganovich, and Voroshilov—but all of them were unknown."[19]

A few months later, on 16 February 1938, Stalin penned a letter to the Komsomol publishing house Detizdat about a children's book by a certain Smirnova:

> I am firmly against the publication of *Stories of Stalin's Childhood*. The book is full of factual inaccuracies, distortions, exaggerations, and undeserved praise. Fairytale hunters, liars (perhaps "conscientious" liars), and sycophants led the author astray. It is a pity for the author, but the fact remains. But this is not the main thing. The main thing is that this book has a tendency of implanting in the consciousness of Soviet children (and people in general) a cult of personalities (*kul't lichnostei*), of leaders, of infallible heroes. This is dangerous and harmful. The theory of "heroes" and "crowd" is not a Bolshevik but an SR [Socialist Revolutionary] theory. Heroes produce the people, they transform it from a crowd into a people—claim the SR's. The people produces heroes—reply the Bolsheviks to the SR's. This book plays into the hands of the SR's. Any such book will play into the hands of the SR's and will hurt our common Bolshevik cause. I recommend burning the book.[20]

The letter was limited to intra-Party circulation where it functioned as a signal: Do not exaggerate the cult![21] Finally, in 1940 Stalin deleted the following words at the very end of a film's screenplay, *The Oath of the Peoples*, to be directed by Mikhail Chiaureli, the leading director of Stalin movies: "Against the backdrop of the flying airplanes stands the gigantic Palace of Soviets Like an endless stream, soldiers march past the foot of the Palace of Soviets. On the tribune we see the Politburo and government of the USSR, ~~with Stalin at its head~~. With his outstretched arm Lenin adorns the top of the Palace of Soviets building."[22]

One could go on and on with examples of Stalin censoring his own cult. They would confirm the thesis that Stalin in both his public and his hidden record was skeptical towards the cult, accepting it only because it sprang from genuine popular will, all the while excising some of the most egregious examples. This was not only the public representation, but it has been confirmed by documents that have surfaced since the opening of the Party archives after the fall of the Soviet Union. Fundamentally, and true to Marxism, Stalin despised his cult. Or did he?

STALIN'S IMMODEST MODESTY

Upon closer analysis one thing becomes clear: Stalin wanted his own cult. The modesty was affected in order to overcome the contradiction of a personality cult in a polity that claimed to be implementing a collectivist ideology, Marxism.

This affected modesty amounted to a pattern of "flamboyant modesty" or "immodest modesty." What is more, when one digs deeper, traces appear of Stalin's jealous control and expansion of his own cult. This also goes to show that the archival documents readily available were part of a deliberate effort by Stalin to place at the easy-to-reach upper layers of his archive—the semipublic "reliquary section," if you will—documents confirming his image of modesty. This too was a strategy of immodest modesty.

Why did Stalin censor his public presence, and create the semblance of a cult against his own will? First, there was the entire prehistory of disdain for personality cults in Marxism and Russian Marxism in particular. A Bolshevik personality cult was an oxymoron, and therefore its self-presentation somehow had to solve this paradox. The cult achieved this by taking recourse to the immodest modesty pattern. Connected with this was Bolshevik Party culture in which modesty was highly esteemed as a personal virtue, and belonged right at the top of the scale of Bolshevik virtues such as will-power and steadfastness. Any typical Bolshevik hagiography stressed the modesty of its subject. Second, and linked with the Bolshevik virtue of modesty, the cultural pattern of immodest modesty actually reached far back into history. This pattern had been part and parcel of left intelligentsia behavior at least since the late nineteenth century and was continued under Stalin by both the highest Soviet powers and by oppositional intellectuals like Anna Akhmatova. Ultimately it extended back to religion and the portrayal of saints as paragons of humbleness.[23]

The earliest clear-cut evidence of Stalin's approval and regular orchestration of his own cult dates from the late 1920s, probably 1927 or 1928. Kaganovich received a letter from Ivan Tovstukha, Stalin's secretary: "The publisher Proletary has published a Stalin portrait (lithograph) of the worst kind. This is the portrait about whose publication in Ogonek and other journals the boss [khoziain, i.e. Stalin] cursed a lot. Besides, it is awfully painted. Could this thing not be liquidated in some quiet manner? In general, we ought to force Proletary to pull itself together and to always ask for our permission when they want to publish something on Stalin (kogda oni khotiat chto libo Stalinskoe vypustit'). They used to do that, but now they published a volume of 1917 Lenin and Stalin articles with lots of misprints, and two days ago Stalin sent an angry letter on this issue."[24] In this letter to Kaganovich by Stalin's secretary, we have the first incontrovertible proof of Stalin's own interest in his representations before he had the absolute power to exert such influence without a paper trail. There is, I believe, even earlier evidence of this kind. In August 1924, exactly seven months after Lenin had died, Stalin received a letter from Kharkov thanking him for sending, as requested, his photograph:

Today we received from Moscow the photographs for which we thank you very much. We had doubts whether you would send them because we had been warned

about your persistent unwillingness to be photographed at all. We think it would be possible that your picture become available to all of the country's Party organizations. Comrade Stalin, we are also looking forward to your letter for the 7,000-strong Stalin [Komsomol] organization of the union. Please do meet our request as soon as you can. We would also like to inform you that the books you gave us have been placed in two clubs of the major mines.[25]

Lev Mekhlis, Stalin's secretary, who is presented as having acted as the intermediary, received a similar letter—but with new details: "After all portraits of Comrade Stalin are so rare in our country. By the way, I don't know how to explain such excessive modesty of the Party leader; in my opinion all Party organizations ought to be supplied with Stalin portraits, but maybe I'm wrong. Everything depends on the characteristics of a person, and Comrade Stalin is by nature unpretentious and modest (*prost i skromen*), as this is a trait you often notice among great people."[26] There is a slight chance this letter exchange actually took place and possibly Stalin had sent his photograph via Mekhlis. But the language of the letters is extremely formulaic and unusual for 1924, when the Lenin cult alone was in ascendance and Stalin was one of the least-known Party leaders. What is more, there are only typescripts and no originals of the letters in the file. I conjecture that these two letters are post factum fabrications strategically placed in the archive in order to bolster the image of Stalin's modesty and project it back onto the entire 1920s.

This opens up more generally the question of sources and archives. What kinds of sources create the impression of Stalin's modesty, of his resistance to the cult? The evidence that seems to confirm this image is from Stalin's personal depository (*fond* 558) at the Central Party Archive (today called the Russian State Archive of Social-Political History, RGASPI). The holdings in this depository do not consist of documents produced by a regular bureaucracy, but rather they consist essentially of two parts, both assembled by archivists.[27] The first part—inventories (*opisi*) 1–10—was collated at the Marx-Engels-Lenin Institute from documents from various archives for the preparation of Stalin's biography during his lifetime (some materials, such as his library with his marginalia, were added after his death). The second part, *opis'* 11, was transferred in the late 1990s from the so-called Presidential Archive (Archive of the President of the Russian Federation), an archive created to save documents from destruction by the putschists in August 1991 during the standoff between RSFSR President Yeltsin and the Politburo communist hardliners (the huge Politburo collection to this day is in the closed Presidential Archive). This is the so-called "personal archive" of Stalin. It was collected by the Central Committee's Special Sector (*Osobyi Sektor*). Created in 1934 and headed by Aleksandr Poskryobyshev, the Special Sector was both a technical unit serving the Politburo and at the same time Stalin's most personal chancellery. Stalin controlled his personal

archive especially tightly. If *opisi* 1–10 were meant for Stalin's biography and hence semipublic, *opis'* 11 contains both materials somehow related to Stalin, among them pieces of evidence that showed his actual control of the workings of his cult (we will review them later), and materials that are mainly a showcase personally arranged by Stalin.[28] "Stalin assembled his archive from those documents that showed the *vozhd'* and his deeds in the best possible light and, conversely, presented his political opponents in the worst way," as the historian Oleg Khlevniuk has written.[29] On top of that, in the Soviet Union archives served different functions from those of archives in many twentieth-century Western countries, and Stalin in particular viewed archives not as sites where historians authenticate the past but rather as repositories of sacrally charged artifacts of leaders like Lenin, and as a storage place, harnessed to the secret service, of surveillance data on the citizenry.[30] The Marx-Engels-Lenin Institute, where *opisi* 1–10 of his personal archive were stored in his lifetime, was the world's supreme shrine of sacred documents of communists from the founding fathers to Stalin. Clearly, it made sense to deposit there materials purportedly documenting the inner workings of the cult—such as the sources adduced above—and to bury whatever documentation did survive from the true creation of the cult in the deepest depths of the more highly secret *opis'* 11.[31] The cult was portrayed as the product of genuine popular veneration, therefore it was only logical that the creation of archival records that would allow posterity to study the cult's construction was to be avoided, and where it could not be avoided, had to be hidden. Thus it is fair to conclude that those documents in Stalin's archive that seem to confirm the public image of his modesty were produced and stored with an intent to bolster just that image.

Stalin's Western biographers have long speculated that, given Stalin's personality and the Soviet system of power from the late 1920s onward, a phenomenon as widespread and resource-intensive as the Stalin cult could only have been initiated and given license to persist by Stalin personally. "The man behind the mask of modesty," wrote Robert Tucker, was "hungry for the devotion he professed to scorn."[32] Under Khrushchev, the Soviet writer Konstantin Simonov confirmed this view, recounting a story Marshal Konev told him. Stalin at first rejected a proposal made by Marshals Zhukov, Vasilevsky, Konev, and Rokossovsky at a Politburo meeting after the war to award him the title of Generalissimo. "In the end," however, "he agreed. But this whole scene was very characteristic of Stalin's contradictory nature: disdain for any glory, for any formal respect for rank, and at the same time an extreme arrogance, hiding behind modesty, which is more than pride."[33] Buttressed by newly declassified sources, Dmitry Volkogonov (in the Soviet Union during perestroika) echoed this sentiment: "It became standard practice for Stalin to condemn the leader cult and to strengthen it, . . . to speak of collective leadership and reduce it

to [his own] undivided authority."[34] As will be shown, these observers of the Soviet scene—coming from vastly different angles, to be sure—were quite correct in speculating that the Stalin cult could never have started without a green light from the dictator and that he played some sort of role in it once it was in place. From archival sources less "public" than *opisi* 1–10 in the Stalin *fond* at the Central Party Archive, it becomes abundantly clear, first, that Stalin was the ultimate arbiter who could, whenever he pleased, remove a cult product from public circulation even after it had passed all filters, and, second, that he either approved or prohibited not every single, but still an impressive number of cult products.[35]

How, then, did Stalin sanction, control, censor, and correct his cult products? Two letters (one from 1929, the other from 1935) illustrate the shift from a more contested, decentralized cult organization in 1929 to an orchestration in 1935 that was still multiagency and often functioned autonomously, yet was always and deliberately oriented toward the center: Stalin. In the spring of 1929 a larger number of agencies played a role in the Stalin cult, including the Central Committee, Anatoly Lunacharsky and his People's Commissariat of Enlightenment, the censorship board Glavlit, and the Agitprop Department of the Central Committee. Later this power was much more concentrated in Stalin and his secretariat. Take for instance a 1929 conflict about a poor-quality *lubok* (popular print) "showing a conversation of Comrade Stalin with national minority women (*natsmenki*)." On 17 May the Central Committee had discussed the publication of the "*lubok Stalin Among The Female Delegates* in issue no. 1 of the journal *Iskusstvo*" (with Platon Kerzhentsev acting as speaker) and decided to "(a) remind Glavlit of the inadmissibility of publishing a confiscated *lubok* in the journal. (b) issue a reprimand to the editorial board of the journal *Iskusstvo* (Comrades Lunacharsky and Svidersky) for publishing in the journal a confiscated *lubok* accompanied by a text of libelous character (*paskvil'nogo kharaktera*)."[36] Lunacharsky rejected the charges, arguing that he had been abroad in Geneva and could not have seen the first issue of *Iskusstvo*.[37] Thus in this story of a broadsheet of Stalin and ethnic minority women we still have a variety of contesting actors including the Central Committee itself, the commissar of enlightenment, Aleksei Svidersky (at that time chairman of Glaviskusstvo), Platon Kerzhentsev (at that time deputy director of Agitprop at the Central Committee), the journal and its editorial board, Glavlit, and perhaps, if invisibly, Stalin himself.

A change can be seen in 1935, when the following incident took place. By this time Maria Osten, a German communist in Moscow exile and common-law wife of the celebrated journalist Mikhail Koltsov, knew exactly that when in doubt, there was only one central authority to write to—the *vozhd'* in the Kremlin—in this case to ask for permission to republish the famous photograph

of Stalin with his daughter Svetlana in her book *Hubert in Wonderland* (see Fig. 2. 9). Her topic was a working-class boy, Hubert, whom she had brought from the Saarland in Nazi Germany to the USSR, where he was now growing up as a happy Soviet child. "This would be such a pleasure for all little and grown-up readers of my book in the USSR and the entire world!" wrote Osten. A terse remark—"I agree. J. St."—by the *vozhd'* sufficed to permit the publication of a photograph that had been shown in *Pravda* just once, only to then disappear together with other depictions of Stalin with his biological family.[38] The period between these two documents (1929 to 1935) is a mere six years, and yet the situation has changed entirely: the Central Committee and other organizations now have no say in sanctioning Stalin images to be released into public circulation. Stalin functions as the single center of approval or rejection.

Stalin impacted cult production alone and with the help of others. The influence of high Party functionaries like Lazar Kaganovich or Kliment Voroshilov (the most involved Soviet arts patron) on the production process of art (such as at the threshold of a portrait's mass reproduction) is well documented. In 1930, Voroshilov received a note that suggests his nodal position as mastermind of the Stalin cult: "I am wondering if it is possible to launch a stamp with a Stalin portrait? How could I get an answer to this question? Granovsky."[39] On 14 March 1934 the artist Fedor Modorov wrote to Voroshilov's secretary : "VseKoKhudozhnik [the All-Russian Cooperative Comradeship 'Artist,' founded in September 1929] is getting ready to print my picture *Politburo of the Central Committee of the Communist Party*. . . . Glavlit needs K. E. [Voroshilov's] reaction (*otzyv*). Glavlit does not print such things without an approval. I hope that you will do everything."[40] In this context, on 4 May 1934, the publishing house IZOGIZ wrote to Voroshilov: "The State Publishing House of the Fine Arts has the intention of publishing a picture by the artist Modorov, *Politburo of the Communist Party*. Considering that you have seen this picture, IZOGIZ asks you to inform us if you think its publication in a mass print run is possible."[41] It is all too likely that Stalin influenced the production process in a similar way—perhaps even using Voroshilov as his mouthpiece—long before the first documents surface that show the approval of Stalin pictures by Stalin's own secretariat.

Whatever the case, in 1937 the publisher Iskusstvo sent Stalin's secretary, Aleksandr Poskryobyshev, a letter asking that he approve the mass printing of several Stalin portraits. In his letter, Osip Beskin, the art critic and head of Iskusstvo, apparently asked that Poskryobyshev approve Stalin portraits at different stages of the production process. For paintings by I. Malkov and Aleksandr Gerasimov, the prize-winning entries in a 1937 Stalin portrait competition, Beskin asked for a general approval to begin the process of mass reproduction. Two other portraits, it seems, had already passed this hurdle; here, Beskin asked

that a trial print run be approved. On 5 September 1937 Poskryobyshev re-
turned Beskin's letter with the following remark written in pencil diagonally
across the upper left top: "No objections. You only need to do additional re-
touching of Comrade Stalin's portrait, especially in the left part of the face."[42]
In March 1943, the editor of the Army newspaper wrote to Poskryobyshev ask-
ing for permission to "publish in *Krasnaia Zvezda* a new portrait of Comrade
Stalin." Written across the letter we see an underlined "no (*nel'zia*)."[43] On 22
October 1947 the publishing house of the Russian Academy of Pedagogical Sci-
ences wrote directly to "the Kremlin, Secretariat of Comrade Stalin, Comrade
Poskryobyshev A. N." about "original woodcut portraits of Comrades Lenin
and Stalin by the artist Neutolimov" to be published in "anniversary issues of
the journals *Sovetskaia Pedagogika* and *Nachal'naia Shkola*."[44]

 This initial letter triggered a chain of responses, involving various mem-
bers of the Agitprop Department and two of the highest-ranking Soviet artists,
who were informally consulted. Stalin's secretariat—perhaps Poskryobyshev
himself—sent the letter written by the publishing house of the Academy of Ped-
agogical Sciences to D. M. Shepilov, deputy chairman of the Agitprop Depart-
ment, for an expert consultation.[45] Shepilov in turn apparently delegated this
case first to N. N. Yakovlev, another deputy chairman of the Agitprop Depart-
ment, who wrote: "The portraits of V. I. Lenin and J. V. Stalin are of poor qual-
ity. In V. I. Lenin's portrait the right eye is depicted inaccurately. One has the
impression as though the eyelids are sick. The moustache and beard is painted
with too harsh brush strokes. The retouching of the face in the portrait of J. V.
Stalin is harsh and dark, especially in the area of the nose, the left cheek, and the
neck. The uniform is depicted incorrectly. The left shoulder strap hangs over the
uniform collar. The uniform buttons are shown unclearly. I believe that artist
Neutolimov's portraits of Lenin and Stalin must not be published without the
necessary corrections."[46] Unsatisfied by or in doubt about this expert opinion,
Shepilov seems to have sought out a second opinion. What we know is that
P. Lebedev, also a deputy chairman of the Agitprop Department, wrote to Shepi-
lov: "I personally think Comrade Iakovlev's appraisal of the portraits is wrong.
The portrait of V. I. Lenin, which successfully conveys Lenin's personal features,
creates the impression of him as a brave, strong person and statesman. The por-
trait underscores traits of sternness in V. I. Lenin's image and is entirely without
the kitsch (*slashchavost'*) that spoils many portraits of Vladimir Ilyich. The
portrait of J. V. Stalin is weaker yet overall suited for publication. The artist's
depiction of J. V. Stalin turned out appealing (*obaiatel'nym*) and at the same
time strong and truthful. But the publisher should be urged to soften the shad-
ows which were applied too harshly in different parts of the portrait."[47] Having
enlisted the support of Aleksandr Gerasimov and Matvei Manizer (two of the
most prominent artists at the time) to bolster his initial positive opinion about

the portraits, Lebedev wrote about a month after his initial letter, referring to the artists as "academicians," invoking their institutional membership to lend status to their given opinions. "The workers of the Agitprop Department have consulted the academicians A. M. Gerasimov and M. G. Manizer, who positively evaluated the artist's work under discussion. It would be appropriate to allow the publishing house of the Russian Academy of Pedagogical Sciences to print in its journals artist Neutolimov's portraits of V. I. Lenin and J. V. Stalin." Lebedev's opinion overrode that of his colleague Yakovlev and he emerged as the winner, for his letter ended: "The publishing house was informed about this verdict."[48]

Were the portraits eventually published? All we know is that Stalin's secretariat in this postwar case—at the height of Andrei Zhdanov's meddling in cultural affairs—devolved its decision-making power to another agency, the Agitprop Department, which first used its internal resources at different ranks of its bureaucratic hierarchy, and when these conflicted, applied to an outside authority—Gerasimov and Manizer—to reach a verdict on the portraits. All of which goes to show that even in 1947, the decision over the publication of a new Stalin (or Lenin) portrait could turn into a contested matter if Stalin had left room for dispute by not voicing his opinion—by this time it was obvious to everyone that Stalin was the ultimate arbiter.

There were more persons and institutions through which Stalin's secretariat fulfilled the function of final filter. Censorship, represented by the organizations Glavlit (responsible mostly for texts and visual products) and Glavrepertkom (responsible primarily, but not only, for theater, cinema, and concerts), was another vital institutional actor in the approval process of Stalin cult products. In November 1947 Glavrepertkom's chief M. Dobrynin wrote to Poskryobyshev: "Glavrepertkom is sending you a photograph of a Stalin portrait by I. M. Toidze and requests that you inform us about your opinion as to the possibility of its mass circulation. Glavrepertkom considers the dissemination of this portrait appropriate."[49] The Toidze portrait in question was a famous painting of Stalin with pipe on a Kremlin balcony with the Spassky Tower in the background (Fig. 4.1). As in the case of Neutolimov's Lenin and Stalin portraits, Stalin's secretariat here also seems to have contacted the Agitprop Department for an opinion. Agitprop deputy chairman Lebedev then wrote to the Central Committee Special Sector, Stalin's private chancellery since 1934: "Glavrepertkom (Comrade Dobrynin) is asking for permission to mass produce a portrait of Comrade Stalin executed by artist I. Toidze. We looked at the photograph of the portrait together with the artists A. Gerasimov and P. Sysoev (Committee for Arts Affairs). The portrait conveys Stalin's outward appearance ably; it shows him against the backdrop of the Kremlin's Spassky Tower. We consider the portrait acceptable. Glavrepertkom was informed about this decision."[50] Next

Figure 4.1. Censorship agencies discussed the dissemination of this Stalin portrait by Irakly Toidze, here reproduced from *Pravda*, 1 May 1946, 1.

we read that the publisher Iskusstvo asked whether it could go ahead printing fifty thousand copies of the portrait and learn that "Comrade Poskryobyshev is not against this."[51] But printing was one thing, circulating another, and both demanded approval by Stalin's secretariat. Poskryobyshev therefore received word from the Agitprop deputy chairman Shepilov that Iskusstvo had printed fifty thousand copies of the portrait. "Please be so kind as to inform us about your decision as to its dissemination," wrote Shepilov. Poskryobyshev noted across Shepilov's letter: "No objections."[52] Furthermore, portraits that were already considered canonical had to be approved a second time by Stalin's secretariat, as a 1948 letter by the publisher Iskusstvo to Poskryobyshev goes to show. It requested that Iskusstvo be allowed to republish eight drawings of Stalin on the occasion of the thirtieth anniversary of the armed forces.[53]

Some pieces of Stalin cult artwork were rejected outright,[54] and some appraisals of concrete artwork were quite searching, as indicated by an August 1947 document, a link taken from the middle of a longer chain of correspondence whose other links are still missing. "The publishing house Iskusstvo (Comrade Kukharkov) asks for permission to publish a portrait of J. V. Stalin by the artist A. Stolygvo," wrote the chairman of the Agitprop Department,

Georgy Aleksandrov, and his specialist for literature, Aleksandr Yegolin, to Andrei Zhdanov.

> The artist Stolygvo is a graduate of the All-Russian Academy of Fine Arts and has been working on the image (*obraz*) of the leader of the Soviet people, J. V. Stalin, for a long time. The work in question is a creative success of Comrade Stolygvo. A good command of form and chiaroscuro has allowed the artist to achieve an almost sculpture-like expressiveness of the portrait. The artist was especially successful in capturing the expression of the eyes, which are full of inspired thought (*glaz, polnykh vdokhnovennoi mysli*). The portraitist managed to convey the image (*oblik*) of the leader with great humanity and warmth. We also welcome the publisher's plan to produce the portrait of J. V. Stalin in small format, intended for wide introduction into the everyday life of workers as a table or wall portrait and as an art postcard. The Propaganda Department considers it possible to allow the publication of artist A. Stolygvo's work by the publishing house Iskusstvo.[55]

Publishers, then, sent a cult product at various stages of the reproduction process to the center of power; Stalin's secretary would reject the product, recommend changes, or approve it. In a sample period, between April 1947 and March 1949, Stalin's secretariat refused to approve five out of twenty-two proposed portraits.[56] Interestingly, Stalin left no signature or any other evidence of his direct influence in the approval process. (From the late 1930s onward, this was also the case with other high Party members from Beria to Molotov, who were sent artwork for sanctioning that focused on their own cults; the publishing institutions uniformly referred to "the secretariat of Molotov," never to "Molotov" personally.)[57] It is very likely that some cult products indeed moved from Poskryobyshev's desk to Stalin's, but that Stalin took care not to show any of his influence in order to uphold the image of a modest leader who merely tolerated the cult that surrounded him.[58] Clearly, because of the sheer volume of cult products that were sent to the Kremlin, it is impossible that Stalin personally approved all of them. In fact, given the tide of cult products sent for approval, it is questionable if Stalin's secretary was able to deal with this work single-handedly. The method of approval was certainly streamlined as time progressed: a 29 November 1952 letter to Poskryobyshev lists the titles of eight pictures; Poskryobyshev then returns the letter with red "plus" or "minus" marks beside each title.[59] Most certainly there was special staff at Stalin's secretariat, trained to uphold the canon and to do the day-to-day work of vetting cult products. During the late 1940s, the letters granting permission to reproduce cult art often bear the signatures of several people other than Stalin's secretary. Thus consider a list (in tabular form) of nine pictures, listing, for instance, "F. Reshetnikov" under "Author," "portrait of J. V. Stalin" under "Name of work," and "Comrade Koziiatko" under "Approved by."[60] When bureaucrats lower in the power hierarchy were involved in the approval process, it seems

to have been particularly important that they sign their permission. Obviously, if Stalin approved a work of art, an off-hand (oral) comment would have been enough. But at the lower levels it was imperative to establish and fix on paper a clear chain of responsibility so that if an approved cult product later met with disapproval at higher levels, the person lower down the hierarchy could be taken to task.

As far as printed cult products went, Stalin's own, direct influence is much more tangible than with visual ones. Stalin meticulously watched over the republication of his own writings, in effect demanding control over his texts, over their canonization and meaning. He left behind a paper trail of, among other things, letters and orders, usually hastily written in his own hand on a writing pad and then wired as ciphered telegrams from Sochi and other southern spas, where he vacationed habitually and, it seems, lacked a safe, scrambled telephone connection to Moscow until 1936.[61] Thus during a 1935 summer vacation in Sochi, Stalin protested against Beria's publication of his writings from the period 1905–1910 because "they are published carelessly, the quotes from Ilyich are misinterpreted and no one besides myself can correct these mistakes; I always declined Beria's request to republish this without my control, and yet the Transcaucasians unceremoniously ignore my protests, which is why a categorical Central Committee ban on republication without my approval is the only solution."[62] Apart from that, Stalin of course filtered the texts of TASS news agency releases and quite often simply forbade the publication of panegyric articles in newspapers.[63] Across an article by a certain Razumov about Stalin's exile in Kureika and Turukhansk, Stalin wrote: "*Nonsense* St."[64] Stalin also controlled the translation of texts by or about himself into other languages; for instance, in 1940 he prohibited the publication of the Russian translation of a book by Konstantin Gamsakhurdia, *The Leader's Childhood,* published in Georgian for his sixtieth birthday.[65] Finally and almost needless to say, the making of Henri Barbusse's Stalin biography was closely overseen by Stalin's secretariat; thus in 1932 it was decided that Stalin's then right hand, "Comrade Tovstukha take care of the preliminary examination of H. Barbusse's work." The German communist publishing mogul, Willi Münzenberg, who seems to have been enlisted as intermediary between the biographer and the secretariat, was supposed to "directly get in touch with Comrade Tovstukha. The latter should select the materials that can be given to H. Barbusse. Comrade Münzenberg must be made to enable the preliminary examination and editing of the complete work by Comrade Tovstukha. A meeting between H. Barbusse and Comrade Tovstukha would be welcome."[66] Later Stalin himself edited different versions of his biography.[67]

Stalin's personal comments regarding movie screenplays have also survived.[68] In the screenplay of Vsevolod Vishnevsky's *First Cavalry* Stalin corrected the

wording of his own quotes.[69] He provided concrete suggestions for changes on Kapler's *Lenin in 1918*, such as: "reshoot the scenes in the kitchen with Sverdlov's participation" or "change the ending after the Lenin-Stalin conversation by direct line with an eye for more precision and clarity" or, more generally, "rewrite the music." On the last page of the script he left the note: "This is a witty film." His final verdict for the film was, "Turned out ok, it seems (comments in the text) (*Vyshlo budto-by ne plokho [Zamechania v tekste]*)."[70]

And all the while Stalin jealously followed the cult-building of those fellow Bolsheviks who were still alive. His aim must have been to let no one come within reach of his top place in the cult pyramid. He was, for example, extremely displeased with the glorification of Ordzhonikidze on the occasion of the latter's birthday in 1936. In the margins of a eulogistic book on Ordzhonikidze Stalin commented on what the author had depicted as Ordzhonikidze's heroic behavior during the July Days of 1917: "What about the Central Committee? The Party? Where's the Central Committee?"[71] Thus the extent to which cults besides his own were allowed was always defined by Stalin himself. He might apply the idea that collective leadership must take precedence over individual leadership to other high Bolsheviks as well.

There are well-known instances in which Party functionaries were purged because of the cults they built (or allowed to be built) around themselves.[72] The most astute *vozhdi* below Stalin in the hierarchy limited any cult-building around their persons, and even left behind paper trails highly analogous to Stalin's "immodest modesty" in *fond* 558. For instance, as early as 1932 Kaganovich wrote to Khrushchev, chairman of the Moscow Party Committee: "I found out that rumors about the renaming of Sokolniki district as Kaganovich district have become so widespread that even the factory newspaper *Krasnyi Bogatyr'* writes about them. I urgently ask you to call in these district people, to scold them severely, and to tell them to stop this thing immediately. This entire affair is absolutely unnecessary, if not harmful."[73]

Thus the pattern of immodest modesty belonged to the Stalin cult—and subsequently also to other Bolshevik leader cults—from its foundation moment, as evidenced in Demian Bedny's 21 December 1929 poem. The immodest modesty pattern, with Bedny's poem constituting one of the first insertions into the public script of the cult itself, in fact reconnected to a culturally virulent pattern that encompassed the entire intelligentsia, including intellectuals opposed to Stalin. This was a pattern of affecting either modest selflessness or the modesty that goes along with the guileless simple-mindedness of the jolly Russian fellow of peasant stock, *rubakha-paren,* while in truth being supremely conscious and controlling of one's image, if not cult. This latent cultural pattern can be seen in Anna Akhmatova's "self-serving selflessness," as Alexander Zholkovsky called it, or in Maxim Gorky's "affected simple-mindedness," as Irene Masing-Delic

wrote. The pattern is evident in the behavior of our painter Aleksandr Gerasi-mov, who habitually played the "simplistic country bumpkin," slept in his Sokol villa in peasant fashion on the studio floor, and enjoyed dressing up in sheep-skins when the Party bosses arrived. Akhmatova's "self-serving selflessness," Gorky's "affected simple-mindedness," and Gerasimov's clownish antics were all intricately linked with Stalin's immodest modesty.[74] Finally and very impor-tantly, the overriding causes for the immodest modesty pattern were Bolshevik Party culture and the internal logic of Marxist ideology. Modesty was one of the key virtues of a Bolshevik. And no matter how much more complex, a personal-ity cult was irreconcilable with a polity that claimed to be Marxist and collec-tivist. The immodest modesty pattern was a sensible way out of this paradox.

STALIN'S MANY ROLES IN STALIN ART PRODUCTION

Stalin's, his secretariat's, his cronies', and others' role as Archimedean point of cult products, as nodal center and final filter, is only part of the story. There were more ways in which Stalin impacted the production process of his cult. In the sphere of visual cult products, one kind of informal leverage consisted of visits by Stalin or, more commonly, one of his cronies to the studios where Stalin art was in the making. At least once, in 1928, Stalin himself visited the Kremlin studio of Pavel Radimov and Evgeny Katsman, two co-founders of the Association of Artists of Revolutionary Russia (Assotsiatsiia Khudozhnikov Revoliutsionnoi Rossii [AKhRR], founded in 1922, renamed Assotsiatsiia Khu-dozhnikov Revoliutsii [AKhR] in 1928 to signify its widened pan-Soviet as-pirations; this book uses "AKhR" to designate both).[75] Radimov, a veteran of the prerevolutionary realist painters, the Peredvizhniki (Wanderers), seems to have obtained this studio through a relative of Vladimir Stasov, a critic.[76] Kats-man joined Radimov in this studio and stayed from 1923 to 1938.[77] Moreover, Voroshilov, the influential patron of the visual arts, regularly made the rounds of Moscow art studios and commented on artwork depicting himself and pre-sumably also Stalin.

The informal influence of Stalin and his subordinates on the cult also in-volved handing out privileges of special access to the Kremlin environment in which Stalin worked. The director of the film *The Battle of Stalingrad*, V. M. Petrov, related how Stalin's secretary, Aleksandr Poskryobyshev, enabled him to enter Stalin's sanctum, his office: "He summoned me to the Kremlin, when Comrade Stalin was not there. I was in Comrade Stalin's office and saw the entire setting of his life and work. These were very moving minutes, I had to memorize everything in this room, all the details. I could not observe for a long time or bother with questions. But I strained my whole memory to preserve all separate details."[78]

Figure 4.2. Photograph of Stalin's visit to the 1928 "Ten Years of the Red Army" exhibition at the Central Telegraph Office on Gorky Street, Moscow. Stalin is on the right in a fur hat, Katsman in the back to his left, and Voroshilov on the far left. The cut-out face in the center is likely Bukharin's, who was purged in 1938. Stalin wrote in the comment book: "I was here on 26 February 1928. Overall, I think, the exhibit is good." © Family Estate Tatiana Khvostenko.

Another form of informal leverage were the statements Stalin allegedly made about certain works of art in different settings—at exhibitions, in privacy to another leader, or to a painter in a studio. This kind of influence belongs to oral culture, circulated between artists and critics in the form of rumors, and was recorded on paper only in rare cases. For example, if one artist wanted to raise his own symbolic capital and was sure enough of a statement Stalin had made about his own artwork, he could risk entering this statement into public discourse. Katsman, for instance, in 1949 wrote about a 1929 drawing of Stalin, published in *Izvestia* for Stalin's fiftieth birthday: "I gave the original to Kliment Yefremovich [Voroshilov], who once told me: 'Joseph Vissarionovich saw this sketch and praised it.'"[79] Furthermore, Katsman minutely recorded Stalin's reactions to various pieces of artwork at the 1933 exhibition "Fifteen Years of the Red Army," one of two exhibitions Stalin is supposed to have visited during the thirty-six years between the end of the Revolution and his death (Fig. 4.2).[80]

> In the Lenin room, I was told, Stalin said about Brodsky's pictures: "Living people (*zhivye liudi*)." Next to Nikonov's picture, Stalin said, when looking at Kolchak with a revolver in his hand: "he wants to shoot himself." . . . When we got to Avilov, Stalin saw himself painted, laughed and immediately turned his eyes to other works. Then back to Avilov, and he examined himself longer. They all laughed over the paintings of the Kukryniksy. We showed them two *Interrogations of Communists*, one interrogation by Deineka, another by Ioganson. They all unanimously approved only of Ioganson. Stalin stopped next to Tikhy's painting *Red Army Soldiers Bathing*: "a good painting," said Stalin and turning to Voroshilov continued, "good because there is a living sky, living people, living water, that's how pictures ought to be done." Stalin carefully and silently examined his portrait by A. Gerasimov. Next to Aleshin's sculpture there was a dialogue between Stalin and Voroshilov. Voroshilov said: "The

Komsomol member is sitting on the Pioneer and crushing him," but Stalin did not agree. "Of course the Pioneers are propping up the Komsomol members, so there is healthy support." They praised Terpsikhorov and Kostianytsyn. Stalin said about Voroshilov on the horse: "A living man, and the horse is real."[81]

Yet there were dangers inherent in quoting Stalin's remarks on particular paintings and art in general. Aleksandr Gerasimov was well aware of these: "I will not quote what Joseph Vissarionovich said because when such a great man speaks, every word is valuable, and I am afraid of leaving something out."[82] The authority to canonize statements by Stalin through their publication belonged, after all, not to the artist, but to the Party and Stalin.

BOLSHEVIKS DON'T MODEL!

One of the most vexing questions for artists and Party leaders was the issue of posing live, of standing as a model, of allowing the leader to be painted "from life" (*s natury*).[83] Some realist artists required thirty and more posing sessions, each lasting many hours, for a single portrait—a considerable sacrifice in time, especially considering that many Party leaders deemed painting frivolous or, in keeping with the imperative of modesty, were concerned that their posing might be interpreted as lacking in that Bolshevik virtue.[84] No artist voiced this problem more directly than a certain Isaev, who, during the preparation for the 1939 Stalin anniversary exhibition "J. V. Stalin and the People of the Soviet Land in the Fine Arts," complained about the difficulties of getting Stakhanovites and other Soviet heroes of the Second and Third Five-Year Plans to pose because they "believe that posing will lead others to accusing them of doing nothing, of wasting time on modeling, therefore they escape posing or pose at the desk."[85] Another painter in the early 1930s proposed to Kaganovich that he first watch Kaganovich at work, in order to photograph him "in the pose that will be most characteristic" and then do a sketch in color that was to eat up no more than an hour of Kaganovich's time. The artist would then work by himself in the studio, and finally request that the leader sit for another "one or two hours in order to enliven my work from nature." "I know," he wrote very typically, "that you, Lazar Moiseevich, are extremely busy, that you don't have a free minute, and that you need every second. But look at it like this: this is not a whim but my work, I do this not just for art but because of its great social significance: a good, truthful portrait of a leader is just as needed as his speech or live performance."[86]

Few professions could match the intimacy of a Party boss's sitting for a painter.[87] For painters, working with their leaders *s natury* both posed a threat and offered immense opportunities. In the intimate working atmosphere of the studio, personal relations between painter and leader usually developed. In a

highly personalized and patronage-oriented power system, painters could use their close access to a leader to ask for favors, such as a new apartment, the release of a loved one from prison, a larger studio. And given the notoriously ambiguous definition of socialist realism, they could ask a leader for his inter-pretation of the Party line at the given moment. On the other hand, a brush stroke that aroused the ire of the portrait's subject, or the kind of visceral an-tipathy that sometimes arose between portrayer and portrayed, could hurl the painter's life into an abyss.

Portraitists' accounts of their sessions with members of the Party elite are extremely codified. Invariably, the painter feels anxious and nervous before the meeting but is soon put at complete ease by the "simplicity" and "warmth" of the *vozhd'*.[88] Gerasimov kept recounting publicly how nervous he had been at the famous July 1933 meeting at Stalin's dacha: "I had to pour the tea. There was a real Russian samovar. I was so nervous that I somehow poured milk from the milk jug into the teapot instead of my tea glass. We all laughed."[89] Kats-man described how, before the same 1933 dacha meeting, the three painters had been both nervous and ecstatic. Voroshilov calmed them down by saying "that he had been just as nervous when he first went to Lenin and walked up to his apartment." But the effect of Stalin's appearance was even more sooth-ing: "Joseph Vissarionovich immediately made everything simple and clear. His calmness and cheerful hospitality delighted us."[90] In 1949 Katsman commented on the occasion of the opening of Stalin's seventieth birthday exhibition: "And you always sense a special nervousness, when you meet, when you see and hear those great people, whom at first only your fantasy drew. I always wondered, 'What is he like in real life?'"[91]

From the early 1930s until Stalin's death, artists constantly pleaded, de-manded, and conspired for him to pose for them. And yet there are competing stories as to how many times and for whom Stalin posed. The first known post-1917 artistic representation of Stalin is an infamous pencil and pastel drawing by Nikolai Andreev, dated 1 May 1922 and autographed by Stalin. This draw-ing, produced three weeks after Stalin had become General Secretary of the Bolshevik Party, is the only example to take realism to the extreme of including Stalin's pockmarks. (Also, Stalin had a stiffened left arm from an improperly treated injury.) Despite the fact that Stalin signed this painting, it is known that he attempted to censor at least one version of it and wrote on one of the copies: "This ear shows that the artist doesn't know anatomy. J. Stalin. The ear screams, is a gross offense against anatomy (*krichit, vopiet protiv anatomii*). J. St." (Plate 9). Likely Stalin was irked not by the ear, but by the pockmarks. While parts of the story remain unknown, it is proven that Andreev's draw-ing was exhibited throughout the Stalin period and called, in an introductory article to the catalogue of the 1939 Stalin anniversary exhibition, a "perfectly finished portrait. No details, everything is concentrated on the representation of

the decisive and powerful movement of the head and the penetrating gaze. But most valuable in this work is the fact that the freshness and power of the direct impression has been preserved in it. The signature of Joseph Vissarionovich on this work suggests that he saw it positively."[92] To be sure, Stalin was never again portrayed with his physical imperfections, neither the pockmarks nor the stiffened arm.[93]

The first written account of depicting Stalin describes two sculpture sessions in 1926. Marina Ryndziunskaia, a sculptor from Moscow, who had already produced busts of several high-ranking Bolsheviks (including one of Aleksei Rykov, to be destroyed in 1938 when Rykov was denounced as an "enemy of the people" during the purges), was asked—probably by the Museum of the Revolution in the context of the sculpture series of prominent Party leaders—to fashion a sculpture of Stalin.[94] She began with a Stalin photograph she had received from the Central Committee. "Then came a moment when I ran into difficulties in my search for the image. I want to and must see Comrade Stalin." Having been told that she "would not, of course, succeed" in getting Stalin to pose, Ryndziunskaia appealed to Stalin's wife, Nadezhda Allilueva, who facilitated a meeting with Stalin in his office at the Central Committee during the late summer of 1926. In keeping with Stalin's canonical image of modesty, Ryndziunskaia emphasizes the "silent sparseness (*molchalivaia skupost'*)" of the office, an "unpretentiousness of the word, unpretentiousness of movements, nothing superfluous."[95] As for Stalin himself: "I was met by a man of medium height, with very broad shoulders, who firmly stood on his feet. . . . And exactly molded from one metal with his torso, a head and strongly developed neck, with a calm and resolute face. To use the language of us artists, I saw a strong composition from the top of his head to the heels of his feet, relating a single thought. A man of exceptional inner will, in an unbelievably calm pose, without the slightest movement. A force, amazing and thrilling, with a head that seemed to sit firmly, a head you cannot imagine moving to the right or to the left, only straight and only forward."[96] Here we have a dress rehearsal for most of the tropes of Stalin representations: the modesty, calmness, immobility, metal-like quality, Nietzschean willpower, and linear, progressive movement— "only straight, and only forward." Clearly, this account was refracted through the prism of the Stalin iconography that developed during the 1930s.

"Without hope of seeing him again," Ryndziunskaia then tried to "use the limited time to study his movements and the bearing of his head." But Stalin agreed to sit for her during a second session at her own studio. Stalin arrived together with his wife, Nadezhda Allilueva:

I met a completely different person in comparison to our first encounter. He was unpretentious, cheerful, joked, criticized my works, and noted a shortcoming in terms of anatomy once in a while ("Please don't laugh, I do know anatomy," he said). . . .

I felt at ease with him, chattered, told him everything that came to my mind, and did not think about what was permissible or not. I even told him that, had I known "that you can be this cheerful and simply talkative, I would not have asked Nadezhda Sergeevna to come with you, because I was so nervous about visiting you at the Central Committee that I was somewhat embarrassed." Comrade Stalin laughed: "Don't tell me you got cold feet, got scared?" "I didn't get cold feet, I ran away worrying my head off, that's how frightening it seemed at your office." "I'm very, very glad, that's the way it's supposed to be,"—he said with a good-natured smile. [Ryndziunskaia:] "Is it true that you wouldn't have come to me if it were not for Nadezhda Sergeevna?" Comrade Stalin burst out laughing: "Of course, she talked me around day and night, and only now, after finishing up with important affairs, I told her that I can go."[97]

The following passage in Ryndziunskaia's memoirs is crucial and projects back on the 1920s the 1930s socialist realist formula of showing the main character traits of the portrayed object (rather than trying to represent mimetically, all blemishes and details included): "In answer to Nadezhda Sergeevna's wish to see a perfect likeness, I said that I was working not for the family, but for the people. If one part or the other will be a little bigger or smaller, by that I emphasize and strengthen the image, not a photograph. . . . 'For example, your chin goes backward, but I will make you one going forward, and the same with everything else. After all it is no secret that you and I lived under the tsar—remember how the people, when they walked by the tsar's portrait, were searching for, wanted to see and understand from the image why he was tsar. But then this was hereditary, now I want the public, when it walks by my depiction, to understand why you are one of our leaders.' 'You are absolutely right,' said Stalin."[98]

In other words, the common purpose of tsar and communist *vozhd'* portraits was to demonstrate to the population that their ruler deservedly ruled. The portrait was supposed to express his legitimacy; legitimacy was inscribed in the way he was portrayed. The difference lay in the nature of this legitimacy: in the case of the communist leader he deserved to rule because of his personal qualities, because he represented the people, and because he embodied the Marxist march of history. The tsar, by contrast and in Ryndziunskaia's reading, had done nothing to deserve his elevated position. His only merit was to have been born a tsar's son. Ryndziunskaia may have had in mind the famous court portrait of Nicholas II by Ernest Lipgart (Plate 10). Dating from 1900, this painting shows the tsar in the White Hall of St. Petersburg's Winter Palace, wearing the uniform of a colonel of the Horse Artillery Guards Brigade attached to the Imperial Escort. His decorations include some that identify him as a member of the Romanov dynasty with international dynastic ties: a commemorative medal of the coronation of Alexander III, his father; a commemorative medal of the

reign of Alexander III; the badge of the Danish Order of the Danenbrog, since his mother, Empress Maria Fedorovna, had originally been Princess Dagmar of Denmark. Apart from that, people might have looked for dynastic continuity in Nicholas's bodily features and would have noticed the same blue eyes as those of his grandfather, Alexander II. Thus portraits of the tsar indeed placed emphasis on symbols and bodily attributes that signified dynastic continuity.

Stalin's portrait session with Ryndziunskaia concluded with a reminder that the sitter had intended to spend only twenty to thirty minutes but had ended up staying almost two hours. "Then I asked him to take off his hat once more, he looked at me with his head up, and I instantly became aware of his face with its bushy eyebrows, which were somehow reminiscent of a mountain bird. We said farewell simply and easily (*prosto i legko*)—how often have I repeated these words so befitting him!"[99] Ryndziunskaia apparently attempted to get Stalin to come for another session, but in vain. "And so I stayed behind all by myself with my work. I left [the sculpture] as it was, having fixed reality, and nothing but that. A year or two later I already began to work differently and, with Stalin's agreement, sometimes departed from the real model, added something, took away something, always trying to maintain the likeness. I tried and try to give the portrait of the leader with all of his inner will and force, to the utmost amazing and thrilling. But when I remember his warm good-naturedness, I feel like incorporating into the portrait of the great leader this rich part of his nature. A difficult task, a task that should be, rather, must be tackled."[100]

Ryndziunskaia seems to have kept in contact with Nadezhda Allilueva while working on the Stalin sculpture. It appears, however, that the sculpture was never exhibited widely and was purchased by the Museum of the Revolution only in 1958, after the deaths of both the sculpted and the sculptor. Ryndziunskaia's career never took off; until the end of her days she worked at the Museum of Ethnography and depicted the national minorities of the Soviet Union.[101]

It also appears that Stalin posed twice, in 1920 or 1922 and in 1926, for the star painter of the 1920s, Isaak Brodsky.[102] There are various stories of Stalin posing after the 1920s, but these stories might be apocryphal. During the 1930s, Stalin supposedly sat as a model for the painter Dmitry Sharapov, who "came from Leningrad to Moscow to do Stalin's portrait; he was arrested after two sessions because Stalin was displeased with the way he was portrayed."[103] After the war, Stalin allegedly attempted to get Vera Mukhina to make a sculpture of him. Mukhina, however, resisted by demanding that Stalin pose for her, "which request, she knew, Stalin would not submit to."[104]

One solution was to engage someone else to pose as Stalin. Gerasimov's heir and son-in-law, Vladilen Shabelnikov, claims to have shared Stalin's height of 162 cm and to have sat as Stalin for Gerasimov in an authentic army greatcoat

and with a pipe, both supplied as props by the Kremlin.[105] The fact that paint-
ers engaged a Stalin model (*naturshchik*) remained secret. Clearly the Soviet
state feared sacral doubling, that Stalin's sacrality would inhabit more than one
body.[106] The other side of the restriction in general of Stalin to Stalin's body
and the taboo placed on Stalin models in particular was the countless stories of
Stalin doubles (*dvoiniki*) in oral lore.

The only opportunity of painting Stalin in person, then, was at the public
events at which he appeared. Only select artists were admitted to these, and
the privilege of sitting, for example, in a front-row seat at the Bolshoi Theater
during Party meetings was a clear mark of an painter's high status in the artistic
pecking order. At such meetings, artists hastily produced sketches that they later
reworked into paintings. As early as 1927, Katsman recorded making a first
"small sketch of Joseph Vissarionovich in my notebook . . . at the hippodrome,
where Budyonny had brought me to watch horse races. . . . On the basis of
these sketches from life, I did a profile portrait of Joseph Vissarionovich for his
fiftieth birthday that was published in *Izvestia*."[107] Stalin's 1933 visit to the ex-
hibition "Fifteen Years of the Red Army" likewise offered artists an opportunity
to study his physical appearance as closely as possible, as Katsman recounted:
"The artists enthusiastically experienced this meeting and kept saying: 'Now
we saw enough of him, now we are going to depict him correctly. We give Stalin
black eyes, but they are amber-colored.' Everyone memorized the shape of his
head, the body's proportion, the color of the face, his posture."[108]

Most famously, Stalin met with Voroshilov and the painters Isaak Brodsky,
Aleksandr Gerasimov, and Evgeny Katsman, at his dacha on 6 July 1933.[109]
This meeting materialized in the immediate aftermath of the "Fifteen Years
of the Red Army" exhibition. The meeting must be seen against the backdrop
of the battle of the realists with the avant-garde, Voroshilov's patronage role,
and the individual interests of the three painters involved. The meeting was my-
thologized in a key painting by Gerasimov and, as is less well-known, in verbal
representations—memoirs by the painters, all of which stressed their closeness
to the leader and some of which were presented to audiences such as the Cen-
tral House of Art Workers, a club-like institution for painters and other artists.
The meeting offered an opportunity for the painters to watch Stalin's physical
appearance closely and to register his pronouncements on art. One month after
the meeting, Katsman reflected upon the meeting in a letter to Brodsky: "Well,
what can we say—we won! But victory is not easy—we have to expand our of-
fensive, we must work better and better." After proclaiming the victory of the
realists over the avant-garde, Katsman went on to discuss Stalin's concept of art
as he supposedly related it to the three painters at the meeting. Katsman began
with the Bolshevik idea of a vanguard of realist painters, who would lead the
entire field of art: "First of all, we must put together a group of masters and

move on in a strong unit, pulling behind ourselves the entire visual arts front." What kind of art should this vanguard of realist painters create and inspire? The new art should depict "the living person (*zhivogo cheloveka*), living water, living grass, sky, living Soviet everyday life, the living Soviet person. We must organize cheerful exhibitions, full of sun, joy, children, women, healthy bodies, and human emotions. Enough of perverts in art, of gloominess, distress, and depression, we do not need the poetry of decay and rot. . . . We ought to be the poets of living, sparkling life. Our country is full of life and the fighting spirit of communism, at its head is the man of genius Stalin—that is what our exhibitions are supposed to be like."[110] This letter can be read as Katsman's attempt to repeat Stalin's remarks on art. The adjective *zhivoi,* meaning lifelike, realistic, proliferates and conforms to Stalin's highest praise, articulated with reference to specific paintings on a number of occasions in the late 1920s and early 1930s: "living people" (*zhivye liudi*).[111] By repeating Stalin's remarks, Katsman was trying to establish his closeness to Stalin and speak "with" Stalin. The danger was that this would be interpreted as speaking "for" Stalin, and after all, Stalin, not Katsman, held authority over Stalin's words. Again, Gerasimov was more aware of the danger.

In the aftermath of the meeting, the three realist artists launched a major offensive to get Stalin to sit for them and seem to have almost succeeded. Brodsky wrote to Katsman on 27 April 1934: "What do you think, are we going to paint Stalin in the summer? We should already start talking about this with K. E. [Voroshilov]. Cheer up, you are still young and we will work."[112] Katsman wrote to Brodsky on 8 September 1934: "And finally. Isaak, we must paint Stalin. Gerasimov will return soon, we have to go to Voroshilov and start working. Sittings (*seansy*) with Stalin will enrich our thoughts and feelings for work at the Artists' Convention, and will generally help the fate of Soviet art."[113] On 25 September 1934, he wrote again: "Voroshilov is gone, he is in Sochi with J. V. [Stalin]. When they return we will pose the question about sittings. Of course we could go there!? Especially since A. Gerasimov returned from abroad yesterday. So you decide! But I think you are right—if the sessions come true, then in wintertime."[114] In an account of how he painted *First Cavalry*, Gerasimov at the Central House of Art Workers on 13 November 1938 alluded to the difficulties of getting Stalin to sit: "Besides, *First Cavalry* is the first painting on our visual arts front that is completely painted from life, with the exception of one portrait, which so far no one has succeeded in painting from life."[115] A 19 August 1939 letter from Katsman to Brodsky reads as follows: "I just cannot understand why our sittings with Stalin are postponed? And we are reacting somehow apathetically to this. I will be in Moscow in two weeks and I will have to take care of this thing again and bring it to a victory. We must paint Stalin or we are scum (*svolochi*)."[116] And in Katsman's words to Voroshilov in 1939:

"Joseph Vissarionovich will turn sixty in December. People from the arts are preparing for this. <u>Let us begin with the main thing</u>. There is no Stalin portrait from life. We need one! This has to be done all the more since Joseph Vissarionovich in life is so expressive and beautiful. We must depict J. V. the way he is. We owe this to history. We owe this to the peoples. We owe this to Soviet art and science. . . . My citizen's and artist's conscience are forcing me to write this letter. You decide how to accomplish this and who will work." He then suggested that Stalin pose for several artists at the same time: "Decide yourself which artists should be given—well, say, 10 sittings for one and a half, two hours. Just imagine—the amazing gift of Comrade Stalin from life will enrich the world in ten days. Different masters will do the portrait of the best man on earth. That is exactly what we need. If we accomplish this I will also paint J. V. from life—that will be the high point of my life and the good fortune of an artist. Even though at the same time there is fear—what if it does not work out? I ask you, Kliment Yefremovich, to acquaint Joseph Vissarionovich with my letter."[117]

Katsman returned to the subject time and again, for example, in a 1940 letter to Voroshilov: "I never forget the dream that we will paint Joseph Vissarionovich from life. I am waiting for those hours when we can do the kind of work that our contemporaries and descendants will be grateful for. We have an obligation to do this work. In me there is some belief that we will paint, and I want only one thing—to be healthy and to finish this work properly."[118] On the occasion of Stalin's seventieth birthday exhibition in 1949, Katsman wrote: "Today opened an exhibition dedicated to the seventieth birthday of our beloved Stalin. A lot of good paintings are there. . . . But I thought to myself, this is a good exhibition, but the main thing has yet to be done, . . . there is no finished portrait from life. Is it possible that there will never be such a portrait? I doubt we will be forgiven this omission."[119]

From all we know, Katsman's wish went unfulfilled and there never was another Stalin portrait from life. One reason for this surely was that Stalin had to remain true to the image of the quintessential Bolshevik, who was modest and who acted rather than sitting for painters. Another reason was, as Ryndziunskaia in 1926 explained to Stalin's wife who asked for mimesis, for "perfect likeness," that she "was working not for the family, but for the people. If one part or the other will be a little bigger or smaller, by that I emphasize and strengthen the image, not a photograph. . . ." Ryndziunskaia's declaration not only foreshadowed socialist realism's call for the realistic portrayal of a person while highlighting that person's psychological characteristics, it also diminished the need for sitting. Her—and later, socialist realism's—agenda could be carried out by using the existing depictions of Stalin or photographic and cinematic templates. After all Ryndziunskaia got her unique shot at fashioning a sculpture

of Stalin in 1926 when there were hardly any Stalin images in circulation, and when the cult surrounding Stalin had yet to commence.

"HERE'S YOUR PERICLES"—VOROSHILOV AS PATRON OF PAINTERS

If any Party elite member besides Stalin has figured prominently so far, it is Kliment Voroshilov, the Old Bolshevik and commissar of war from 1925 to 1940. Whenever he celebrated a birthday or Soviet holiday, he received, just like the rest of the Party elite, large quantities of congratulatory letters. What made Voroshilov's correspondents different was their profession: most were artists and other members of the artistic intelligentsia. Voroshilov, they all agreed, was their patron among the Bolshevik luminaries, even if others had kinship ties to painters (Ordzhonikidze's daughter at one point was married to the artist Eduard Barklai and Maksim Litvinov's daughter was married to the painter Ilia Slonim).[120] Thus Evgeny Katsman, the painter, sent a typical letter to his patron on the occasion of the thirty-sixth anniversary of the October Revolution in the year of Stalin's death: "In your speech you mentioned us artists—no one has ever done that! But artists need to be pampered, who will decorate communism without artists?! Communism without beauty is poor communism. But artists are like flowers, when you water them, they grow, when you don't water them, they dry up and die. Pericles nurtured Phidias. The Medici nurtured Raphael, Leonardo and Michelangelo, Tretyakov and Stasov [nurtured] Repin. You nurtured and are nurturing Soviet artists. Remember, Stalin once told us about you—'Here's your Pericles.'"[121]

Who was this modern-day Pericles and how did he become patron of the arts? What was the role of patronage in the production of Stalin cult art? Kliment Yefremovich Voroshilov (1881–1969) was born in a railroad worker's family in the village of Verkhnee in Ekaterinoslav oblast in present-day Ukraine (Fig. 4.3).[122] Voroshilov joined the Bolshevik Party in 1903 and engaged in underground Party work in the following years, especially in the Ukrainian town of Lugansk.[123] He occupied important positions in the Red Army during the Civil War, particularly in the famed First Cavalry, and, in the words of the *Great Soviet Encyclopedia,* was Stalin's "closest aide" in the defense of Tsaritsyn, later Stalingrad.[124] In fact, apart from the legitimacy that Stalin derived from the myth of having been handed power by the dying Lenin, the battle of Tsaritsyn matched the October Revolution as a founding narrative of Stalin's reign. Voroshilov's proximity to Stalin in this narrative accorded him (and the Red Army, which he embodied) a more prominent place in Soviet cultural representations—in the films, novels, and paintings of the 1930s and 1940s—

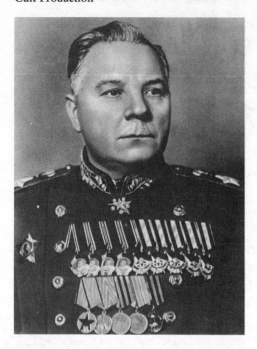

Figure 4.3. A postwar photograph of Voroshilov. Source: *Bol'shaia Sovetskaia Entsiklopediia,* 2nd ed., vol. 9 (Moscow: Gosudarstvennoe nauchnoe izdatel'stvo "Bol'shaia Sovetskaia Entsiklopediia," 1951), pictorial insert between 128 and 129.

than the power that he actually wielded in comparison to the likes of Molotov or Beria. Voroshilov was also a member of the Revolutionary War Council and in November 1925 became People's Commissar for Military and Naval Affairs (renamed People's Commissar for Defense of the USSR in 1934), a position he held until the 1939–1940 fiasco of the Soviet-Finnish Winter War. During World War II he was appointed commander in chief of the Northwestern Armies but was removed from that position when the Germans surrounded and besieged Leningrad. He held numerous other posts during and directly after the war, most importantly as director of the Allied Control Commission in Hungary from 1945 to 1947. From 1946 to 1953 he served as deputy chairman of the USSR Council of Ministers. It was only this portfolio that included cultural affairs.[125] Katsman congratulated him on the appointment as deputy chairman but pointed out that it was merely the official recognition of Voroshilov's de facto role over the course of more than a quarter-century.[126] Voroshilov lived through Khrushchev's de-Stalinization unscathed and died a peaceful death in 1969. He was buried with full honors on Red Square.

Voroshilov seems to have taken a liking to the arts, especially the visual arts, early on. His first remotely related activity was during his teens, when he worked at showing slides with a "magic lantern" for his admired village teacher Semyon Ryzhkov, as he wrote in his memoirs. The slides were projected onto the white wall of a barn; the local "farmers had never seen anything like it" he recalled.[127] Recounting his teens and twenties in his memoirs, Voroshilov

dedicated an entire section of a chapter to "Getting Familiar with the Arts" and one of the posthumous biographies, a composite of newspaper clippings, photographs, and reproductions of archival materials, seamlessly wove paintings by Igor Grabar and Mitrofan Grekov as "documentary material" into his life story.[128] He was instrumental in the creation of the Museum of the Armed Forces of the USSR and the founding of the M. B. Grekov Studio of Military Artists in 1934.[129] He amassed a private collection of realist art, both prerevolutionary and socialist.

His wife, Yekaterina Davydovna Voroshilova, wrote diaries and letters that give some clues about the scope of the Voroshilov family's private collection. Voroshilova, herself from February 1947 a deputy director at the Central V. I. Lenin Museum and thus intimately connected to one of the main repositories of Lenin-Stalin artwork,[130] wrote in a letter to her thirteen-year-old grandson Klimushka, who together with four ten-year-olds was responsible for a 7 January 1949 fire in the Voroshilov dacha in which much of the picture collection perished: "Pictures which I selected one by one and hung in the rooms for collection purposes and so that they might give us pleasure, burned. Gone are the wonderful paintings of A. M. Gerasimov, *Comrade Stalin and Voroshilov on the Volga Steamship*, *The Apple Trees are Blossoming*, *Peonies*, and the portrait of Timur Frunze. Gone are the paintings of I. I. Brodsky, *Lenin at the Smolny*, which hung in your grandfather's study. . . . Klimushka, speaking only of artwork, about forty pieces perished: paintings, drawings, porcelain sculptures, vases with paintings from the biography of your grandfather." Gone were these many paintings, most of which must have been artist copies, as the originals hung in public museums. Gone too was the Voroshilovs' impressive collection of works by the prerevolutionary Wanderers, which Voroshilova did not mention. She wrote that she was doubly sad because "almost all letters that Kliment Yefremovich wrote to me burned."[131] Voroshilova's diaries are full of encounters with artists, testifying to a perplexingly close intermingling of the professional and private lives of Soviet artists and their main patron. Even in Hungary (1945–1947), Voroshilov made friends with numerous artists and managed to sit many a time.[132] His friendship with the Hungarian sculptor Zsigmond Kisfaludi Strobl (1884–1975) was publicly celebrated as an example of the friendship of fraternal socialist peoples.[133]

Voroshilov was a typical Bolshevik patronizing a sector of the arts outside his government and Party portfolio. This practice later became widespread.[134] Kaganovich patronized architecture, Yenukidze the theater, Molotov—after Yenukidze's death—the theater and opera. Stalin directly patronized literature and film. However, the artistic medium that a Party leader chose to patronize (or was drawn into patronizing) did depend on his personal inclinations. Voroshilov's patronage relationship to realist artists goes back to the period

of the Civil War, when he was in a position to distribute scarce resources such as painting materials, and also money, food, and living space. In return, artists painted battle scenes and portraits of army officers. The Civil War in general was a crucible for patronage relations that were to continue long afterward.[135] The realist battle painter, Mitrofan Borisovich Grekov (1882–1934), seems to have been the first in a long series of Voroshilov's clients. Starting in the late 1920s, realist artists created a lineage back to the "founders" (*osnovopolozhniki*) of realism: they enlisted the greatest of prerevolutionary realist artists, Ilya Yefimovich Repin, for the role of ur-realist and continued the line with Mitrofan Grekov. The realists were eager to "invent their tradition" and to present a story of uninterrupted Bolshevik fostering of realist art—a story that glossed over Bolshevik support of avant-garde art during the Revolution and much of the 1920s. In both cases, concrete resources were funneled to artists' surviving relatives and to publicize their connection to the Soviet regime.

The next milestone in Voroshilov's career that prepared him for the role of patron of the arts was his participation in the Commission for the Immortalization of Lenin's Memory.[136] As a member, Voroshilov engaged in judging depictions of Lenin that prefigured Voroshilov's later activities on behalf of Stalin art and Soviet art in general.[137] In 1928, Voroshilov headed a new, Stalin-sponsored commission with the same name. Taken together, these experiences made it all the more natural for Voroshilov to become the patron of the arts and, it appears, the mastermind of the Stalin cult. In the long run, one could argue, this position saved his life, which was under threat not only during the Great Terror but also especially after the botched Soviet-Finnish Winter War of 1940.[138] Voroshilov had been immortalized so many times in paintings with Stalin that the iconoclastic effort of purging his image would have been staggering. In this case, symbolic power, as manifested in the combined Stalin-Voroshilov cult, preserved a life.

Social historians have often explained the vitality of informal patronage networks in the Soviet Union by shortages in the economy or as a function of "neotraditionalism"—the "'archaizing' phenomena that were also a part of Stalinism: petitioning, patron-client networks, the ubiquity of other kinds of personalistic ties like *blat*."[139] This explanation hinges on time lag. The alternative explanation goes like this: the malfunctioning planned economy could not supply the needs of the population; therefore extra-institutional, personalized networks replaced formal, bureaucratic patterns of supply.[140] I submit that time lag and shortages both played important but not mutually exclusive roles and that there was, indeed, a fundamental linkage between the kind of personalized authority expressed symbolically in the Stalin cult and patronage in the classical sense, that is an exchange relationship between a superordinate person in command of scarce material resources and a subordinate person in command

of something else—art, in our case. The symbolic celebration of personalized relationships, especially between political leaders and writers (Bedny-Stalin, Gorky-Stalin) reinforced material patronage—and vice versa. Patronage was publicly celebrated; it was reconcilable with Bolshevik ideology (despite planning and the attempt to regularize and rationalize all economic relations) because of the embodiment, in the leader, of an institution. Since Voroshilov and the Red Army were linked metonymically, it was the institution, the Red Army, not Voroshilov himself, which disbursed patronage and favors.[141]

There was a further linkage between patronage and the Stalin cult: Stalin's image as "father," especially as "father of peoples," entailed an understanding of paternal care for his children. Material and other goods given to a certain ethnic or other group in the Soviet "family of peoples" were often portrayed as warm solicitude by the stern but generous father Stalin for his family. The cultural celebration of the material, caregiving aspects of the father-child relationship in the Stalin cult added legitimacy to real patronage in Soviet society, including the arts. If paternal imagery extended to all levels of the Party hierarchy, and if local leaders in their regional cults were also portrayed as caring fathers, then genuine, material patronage also gained in acceptance.

In the end, however, the cross-pollination of artist and political leader becomes intelligible only when seen in the larger historical-aesthetic setting that was Soviet socialism. "The highest aspiration" of Soviet artists, Jochen Hellbeck has noted, "was to occupy a place near Stalin in order to share in his prophetic vision and transformative powers."[142] Socialism under construction was a kind of *Gesamtkunstwerk*-in-progress in which Stalin, the Hegelian-Marxist world spirit personified, was creating a new world and artists, by aligning themselves with this spirit marching inexorably toward the goal of socialist utopia, partook in the creation process. Stalin and artists were thus indispensable to each other and in fact indivisible. This is why it is "irrelevant," as Boris Groys has written, "that Voroshilov or Kaganovich or Stalin himself were not experts of literature or art, for they were in reality creating the only permitted work of art—socialism—and they were moreover the only critics of their own work. Because they were connoisseurs of the only necessary poetics and genre—the poetics of the demiurgic construction of the new world—they were as entitled to issue orders on the production of novels and sculptures as they were to direct the smelting of steel or the planting of beets."[143] And this is how the Stalin cult and the mundane facts of everyday patronage were linked most fundamentally.

VOROSHILOV AND THE VARIETIES OF STALINIST PATRONAGE

Indeed, what were the coveted goods that the patrons were capable of meting out? One of the scarce resources patrons were asked to distribute was, of

course, housing—an issue of great contention in the Soviet Union.[144] Likewise, if an artist had been arrested, Voroshilov was the natural patron to whom his relatives appealed for intervention on his behalf.[145] And of course, the patron could help in procuring the rare commodity of travel abroad.[146]

More specific to the artists' profession, the *vozhd'* could also distribute the coveted perk of authorization to be present at events of truly historical significance, where the artist could paint from life. Thus a day after the Kirov murder (1 December 1934) a group of Moscow artists sent a letter, on the stationery of the Moscow Section of the Union of Soviet Artists (MOSSKh), to Yenukidze, the "chairman of the governmental commission for the funeral of S. M. Kirov," with a copy to Voroshilov (probably because he was their acknowledged patron) in which they wrote:

> Shocked by the death of the TsK VKP/b/ Politburo member, the *vozhd'* of the Leningrad proletariat and friend of artists Comrade S. M. Kirov, the Moscow Oblast Artists' Union is asking for the governmental commission's permission for a MOSSKh brigade selected according to the attached list, which includes major Moscow artists, to make sketches. The immortalization in the fine arts of S. M. Kirov's memory is indispensable, just as it is absolutely necessary to organize sketches and the drawing of studies from the historical museum as well as from the buildings of former GUM and from other places where the funeral procession will take place and the body of the deceased will be present.[147]

Volter, the head of MOSSKh, signed the letter, and the list had a total of forty artists, including Brodsky, both Aleksandr and Sergei Gerasimov, Katsman, Grabar, Ioganson, Perelman, Pimenov, Deineka, and Svarog.[148] Similarly, Kirov himself had once arranged for Brodsky to meet two participants in a historical event he was painting who were imprisoned in the basement of the Lubyanka. The painting was Brodsky's *The Shooting of the 26 Baku Commissars*, and the incident took place in 1924 when the two organizers of the shooting, Funtikov and Rybalkin, were being held at the secret police headquarters.[149]

There were varying degrees of closeness to the patron, and an elite core group of clients often acted as intermediaries to more distant clients.[150] Thus the painter Vasily Yakovlev sent an invitation to his exhibition not directly to Voroshilov, but rather through Katsman, a member of the core group. Katsman accompanied Yakovlev's letter with the ambiguous words: "Brodsky has seen his pictures and praised them a lot. I have also seen his pictures but am so far withholding judgment since they are still in progress and the outcome is difficult to predict. But he is certainly an excellent craftsman."[151] Even Brodsky, who was extremely close to Voroshilov most of the time, at one point appealed to Voroshilov via Katsman, who was closer at that moment.[152] Geography al-

ways played a big role, and Brodsky's Leningrad location became a liability, as the patrons all resided in Moscow.

Voroshilov, to be sure, also acted as an intermediary patron and brokered access to Stalin himself.[153] In 1930 Voroshilov wrote to Kalinin at the initiative of Aleksandr Gerasimov about the hard times Gerasimov's family experienced in their village of Kozlov, because of their prerevolutionary kulak status and because of special taxes that had been exacted from them during collectivization: "In fall of 1929, in connection with our general new course, the artist Gerasimov's family turn also came. A tax of at first 500 rubles, then another 150 rubles, and finally 720 rubles was imposed on them. According to the artist Gerasimov, he paid all this money, partially out of the family pocket, but mostly from his own income. But he thinks that . . . new taxes will follow. From this whole affair his father has become paralyzed and the artist Gerasimov is upset and has stopped working." "In all of this," wrote Voroshilov, "there is nothing unusual. The authorities in Kozlov are obviously acting correctly." But the artist Gerasimov was too valuable to the Soviet state to be left inactive and deep in his family's woes. Therefore the taxes should be postponed for two months and no new ones imposed. "I do not know if these requests are realistic, but I think that the artist Gerasimov definitely ought to receive help to preserve his ability to work."[154] The argument that an artist deserved help because he was useful to the state, not because his request was intrinsically justified, was quite typical. Sometimes efforts to enlist a high-placed figure as intermediary for access to Stalin failed. This was generally true for Stalin's secretaries, who received patronage requests themselves and usually turned them down. The caricaturist Deni, for example, asked that Mekhlis give him personal instruction about political events so that he, Deni, could draw about them more appropriately. Deni wrote, "you would have to give me a chance to meet with you personally once in a while so that I could hear from you the leadership's position on this or the other question. . . . They call me a leading artist, and I must justify this title. . . . I am asking you to spend very little time on me, since I understand right away (s poluslova)."[155]

The system of subpatronage, of patron intermediaries or patron brokers, whatever one wants to call it, also had an eminently practical function. An important element of patronage was a client's access to the patron for personal communication. Stalin, however, who would have certainly received the bulk of patronage requests given the leader-centered political system, only had limited time. Hence the division of patronage among different patrons was a division of labor of sorts. In May 1946 Vera Mukhina, the sculptor of *Worker and Female Kolkhoz Farmer* (1937), opened her letter to Stalin by enumerating a number of sculptures that she had produced "since I have become 'famous' (since 1937)."

But "not one of these" sculptures, she wrote, "has been put up, not because they were bad, but simply because the people who have the right to approve their implementation did not look at them." By appealing to the *vozhd'*, she expected that pressure would be put on the right people. "I am already 57 years old," she closed powerfully, "and I want to succeed in leaving something behind for the country."[156] Was Mukhina aware that her letter was most certainly never read by Stalin, but that it triggered a well-oiled machine of other officials who acted upon it? However that may be, Mukhina's letter was forwarded to Andrei Zhdanov, the secretary of the Central Committee. He sent it to the head of the Committee for Arts Affairs, Mikhail Khrapchenko, and the head of the Agitprop Department at the Central Committee, Georgy Aleksandrov, with the request that they recommend what action he should take. Both Khrapchenko and Aleksandrov gave detailed comments on each of the sculptural projects mentioned by Mukhina, included photographs, and sent their recommendations back to Zhdanov.[157] Here the chain ends, but it was likely Zhdanov who made a decision on which project to foster. Thus the scarcest of all goods was Stalin's personal intervention. It was, of course, also the most valuable and had the greatest impact. Indeed, scarcity and value (in the sense of the ability to achieve intended results) were inextricably linked.

An artist or a writer could also actively initiate a client-like relationship with a patron-*vozhd'* by sending him a cult product and asking him about some detail. In a prime example of how Voroshilov was integrated into the production process of a cult painting of himself, the artist Vasily Dubrovin in 1937 wrote to him:

> This fall the Baku Museum of the Revolution is organizing an exhibition of pictures of the Stalin era. I took on the subject: *Voroshilov as Boilerman on the 'Oleum' Fields in 1907 in Baku.* I have nothing [to go by] except for one 1907 portrait of you. Considering that I have caught fire for this subject and cannot wait to start, but am lacking extensive material, I am earnestly asking you not to refuse answering three questions, which I will be grateful for all my life, Kliment Yefremovich! 1. Did you work as master, apprentice, or laborer at the boilerhouse? 2. What did you wear? What work clothes were there . . . ? 3. Your comrades from underground work, Comrades Shaumian and Alyosha Dzhaparidze, did they directly come by the boilerhouse?[158]

Half a year later Voroshilov's secretary answered all of Dubrovin's queries: "1. As far as I know from Comrade Voroshilov's biography, he was in Baku for underground Party work, therefore he was not a master at the boilerhouse. 2. As far as the clothes of that time are concerned, at the Museum of the Revolution you will probably find a contemporary photograph. 3. Did Dzhaparidze and Shaumian stop by at Voroshilov's and did they meet?—well, where can one find this out more easily than in Baku from the comrades of that period."[159]

Time and again cultural producers tried to enlist a high Party patron along ethnic lines, invoking, for instance, Mikoian's Armenian heritage.[160] This was a sensitive issue and Party bosses were careful to stress their supra-ethnic identity as Bolsheviks and to leave behind a paper trail that turned down any such patronage along ethnic lines. This is not to say that such patronage never took place. In oral testimony of the period it certainly played a role. Gerasimov was considered by some an anti-Semitic Russian chauvinist and Gerasimov himself, according to his son-in-law, was convinced that he was surrounded by a Jewish conspiracy of Brodsky-Katsman-Perelman who worked through their ethnic patronage channels.[161]

It can be argued that the entire discourse around *shefstvo,* translated as "patronage" or "sponsorship" in dictionaries, was a formalized and culturally celebrated variant of patronage. *Shefstvo* was when a factory, for example, sponsored a soccer club in an organized, officially publicized fashion. Often *shefstvo* was couched in metaphoric kinship terms, of an older brother (rarely a sister) taking a younger sibling (of either gender) under his tutelage. There was collective *shefstvo* and individual *shefstvo*. In a reversal of the usual roles, the artistic intelligentsia—musicians, actors, and artists—was engaged in a *shefstvo* relationship with the Red Army since 1923, with artists taking on the role of older brother. Parts of this relationship seem to have been codified with a contract.[162] It is unclear to what extent this was a give-and-take relationship and what artists gained from it. Nonetheless, the cultural newspaper, *Sovetskoe Iskusstvo,* duly celebrated this relationship. An article entitled "The Union of Warriors and Artists" prominently displayed a drawing of Voroshilov in the upper right-hand corner of the front-page and Voroshilov's address to the artists, "the *shefs* of the Red Army." "Dear Comrades! You are asking me, 'how I assess the results of the *shefstvo* work of the Union of Art Workers over the Red Army.' I always knew . . . that the *shefstvo* of RABIS over the Red Army is deeply meaningful, active, and highly useful. The Political Department of the Red Army gave me a report which shows that over the past year the Moscow, Leningrad, and Kharkov branches of RABIS through *shefstvo* sent 82 highly artistic brigades that gave 2,626 concerts in distant garrisons, at which more than four million listeners were present."[163] In a 1933 conflict over who had the right to publish certain portraits by Gerasimov, a representative of VseKoKhudozhnik wrote to Voroshilov as arbiter, apologizing for seeking to make use of his "*shefstvo* over the artists."[164]

The principle of an institution's embodiment through a patron, as in the case of Voroshilov and the Red Army, was not the only symbolic aspect of patronage relations that confounded the logic of maximum profit economic rationalism. For example, either patron or client might fall from favor, and yet their personal ties sometimes survived.[165] Often patron-client relations extended to the

kin of the client after the client's death. In 1963 Voroshilov wrote, for example, to the head of the Party-state Control Committee, Aleksandr Shelepin, to access bank accounts that Gerasimov had lost track of, but that his wife and daughter needed. "One of the character traits of the deceased was his love for people," wrote Voroshilov, "the absence of commercialism, and a sometimes excessive forgetfulness towards his debtors, a carelessness in record-keeping. All this is now hurting to some extent his legal heirs—his wife L. N. Gerasimova and his daughter G. A. Gerasimova."[166]

THE RHETORIC OF LETTERS BETWEEN PATRON AND CLIENT

The rhetoric that artists used in their correspondence with their patrons deserves to be examined in greater detail. In 1926, Brodsky flattered Voroshilov in a letter by telling him that "all artists see their savior in you, and they are not wrong, that is the way it is. You are the only one who takes the interests of artists seriously and sincerely wishes them well."[167] The artist, Fedor Bogorodsky, displayed both greater effusiveness and more self-interest in his letter to the patron of the arts: "I am using the opportunity to greet you sincerely and warmly! Actually allow me—a mere artist—to declare my love for you once more. Of course, like everyone, I am <u>dreaming</u> of a meeting . . . The artist F. Bogorodsky."[168]

Two letters to Voroshilov, one by Brodsky, the other by Katsman, written six years apart, show striking similarities. Both begin by noting a change in Voroshilov's relationship to the respective painter. "I always felt that you like me and I have appreciated that and have always been proud of it, but for a number of months already, it seems to me, your relationship towards me has noticeably changed," wrote Brodsky in 1928.[169] "In the ten years that we know each other I saw you this unsatisfied and strict for the first time. When we greeted each other, you were on a horse, and I already felt the harshness on your face," wrote Katsman in 1934.[170] Brodsky attributed Voroshilov's mood change to the slanders of his foes in AKhR (this was at a time when he had been excluded from AKhR), whereas Katsman, following a conversation with Voroshilov, was convinced that serious problems with the state of socialist realist painting were at issue. Both Brodsky and Katsman claimed to suffer from what today might be called psychosomatic symptoms, caused by Voroshilov's rejection: "This whole story cost me health problems and the loss of 50 percent of my vision because of bad nerves," in Brodsky's words, and, in Katsman's words: "I returned from you completely sick, both physically and morally. I caught a cold with fever . . . I slept poorly during the night and constantly thought about you, about Stalin, and about the fate of Soviet art. I even thought I had fallen seriously ill, but in

the morning I had thought everything through and am now in control of myself and healthy."

Brodsky asked Voroshilov to grant him a meeting. He claimed to have desired such a meeting throughout the AKhR scandal, but had been afraid of Voroshilov's wrath; only after a government commission's inquiry and his acquittal did he feel "rehabilitated and all the rumors and dirt are taken from me and I can look you straight in the eyes." He pleaded that Voroshilov set up an appointment, "at home or even on a holiday": "I feel an urge to talk to you, to get your advice, to open my soul, and to return home with my soul assuaged." He closed by emphasizing that he had stopped working on a large Lenin painting because of the AKhR scandal and desperately needed the meeting with Voroshilov: "I know that you will cheer me up and inspire me for work." Voroshilov left a typically terse bureaucratic note on the letter: "Summon for Friday morning."

Katsman, by contrast, had already had his meeting with Voroshilov, where Voroshilov had seemingly criticized either socialist realism in general or the realists' failure to produce a Stalin portrait of high quality in particular. Whatever the case, Katsman proposed to make up for his sins by painting such a portrait: "The main thing is to understand one's mistakes and to be able to correct them! . . . If we paint Joseph Vissarionovich, we will make up for half of our mistakes."

Both letters exhibit a fascinating dimension that has not been treated so far: Brodsky and Katsman tie their personal growth as artists (and implicitly, as new men, as communists) to their patron, Voroshilov.[171] If art progressed in linear fashion toward new and greater heights, the artists also understood themselves as being involved in a process of movement. "Meetings with you always give me so much, it is as if I grow more and more (*svidaniia s Vami vsegda mne mnogo daiut, ia kak by eshche i eshche vyrostaiu*)," wrote Katsman. This dimension is generally present in various forms of patronage, including *shefstvo*: the patron serves a spiritual father, who aids in the growth of his pupil.

But there is yet another facet. Both Brodsky and Katsman link their inspiration to their patron-*vozhd'*. It is Voroshilov who inspires them to great art. When Voroshilov is unhappy with his artist clients, they fall ill and lose their capacity for artistic work. Whether the passages in the letters in this regard are read as mere window-dressing for underlying pragmatic interests, or whether these utterances are seen as coextensive with a sphere of "belief" or "thinking," plays no role for our purposes here. I am interested in the discursive continuities of these statements and, from another angle, in their contexts at the time that they were made. In my reading, they exhibit continuities with the ancient notion of inspiration (derived from the Latin, literally being "breathed upon")

through a Muse, and with the Christian notion of inspiration through the Holy Spirit. They mark a rupture with Romanticism which moved the godlike source of inspiration inside the creative person, designating this secular source "genius." They also differ from many Marxist theories of inspiration, according to which art derives from tensions between base and superstructure or from class consciousness. "Your huge temperament of leader would inspire the collective, it would let it believe in its capacities and would give a feeling of its importance for the Revolution," wrote the poet Ilya Selvinsky to Kaganovich in 1935, suggesting that the latter patronize a poem, jointly composed by a group of young poets, about a single Moscow house that was to serve as a metaphor for all of Soviet history and society.[172] It is striking that this rhetoric of inspiration (*voodushevlenie*) is unthinkable of letters from social milieus other than the artistic intelligentsia. A worker on a site of socialist construction could hardly have written a similar letter, simply because he was so entangled in plans and other new methods of the socialist economy. There was no room for individually inspired work. In the case of the artistic intelligentsia, however, Greco-Roman and Christian notions carried over into the Soviet period. Paradoxically, this was despite the self-professed production of art according to plan and with new socialist methods. It is this fascinating hybrid of planning and ancient artistic rhetoric that we will meet time and again.

Let us examine an entirely different case. In 1934, Voroshilov received a letter from Raisa Azarkh, a writer who he had known since 1918.[173] Azarkh, it seems, had been Voroshilov's lover—whether before or during his marriage to Yekaterina Voroshilova is unclear. In Azarkh's letter, she linked her writing about the Civil War to Voroshilov and Stalin, and her personal romantic love for Voroshilov to Stalin's love for Voroshilov. "Dear Kliment Yefremovich," she began. "By the way," she continued, "today is the sixteenth anniversary of our acquaintance, if we want to talk about anniversaries. No, my letter will be strictly businesslike and not at all lyrical." She wrote this simply to keep mingling hints at their former romantic relationship with business matters, in order to keep conflating history with personal romance: "When studying materials about the anti-Soviet Czechoslovak uprising—incidentally, I have wonderfully recuperated, am completely healthy now, have pulled myself together, have lost weight and instead of my 37 years I am now considered 27, and have finished the first part of the novel *Fifth Army*—so when studying these materials, I found out the following thing, which was entirely new and staggering to me." She then related as fresh "historical facts" a story of how Trotsky, the traitor, had actually cooperated with the Czechoslovak Legion and how Stalin had saved the Red Army in the Civil War. "It's time to tell the workers and peasants about this. Who knows <u>that Stalin's genius anticipated the Czech uprising and if this had been foreseen no rivers of blood would have flowed in the East!</u> I

talk about this in my book, but you, dear People's Commissar of Defense, must know about this more than anyone else. Awfully dear, dearer than ever before in my entire life." She asked that Voroshilov meet with her, "but then this misfortune happened"—the Kirov murder.

> I wanted to fuse Comrade Stalin's vigilant paternal gaze with my own, which came from the greatest depths of my heart, and went to you, as you stood shocked at the coffin. Dear Klim! One could read Stalin's way of looking at you: don't get killed, my young one, my closest and only one, I still need you so much! (*Ne ubivaisia, moi mladshii, chto u menia samyi blizkii i edinstvennyi, a eshche tak mnogo nuzhno!*) Following Stalin, I am telling you: you are the most wonderful, the most radiant, the most sparkling of everything that life has ever given! And my only one. I have now understood this forever. Take care, my dear beloved. . . . Goodbye, Raia.

On the back of her letter she continued: "See, I am no crybaby but crying nonetheless. . . . My letter ends strangely. From the lines . . . of an epic writer to the passionate outcry to a loved one. Call . . . 1-16-35, tell me your direct telephone. What do you think about the Czechs? And about everything in general. I shake your hand. Raisa Azarkh." But the letter was still not finished: "I cannot finish this way, you have not seen me in four years, and I do not know when you will see me again. I was very sick after all and lived at the seaside and in the mountains for a long time. I want to send you my photograph. . . . Perhaps it is ridiculous that I am sending it to you. But I have your photographs on the wall . . . and I would be happy if you at least took a glance at mine. All right. Please call and comfort me. That way it will be easy and more joyful to work. Raia." Voroshilov left a terse comment in blue pencil across the page of his former lover's letter: "Idiot!"[174]

There are many possible readings of Azarkh's letter to Voroshilov. One could emphasize Azarkh's shrewd manipulation of official discourse—the Civil War novel in need of historical details, the fusing of her loving gaze with Stalin's paternal gaze—in order to pursue what seems to be her main aim: to get back her old lover. Indeed, Voroshilov's disparaging comment suggests such a reading. The comment, however, might also be read as his manipulation of his own archival record in line with the "immodest modesty" paradigm. In making sense of Azarkh's intriguing letter I would like to pursue two other lines. First, the very conflation of a request of information for a historical novel from a participant, a romantic love letter, and a request for patronage, implies how closely related these genres were in epistolary rhetoric. This conflation hints at the difficulty of disentangling these distinct elements from one another; it also shows how difficult it was to measure, bureaucratize, and standardize patronage. Moreover, it shows how patronage was legitimized by the personality cult: if the writing of history had not depended on the leader, if history had not rested on the shoul-

ders of Kirov, Voroshilov, and Stalin, a request for protection would have been out of place.

Second, the difficulty of disentangling genres is matched by the difficulty of keeping separate a Soviet woman's love for a concrete man, Voroshilov, and for Voroshilov in capital letters, as it were—a model Soviet man, the personification of the Red Army, and the closest comrade-in-arms of Stalin, the embodiment of the Hegelian-Marxist spirit. The model personality of Voroshilov and the physical person of Voroshilov, whom she must have known intimately from their days as lovers, kept getting commingled and confused in the writer Raisa Azarkh's rich imagination. She was not alone with this problem. It was shared, among others, by the female Russian-language folklore performers from Karelia, a region northwest of Leningrad on the Finnish border. They enthusiastically glorified Stalin as their "father" and thereby cemented the image of Stalin as "father of peoples," presiding over a Soviet mythic family of nations connected by the "friendship of peoples." Yet a competing strand of Stalin as man/sexual object always made for incestuous undertones in their folklore, endangering the myth of the harmonious family of Soviet peoples.[175]

MASLOVKA: EASING PATRONAGE BY CONCENTRATING ARTISTS

If the dissolution of the artists' and writers' groups in 1932 and the foundation of monolithic unions simplified the logistics of the state in dealing with the artistic intelligentsia, then the creation of concentrated spaces, where artists would combine work and life, served a similar function. Patrons could inspect more work and visit more artists within their scarce time. Some of the sites of concentrated sociability that were created for visual artists in the 1930s included dacha villages in Ambramtsevo and Peski outside Moscow, the Central House of Art Workers, and rest homes on the outskirts of Moscow, specifically earmarked for visual artists.

Most importantly, however, a model housing complex was built on Upper Maslovka Street, in a district that was then still considered quite far from the center of Moscow. In the complex, sites of labor (studios) and living (apartments) were combined under a single roof. The complex was built at the behest of AKhR and finished in 1930, before the unification of artist groups. Once built, it might well have been a showcase for the feasibility of monolithic unification *avant la lettre* (Fig. 4.4).[176]

The newspaper *Sovetskoe Iskusstvo* and memoirs by a lifelong inhabitant, the artist and restorer Tatiana Khvostenko, a sixth-generation artist whose ancestry went back to icon painters from the Kursk oblast village Borisovka, serve as useful vehicles for studying the House on Maslovka (as the complex

Figure 4.4. Upper Maslovka: an architectural rendering of the project. © Family Estate Tatiana Khvostenko, Moscow.

was often called). Khvostenko was the daughter of painter Vasily Khvostenko, whose mother had been godmother to Nikita Khrushchev. She moved into the Maslovka complex at age six in 1934.[177] According to her, the initiative for a cooperative artists' house went back to a general meeting of Moscow artists (of both the avant-gardist and the realist directions) in 1925. The case was taken up by the *AKhR-ovtsy* Katsman and Radimov, who shared a Kremlin studio with Stefania Unshlikht. Unshlikht advanced the cause through her Civil War–experienced Chekist husband Iosif Unshlikht and with the help of resolutions by People's Commissar for Education Andrei Bubnov and Nikolai Bukharin at the Moscow City Soviet. After the initiative had failed in a first reading, the personal intervention of Lunacharsky and Voroshilov led to its subsequent approval, and one million rubles were designated for the complex. In 1930 the first building, House No. 15, opened, and more followed.[178] The *Sovetskoe Iskusstvo* article summed up: "The house was finished during the winter of 1930. It has 90 studios and 24 separate apartments. The house also features a cafeteria, a kindergarten, a laundry, and a tailor shop."[179] The cafeteria was run by artists' wives. In addition the complex had a club in House No. 15 and "At the very top of the house there is a library and reading room. The library . . . holds 25,000 reproductions and 4,000 books on art. . . . The collections of the collector D. I. Shchukin and the lawyer and art lover M. F. Khodasevich served as the basis for the collection of album and book treasures."[180]

The House on Maslovka was home, at one point or another, to such radically different painters as Fedor Bogorodsky, Aleksandr Deineka, Sergei Gerasimov, Boris Ioganson, Evgeny Katsman, Yury Pimenov, Arkady Plastov, Pavel Radimov, Serafima Riangina, Grigory Shegal, David Shterenberg, Pavel Sokolov-Skalia, Vasily Svarog, and Vladimir Tatlin. Some of the most famous Stalin

portraitists also lived on Maslovka, including Vasily Yefanov (*An Unforgettable Meeting*, 1936–1937), Fedor Reshetnikov (*Stalin Reading Letters from Children*, 1951), and Fedor Shurpin (*Morning of Our Motherland*, 1949) who stopped painting entirely and lived off the royalties of his masterpiece, according to Khvostenko.[181] Isaak Brodsky's daughter Lidia Brodskaia lived on Maslovka, as did the art critic Igor Grabar and Jim Patterson, the child actor who portrayed the black baby of white American circus acrobat Mary Dixon (played by Liubov Orlova) in Grigory Aleksandrov's 1936 Soviet blockbuster movie *Circus*. Some artists' apartments turned into veritable salons. The Svarog family's apartment at one point regularly hosted children's writer Kornei Chukovsky, film director Mikhail Romm, Maxim Gorky, and the Party bosses Voroshilov, Molotov, and Valerian Kuibyshev.[182] Because of the concentration of artists in one place, sociability intensified manifold. Artists forged both friendships and enmities; denounced one another during the Great Terror; visited each other's families, formed string quartets; shared sexual entanglements with female models; associated according to stylistic preference, geographic background, generation, and doorway (*podiezd*); and exchanged enormous amounts of gossip and rumors. They smoked and drank together outside the "official" space of the cafeteria, club, or library in an old, single-story wooden house located across from House No. 1—a smoke-filled beerhall artists called "Radimovka" after its heavy-drinking most frequent visitor, Pavel Radimov, the oldest *AKhR-ovets*. This wooden beerhall was a fragment of precisely the kind of city the new Moscow had tried to leave behind forever; here every visitor had a reserved place and the sales staff knew every painter by name and even gave credit when paydays for pictures were far away, running the equivalent of an informal artists' bank. Radimov once organized a personal exhibition at "Radimovka" and allegedly rejoiced when several paintings were stolen, seeing this as proof of their true popularity.[183]

By contrast, the *Sovetskoe Iskusstvo* article portrayed the House on Maslovka as a successful transformation of a "former petty bourgeois, philistine Moscow street" into a modern, socialist, collectivist artist compound. It compared Maslovka to the living and working conditions of artists in the capitalist West:

> Artists in Paris live in dark and empty alleys, on the quietest streets and boulevards in the Montparnasse quarter and in Old Montmartre, and in attics, which are romantically called *mansardes*. When an artist turns famous, he moves to a different quarter or moves down to the lower floors of the house. But the path from the attic to the *bel-étage* or the *entresol* is long. A whole life is needed for this. And not everyone succeeds. Jules Romains would probably be prepared to even call artists with warm-hearted irony good-for-nothings (*obormoty*). Fantasizers, idlers, funnymen, buffoons—artists are running from reality and are saving themselves in an idyllic niche, which has been preserved even in Paris. Going to the outskirts is a dream of

every exhausted "bohemian." . . . The provinces in Paris—such is the dream of the French artist of the 1930s.

The situation of Moscow artists was portrayed as entirely different: "Our artists do not long for the cozy old mansions, for the romanticism of deserted quarters and dilapidated streets. Had Utrillo worked in Moscow, he would not have succeeded in drawing one of the most antediluvian outskirts of the town— Upper Maslovka."

The Maslovka complex had been such a success that plans for new artists' housing were already being formulated—and were described by *Sovetskoe Iskusstvo* in the brightest colors:

> The studios on Maslovka are now overcrowded. A project for an entire town of artists has been developed. Alongside the paths of Petrovsky Park spacious, seven-storied houses are spread out. A solemn, almost triumphant arch will lead into the interior courtyard. All 400 studios of the town will be located on the sunny side. In the cellars special carpenter's shops are being set up for the creation of frames. . . . The roof itself will be turned into a magnificent terrace, into a studio under the sky, where one can paint on clear and sunny days. A majestic exhibition building is being raised in the center between the other buildings. The shows of the Maslovka studios will take place here. The works of artists from the national republics of the Soviet Union as well as of our foreign friends will find a home here. The tiny, old private residences on Upper Maslovka Street are gradually being torn down. There is nothing left to remind one of the old, wooden outskirts of Moscow. Green plantings surround the artists' town. Petrovsky Path will turn into a gigantic boulevard. Not only the architectural project of the young masters Krinsky and Rukhliadev from Academician Shchusev's office speaks to this, but also the work that is in full swing on the construction site. Artists are going to work in the 400 studios. Memorials, sculptural reliefs, statues, sketches of frescoes and murals of public buildings will go to the squares of Soviet towns from here. Great Soviet art will be created here.[184]

Characteristically, the article constantly switched between present and future tenses, as if, as in socialist realism, the future was so close and tangible that it could be described with the (realist) means of the present (Fig. 4.5).[185]

The patrons had much easier access to the artists once they all began living and working in the same place. Voroshilov could now pay visits to numerous clients, whereas before he had to make trips all around Moscow. Art soviet (khudsovet) commissions, responsible for the judging of art for sale and reproduction, began inspecting paintings on-site at the Maslovka studios.[186] Conversely, distance from Moscow now became an increasing problem. The Leningrad artists acutely felt this distance, and any aspiring artist from the provinces had to move to Moscow to enter the loop of patronage and clientage.[187] To be sure, the very greatest "court" painters resided not on Maslovka but in their own luxurious living quarters: Gerasimov in his villa and Nalbandian, who

Figure 4.5. Photograph of Upper Maslovka. The artists' complex is in the back. © Family Estate Tatiana Khvostenko, Moscow.

is often called the postwar "court" painter, in his apartment on Gorky Street (Fig. 4.6). This is how one observer described the visits of Gerasimov et al. to Maslovka: "Often our luminaries Vasily Yakovlev and Aleksandr Gerasimov entered the courtyard of the first house stylishly in their cars and with their glamorous wives with jewels, in long velvet dresses, and expensive fur coats."[188] Yet after Stalin's death in the public perception all of these painters, court or run-of-the-mill, were lumped together and Maslovka became a symbol of the Stalin cult and socialist realism *tout court*. "Down with Maslovka" was the title a group of artists gave an evening at Moscow's Central House of Art Workers in January 1955, at which satirical verses were read and mockery was heaped on Stalin's painters.[189]

At the birth of the public Stalin cult on 21 December 1929 Demian Bedny thought it necessary to embellish his eulogistic Stalin poem "I am certain" with the stanzas, "Never mind that Stalin/Gets mad and thunders" and to add in prose, "I know: to write intimately about Stalin means to sacrifice oneself. Stalin will awfully scold you." In the beginning, right after Lenin's death, everything had been different. When the Stalin cult was nonexistent, when there were al-most no Stalin portraits and when Stalin was still scheming for leadership in the Party, he happily agreed to have a young boy named after him. On 29 July 1924 the seventeen-year-old Komsomol member Mikhail Blokhin from a village near

Figure 4.6. Caption: Aleksandr Gerasimov villa in Sokol. From Fototeka Gosudarstvennyi Nauchno-issledovatel'skii Muzei im. A. V. Shchuseva, Moscow, negative no. XI 4729. N.d., no photographer (thanks to Monica Rüthers for supplying me with this picture).

the Niandoma station on the Northern Railway wrote to Stalin: "After [Lenin]'s death I wanted to change my last name Blokhin to Lenin, but I thought it over and decided that I don't deserve such an honor. And so I decided to change my name to yours, that is Stalin, and when they ask me, 'why did you change your last name to Stalin,' I will answer 'in honor of Ilyich's favorite pupil, Comrade Stalin.' Now I'm writing to you, Comrade Stalin, because I wonder if you have anything against this."[190] A month later Stalin replied: "I have nothing against you taking on the last name Stalin, on the contrary, I will be very happy since this circumstance will give me a chance to get a smaller brother (I never had nor do I have any brothers)."[191] Clearly at this early point in 1924 Stalin readily gave in to the smallest occurrence of cult-building around him. Later when the cult was everywhere, his posture toward this changed dramatically and his opposition to any cult-building efforts whatsoever became a permanent feature. In practice he personally masterminded, limited, and filtered a number of those efforts that were allowed to continue. Yet the volume of cult products exceeded the capacity of a single person to control. Therefore a great variety of other personal and institutional actors exerted the control—and many additional— functions in the production of the Stalin cult, which ended up looking like a multifocal matrix that worked autonomously. Autonomously is correct indeed, with one caveat: the autonomous everyday functioning of the cult was always directed toward the pinnacle of power, Stalin, who could interfere in customary

decision-making processes and unhinge established mechanisms of cult production as he pleased. His fiat was decisive.

There were many similarities in the way the Mussolini, Hitler, and Stalin cults functioned. The great difference lay in the modesty question: the Mussolini and Hitler cults did not need to solve the paradox of their existence, they were cults "without discontents," while the Stalin cult—bound to the procrustean bed of Marxist collectivism—always remained a cult *malgré soi*. One of the strategies of overcoming this paradox was to enter the unabashed cults of Mussolini and Hitler into the public script of the Stalin cult and by contrast, to present Stalin's cult as superior, because unwanted by him.

Patronage also characterized Stalin cult production. There was a mutually reinforcing nexus between the personality cult and patronage that ultimately rested on the entanglement of politician and artist in the demiurgic realization of the world-historical-cum-aesthetic project called socialism. In the early 1930s, patron-client relations coalesced into a semiformalized system, in which each artistic field had its own—more or less tacitly—acknowledged patron; even if this patron had no formal relation whatsoever to the art he mentored, and even if cultural producers never ceased trying to enlarge their base by enlisting other patrons across artistic fields.[192] In this system Stalin was, of course, the overtowering patron. All other patrons were "subpatrons" who brokered the scarce resource of access to Stalin. If Stalin intervened in any artistic field, he did so most often in questions of literature and, increasingly, cinema. For both of these areas no Party luminary besides Stalin would have fit the description of patron. Music (excepting opera, which came under the rubric of theater) also seems to have been without an unofficially acknowledged patron. The visual arts were patronized by Voroshilov, architecture by Kaganovich, and the theater and opera at first by Yenukidze and later by Molotov.[193] The question, however, of just how a Party boss became a patron is a difficult one. Factors such as personal taste, historical contingency, and the compatibility of the professional portfolio with the patronized artistic medium all seem to have played a role. Such is the tentative picture of semiformalized art patronage that emerged in Stalinist Russia.

5 How to Paint the Leader?
Institutions of Cult Production

SO FAR PERSONAL actors from the world of politics have held center stage. And rightly so, considering the prominence of personalized social relations in the Soviet polity, with its dictator Stalin towering above all. Now the moment has come to examine the institutional actors (defined broadly as ranging from artist organizations to the art press) and institutional practices (from Stalin portrait competitions to art criticism of the leader portrait in socialist realism) that were involved in the making of the Stalin cult.

During 1933–1935, when the Stalin cult in painting started in earnest, all painters of note were organized in branches of the Union of Soviet Artists. The Moscow Section of the Union of Soviet Artists (MOSSKh, Moskovskoe Otdelenie Soiuza Sovetskikh Khudozhnikov, renamed in 1938 Moscow Union of Soviet Artists, MSSKh [Moskovskii Soiuz Sovetskikh Khudozhnikov]) and its Leningrad mirror organization LOSSKh were the most important. MOSSKh was founded on 25 June 1932 and marked a high point in a process of institutional—as well as material, stylistic, and ideological—centralization.[1] Yet it was only a stepping stone toward a countrywide, translocal artists' union, a development that reached a further stage with the 1939 formation of an organizing committee (orgkomitet), headed by Aleksandr Gerasimov, and culiminated in 1957 with the organization of the USSR Union of Artists (SKh SSSR, Soiuz khudozhnikov SSSR). This final stage was reached much later than in other spheres of the arts—the Soviet Writers' Union, for example, was formed in August 1934. Under Stalin centralization, unification, and planning were the order of the day in all spheres of social life, from the economy to the arts. But centralization, unification, and planning did not usher in conflictless harmony among the twenty-four thousand persons who defined themselves as artists in the 1939 census.[2] The fault lines that traversed monolithic artist unions, the

debates about socialist realism and the leader portrait, and the institutional mechanisms of Stalin cult production can only be understood against the background of the history of the art world between the October Revolution and Stalin's rise to power.[3]

Painting portraits of political leaders was by and large the domain of artists with realist stylistic preferences. This is not to say that avant-garde artists never produced a leader portrait (Plate 11); in fact, some of the very first portraits of Lenin (painted during his lifetime from 1918 onwards) were by avant-garde artists.[4] Artists allied with the realists were by far more numerous after 1917, even if the modernists of various ilk have received more attention and are perceived as emblematic of the experimentalism of the first decade following the Revolution. This is because Russian modernist art was institutionally and personally intertwined with Western modernist movements and because Russian modernism generated artists who have become familiar names—Kandinsky, Malevich, Rodchenko, and Tatlin—in the Western avant-garde canon. Another reason is that both modernists and realists cast their conflicts over art and over limited resources during the 1920s as an epic battle between two diametrically opposed poles, even if in truth there were more commonalities and more movement between the groups than they cared to admit. A final explanation is that modernism ultimately lost out to realism—and there is such a thing as the charm of the loser.

Before turning to the institutional practices it is essential to cut through the maze of the institutional actors. What follows, then, is a list of the artist associations, Party-state organizations, educational institutions, publishers and visual art factories, newspapers and journals, censorship bodies, and the secret police that together constituted the institutional matrix of socialist realist Stalin portraiture.

Artist associations. The Russian realists built on the tradition of the Wanderers. The Wanderers had coalesced in the 1870s around itinerant exhibitions, they painted in realist styles on subjects going beyond the "academism" (institutionally based in the Academy of Arts of St. Petersburg) and ranging from popular peasant scenes to lifelike depictions of Christ. Their source of patronage was partly the court, partly—and increasingly during the twilight of the old regime—the new merchant class represented by such entrepreneurs as Pavel Tretyakov. After the Bolsheviks came to power this group of patrons vanished through expropriation, emigration, and physical annihilation. A new group of private collectors emerged—drawn partly from the Nepmen of the 1920s, partly from the Stalinist elite of Party bosses, Red Army generals, and factory directors, who might privately order portraits of their wives or children—but its share of art commissions or purchases remained insignificant and it operated in the dark because of the prohibition on private trade.[5] The Wanderers

as an organization continued to exist until 1923, when they joined the 1922-founded Association of Artists of Revolutionary Russia (AKhRR), which was renamed Association of Artists of the Revolution (AKhR) in 1928. The painter Evgeny Katsman, who in a 1925 diary entry called the Wanderers "sentimental Populists" who "did not understand the 'brave ideals' of the revolution and the beautiful harshness of Bolshevism," was among the founding members of AKhR on 1 May 1922 together with Pavel Radimov and Aleksandr Grigoriev.[6] Between 1923 and 1938 Radimov, we recall, shared a studio with Katsman in the Kremlin and in 1926 Grigoriev had accompanied Katsman and Brodsky on their visit to Repin in Finland.[7] AKhR went back not only to the Wanderers, but also to the common experience of the Civil War, when an institutional vacuum forced many painters—lacking not only canvases and commissions but also the barest means of survival—to fight for their existence. The most important new source of patronage during these harrowing years was the Red Army, which commissioned battle scenes and officer portraits, thus feeding a growing group of painters of almost entirely realist orientation. The best known was Mitrofan Grekov, in whose honor in 1934 a famous studio for amateur soldier-painters was named. During the Civil War the bond between realist painters and their later "Pericles," Voroshilov, was forged. The new Bolshevik festivals became another source of commissions during the chaos of the Civil War.[8]

AKhR's immediate function was to organize exhibitions of its members' artwork, and its overarching aim was to advance their interests. This meant easing access to the new primary source of patronage, the Party-state, and fending off others, among them modernist artists, who were also seeking much-coveted material means for art—such as money, brushes, paints, and easels; exhibition space, studios, and living-space; and trips to Venice and Paris. Opposed to AKhR stood the modernist artists organized in visual arts studios and around exhibitions of the Proletarian Culture movement, Proletkult (founded on 20 January 1918 and subsumed in the Party in November 1922); around the journals LEF (*Levyi Front* or Left Front, 1923–1925) and New LEF (*Novyi LEF*, 1927–1928); and around the association of nonfigurative easel painters, OSt (Obshchestvo Stankistov, Society of Easel Painters, 1925–1931). Again, in truth there was more conflict within and interchange between the two factions than they were willing to admit. Artists oscillated in their allegiance to "left" and "right" artist organizations, and changed their styles. Deineka was increasingly painting in realist fashion by 1934 and even the founder of suprematism, Malevich, reverted to impressionist and realist styles between 1927 and his death in 1935.[9] There were also kinship ties that linked the two factions: for instance, Katsman's and Malevich's wives were sisters, and the women forced their quarreling husbands to socialize in their private lives.[10]

Party-state organizations. The new Red patrons related to these modernists and realists in varying ways. An initial predilection for the modernists (from 1917 until roughly 1922) by the main organization of the cultural bureaucracy, the arts section of the Commissariat of Enlightenment, Narkompros (Narodnyi komissariat prosveshcheniia), and an initial penchant towards the realists among other sources of Bolshevik patronage, especially the Red Army during the Civil War (1918–1921), gave way to a general favoring of realism by the mid-1920s. There was a certain renaissance of modernism during the early stages of the First Five-Year Plan (1928–1932), which ended in an all-out victory of realism in 1932.[11] Let us simply note here that both factions received some support throughout the entire 1920s. Contrary to the claims of both, the game was relatively open until 1932.

Nominally the visual arts were kept within the purview of the state, not the Party. Not to say that the Party in its various incarnations—from the Party organization in AKhR up to the Central Committee, and later, as we have witnessed, increasingly Stalin himself—ever ceased calling the shots. Narkompros (founded on 9 November 1917 and headed by Anatoly Lunacharsky until 4 July 1929), and especially its Izo (Visual Arts) Department (Otdel izobrazitel'nykh izkusstv, set up between January and May 1918), were the primary institutional patrons of the visual arts.[12] At different times throughout the 1920s, Narkompros purchased recent paintings for state museums and institutions, organized exhibitions, and provided studio space for artists. But it did not put the relationship with artists on a regularized footing until the 1928 foundation of the Main Administration of Belletristic Literature and the Arts, GlavIskusstvo, a new, better-staffed, and more powerful organization.[13] In 1929, GlavIskusstvo was responsible for the widespread introduction of a system known as *kontraktatsiia,* which put the financing of artists' work on a contractual basis and provided regular, centralized support that greatly helped to draw artists further and further into the first socialist state. From now on, the state financed not only the purchase of finished artwork, but its very production. Two organizations subordinate to GlavIskusstvo administered the new contract system. First, the All-Russian Cooperative Comradeship "Artist," VseKoKhudozhnik (founded in September 1929), commissioned paintings, assembled exhibitions of the resulting artwork, and distributed trips to vacation resorts.[14] It also organized trips to the kolkhozes and factories mushrooming all over the country, in order to acquaint painters with the "new life" developing all around them. Regional branches of VseKoKhudozhnik were set up and by mid-1931 more than fifteen hundred artists had joined the "Comradeship" and paid the small membership dues. Second, the state art publishing house IZOGIZ took over publishing operations from AKhR and began to administer art publishing centrally. Through IZOGIZ artists could make money from reproductions of their artwork.

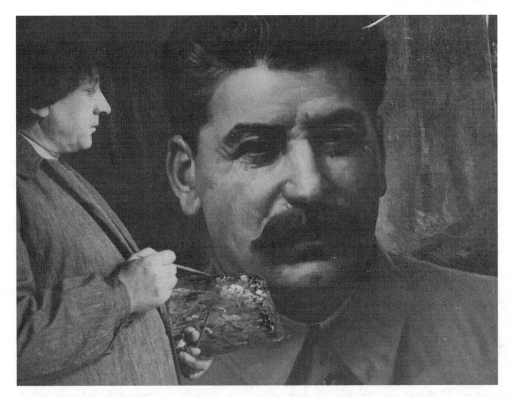

Figure 5.1. Isaak Brodsky and one of his Stalin portraits, 1934. Photograph by Iakov Khalip. © Muzei-kvartira I. I. Brodskogo, St. Petersburg.

This restructuring of the world of the visual arts during the Great Break fundamentally changed the mechanisms of art production, including the creation of leader portraits. From 1929 onward, most Stalin portraits were produced under the *kontraktatsiia* system, including the many copies of the celebrated Stalin canvases of Gerasimov, Brodsky, and their peers that started appearing in the mid-1930s. In January 1936, *kontraktatsiia* was transferred from Narkompros in the newly created All-Union Committee for Arts Affairs (Komitet po delam iskusstv), which remained under the larger umbrella of Sovnarkom and was first chaired by Platon Kerzhentsev. From the late 1930s, inside this new agency the Art Fund (Khudozhestvennyi Fond, abbreviated Khudfond) took over the *kontraktatsiia* functions of VseKoKhudozhnik. The Stalin Prize right from its establishment in 1939 acted as another powerful institutional force. The last major institutional player appeared toward the end of Stalin's reign when in August 1947 the USSR Academy of Arts was created. Aleksandr Gerasimov became its first president. The Academy of Arts effectively represented the Party's arm in the art world, for its full members were appointed directly by the Party rather than elected by the membership (as was the case in

MOSSKh) or appointed within the bureaucratic organization (as was the case in VseKoKhudozhnik).

Educational institutions. The institutions of art education went through changes similar to those undergone by the other institutional actors. The hotbed of modernist art education, the Higher Art and Technical Studios, VKhuTeMas (Vysshie Khudozhestvenno-Tekhnicheskie Masterskie, founded in 1920, first directed by none other than Kandinsky and renamed High Art and Technical Institute, VKhuTeIn [Vysshii Khudozhestvenno-Tekhnicheskii Institut] in 1927) shunned traditional teaching in painting technique, but the Leningrad Institute of Proletarian Visual Art was more hesitant to break with tradition. This traditionalist orientation and the full-scale victory of realism during the Great Break was reflected in its October 1932 reorganization into the All-Russian Leningrad Academy of Arts, which now included an art university (Art VUZ), an art history institute, a museum, a library, and laboratories. Isaak Brodsky became its rector in 1934 (Fig. 5.1). Let us remember: a decade earlier the very word "academy" had triggered a series of negative associations. "Academy" stood for precisely the tradition that influential members of the Soviet art world were trying to overcome. Leningrad's VUZ, called Repin Institute since 1944, was subsumed under the USSR Academy of Arts right after that body was founded in 1947. A year later the Moscow Art Institute was renamed Surikov Institute (it had opened in 1936 as the Moscow Institute of Visual Art and had been called the Moscow State Art Institute from 1940 onward). With the triumph of academism and the symbolic invocation of prerevolutionary realist artist luminaries, in 1949 the main institutions of undergraduate art education changed their names back to their pre-1917 designations: Stroganov Art College (Moscow) and Shtiglits Art College (Leningrad). Thus by the 1940s there was was in place a smoothly running, hierarchical system of art education. It ensured that future Stalin painters would receive a sound training in the painting techniques required to produce portraits of their leader.

Publishers and visual art factories. The publishing house IZOGIZ has already been mentioned as a significant contractor. In fact, there were other publishing houses—most important, Iskusstvo—and other influential actors responsible for the technical and mechanical reproduction of artwork. Publishing houses commissioned artwork for posters, lithographs, prints, postcards, and much more. They wrote to the secretaries of Party leaders to ask, in the absence of sittings, for photographs and screenings of documentary film material on Stalin (*kinokhronika*);[15] and they paid honoraria and royalties. Artists might publish a portrait with one publishing house and later transfer the rights to another.[16] There were also such institutions as the "visual art factory" (*izokombinat*), responsible for the mass reproduction not only of oil paintings (especially canonical Stalin portraits) and prints and posters, but also busts and statues.

Newspapers and journals. Especially in the 1930s, when cult production was more open-ended and less regularized, the press was a tremendously influential institutional actor. *Pravda* (and to a lesser extent *Izvestia*) provided guidance, as the "Don't you read the papers?" incident shows.[17] *Pravda* was required reading for painters who wanted to remain in tune with the vagaries of Kremlin politics, if only to find out if the subject of the portrait they were painting had been exposed as an "enemy of the people." Some leading *Pravda* pronouncements on the arts were republished in the culture newspaper *Sovetskoe Iskusstvo*, which from 1931 onward appeared twice a week for most of its existence.[18] In the early stages of Stalin painting *Sovetskoe Iskusstvo* also served as a nodal point where different channels of the Stalin cult—announcements of open Stalin portrait competitions, criticism of exemplary Stalin portraits, art-theoretical articles on the portrait in general and the leader portrait in particular—came together. Later these functions were assumed by the art bureaucracy and other institutional actors. The monthly "thick journals" *Iskusstvo* and *Tvorchestvo*, both established in 1933 and both edited (at first) by the famous critic Osip Beskin, were also important reading for the Stalin portraitists.[19] *Iskusstvo* was more intellectual and featured long articles on subjects ranging from Rembrandt's treatment of shading to Nikolai Andreev's drawings of Lenin, while *Tvorchestvo* was more heavily illustrated, featured shorter articles, and generally reached out to a wider audience, including amateur painters.[20]

Censorship. These newspapers, journals, publishing houses, and visual art factories—in fact all media of reproduction—were heavily controlled by the censorship board Glavlit (founded in 1922) or by Glavlit censors at the publishing outlets themselves. As a rule, when particularly sensitive cult products were under scrutiny—for instance, a coffee table book–like album of Stalin paintings compiled for his sixtieth birthday—regular censorship channels were bypassed and the Glavlit chief had to give the green light personally. This rule can be generalized for all Stalin cult products: the more sensitive the product, the less institutional the actor consulted for judging the product, with Stalin's secretariat at the top of the pyramid, and the less bureaucratized, the more informal and verbal, the mechanism of judging.

The secret police. Last but not least, the secret police force quietly exerted its chilling influence. During the 1920s its role was not as ominous as it was to become. Together with other Soviet institutions like the Red Army it was in fact a commissioner of paintings, including one of its founder "Iron" Felix Dzerzhinsky. Later it made its influence felt via informers inside the art world, who were widely known and feared among artists;[21] via officers at organizations within the art bureaucracy who looked into personnel questions; and as an executive arm of the Party-state once an artist had been found guilty of an offense, for example creating a "counterrevolutionary" representation of Stalin.[22]

These artists' organizations, art bureaucracy agencies, art education institutions, outlets of technical reproduction, Party organizations, and repressive Party-state organs were the most important institutional actors involved in the making of the Stalin cult. Together they formed a maddeningly complex field of institutional and personal operators. They interacted multidirectionally, though never on an equal footing as there surely was a hierarchical power gradient involved. This field was so complex that most painters had difficulty navigating within it, and cartographic knowledge became a highly valued skill. Such knowledge was held mostly among the elite group of the Aleksandr Gerasimovs of the art world, and it was of course transmitted orally, if at all. Many of the regular painters made mistakes while operating within this field, for some of which they had to pay dearly.

This relational field deserves a closer look as it changed over time. We first turn to early institutional practices such as the portrait competitions and related exhibitions, then once the canon was established (by 1939 at the latest) to regularized Stalin cult production in painting, and finally to art criticism and the leader portrait.

STALIN PORTRAIT COMPETITIONS AND EXHIBITIONS OF STALIN CULT ART

Competitions on a specific theme, usually leading to large-scale exhibitions, became a regular practice in the making of socialist realist art during the 1930s. In the first half of the decade, the organization of these competitions and exhibitions was quite open-ended and chaotic, and individual artists had greater possibilities for personal input than in later years. *Sovetskoe Iskusstvo* was a point where the different organizing forces converged in a public arena. A competition for the first major exhibition since the proclamation of the doctrine of socialist realism in 1932, an exhibition entitled "Artists of the RSFSR over the Past Fifteen Years," was announced in an article on 8 May 1933. This retrospective exhibition of realist art in the Soviet Union was to be monumental and involved three museums. The Tretyakov Gallery was to show caricature, the Historical Museum on Red Square was to show painting, and the Pushkin Fine Arts Museum was to exhibit posters and etchings. The newspaper was clear on the organizing principle of the exhibition: each section was to feature "an introductory subsection" in which "the main lines of development of a given art over fifteen years ought to be illustrated with representative examples." Above all, the exhibition was to show linear, "natural (*zakonomernyi*) movement of each art form toward socialist realism" and "the growth of each separate artist." The "'Lenin' and 'Stalin' rooms, in which the best artifacts depict with artistic means the image of the leaders," were to be the telos of this movement

and the pinnacle of the exhibition. In closing, the article even pondered opening the exhibition later than planned, since the selection of artwork commissions was yet to be finished—an example of the open-endedness that was characteristic of the early 1930s and so atypical of subsequent years.[23] Three weeks later another article published the statistics for the selection of artwork: "Until 23 May in the painting section 1,178 works have been examined, of which about 800 pictures by 175 painters have been preliminarily accepted."[24] Clearly, in 1933 the newspaper fulfilled functions that just a few years later were taken on by artists' union meetings, cultural functionaries from the Committee for Arts Affairs, publishing houses, and other institutional actors.

Another competition was organized by the publishing house Iskusstvo in 1937, on the occasion of the twentieth anniversary of the October Revolution. By then the situation was quite different from that of 1932. This competition was closed: the jury only commissioned contributions from a select number of invited artists. In the 1937 competition, Iskusstvo sent out letters to fifteen artists, in which it explained the conditions of the competition: each artist was to receive photographs of Stalin (ordered by Iskusstvo from the newspaper *Izvestia*); and a screening of movies with Stalin themes as well as the more documentary *kinokhronika* was to be organized. This time the financial rewards were remarkable; the first prize was fifteen thousand rubles. Additional fees certainly followed, earned from reproductions: the two prizewinning portraits had print runs of over one million and the two winners received 5 percent of the earnings).[25]

Twelve artists then signed contracts with Iskusstvo. Three (Igor Grabar, Boris Ioganson, and Georgy Riazhsky) declined, citing their involvement in other projects (the language of their rejections was full of anxiety that this might be interpreted as an affront to Stalin). The contracts were signed in early April and the deadline was set for 1 July. On May 1, June 1, and July 1 each artist received a thousand-ruble advance. At first the artists themselves seem not to have known the names of the other participants, for Isaak Brodsky asked the organizers: "If possible, let me know who signed the contracts, who are my competitors?"[26] The portraits had to be painted in oil, watercolor, or pastel, and were to be at least one meter in height.[27] Despite the short time allowed for production of the paintings, most of the twelve artists managed to submit them on or around July 1. Star painter Aleksandr Gerasimov was five days late, but compensated for his lateness with a surprise submission of two portraits.

The portraits were then exhibited in a specially prepared, closed room of the Tretyakov Gallery for the members of the jury, which included well-known artists like the Kukryniksy, as well as Aleksandr Poskryobyshev (the head of Stalin's secretariat), Platon Kerzhentsev (chairman of the Committee for Arts Affairs), and Glavlit chief Sergei Ingulov.[28] The participating artists were the

cream of the official Soviet art world and included Isaak Brodsky, Aleksandr Gerasimov, and Evgeny Katsman. The jury decided not to bestow a first prize but rather to divide the fifteen thousand rubles into a second prize of ten thousand rubles, awarded to Aleksandr Gerasimov, and a third prize of 5,000 rubles, awarded to P. V. Malkov. The jury commented on Gerasimov's portrait: "The simple working atmosphere of an office, a table with books, journals, and letters. Comrade Stalin in an armchair at the table. The portrait is painted in an expressive, lively fashion. The artist succeeded in avoiding the dryness and boredom of an official portrait."[29] By contrast, Brodsky's standing and style were already rapidly eroding, and his "large, official portrait" was charged with being painted "in Brodsky's usual manner—painstaking and cold mimesis (*protokol'nost'*) in general and in the details" (Plate 12). Another painter, Mashkov, was criticized even more harshly: "The artist, who deservedly has the reputation of a great painter, presented for the competition the helpless work of an autodidact, a dead and tasteless *lubok,* without any signs of painterly craftsmanship or quality." Nonetheless, Iskusstvo concluded, "competitions for portraits and thematic pictures are one of the most effective methods of increasing the quality of our art publishing."[30]

Also in 1937, there was a parallel competition for Stalin portraits by Iskusstvo's rival IZOGIZ, located on Moscow's Tsvetnoy Bulvar, a mere fifteen-minute walk from Iskusstvo's Kuznetsky Most location. Indeed, it is quite possible that the two portrait drives were in "socialist competition" (*sotssorevnovanie*) with one another, as these were the prime years of socialist competition and Stakhanovism. With a first prize of twenty thousand rubles, a second of ten thousand, and a third of five thousand, this competition was even more lucrative. Like its Iskusstvo twin, this competition was closed, but no list of invited artists has yet surfaced. Some of the painters must have been identical, for Brodsky pressured IZOGIZ to return his contribution in timely fashion so that he would be able to submit it to the second, slightly later, competition—after it had failed to receive a prize at the first one. Four people served on both competition juries. The artists in the IZOGIZ competition also received a list of the themes they should focus on. The list began with "the portrait or bust," continued with "on the tribune of the mausoleum" and "among children, aviators, heroes of the Soviet Union," and finished with "J. V. Stalin and Yezhov." Portraits were supposed to be fifty by sixty centimeters in size and "had to satisfy the demands of mass reproduction"—rougher brushwork, we know, was more suitable than fine brush strokes.[31] And of course "the publishing house supplies all photographic materials on the planned themes for every participant in the competition and also organizes a showing of relevant movies."[32]

The late 1930s were the years of monumental art exhibitions. Apart from those that we have already examined, other large-scale exhibitions in the sec-

ond half of the 1930s included a thematic Komsomol one and Lavrenty Beria's exhibition, "Art of the Georgian SSR," which opened in November 1937. The same year, the Soviet pavilion at the Paris World's Fair (followed in 1939 by the pavilion at the New York World's Fair) opened with numerous commissions from socialist realist artists. An exhibition in honor of the twentieth anniversary of the Red Army commenced in 1938. The exhibition "Industry of Socialism," originally organized by Sergo Ordzhonikidze's Commissariat for Heavy Industry, was also supposed to open in 1937, but its beginning was delayed until spring 1939 because of infighting among various artist factions and by the Great Terror, which affected Ordzhonikidze's organization particularly deeply.[33] Also two years behind schedule, the permanent All-Union Agricultural Exhibition opened in 1939.

Indeed, various bureaucratic organizations initiated and financed these exhibitions in order to solidify their share of power through symbolic means. At the head of each organization stood a *vozhd'*—Ordzhonikidze in the case of "Industry of Socialism," Beria in the case of the Georgian exhibition, and Voroshilov in the case of the Red Army exhibition—who personified his institution and was celebrated in the exhibition concerned with a display of cult products. At the same time, the *vozhd'* was involved in everyday organization through very real patronage, as the preceding chapter has shown.

After 1937, competitions with subsequent exhibitions served much less often as vehicles for producing new Stalin cult art.[34] Stalin's sixtieth birthday in 1939 prompted several exhibitions that simply displayed extant art devoted to the Stalin theme. Only the less spectacular 1939 sculpture exhibition "V. I. Lenin and J. V. Stalin in Sculpture" began with a competition. Despite the overwhelming role of the state in the organization of all these exhibitions, they were represented as spontaneous products of popular initiative. Thus "the initiative to organize the all-Union exhibition, 'Lenin and Stalin in the Visual Folk Arts,' belongs to the people," according to an article in *Iskusstvo*.[35]

The stellar exhibition in 1939, "J. V. Stalin and the People of the Soviet Land in the Fine Arts," opened on Stalin's birthday, 21 December. It offers a good perspective on both the large exhibitions of the 1930s and the Stalin cult itself. The exhibition began not with a competition—a call for creative production—but in a retrospective key. The visual section of the Committee for Arts Affairs sent out a barrage of letters to individual artists, to local artist unions in places as far away as Leningrad, Turkmenistan, and Kiev, to museums and publishing houses, and to the directors of the "Industry of Socialism" exhibition and the Pushkin Fine Arts Museum, asking about any artistic representations of Stalin that the artist or institution might have on hand.[36] The original letter by the Committee for Arts Affairs went out in April 1939, eight months before the exhibition,[37] but the actual organization of the exhibition began only in Septem-

ber and turned into a race against time.[38] It is unclear why the exhibition was organized so late. Did the Terror play a role, since many depicted heroes were relegated to the dustbin of history as "enemies of the people?" Or was an unambiguous signal by Stalin necessary in order to go ahead with the exhibition?

At any rate, after the initial inquiry by the Committee for Arts Affairs various individuals and institutions submitted lists of finished and unfinished Stalin art. The sculptor Marina Ryndziunskaia, whom we encountered in Chapter 4 as the designer of a 1926 Stalin sculpture, wrote from Moscow of "a 1933 sculpture in wood," and the chairman of the Urals Artists' Union sent "a list of Sverdlovsk artists who are working on the subject of Comrade Stalin's life and activity: 1. Zaitsev Ya. P. (sculptor) *Comrade Stalin with Pioneers.* 1 meter 30 centimeters tall, plaster . . . 2. Melentiev G. A. (painter) *Comrade Stalin at the Meeting of the Constitutional Commission.* Oil, size 4 x 2 meters. Property of the Sverdlovsk Museum of the Revolution."[39] During the late spring and summer the Committee for Arts Affairs then sent cultural functionaries to the studios of individual Moscow artists and to the Soviet periphery to check what kind of Stalin art was in progress. But the overall organization of the exhibition remained chaotic. As late as September, it was not yet decided whether the exhibition would take place at the Tretyakov Gallery, the Pushkin Fine Arts Museum, or in several rooms of the "Industry of Socialism" exhibition. At the same time, Moscow's Museum of the Revolution and the Lenin Museum were planning their own more historically oriented Stalin exhibitions, and were vying for some of the same pieces of artwork. The socialist competition between the different museums was described as something positive.[40]

As far as substance is concerned, the exhibition roster was also far from settled in the early fall. At an organizational meeting, one participant demanded that "all the artwork at this exhibition ought to be directly connected with Stalin."[41] Another wanted to add to artwork "about the life and activity of Comrade Stalin," artwork showing "themes of somewhat allegorical character, such as the Stalin Constitution, where the image of Comrade Stalin will not be shown directly, but where the entire picture will give an idea of the era of the Stalin Constitution."[42] Moreover, there were different opinions as to whether the exhibition should show as many objects involving Stalin from as many parts of the Soviet Union in as many techniques as possible (from traditional easel painting to ceramics and walrus ivory carvings), or whether quality ought to overrule quantity. The latter principle seems to have won, as many art functionaries emphasized how "responsible" this exhibition was—with Stalin's power at its height and the Terror fresh in everyone's mind.

In the end, the Tretyakov Gallery was chosen as the single location for the exhibition. To pool resources, another initially separate exhibition on "Famous People of the Country," devoted to images of Stakhanovites and other "he-

roes" of the 1930s, was fused with the Stalin exhibition. The artwork was to be assembled from existing Stalin iconography "plus a small number of works (about 30) that the Committee for Arts Affairs commissioned from leading masters." "Apart from these commissioned works," the functionary of the Committee for Arts Affairs continued, "we have collected information in the Union republics—Central Asia, Georgia, Armenia, Ukraine."[43]

Indeed, the involvement of places far from Moscow in this exhibition was significant.[44] The exhibition was instrumental in promoting Stalin's image as "father of the peoples." The mechanics of involving the periphery were as follows: in the spring central art functionaries visited artists in the Caucasus republics, in Leningrad, in Siberia, in Central Asia, and in Ukraine. Everywhere the central functionaries communicated with local artists through the regional artists' unions, all of which were subordinate to the Moscow Union MOSSKh anyway. On return to Moscow from these trips, the functionaries reported, for example:

> I recently was in Armenia and had a chance to look at the materials there. I must say that we have never seen Armenian visual arts, despite the fact that a large exhibition devoted to the Stalin Constitution took place in the Armenian Republic two years ago. . . . After looking at the paintings, which are partly finished, partly still in an unfinished state, after looking at the artwork of the sculptors, and after looking at what they (the jewelers, carpet-makers, and embroideresses) have in the sphere of folk arts, I came up with about 45 pieces of artwork.[45]

In October Moscow again wrote to local artists' unions, inquiring, for instance, if paintings by a number of Kiev artists (inspected during the spring) were nearing completion; Moscow "asked to send photographs of these works as soon as possible."[46] Or an individual Leningrad artist received the following advance notice: "The State Tretyakov Gallery informs you that after 9 November the commission for the selection of artwork for the Stalin exhibition will be in Leningrad. This commission will visit your studio and inspect your paintings."[47] This was in line with the organizers' goal of "convincing the [artists] that this [exhibition] is a very important political enterprise"; it was also consonant with the intention to "implement stricter control."[48] "On the one hand it is indispensable to prod the artists," echoed Aleksandr Gerasimov, "on the other hand we need to offer them help when they encounter difficulties. What, for example, if we have commissioned a portrait but the painter has no model?"[49]

Artists responded to the committee's October inquiries with letters and photographs, showing the state of completion of their work. After the news of the exhibition had spread widely among artistic circles, some artists who were not invited proposed to submit Stalin busts and paintings at their own initiative.[50] In late November and early December a jury, composed of famous artists and

cultural bureaucrats, met in Moscow and judged the art that had been gathered. Certain works were accepted unconditionally, others were designated for alterations, and yet others were rejected outright.[51] As was to be expected, given the short notice, many works were submitted late.[52]

Patronage in the highest reaches of power resolved conflicts over the exhibition or availability of specific paintings. If a famous work was on display at a different exhibition, powerful forces made it available to the Stalin birthday exhibition. Thus the director of the Tretyakov Gallery wrote to Voroshilov in early November, asking that the commissar of defense allow the transfer of Aleksandr Gerasimov's *Stalin and Voroshilov in the Kremlin* to the Stalin birthday exhibition directly after its return from the New York World's Fair.[53]

One of the complaints of participating artists was the difficulty of getting the "notable people" (*znatnye liudi*)—the Stakhanovites, Arctic explorers, biologists, and kolkhoz milkmaids—to pose. "I was ordered to do a portrait of Ostuzhev," ventured one artist. "He came to my studio, I tried to win him over. . . . He looked at everything and left—I do not know why, but perhaps my art did not convince him. . . . Then I was supposed to do Shchukin, but he unfortunately died."[54] Another artist was just as pessimistic: "I had a commission for a portrait of Lysenko." After several attempts to paint the quack biologist, Lysenko disappeared—"no answer, and when I visited him twice he was not there."[55] A certain Isaev of the Committee for Arts Affairs agreed that getting *znatnye liudi* to pose often was problematic: famous scientists or Bolsheviks "believe that if they sit, they will be accused of laziness, of wasting time on modeling, therefore they escape sitting or do so at their desks." Sitting for one's portrait was considered frivolous, as we saw in Chapter 3. It was hard to reconcile with Bolshevik notions of modesty and relentless, around-the-clock work for the Party cause. The Stakhanovites and decorated kolkhoz farmers were "easier to get to sit, but they want to keep the painting as a memento. That is why the Committee . . . must give a public explanation."[56] Often the artists were unhappy with the micromanagement by the Committee for Arts Affairs. Katsman complained:

> I was supposed to do a portrait of Gudov. I know Gudov, he is a very interesting person. I wrote a note to Bykov [the responsible functionary at the Committee for Arts Affairs, with whom the artists corresponded] that it would be a pleasure to do a portrait of Gudov, but an even greater pleasure to do a portrait of my favorite Dzhambul [Dzhabaev, the celebrated Kazakh folklore performer]. After this I received a reply that this is impossible since Dzhambul is being portrayed in sculpture. I think this is not right, and if I get Dzhambul, I am prepared to fly to him by airplane or by whatever means, because as an artist I want to portray him. And this is important, because we are talking about art here.[57]

Meanwhile artists accused artists—and art functionaries accused artists—of not trying hard enough to get their intended models to sit. "As far as Fadeev

[the writer] is concerned," sniped one artist, "I suspect that Yakovlev did not look for him seriously. He is such a man of culture, understands so much, that he is always helpful."[58]

Right before the opening of the exhibition, powerful cultural functionaries and Party members probably walked the rooms to see if anything needed to be changed at the last minute. This is conjecture based on our knowledge that the chairman of the Committee for Arts Affairs, Platon Kerzhentsev, made last-minute changes in the way pictures were hung at the 1937 "Art of the Georgian SSR" exhibition. He removed several pictures from the exhibition, and had details changed in others.[59] As the director of the Tretyakov Gallery reported to Kerzhentsev, "On the basis of the remarks that you made when inspecting the exhibition of art of the Georgian SSR, we have removed the painting of M. I. Toidze, *Stalin with Lenin in Gorki*. . . . The artist U. M. Dzhaparidze has been ordered to correct the position of the hand of Comrade Stalin in his picture *Comrade Stalin and V. Ketskhoveli,* and I. A. Vepkhvadze has been told to change the chin in his *Portrait of S. M. Kirov.* From the pictures that we had rejected we have returned Bagrationi's painting *Abundant Harvest.*"[60]

At the Stalin exhibition several artists asked the organizing commission why their pictures had been rejected. Exhibiting artists were interested in the success of their paintings in the show: "Is the exhibition well attended? Do you have a visitor comment book and do they criticize me a lot there? Were there any remarks from the government commission? These questions interest every painter, not just me, so please do not think that I am an exceptionally ambitious painter."[61]

Once the Stalin exhibition was scheduled, the Tretyakov Gallery was actively involved in propagandizing it. In general, many efforts were made to reach as many people as possible, from all stretches of the vast Soviet state. Not only were people brought in organized groups from the periphery to the exhibitions in the center, but also the main provincial towns organized their own exhibitions or hosted mobile exhibitions that had traveled from the center.[62] The Tretyakov's public relations even included sending its own press release to *Pravda*: "THE SUCCESS OF THE EXHIBITION *STALIN AND THE PEOPLE OF THE SOVIET LAND IN THE FINE ARTS.* The exhibition devoted to the life and activity of Stalin, and to the people of the Soviet land, was opened at the State Tretyakov Gallery in connection with Stalin's sixtieth birthday and is very successful. The exhibition has already been visited by more than 150,000 people."[63] One sure way to boost an exhibition's visitor statistics, according to the artists, was to get Stalin himself to visit it.[64] But Stalin did not make an appearance at his birthday exhibition.

In May 1940 the Tretyakov Gallery began to prepare a public discussion of the exhibition with some of the most famous representatives of the Soviet artistic intelligentsia. It invited such artists as Gerasimov, Grabar, and Mukhina; the writers Pogodin, Tolstoy, and Fadeev; the composers Khachaturian and Khren-

nikov; the movie directors Kapler, Romm, and Ermler; as well as actors and Heroes of the Soviet Union, among them, the Arctic explorer Papanin. The evening was to take place on 28 May and the Committee for Arts Affairs insisted that each invited participant receive a list of questions that should preferably be touched upon:

> 1. Collection of materials. Selection of the most typical, studying the atmosphere, surroundings, and facts characteristic of the life and activity of Lenin and Stalin. 2. Which ideas, facts, and details impress through their artistic concreteness and how did you use them? 3. Questions about the physical likeness and its expression in artistic images. 4. The creation of an artistic image: the poetic, heroic, and lyrical in the image. 5. Which image do you consider the most successful? In literature, theater, painting, sculpture, and cinema. . . . 6. Recount your personal creative work on the image. 7. How do you think the unity of the *vozhd'* or hero with the people can be expressed more deeply and truthfully in works of art?[65]

There was a postscript to the 1939 Stalin exhibition. Ten years later Stalin celebrated his seventieth birthday. By that time, exhibitions were mounted not only in Moscow and the Soviet provinces but also in the Eastern European satellite states, each of which had acquired its own Stalin cult. The iconography was imported from Moscow, to be sure, but the Hungarians, Poles, East Germans, Romanians, and others all executed the Soviet templates in the vernacular, so that distinctly "Polish," "German," or "Romanian" Stalins emerged. Here they were similar to the Central Asian Soviet republics, which earlier had created their Stalins with slight, yet noticeable Kazakh, Tadzhik, Uzbek, or Kirgiz features. In 1949 Moscow too put on another large Stalin exhibition, "Joseph Vissarionovich Stalin in the Visual Arts." The preparations for this exhibition were less haphazard than those for its 1939 predecessor. The organizers were able to draw on the 1939 experience and on the even larger body of existing Stalin pictures created in the preceding decade.

The cult, then, was in a state of flux during the early 1930s, when its mechanisms were still being consolidated and its canon was still evolving. Hence the greater importance of portrait competitions in the first half of the decade; these allowed for more creativity than in later years. But they were also typical of production-raising practices of the Second Five-Year Plan, such as socialist competition and Stakhanovism. This also explains the role of the press as an organizing tool for the earliest competitions. In the absence of strong institutions and a developed interplay between them, the press functioned as the central public vehicle through which Stalin portrait competitions were organized. The competitions had another function: in the early 1930s different publishing houses were still competing against each other and each was trying to win its own original depictions of Stalin. Later, for example in the exhibitions con-

nected with Stalin's sixtieth and seventieth birthdays in 1939 and 1949, there was a much greater sense of images and procedures being settled and unified. What is more, there were enormous financial stimuli for artists who participated in portrait competitions. Both prize money and royalties from reproductions allowed artists to increase their income and in fact enabled a standard of living that was comparable with that enjoyed by the highest Party *nomenklatura*. Unlike the Party members, the painters had the license to flaunt their wealth. This was because of residual preevolutionary cultural expectations for artists to act Bohemian. Dmitry Nalbandian had the celebrated Georgian restaurant, Aragvi, deliver meals to his Gorky Street apartment. Aleksandr Gerasimov built a Spanish Colonial–style mansion according to his own design and owned several cars (including a Buick), complete with chauffeurs. To be sure, and true to Bolshevik values of modesty, Gerasimov occasionally affected the "simple country bumpkin" and dressed up in sheepskins when the Party bosses arrived.

EVERYDAY STALIN PORTRAIT PRODUCTION

While the Stalin portrait was the most lucrative kind of painting an artist could create, not all artists produced Stalin portraits. And of those who did, not all were paid as well as Gerasimov and Nalbandian. As members of the artists' union, the mass of artists received salaries comparable to those of an engineer with average qualifications. Average writers are believed to have lived better than average artists.[66] On top of their regular salaries, artists earned money through the *kontraktatsiia* system. The majority of Stalin painters got their commissions from the Art Fund (from VseKoKhudozhnik until the mid-1930s). Most commissions were issued on the basis of a sketch (*eskiz*—famous artists were exempt from having to submit one) in the context of the many thematic semiannual exhibitions organized by artists' unions, all of which were modeled on the monumental exhibitions of the 1930s (the 1933 exhibition "Artists of the RSFSR over the Past Fifteen Years" serving as the ur-model).[67] It was also possible to offer to the Art Fund a finished Stalin portrait, but this was less common.

And, as we have seen, some of these exhibitions originated in either open or closed competitions. The thematic organization of the exhibition—in such rooms as "Stalin as Military Commander," "Stalin as Marxist Theoretician," and "Stalin Among Kolkhoz Farmers"—structured Stalin portrait production in advance. This thematic taxonomy, closely tied to the *obrazy*, the stock images of Stalin (which we examine below), had solidified by the late 1930s. Once a contract for a commission had been concluded between a painter and the institution organizing the exhibition, the painter received a portion of the honorarium as an advance payment, and once the painting was more than half finished, another advance was paid. Letters asking for the postponement of

deadlines for paintings were often met with positive replies, unless the deadline was truly pressing (such as that of an important exhibition). After submitting the completed painting, the artist received the remainder of the honorarium.[68] The amount of the honorarium varied greatly. As the Georgian artist V. V. Dugladze recounted, "I worked exclusively on the image of 'the young Stalin' and got paid a lot. For example, for the picture *The Young Stalin in the Gori Citadel* I received forty-five thousand rubles. This was at a time when a bottle of vodka cost twenty rubles!"[69]

The economics of Stalin portrait production pivoted around planning. There were supply-demand aspects to planning, but these were structured very specifically. On one hand there was of course "true" demand for Stalin portraits, as when a Red Director of a factory desired (or deemed it appropriate) to hang one behind his desk, as was customary for Soviet officials. On the other hand, a theoretical physics institute in Ukraine, a reindeer kolkhoz in northeastern Siberia, and a rubber boot factory in Leningrad all had a small allowance in their budgets for "cultural-everyday expenses" (*kulturno-bytovye raskhody,* abbreviated *kultbytraskhody*).[70] Toward the end of the financial year, they were especially interested in spending this part of the budget because unspent money would be omitted from the next plan. They spent some of the money on new furniture or Red corners, and some on Stalin portraits purchased from the Art Fund. Demand also affected the Art Fund. It too worked according to plan and had to overfulfill its sales quota of Stalin portraits during a given year. To sell its production it made use of informal "plenipotentiaries" (*upolnomochennye*) around the Soviet Union. These "plenipotentiaries" collected commissions from institutions for specific artwork. Since the artists were dependent on sales of their artwork, they clandestinely paid the "plenipotentiaries" 10 to 25 percent of the honorarium they received from the commissioning institution via the Art Fund. In artists' lore, tales about men like Ostap Bender abounded. They worked "according to the saying, 'they kick him out the door but he comes back through the window.'"[71] In general, since no one ever counted true demand, there was a constant surplus of artwork, Stalin portraits included. These "nonliquidated assets" (*nelikvidy*) tended to pile up in the storage rooms of the Art Fund.[72]

Once a Stalin portrait was finished, it entered a whole new phase, often of technical reproduction. Original, oil-painted Stalin portraits were reproduced— independently or in books and other print media—as lithographs, posters, photographs, and postcards. A number of organizations were responsible for disbursing the resulting royalty payments to artists—among them, for primary reproduction, the publisher itself, and for further reproduction, the Bureau for the Protection of Authors' Rights (*Biuro po okhrane avtorskikh prav*).[73] And of course, organizations were often late in paying honoraria.[74]

During the process of reproduction, the Stalin portraits were retouched. The publishing houses specializing in art reproduction had an "art workshop" (*khudozhestvennaia masterskaia*) responsible for retouching. "We are enclosing thirty-two portraits of J. V. Stalin by the artist A. Gerasimov for corrections," wrote the senior editor for technical reproduction to the art workshop at Iskusstvo publishers in 1938.[75] The amount and detail of documentation on retouching (and the entire reproduction process, for that matter) is astounding. At every step the names of everyone involved were painstakingly recorded.[76] This reflects a heightened concern to fix on paper clear responsibilities—and tremendous anxiety, lest something go awry.[77] Apparently artists had to consent to the retouched versions of their Stalin depictions. In a letter to the "editorial team of the photo album 'Comrade Stalin in Photography'" one "artist I. Rerberg" wrote of a series of retouched photographs that "such excessive retouching completely destroys the vitality of the photographs and everything most important in photographs, namely the rendering of the body, mannerisms, etc." He concluded with typical candor, "One gets the impression that the entire face is made of a single material—rubber or wax."[78]

The actual printing process of Stalin portraits was also highly sensitive and pressroom jobs must have been among the most stressful. As in retouching, here too the responsibility for each step in the typographical process was meticulously recorded. Often the proofs of a printed product were harshly criticized. "The proofs of the J. V. Stalin portrait," wrote the Iskusstvo department of reproductions to VseKoKhudozhnik's printing shop, "cannot be accepted; they require serious corrections: 1. soften the large-grained dots in the painted area. 2. Accentuate more strongly the lines of the nose and cheeks. 3. Redo hair and eyes."[79] Money was also an issue. A press that had printed a Lenin portrait with "red dots on the face" and a Kirov portrait with "a glaring spot in the background" was ordered to "redo the entire order at the press's expense."[80]

At different stages in the production process the censorship board Glavlit interfered routinely. It seems that the Glavlit representative at a publishing house had to approve the plate (*klishe*) for typographic reproduction, the proof, and the finished product. Sometimes the director of the publishing house wrote to the chief of Glavlit personally in order to override the on-site Glavlit representative's decision.[81] Besides this prepublication censorship, there were various forms of postpublication censorship. First, a Stalin portrait could be withheld from circulation (for example, it went to press but was destroyed rather than delivered to stores). Second, portraits already in circulation might be recalled. Third, restrictions might be placed on access to products already in circulation (a portrait went into "special storage" [*spetskhran*] at libraries).[82]

At some point during the 1930s, the production of Stalin sculptures must have been put on a more industrial footing.[83] Visual art factories were set up.

The early phases of these factories were poorly documented; the only sources available today are newspaper articles, which may bear little relation to real-life practices. On 11 May 1935 *Sovetskoe Iskusstvo*, under the headline "Construction of a Visual Art Factory" featured the following report:

On a 12-hectare lot . . . in the village of Vsekhsviatskoe extensive construction of a visual art factory has started. The factory is going to consist of separate buildings that are intended for various production shops (the making of brushes, colors, art puppets, the preparation of sculptural stone, a bronze foundry, and so on). A special building will be reserved for individual studios of 60 artists and sculptors. A special pavilion for plein-air work is being built on the territory of the factory as well. The walls and cupola of the pavilion are of glass. A special factory building will be allotted for the manufacturing of monumental sculptures for the Palace of Soviets.[84]

At least one visual art factory must have reached completion, for on 17 October 1937 *Sovetskoe Iskusstvo* carried an advertisement: "VseKoKhudozhnik. Sculpture production factory. Moscow, 96, Baltic Village, house 42-a, telephone D 3–27–26 is accepting orders for architectural-stucco works and for sculpture: political, athletic, military, domestic, and children's. We have in stock figures, busts and bas-reliefs for the adornment of new buildings, clubs, reading rooms, sports arenas, and so forth. We will send you photographs and price lists upon demand."[85] Moreover, some production statements have survived: in 1940, another sculpture factory in Moscow oblast produced 449 Stalin statues, 136 Stalin busts, 168 Lenin busts, 54 Kirov busts, 50 Beria busts, 36 Marx busts, 32 Engels busts, and 15 Kuibyshev statues.[86]

Later on paintings were added and we know for sure that by 1949 a new technical reproduction establishment, the Painting-Sculpture Factory of the Moscow Association of Artists, existed.[87] This visual art factory (re)produced art as follows. Its art soviet ordered a sketch, which was then turned in by the artist. The soviet could either reject this sketch outright or mark it for reworking, sometimes with concrete suggestions on how to change it. The soviet could issue several of these decrees one after the other, or accept the sketch. An order could then be placed, either with or without an advance payment. After the artist turned in the finished order, the work could again be either directly rejected, recommended for reworking, or accepted. Once accepted, the work of art often had to undergo an appraisal to determine the price it ought to receive. Some artists were paid forty thousand rubles (such as the first prize winner of a 1949 Stalin portrait competition), others only three hundred rubles. For the most expensive paintings, the advance payment could exceed the price paid for the finished painting.[88]

On one occasion (19 April 1948) art soviet members received payment at the rate of forty-five rubles for each meeting; the art soviet chairman received seventy-five rubles.[89] A jury could also go on inspection tours and see, on site,

what works of art needed to be changed. In July 1949, for example, the two members of the jury traveled to Savelev train station and "in the presence of the station master and the artist Antipov" inspected Antipov's seven easel paintings (oil on canvas): "1. Full-length portrait of J. V. Stalin inside his office, 2. A copy of artist A. M. Gerasimov's painting *J. V. Stalin and A. M. Gorky,* 3. A copy of artist F. A. Modorov's painting *J. V. Stalin and M. I. Kalinin,* 4. Guarding the Sea Borders. View of the sea with a naval ship, 5. Portrait of J. V. Stalin, 6. Portrait of V. I. Lenin, 7. Portrait of V. M. Molotov." The jury members found "that all paintings mentioned have been considerably improved in comparison with the last inspection along the lines of the suggestions earlier given to the artist and can, however, be accepted overall only after artist Antipov . . . makes the following corrections on site: 1. In the painting *J. V. Stalin in His Office* (full-length portrait) the perspectival arrangement of the desk needs to be corrected and the light falling on the figure's chest needs to be strengthened, in equal proportion to the light's strength on the face and legs." In "the portrait of J. V. Stalin the shoulders ought to be very slightly widened," but "the remaining paintings did not require changes."[90]

The more routine examination of pictures took place at the art factory itself. A typical 1949 meeting of the "Great Art Soviet for Painting" (Bolshoi khudozhestvennyi sovet po zhivopisi) was attended by the chairman, the well-known artist Pavel Sokolov-Skalia; a (female) secretary; four standing members of the art soviet (all artists); two "art historians–consultants"; a member of the artists' union; and the director of the art factory. Five art soviet members were missing—"ill," "outside Moscow," "for unknown reasons."[91] The summary of this meeting's decisions is shown on the following page.

As can be seen from the second item in the summary, some artists owed paintings from earlier commissions—apparently having received an advance payment on the basis of their sketches but never having delivered the final product—and paid the art factory back by means of a new, unpaid-for work.

THE ART SOVIET DISCUSSES A LEADER PORTRAIT

Summaries of decisions were one thing, detailed stenographic records of art soviet meetings were another. The latter were products of intense contestation, much like the stenographic records of Politburo or other Party meetings. The stenogram was circulated to the jury members (not the artists) present at the art soviet meeting according to a—changing and disputed—hierarchy, so that the member next in line would get the stenogram with the comments of the preceding member worked in, making it impossible to discern what differences from the original had emerged. The art soviet jury members last in the line were least able to shape the written record of the meeting. One can only imagine the

Summary of Meeting of the Art Soviet of the Painting-Sculpture Factory of the Moscow Association of Artists, 8 February 1949

# Author	Name of Work of Art	Art Soviet Decision
1. AKSYONOV K.N. sketch per order #190 of 13 January 1948. Advance payment. 1.0. Subject: Comrade Stalin in the Metro.	Sketch. Comrade Stalin in the Metro (second attempt)	Sketch accepted, take seriously the remarks of the art soviet when working on the painting
2. MOLCHANOV, K.M. sketch per contract #27 of 27 February 1947 Advance payment. 17.5. Subject: Lenin and Stalin in Gorki.	Sketch. Lenin and Stalin in Gorki (2 versions) and 2 sketches.	Sketch accepted (version on Terrace)
Finished work. In satisfaction of debt	The Schoolgirl	Rework the picture, taking into account the art soviet comments
[. . .]		
6. KELERMAN V.G. Sketch per order #107 Of 1 August 1948. Advance payment. 6,300. Subject: Stalin in Turukhansk exile.	Sketch. Suren Sandarian's arrival at Comrade Stalin's place of exile (2 versions)	Reject

Source: RGALI, f. 2470, op. 2, d. 18, ll. 7-8

amount of informal lobbying of artists and jury members to achieve the kind of depiction of the meeting that suited them.[92]

A full-scale meeting of the Painting-sculpture Factory's "Great Art Soviet for Painting" is an excellent window on this key institutional practice in Stalin cult art production.[93] In some ways the atmosphere of the art soviet resembled that of a workshop; one artist, for example, demonstrated a sketch, *At the Sculptor's Studio,* and asked the soviet to provide him with a sculptor for specific advice on the reality of a sculptor's art practice.[94] Generally the artist whose work was being discussed was expected to be present.[95] Often the other artists at the soviet had already seen the work under review in the studio and presumably made comments there. Thus Fyodor Shurpin remarked about one painting: "I have seen this painting many times and must say that, to my surprise, it looks much better than in the studio. It is rare that you take a painting to a different location and it seems better."[96]

A typical art soviet discussion was of a work by the painter N. N. Yerushev, *V. I. Lenin's Funeral on Red Square,* submitted after another commissioned painting, *The Stalin Harvest* had been declined. The visual art factory had forgiven half of Yerushev's debt for the failed first painting and Yerushev was attempting to pay off the other half by presenting the painting of Lenin's funeral.[97] The obligatory chairperson and several artists gathered for the first discussion of this painting on 27 April 1949. They opened a first round of devastating criticisms by condemning the depiction of GUM in the background. They next turned to the portrayal of persons in the painting. In answer to one artist's complaint that the "figure of Dzerzhinsky is awfully tall, and it has a small head," Yerushev defended himself: "But Dzerzhinsky was very tall. I got photographs from the Lenin Museum, and our laureates—Sokolov-Skalia, Bubnov, Moravov, Nalbandian—met with me three days ago. . . . Of course this is a difficult painting. I have been sitting over it for nine years." Thus Yerushev tried to fend off criticism by invoking the photographic templates representing the "real" Lenin and by alluding to his connections in the upper echelons of the Soviet art world. But the critics were not convinced. They went on:

POKARZHEVSKY: Don't you have eyes? Then there is Stalin's face. You should have shown the face and the body in the center, but you have the balustrade and snow-covered fir tree branches at front center. That is your center. And no people to be seen. . . . Lenin can hardly be made out. After all, this is a picture, you should remember that Lenin is surrounded by people, friends, you should have made them stand out. Tone down the snow, you should have made a gray day and more light on the faces.—The picture is unsuccessful. Its main flaw is that there are no people and no faces. . . .

PLASTOV: Comrade Yerushev, what happened on that woeful day? The leader died, next to him stands another leader, Stalin, stand comrades, comrades-in-arms, soldiers, stands the entire Russian people. . . . And how are you solving this question?

You are solving it, it seems to me, without an understanding of the moment and the faces that you are depicting. How are you composing? In the foreground, you devote one-third of the composition to the most motionless [element] in the composition—the balustrade, the branches, the smoke, etc. The main, key elements—Stalin, Kalinin, Dzerzhinsky, and other comrades-in-arms of Lenin—cannot be seen. . . . It is confusing. Then you begin searching—who is standing there? That is probably Stalin—yes, it is him. . . . And altogether you get neither the people, nor the atmosphere in which this is taking place, nor the people behind these leaders, nor the leaders in front of the people. . . . Furthermore, regarding the psychology of those present: Stalin's face should express the sorrow of a great man about a genius who has passed away, and how have you expressed this? You have not. All we see is a man with a lowered head, and so forth. On to Dzerzhinsky. It is impossible to see his face, how he looked. Even his felt boots are better drawn than his head. The people who are coming up, the simple people, how have you painted them? Very superficially, very dryly, without any details of what they felt, with what kinds of eyes they looked at the terrible grief that had struck the country. Whichever spot you look at, you find low-quality drawing, a lack of precision, or an inability to express the emotion that you undoubtedly felt in the most authentic and sincere way. I think it would help if you worked on this theme more thoroughly. . . . Do keep in mind that you have chosen an exceptional moment in the history of the country, in the history of mankind, and all of a sudden you approach this moment somewhat mechanically. I do not think this is right.

This is an impressive concrete example of a well-known painter, Arkady Plastov, explaining—"in comradely fashion," as another member of the art soviet put it—to a younger painter how to put into practice the principles of socialist realism. Yerushev's subject was a moment of truly mythic proportions in the history of the first socialist society: the transfer of power from the founding leader Lenin to his successor Stalin.[98] This transfer meant nothing less than the progression of a Hegel-like world spirit from one body to another. Encapsulated in the new leader, Stalin, this spirit would march on toward the Marxian goal of socialism, the kingdom of freedom. To depict this crucial moment, realism as the style of choice was never in doubt. Yet this realism should move beyond mimesis. The task of this kind of realism—socialist realism—was to express on canvas a time better characterized as kairos than chronos. A depiction of an event like Lenin's funeral had to show more than just Lenin's funeral. It had to show not just history as it was, but history as it ought to be and indeed would be. It had to give an inkling of a place mankind had not yet been to but was inexorably moving towards—utopia. Plastov's comments for his fellow painter come as close to an elaboration of the principles of socialist realism in the case of a concrete painting as one will find. This was socialist realism in situ.[99]

Yerushev was desperate. "Comrades," he said, "I have been painting this picture for a long time and am getting confused, because I am one student and

have a lot of teachers. During those nine years [the painting] spent one and a half months at the Lenin Museum, everyone looked at it, at the balustrade, at the columns. I wanted to remove them and the artists recommended that I do so, but [the Lenin Museum] said that it would be historically false, 'you have to show it the way it was.'" Yerushev had failed to grasp the synthetic nature of socialist realism. He had failed to understand that he could drop the balustrade and show Stalin with a larger-than-life face on which the forces of history were inscribed. He had failed to understand that he should paint the columns smaller than they had been and instead direct Stalin's gaze at a point outside the picture, so as to express the leader's foreknowledge of the future of socialism.[100] Yet the art soviet gave Yerushev a second chance: "You should draw sketches," said the chairperson. "We have decided that you should perfect this painting."[101]

Four months later, on 29 August 1949, Yerushev presented a new version of his painting of Lenin's funeral. The painting now moved to a stage where the art soviet was supposed to make a decision about accepting or rejecting it.

CHAIRPERSON: . . . I think we can ask whether to accept this piece. (The painter: "I was told to get rid of the smoke to the right, to make GUM lower, to lighten up J. V. Stalin's face, and to tone down the yellow of the snow on the platform.")

ANTONOV: If we are going to talk about what was said, which critical remarks were made—we spoke of the quality of the drawing, we said that the proportions of J. V. Stalin's head and all proportions of human figures are not right, that the entire crowd is not on the right plane, that everything is done poorly, unprofessionally. The painting has stayed on this level. I think that it is impossible to accept this thing the way it is . . .

CHAIRPERSON: In my opinion we cannot demand more from this painter, we know his capabilities.

KOTOV: We can discuss if Yerushev is a professional or if this is amateur art. . . . If he owes something, one could petition that his debt be written off. That would be correct, but it is wrong to accept a painting which should not be accepted. . . . I must say that the worst here are the figures in the center—the figure of J. V. Stalin and the coffin with the body of V. I. Lenin. . . . Concretely, the figure of J. V. Stalin is too short, the head too large, the figure too small in relation to those behind it. . . .

BUBNOV: I would not like to reject this painting entirely. I agree that there are a lot of awkward elements here, for example, the figure of J. V. Stalin. It needs to be [seriously] drawn and painted, especially since it is in the center of the painting. What do I like in this painting? It captures the mood of the time, it is somehow warm, it is painted with great feeling. . . . I think this painting needs more work and someone should help Yerushev with this.[102]

Even at this point in the appraisal process, it turned out, there existed a range of opinions and the art soviet could not make up its mind. It is unclear what

happened to Yerushev's painting. Its whereabouts are unknown and no repro-
ductions have surfaced, therefore it is likely that it was never accepted.

As can be seen from the discussion of Yerushev's painting, the criticism of
artistic representations of Stalin often concerned concrete physical details, as
other examples also show. In one painting his "left arm up to the elbow" was
described as "too long," his "hands too poorly illuminated"; "Stalin has small
hands. They need light and must be brought to life."[103] In another, "the ear
needs a close look, it is small, it is out of place" and "the lower part of the nose
is too dark and appears like a nostril, therefore the nose seems short."[104] A third
painting was criticized for featuring "too pointed a head, even though Stalin
has a round head"; "the entire head is too pointed, it should be slightly enlarged
by making the chin rounder."[105] Finally, one painting was inspected for the third
time and evoked such comments as, "it has become a lot better!" "Except for
Stalin's hand," remarked one artist, and the painting was accepted only with the
condition of "fixing the hand."[106]

The commissioning institution of a work of art could substantially influ-
ence the final outcome. In the highest reaches of power, Voroshilov changed
the places of the personages depicted in Gerasimov's *First Cavalry* during an
informal visit to the artist's studio.[107] Lower-level institutions exercised simi-
lar control. The Kalinin Museum ordered a painting by M. G. Sokolov, *M. I.
Kalinin Speaks with Delegates at the All-Union Congress of Female Workers
and Farm Women,* and directed exactly who was to stand where in the picture.
However, unlike in the upper reaches of power in the case of the Kalinin Mu-
seum this clashed with the standardized process of the verification of paintings
by the art soviet, which saw its own prerogative of upholding general standards
for paintings violated by the museum. The art soviet complained: "The painter
showed us this picture twice in the form of drawings and said in regard to our
instructions and objections that this was precisely how the museum wanted
the figures arranged."[108] In fact, at the heart of this conflict was not only the
clash between personalized patronage and modern, standardized, bureaucra-
tized forms of power. This conflict also revealed tensions over who, at the lower
end of the power hierarchy, had the authority over the Soviet canon (how to
represent Kalinin, in this case), as well as tensions between the seemingly single
"correct" artistic representation of a leader and the mundane exigencies of a
mass art industry that operated to a certain extent in response to market-like
supply and demand forces.[109] At the very top of the power pyramid, these ten-
sions were unthinkable since there was no mediating institution between the
commissioning person, Stalin, the decisive voice on what was a "correct" repre-
sentation, and the executing painter. At most, Voroshilov shuttled between star
painters to convey the demands of Stalin orally and personally.

As always, a critical issue in art soviet discussions was Stalin's relationship with other figures in pictorial representations. By 1949, for example, Stalin was to be depicted as listening to Lenin with great attention and respect, invariably in a conflict-free, harmonious situation, and never from the inferior position of a schoolchild. A. I. Makarov's *Stalin and Gorky with Lenin*, which featured a scene of Stalin and Gorky listening to Lenin in the latter's office, was criticized for its untypical depiction of Stalin in relation to Lenin: "the interaction of Lenin with Stalin is not convincing. The impression that they are arguing is particularly underlined by Stalin's facial expression, which needs to be improved psychologically." As another artist elaborated, Stalin was portrayed as too agitated, "but Stalin always listens very calmly and intelligently. According to witnesses, when he spoke with Lenin he was always very attentive, even somehow acted like a military officer with his superior, with great dignity. . . . He might have behaved like this at the Batumi demonstration, but not with Lenin."[110] Similarly, there were conventions as to the place of a Stalin portrait in a picture. Arkady Plastov criticized N. P. Kucherov's painting *In the Classroom* for violating the canon in this respect: "You have placed a Stalin portrait here, but it is usually located in a more respected place. Moreover, you hung it below the blackboard." Fyodor Shurpin, who was also present, interjected: "That's no problem!" Kucherov offered an explanation of his spatial arrangement: "I thought allegorically," only to be outwitted by Plastov: "But this is already thought in touch with reality (*a eto uzhe real'no myslitsia*)." Shurpin intervened again: "He doesn't need to take down the portrait!" But Plastov had the final word: "He simply needs to give this brains (*nado prosto obmozgovat' eto*)!"[111] Finally, there was critical talk of a case where "V. M. Molotov and J. V. Stalin are of lesser height, and Kaganovich is a lot taller."[112] It seemed to be clear to everyone involved that Stalin—with some rare exceptions—was to be depicted as being taller than other Bolshevik luminaries. This was never a mere issue of convention or of power, Stalin's height was always indexical of his outstanding position as "locomotive of the revolution," as incarnation of the revolutionary world spirit in an inexorable movement of history toward the telos of socialism.

Critics were also concerned that paintings might be ambiguous, where an unrelated object, person, or body part might be viewed as belonging to Stalin. In one painting Maxim Gorky's hat and cane "seem like Stalin's!" but "belong to Gorky," as Pavel Sokolov-Skalia exclaimed.[113] In a similar case, it was feared that an elderly lady in Lenin's proximity would be seen by contemporary viewers as Nadezhda Krupskaia, Lenin's wife. The art soviet bemoaned the anachronistic reading this elderly lady was likely to produce among viewers, who remembered Lenin as having died young but were used to seeing Krupskaia as

an elderly lady from the 1930s onward. In truth, they figured, Krupskaia had been young in the historical scene depicted. "This old woman, she remotely resembles Krupskaia and that is unfortunate, because at the museum the visitor will go up to the painting and say: ahh, Krupskaia! She is so much older than him! But Krupskaia was young and beautiful then. Maybe she should be given a shawl or her face should somehow be changed so that she no longer reminds one of Krupskaia. My first thought, for example, was 'Krupskaia'! Even though I know this episode very well. It is bad when the viewer thinks this way, he ought to interpret these things painlessly."[114]

ART CRITICISM: PORTRAIT, *OBRAZ*, DIALECTICS

So much for discussions of Stalin portraits at the art soviet. But on what theoretical foundations did these discussions rest?[115] A precondition for the development of art-critical theory about the leader portrait was the reevaluation of the portrait.[116] In modernism broadly understood, the portrait had undergone a process of devaluation. During the 1920s, realist artists and their critics restored the portrait to its former important place because it allowed them to celebrate the Soviet new man, by which they had in mind not a specific individual but a generic person who stood in for an entire social group. "The 'social portrait,' according to Lunacharsky, was one in which the artists should 'in a particular face, in a particular individual see and show us a whole layer of society.'"[117] This was the concept of "typicality" (*tipazhnost'*). But pragmatic reasons also played a role: many of the commissions for realist art during the 1920s came from such institutions as the Red Army, and portraits of leading soldiers were extremely popular. Not surprisingly, "the 1923 Red Army show was three-quarters portraits." And in 1928, "the critic A. Mikhailov, reviewing the tenth AKhR exhibition, counted 121 portraits out of 283 works."[118] By decade's end the portrait had returned to the top of the hierarchy of painting genres, a place it had firmly occupied in the realist art of the nineteenth and early twentieth centuries. There it remained until at least Stalin's death, even if the justification for its position at the top changed: during the 1930s "personality" (*lichnost'*) replaced 1920s *tipazhnost'* and it became entirely acceptable to portray individuals for the sake of their personal achievements rather than as anonymous proxies for social groups.[119]

The portrait was not only elevated to the master genre of socialist realist art, it was also presented as a sign of Soviet humanism, of Bolshevik care for man. Conversely, the decline of portraiture in Western art was portrayed as a symptom of the West's antihumanism. "[The portrait] is the point of departure from which realist art emerges," declared Aleksandr Gerasimov in 1950. He continued: "in one of the French journals there was a story about the attempt

to organize an exhibition of the modern portrait in Paris, and this exhibition was a complete failure." Gerasimov concluded that "it apparently was a failure because the artists have no respect for man, whom they portray. This respect for man disappeared in the age of bourgeois art, and together with it disappeared the portrait."[120] Similarly, the journal *Iskusstvo* argued in 1947 that individual portraiture had been effaced with the mid-nineteenth-century arrival of capitalism in the bourgeois West, while portraiture was rising to new heights in socialist Russia. Capitalism reduced the human person to a cog in the machine, while the Bolshevik Revolution had ushered in the flowering of the individual.[121]

Art criticism of Stalin portraits revolved around a taxonomy of canonical *obrazy vozhdia,* images of the leader (a similar taxonomy prevailed in other sectors of the arts). These images were not only schematic and the boundaries between them fluid, but also rather crude from today's perspective. They were the result of an interactive process between the artists, the art-critical press, and the general press. No matter how crude, for painters these images confined and configured the thematic range of pictorial possibilities for their Stalins. They were also congruous with the thematic rooms of the Stalin exhibitions.[122] They included the "leader" (*vozhd'*), the "people's tribune" (*narodnyi tribun*), the "father of peoples" (*otets narodov*), the "builder of communism" (*stroitel' kommunizma*), the wartime "commander" (*polkovodets*), and the postwar "generalissimo" (*generalissimus*). Each of these verbal designations triggered a cascade of pictorial associations: Stalin as the "father of peoples" invariably was shown with representatives of different Soviet nationalities; Stalin as the "builder of communism" was depicted amidst the factories and tractors of the First Five-Year Plan; Stalin as the "commander" was placed either in the Kremlin over a map, planning the war, or on the battlefield with binoculars; and Stalin in the role of "generalissimo" was unimaginable without his white uniform.

Art criticism often did not go beyond identifying the *obraz* that a particular picture or sculpture was trying to convey. The Stalin *obraz* appears to have been the functional equivalent of the *podlinnik,* the collection of model drawings from which icons were painted. Indeed, art-historical dissertations were written in this vein.[123] The art-historical "expertise" of these dissertations boiled down to recognizing one *obraz* or another, or several *obrazy* in a single work of art. Thus the sculptor A. V. Protopopov in his 1953 dissertation's review of existing Stalin sculptures credited S. D. Merkurov with realizing, in his Yerevan Stalin statue, the *obrazy* of "strategist of genius" and "wise commander." The sculptor N. V. Tomsky, according to Protopopov, "wants to show the figure of the leader in his generalissimo's uniform, with which the artist managed to personify the wisdom of the leader, the genius of the commander." M. G. Manizer's Stalin bust is treated as follows: "The calmly looking, expressive eyes convey the image of the statesman, the wise leader and teacher."[124] Another sculptor wrote

in a dissertation about his own statue, *J. V. Stalin in His Youth*: "I did not want to show an individual episode of his activity, but to do a synthetic solution of the theme, to show the young leader of the revolutionary proletariat, who was already an important theorist, a thinker and revolutionary-*praktik*."[125] One painter described the "main goal" of his picture in the following terms: "To create a synthetic image of the great Stalin—the great Bolshevik strategist and commander of the Soviet land."[126] And the painter V. G. Valtsev in 1953 summarized as the "main idea of his picture," *J. V. Stalin among the Yenisei Fishermen*, the "more truthful portrayal of the relationship between Stalin and simple people—fishermen."[127] Noticeably, the "synthetic" fusion of more than one *obraz* in a single work of art was valued highly. Aleksandr Gerasimov was lauded for showing in his Stalin portraits several *obrazy* at the same time: "The great value of Gerasimov the portraitist lies in his ability to convey in the images of the leaders the unity of the features of the state leader, the tribune of the people, and the man."[128]

Art criticism regarding the leader portrait was constructed around the poles of mimesis on the one hand and psychologism on the other. Both harked back to nineteenth-century intelligentsia discussions about the arts, but as far as mimesis was concerned, photography was the major new element.[129] As Ivan Gronsky wrote to Central Committee member Aleksei Stetsky in 1933, "the difference between the artist and the photographer lies in the fact that the photographer records the object, whereas the artist notices typical, characteristic features of people and things and gives, in his work of art, an artistic image which is composed of separate traits and details, taken from a multitude of people or things. This is the fundamental difference between realism and naturalism, between art and simple photography."[130] In other words, the doctrine of socialist realism was budding in Gronsky's letter—the artist fulfilled both the photographer's function of mimetic representation and took care of the painter's task of interpretation. An article in *Iskusstvo*, also published in 1933, spelled out more clearly this aim of socialist realism, synthesis: "Here we need authenticity (*podlinnost'*) and likeness (*skhozhest'*), which can only be attained through a realistic perception of reality, synthesized through socialist realism. Nothing in the portrait can be indifferent, neither the pose, nor the setting, nor the dress. [The portrait] must be truthful, reflect the inner life, and give a profound social synthesis of the person."[131] Compact theoretical statements like this one strove to serve as orientation for portraitists in the early 1930s, when the doctrine of socialist realism had only recently been proclaimed and when there was still a great deal of uncertainty about how to carry it out.

Artists were one thing, but how were such theoretical statements put into practice by art critics? In other words, how did art critics apply the theoretical proclamations to specific pictures? Consider how one art critic closed a journal

discussion of Sergei Gerasimov's *Stalin Among the Cadets* (1932): "All in all, despite a certain *portretnost'* ["portraitism"] of individual faces that were painted from life, the painting is solved with a fair amount of generalization and the flatness of monumental murals."[132] Both naturalism ("a certain *portretnost'* of individual faces that were painted from life") and abstraction ("a fair amount of generalization") were present in the painting. Thanks to this dual presence, the painting was considered "solved." Sergei Gerasimov had produced a successful synthesis that truly deserved the hybrid label "socialist realist."

An article such as this one, in a thick journal on an individual artist and his realization of socialist realism, constituted one approach to educating artists on how to put the new doctrine into practice. Another approach was used by the artists' union MOSSKh during the first half of the 1930s: the holding of meetings to discuss the portrait as a socialist art form, at which artists listened to exegesis of socialist realist tenets by different critics (and some artists). The critics used many examples of existing paintings by artists present at these meetings. (Here one can detect parallels to the "criticism" and "self-criticism" rituals, borrowed from the communicative culture of Party cells.) The newspaper *Sovetskoe Iskusstvo* then described and summarized the meetings and guided the artists as to who had been wrong and who had been right among the critics, thereby mapping the route to be followed for the benefit of the wider artist public outside Moscow.

More specifically, under the title, "Discussion of the Portrait," *Sovetskoe Iskusstvo* in November 1935 published its own treatment of such a MOSSKh meeting. Any artist anywhere in the Soviet Union reading this article would have come away with a sense of which paintings to emulate and which critics and artists to listen to, since all were given individual assessments. The article started by recapitulating its verdict on a first meeting in the spring of 1935: "As we noted earlier, the discussion in the spring about the Soviet portrait, organized by MOSSKh, ended in failure. I. E. Grabar's talk at the first meeting on the portrait was too abstract, it did not mention a single Soviet artist. Therefore this talk did not serve as a basis for any fruitful discussions." This criticism must have been voiced earlier and have struck a chord, for MOSSKh organized a second meeting:

> The packed room in the Tretyakov Gallery, which assembled the main Moscow painters, graphic artists, sculptors, and art historians, was testimony to the huge interest in the subject of the meeting. Igor Grabar repeated the points of his spring lecture and emphasized that portrait painters ought to convey a living image of a given person with his exterior and interior content, that the portrait ought to be similar to the original, and that the artist's work on the portrait ought not to be obscured by scholastic theorizing. . . . Even though he pointed out a photographic quality (*fotografichnost'*) and a naturalistic approach to the depicted people in the portraits

of Brodsky and Kosmin, Comrade Grabar still thought that their works completely satisfy the main criterion of a true portrait—they resemble the original. Comrade Grabar contests the claim that Katsman is a naturalist. On the contrary, there is not the slightest illusiveness in his portraits. . . . In Konchalovsky's portraits Comrade Grabar sees vestiges of the still-life approach to the living person. Aleksandr Gerasimov and Denisovsky made enormous progress in the area of the portrait. But no one comes close to the achievements of the seventy-year-old Nesterov.

Yet Grabar was the critic to turn a deaf ear to, while Beskin deserved to be listened to: "The vagueness of the criteria that I. E. Grabar proposed was the basis of O. M. Beskin's criticism of his points in a great speech that the audience listened to with enormous interest. . . . 'Of course,' says Beskin, 'the portrait must resemble the original: this is indisputable. But this is only the first stage in the work of the portraitist, who, without violating the individual characteristics of the model, must elevate reality to some level of generalization that will elicit a whole series of associations. At the same time the portrait must represent what the artist thinks of the depicted person, because art is the fusion of the subjective with the objective, as Hegel put it.'" This was one of many times that Hegel was cited as the direct inspiration for the dialectics of the portrait.

Beskin next turned to the background against which the person was portrayed. Because this environment had been created by the new Soviet person during the construction of socialism this background could be shown more cheerfully than was conventionally done. This meant using brighter colors than "the conventional bluish or grayish background." Finally Beskin appraised concrete artists, surely one of the most reliable ways of guiding other artists: "In evaluating individual masters of Soviet painting, Comrade Beskin emphasizes that the portraits of Katsman and Kosmin cannot serve as positive examples. To be sure, Comrade Katsman has attained virtuosity, but this virtuosity is only exterior and does not contribute to progress."[133]

Meanwhile the purely theoretical discussions of the dialectics of the portrait progressed. As L. Gutman elaborated in the thick journal *Iskusstvo* in 1935, with the October Revolution the demands on the portrait had changed: no hidden reality had to be exposed, but this did not mean that pure realism was needed—too many portraits were realistic-naturalistic. What was needed was to show both the real traits of the leader *and* his inner genius, his idea. To prove his point, Gutman quoted Hegel at length and concluded that portraits had yet to become genuinely dialectical. He used the following sets of binaries that truly socialist realist portraiture of the leaders was to overcome: "the factographic record of the appearance of a leader" vs. "the solution of formalistic problems of the portrait genre";[134] "content" vs. "form";[135] "the concretization of individual features" vs. "deep and broad generalizations";[136] and finally, a "double view of reality," that is "from outside" vs. "from inside."[137]

By 1937, thanks to the portrait competitions and the general emphasis on portraits, many more representations of Stalin in this genre had been produced. Consequently an article in *Iskusstvo* did not dwell on telling artists in abstract fashion how to portray Stalin, but rather critiqued existing Stalin portraits in order to give artists practical advice. To be sure, the article also quoted a well-worn dictum by Marx and Engels about Rembrandt, but its main source of verbal inspiration was the hagio-biographical accounts of Stalin's life. Henri Barbusse was credited with conflating Stalin with history, and his personal development with historical development. Thus the task of the ideal Stalin portrait was to depict "society" and "history" through the personal: "'The 'personal' (*lichnoe*) and the 'social' (*obshchestvennoe*) flow together. The image of the leader comes to light in historical reality, in the manifold situations of the revolutionary past and present, in his contact with people and with the masses."[138]

A 1940 assessment of the leader portrait sounded as though progress had been made since the early 1930s:

> When working on a portrait, the artist increasingly and with growing confidence takes the path of a synthetic-generalized image, tries to combine personal and "social" elements, and strives to fill the generalized image of the leader with living and expressive concrete features of his character. . . . In each of these pictures the action unfolds while being in deep and intrinsic connection with the telos of the most significant political events. Stalin as the leader who realized his idea of building socialism through his guidance, Stalin as the teacher and friend, the embodiment of constant love and care for the masses—this, in essence, is the basic theme to which these pictures are devoted.[139]

Similarly, a 1941 article positively noted that "The image of the leader in the imagination of the people lives and becomes richer depending on the spiritual growth of that very people. Straightforwardness and hyperbolization for a long time seemed the only way of realizing the image of the leader. But now the image of the leader is unthinkable outside of his portrait, outside of the uncovering of the whole richness of the individuality of the person portrayed."[140]

Throughout the 1930s, then, art criticism regarding the leader portrait retained its basic dialectical structure. Over the course of the decade the antagonism of the two poles realism vs. abstraction (or their many subsequent incarnations) lessened and the "versus" that separated them changed into an "and" that bridged them. In 1933 Ivan Gronsky counterposed "realism" to "naturalism" and "photography" to "art," yet in the same year Sergei Romov had already claimed that a combination of "authenticity" ("likeness") *and* "reflection of inner life" constituted the radiant path to a higher "synthesis of socialist realism." In 1934 S. Razumovskaia spoke of *portretnost'* vs. "generalization," whereas a year later Osip Beskin pleaded, "the portrait must resemble the original" *and*

have "some level of generalization." Why? "Because art is the fusion of the subjective with the objective, as Hegel put it." In 1935, L. Gutman identified a whole battery of binary oppositions, beginning with "the photographic record of the appearance of a leader" vs. "the solution of formalistic problems of the portrait genre" and ending with "from outside" vs. "from inside." By 1937 the synthetic "and" clearly outweighed the oppositional "versus." Mark Neiman spoke of how the "personal" *and* "the social" must "flow together." By 1939 Osip Beskin's ideal portrait had to "reflect reality" *and* "reveal the inner truth of a phenomenon," it had to feature both "nature" *and* "illusiveness," and in 1940 F. S. Maltsev clamored for a fusion of "the personal" *and* "the social."[141] By the mid-1940s, art criticism of the leader portrait practically disappeared from the pages of cultural journals and newspapers. Was there nothing left to say, since the portrait had become truly "synthetic" and entered the realm of socialist realist harmony?

"MILLIONS ARE USED TO SEEING LENIN DIFFERENTLY": THE CANON AS A PROBLEM

The sum of canonical representations of Stalin was called "iconography" (*ikono-grafiia*). This term was part of Soviet art criticism of the 1930s and 1940s and was stripped of previous religious connotations.[142] The existing iconography of leaders caused serious tensions in art crticism about leader portraits: how could portraiture further change and develop, if it was supposed to conform to existing portraits? In other words, how could the Marxist demand for historical progress, for linear, forward development, be reconciled with an immutable canon? And what if, after all, portraits needed to be changed according to the political vagaries of the time?[143]

A concrete case makes plain the dilemma that Soviet art criticism faced. The case concerns a Lenin portrait, but the pattern applies to the Stalin iconography as well. In November 1955 an artist by the name of Denisov, who did not belong to the top tier of Soviet artists but had previously copied Stalin portraits by stars like Gerasimov and Nalbandian, wrote to the chairman of the Central Committee Cultural Department, A. M. Rumiantsev, about a Lenin portrait he had been painting for the Lenin Museum since 1947. This portrait had been rejected at various levels and by various institutions of the cultural bureaucracy. The main reason was that it did not conform to the canonical image of Lenin. "My attempts to get my painting through the so-called 'Great Art Soviet' of the visual art factory," wrote an offended Denisov, "came up against statements of artists, such as that of Comrade Nalbandian—'millions are used to seeing Lenin differently.'"[144]

Denisov then tried to make his case. His greatest weapons were patronage and the visual memories of people who had seen Lenin. Thus he added three

written comments by well-known Soviet celebrities. Olga Lepeshinskaia, an Old Bolshevik and deputy of the Supreme Soviet of the RFSFR, wrote: "I was delighted by the artist K. A. Denisov's portrait of Vladimir Ilyich Lenin. Before me was the living Vladimir Ilyich, just the way he stayed in my memory. I believe that we must distribute this portrait among the masses, so that they get a vivid impression of the living Lenin."[145] Another Old Bolshevik, Tsetsilia Bobrovskaia, concurred: "A living V. I. Lenin—the Sovnarkom president is looking from this portrait, painted by the artist Comrade Denisov, and the eyes are particularly good. These are the eyes of V. I. Lenin. A great success for the artist."[146] Apart from the "affidavits" of these witnesses and guardians of Lenin's memory, Denisov had also secured Voroshilov's support:

> He acknowledged the portrait's quality and was irritated when he heard that artists are forced to paint Lenin portraits from only one or two widely distributed photographs. "How can one," said Kliment Yefremovich, "reduce to clichés a man as alive (*zhivoi*) as Lenin, a man who was someone else every minute, while always remaining himself!" That was said on 31 December 1953 to a whole group of old Communists, whom Comrade Voroshilov hosted. He immediately ordered that A. M. Gerasimov be called so that the portrait could be shown to the people, that is, to accept the portrait. After looking at the portrait, Comrade Gerasimov told me that he would call the visual art factory for approval. But I did not hurry to sell the portrait and later improved it further and further, testing my visual memory (I worked and often met with Lenin myself)—with Comrades G. I. Petrovsky, O. B. Lepeshinskaia, and finally with Comrade Krzhizhanovsky.[147]

After trying since 1947 to bring "Vladimir Ilyich closer to the viewer and the viewer closer to him," Denisov's final plea was to "protect my aspirations against the hollow, cold wall of the stencilers (*trafaretchikov*), that is those people who fear taking the slightest responsibility for something that is unusual or new to them."[148]

A deputy at the Central Committee Culture Department then produced a note that was discussed and accepted at a session of the Central Committee. In this note, he argued that Denisov's Lenin portrait had been evaluated by the Moscow visual art factory's art soviet and "was rejected because of its poor professional realization. The painter of the portrait received comments and advice from the artist-members of the art soviet, but Comrade Denisov did not agree with their opinion and is asking to organize a viewing of the portrait with comrades who knew V. I. Lenin closely." Most importantly, "the portrait at hand differs significantly from the well-known photographs and the established popular image of V. I. Lenin." Like other institutions before it, the Central Committee hammered home the point that Denisov had violated the Lenin iconography. "We think it makes sense to recommend that the painter take these comments into account and continue work on the portrait," it concluded.[149]

The memory wars over the iconography of Lenin went on. In October 1957 Denisov complained in a letter to the Old Bolshevik Otto Kuusinen about the "callous attitude of some Central Committee workers towards the sincere work of a person for the good of the Party." "Judge for yourself," Denisov wrote. "A man strove to create, and did create, a portrait of V. I. Lenin for more than ten years with his left hand alone (the right one is missing), about which O. B. Lepeshinskaia writes: 'I was delighted.'"

In the meantime Denisov must have also organized a public protest against the rejection of his Lenin portrait: "Sixteen old communists, who knew and saw Lenin alive, wrote in a letter to the newspaper *Sovetskaia kul'tura* that 'the image of Lenin must not be reduced to clichés (*nel'zia zatrafarechivat' obraz Lenina*)' and that they 'consider the keeping of the artist Denisov's portrait of V. I. Lenin from public showing incorrect.'" Similarly, *Literaturnaia gazeta* carried an appeal by Old Bolsheviks in favor of Denisov's Lenin portrait.

Finally, Denisov reported receiving a note from the Central Committee, which read as follows: "Many have looked at your portrait, even secretaries have looked at it. Some like it, others do not. Therefore pick up your portrait and take it to the exhibition [at the Lenin Museum] through the usual channels." "If they had at least said," Denisov concluded, "who does not like his painting and what is bad in it. After all, we are not talking about canons that have been established by painting for the sake of painting, but about a different image of Vladimir Ilyich—about the question of the life of an artist, a comrade-in-arms of Ilyich."[150]

The archival record next has a letter by Denisov to "Comrade [Petr] Pospelov" of the Central Committee, who had once "cut this Gordian knot and ordered the Lenin Museum to acquire my portrait for their exhibition and to publish it through the Ministry of Culture." Yet the knot must have miraculously refastened, for the director of the Lenin Museum enlisted various representatives of the artistic intelligentsia to give Denisov further advice on how to change his painting. After that the director of the Lenin Museum sent Denisov on a Kafkaesque journey from one bureaucratic institution to another. The one-armed artist ended up feeling as though he had "turned into a soccer ball."

The story ends with the following communication, an appeal to Denisov's patron at the Central Committee to renew his pressure on the Lenin Museum to buy his portrait: "Comrade Krzhizhanovsky wrote in his comment on my portrait: 'I think that the reactions of our society will undoubtedly be positive.' Just like the deep conviction expressed in the letters of Lenin's comrades-in-arms, this opinion could, it seems to me, be enough grounds for the director of any museum to take the small risk connected with exhibiting a portrait of V. I. Lenin—a new interpretation that everyone who knew him alive likes so much."[151]

We do not know what subsequently happened to Denisov's Lenin portrait, nor has a copy of the controversial picture come to the surface. But the case highlights some of the inherent tensions of art criticism of the leader portrait genre. On the one hand, depictions of a leader were supposed to be "truthful," and those people who had personally seen a leader were one of the sources of "truth," especially after his death. On the other hand, a canon of leader portraits developed over the years, and this canon was firmly implanted in the collective imagination. Violating this canon came close to iconoclasm. Denisov had been a lowly *kopiist,* who had done little but keep up the canon by painting oil copies of masterpieces like Gerasimov's *Stalin and Voroshilov in the Kremlin* for the spot on the wall behind the desks of regional Party bosses. It was ironic that he at last broke out of the canon with his Lenin portrait. The Khrushchev years must have played a role—the Stalin cult had been discredited and the Party claimed to be returning to its Leninist origins. De-Stalinization demanded a de-Stalinized Lenin and made the Party insecure about the established Lenin iconography. It is a combination of this sense of insecurity, of patronage (Voroshilov), and of the renewed power of Old Bolsheviks during the Khrushchev era that allowed Denisov's case—a case that began (unrelated to the times) in 1947 under Stalin and that was motivated by a desire to restore the "real Lenin"—to enter the archival record of the highest reaches of Soviet power.

Had Denisov's painting materialized and been released into mass production, the art criticism surrounding it would have been fraught with further serious and generic tensions. The Romantic doctrine of original, autonomous authorship and a process of spontaneous, inspirational creation clashed with the reality of a multiplicity of "authors" in a system of mass production organized around socialist planning. "Masterpieces" had an aura—they were presented as unique and their exhibition in the main museums of the country was treated as a singular experience, a pilgrimage site to be visited by as many Soviet citizens as possible. Yet in truth these very paintings were copied for local Party offices, houses of culture, and factory cafeterias by the artists themselves and an army of impecunious colleagues, copyists like Denisov. This tension in art criticism was almost as prominent as the tension between the existing canon and new paintings (as in the case of Denisov's Lenin portrait) or between the ideal of painting a leader from life and the reality of painting from photographic and cinematic templates.

The Denisov case was not isolated. Between 1953 and 1961, Stalin's body lay next to Lenin's in the mausoleum on Red Square. According to one member of the embalming team, Yury Romakov, the guiding principle of the embalming process was to achieve the greatest possible likeness between the corpse and the established image of Stalin in art, photographs, and film—to avoid shocking

the people.[152] Here too, the march of time, which left its traces even on Soviet leaders, was the canon's great source of contamination. How to reconcile current images of Stalin with pictures whose subject was in the distant past? To be sure, the Soviet painters worked out a Stalin iconography showing the leader at different ages. Sometimes, however, the current image was superimposed onto paintings with historical subjects, as in a painting reproduced in *Pravda* depicting the Wrangel front during the Civil War, when Stalin should have actually looked much younger.[153] Time and again, questions of temporality and mimesis moved to the center of the search for the perfect image of the leader.

If photography failed to deliver the utterly mimetic representation, were there other media that could do so? There was an earnest suggestion to use a plaster molder to create an archive of life masks of the leaders. A death mask already was a distorted representation of the leader, whereas a life mask would furnish the "real," perfectly mimetic template for an endless stream of works of art. Thus Voroshilov received a letter from Anna Ellinskaia: "I live at the dermatology hospital, where the well-known molder Sergei Pavlovich Fiveisky has created a huge museum of casts of very high quality. S. P. Fiveisky has grown old and almost blind, but his son Sergei Sergeevich Fiveisky works just as well, if not better than him. Now, this molder could assemble a gallery not of portraits, but of precise depictions of our dear leaders in their lifetime. Not only we, but also posterity would appreciate this gallery." "I have not," she finished, "told anyone of my thought and am first turning to you as a countryman, since I am also from Lugansk and approximately your age. My name will tell you nothing, I am merely a housewife, but I love my country and my leaders no less than any worker."[154] Anna Ellinskaia's letter seems to have been taken quite seriously, for Voroshilov's archive contains a note with her main proposition and pencil remarks ("we ought to take a look at the work of these molders and then decide"—Voroshilov). Did this note circulate at a Politburo meeting?[155]

Life masks of the Bolshevik pantheon, Stalin's embalmed body, and Denisov's Lenin portrait—they all point to deep and large problems of socialist realism. Artists may have been able to synthetically bridge the seemingly irreconcilable prescriptions of representing the world as it was and as it ought to be, of fusing realism and socialism. Here socialism—the "ought-to-be," future, or utopia—was in fact less challenging, precisely because it was nonexistent and therefore allowed for a wider range of approximations. Realism—the "as is" or the present—proved to be the real challenge. For as time moved on, the perception of what was, of reality, changed. The Lenin of Khrushchev's time was no longer identical with the Lenin of Stalin's time. Yet when Khrushchev came to power a collective visual memory had formed—"millions are used to seeing Lenin differently." It was this chronological vector that posed one of the greatest threats to representations of the leader, to socialist realism, and indeed to socialism.

6 The Audience as Cult Producer
Exhibition Comment Books and Notes at Celebrity Evenings

AN ASTONISHING VARIETY of persons and institutions interacted multi-directionally to produce the Stalin cult in painting. Together they constituted a field with multiple foci. This field was always oriented toward the Archimedean point of Stalin. One collective personal actor in this field has been missing so far: the audience. Who were the Stalin portraits intended for? Who actually "consumed" the cult products? And how? Was the audience an active participant in the production process of the portraits, or were they merely passive onlookers? These issues of reception are knotty ones. For one, reception is a problematic concept embedded in an outdated communication schema that presumes a sender of a message through a medium to a recipient. The ways, however, in which Stalin "messages" or images were made, the mechanisms of cult production, were vital in processes of meaning-making, as this book has tried to show. The classical communication schema is further confounded by Stalinist cosmology, which saw artists inspired by Stalin, the incarnation of Marxist historical development, producing an art that showed the Soviet world including its people as a work-in-progress moving toward a final historical stage, in which chronological time would be suspended just as differences between artists, the people, Stalin, and anyone else would cease to play a role.

Since the demise of the Soviet Union and the opening of the archives source genres have surfaced that, at first glance, seem to lend themselves to a straightforward study of reception in the classical sense. The comment book (*kniga otzyvov*) that was laid out at exhibitions and the anonymous notes passed forward to the stage at a celebrity evening (*tvorcheskii vecher*) with an actor who played Stalin are two such source genres. They are the centerpieces of this chapter. Yet these sources, we shall see, are best interpreted not as windows into "popular reception" of the Stalin cult, but as elaborate cultural artifacts

in their own right that served numerous and varied functions. In this they resemble other sources that have become prominent since the opening of the Soviet archives, such as the "reports on popular moods" or *svodki,* which many historians at first were inclined to read as Gallup poll–like reflections of Soviet public opinion.[1] Historians further saw this public opinion coalescing around binary poles of "affirmation" vs. "resistance." In general it is helpful to approach the issue of reception not through the affirmation/resistance lens but instead by allowing for vastly different reactions—even in a single person, and even over very short periods of time. Rather than viewing these reactions as "conflicting" or "paradoxical," we might best understand them as responses of a flexible, fractured, yet historically specific subject that can accommodate multiple utterances, actions, and thoughts over the course of hours or even minutes.[2] More specifically, it is useful to watch out for the actual templates which informers followed in recording what they allegedly heard. Which categories, which rubrics were available in a given document? It helps, in other words, to look beyond the ocean of *svodki* we drown in at the archives and to search for the rare documents that allow us to reconstruct how they were produced, much as Jean-Jacques Becker uncovered the categories given to French school teachers, who were then expected to push "public opinion" during World War I into these state-supplied rubrics.[3] Exactly the same applies to comment books at exhibitions and notes at celebrity evenings: the interesting and methodologically sound question is not how they reflect what the Soviet people thought about Stalin, but what purposes they were supposed to serve, what logic they followed, how this logic changed over time, and what this tells us about historically variable, "local" concepts of "reception" in Stalin's time.

THE COMMENT BOOK

> Comrades, I believe that our greatest kind of criticism is mass
> criticism, not the criticism of art historians.
> —Culture functionary Zhukov at selection meeting for 1937 MOSSKh
> Sculpture Exhibition

As we saw in Chapter 1, World War I greatly accelerated the continual movement toward mass society, mass politics, and mass culture. The Great War forced states across Europe and North America to draw upon and engage their populations in new and expanding ways—aided by the technological advances of the mass media. When the war was over, the population as a collective actor—"the masses"—had to be reckoned with in one way or another most everywhere. Bolshevik Russia was part of these developments, and it is here that the beginnings of the Russian comment book lie.

In the sphere of culture the audience became both a target of cultural products and an active participant in the processes of cultural production. One study has shown how Soviet literature studied readers' reactions and these reactions then began to partially prestructure the kinds of literature that emerged.[4] Works on Soviet cinema document how the reactions of moviegoers were investigated in the mid-1920s by "scientific brigades" that had developed quite sophisticated sociological methods of studying viewer reactions.[5] Due to its interactive potential, the new Soviet theater of the 1920s was a front-runner in terms of studying audience reactions to plays.

There were numerous attempts, especially during the heady days of scientific utopianism during NEP, to quantify spectator comments and turn their analysis into a "science." For example, in 1927 a Commission for the Study of the Spectator (Komissia po izucheniiu zritelia) was formed to study from psychological and sociological perspectives the "reflexology" of Moscow theatergoers. "We consider it necessary to introduce at large theaters a kind of psychological service, i.e. a permanent psychologist, who conducts the work of studying the audience, the actor, and the forms of interaction between these sides." After one theater had been chosen as the "central laboratory for methods of studying the spectator," the commission really set to work.[6] Besides the questionnaire method and the statistical analysis of questionnaires, the commission observed the audience during the play. The play was divided up into time segments,[7] and a graph showed "laughter" in red, "fright" in brown, "intense silence" in continuous blue, just "silence" in dotted blue, and "inattention" in yellow (Plate 13).[8] Such social science techniques derived from a number of national and international sources, including Soviet sociology and Soviet advertising (which during NEP conducted studies with focus groups and was influenced by German and U.S. "advertisement science").[9] In turn, these techniques shaped Western practices, as cross-fertilization still reigned supreme between the October and the Stalin revolutions.

Art, too, began to collect audience opinions through the institution of the comment book.[10] It is unclear exactly when this institution was imported from the West, but it seems that no comment books existed before the Revolution, not even at the exhibitions of the Wanderers.[11] The comment book became one of the most entrenched institutions of museum-going and lasted well past the collapse of the Soviet Union. It was a genuine tool for measuring audience reactions during the 1920s, and became mere window-dressing, a kind of pseudo-participatory institution, in the early 1930s. The comment book, together with spectator sociology, was later reactivated as a sign of the democratic-consultative changes taking place under Khrushchev.

Comment books were usually notebooks that were laid out in particular exhibition rooms or were available for an entire exhibition (Plates 14, 15, 16).

According to a curator at the Tretyakov Gallery who participated in the 1949 exhibition in honor of Stalin's birthday, the general purpose of comment books was to study the viewer, to find out "what he likes, why he likes it, does he like it the right way and for the right reasons?"[12] In the early days pages in a comment book were sometimes subdivided, with comments in the center and reactions to the comment by other visitors in the margins.[13] Asked about this practice of commenting on comments, the Tretyakov curator said that this was rare and existed only at the beginning, when the viewer was "less educated, less enlightened."[14] Thus as a forum of interpersonal written communication, the comment book also served didactic purposes, with viewers educating each other. From the perspective of the museum, the comment book also furnished information on how to rearrange the exhibition. On every wall, the center was to be occupied by a single important painting (*derzhashchaia veshch*, in the curator's words) and if too many comments referred to other paintings, the placement of these could be changed to redirect attention to the main painting. Visitor comments further prompted curators to change the guided tours that invariably accompanied exhibitions.

With the monumental exhibitions of the 1930s comment books became more formal and decorative. They were now often leather-bound and sported the gold-emblazoned name of the exhibition on the front cover (Plate 17). This change in outward appearance attests to the shifting functions of comment books. If they originally were intended as pragmatic, "scientific" statistical instruments to collect data on viewer reactions, or as forum-like educational tools, they later turned into a standardized, codified, eulogistic representation of power. The handling of comment books at exhibitions also changed. At the Georgian exhibition, for example, the guard of a specific room countersigned all visitor comments, supposedly to assure that no undesirable comments were recorded. Or, as Voroshilov's wife, Yekaterina Voroshilova, the deputy director of the Lenin Museum, noted in her diary in 1949, "I checked the comment books on 30 April. Comrade Borynin's attitude toward this new job was formalistic. He didn't look at the comment books for an entire month and he poorly instructed the guard in the room, who was supposed to look after the comment book."[15] According to the Tretyakov curator, at many of the Stalin exhibitions there were no comment books but rather boxes into which visitors put pieces of paper with their comments. Thus negative comments—*khuliganskie otzyvy*, in her words—could be filtered out.[16]

The comment book differed from the questionnaire method (*anketirovanie*) in that the latter was an all-out effort to gather each and every visitor's reaction, whereas the comment was a largely voluntary action on the part of the viewer. True, given the large number of visitors who came in a collective, from their factory committee, their union, their Komsomol cell or Red Army unit, the social

pressure to leave comments was intense. *Sovetskoe Iskusstvo* was unabashed about what could be called the "organized voluntarism" of visitors at the 1933 "Fifteen Years of the Red Army" exhibition: "in conjunction with the exhibition, political propaganda as well as agitational and mass work will be widely organized. According to preliminary targets about 300,000 organized visitors are supposed to go through the exhibition—first and foremost shock workers, *osoviakhimovtsy* [members of The Society of Friends of Defense and Aviation-Chemical Construction, one of the largest Soviet voluntary organizations], Red Army soldiers, and Komsomol members."[17] And while the exhibition was in full swing, the newspaper noted, "for the popularization of the exhibition a cycle of current radio programs, 'With the Microphone Through the Exhibition,' was organized." The medium of film was also mobilized: "*Soiuzkinokhronika* [the Soviet newsreel agency] filmed the exhibition and released a short sound film. Besides this film, all Moscow movie theaters are showing agitational movie advertisements for the exhibition." Finally, "at the main factories informational talks are being organized."[18]

The open reporting on the constructed nature of visitor habits did not hinder *Sovetskoe Iskusstvo* from celebrating the daily number of actual visitors. These numbers were meticulously displayed, as a sign of an exhibition's popularity, in the newspaper's most prominent place, the masthead next to the title.[19] In 1933, the media made transparent the manipulation of visitors at exhibitions and at the same time celebrated these visitors as a statistical victory of the popularity of socialist realist art, as though the visitors at Soviet exhibitions were exclusively "voting with their feet."

In spite of the uncertainty as to when and how comment books were first introduced in Soviet Russia, it is clear that as early as 1923 at the second Red Army exhibition a comment book was available.[20] In 1925 a professional propaganda worker from the Urals mentioned comment books with entries about a painting by Isaak Brodsky:

> Your painting attracted the general attention of all visitors in Sverdlovsk, the capital of the Urals. 325 comments are distributed as follows: very good—305; satisfactory—15, and unsatisfactory—5. The latter are primarily from our "artists," who did not criticize but engaged in demagoguery, for which they were blamed by the workers, peasants, and proletarian intelligentsia. . . . A worker from the diamond-cutting factory was correct when he wrote the following: "Having seen several comments about Brodsky's picture, I see that our local artists for some reason do not give Brodsky's picture enough credit, or rather, that they are jealous of his talent. But I will tell you why: our artists cannot do a picture that is better done than this painting." These simple and clear expressions of the proletariat of the Urals say almost everything regarding the undeserved criticisms of your painting. . . . It was particularly gratifying for me, a political education worker, to see your painting—full of life,

truth, and genuine beauty. It depicts the leaders of the revolutionary proletariat and their characteristic features in such a way that one could not wish for anything better. I saw and listened to Comrades Lenin, Zinoviev, Trotsky, Kalinin, Lunacharsky, Stalin, Tomsky, and others. Your painting renders them wonderfully and makes me recall the leaders precisely the way I saw them two or three years ago.[21]

During his 1928 exclusion proceedings from AKhR, Brodsky pointed out that his painting *Meeting of the Revolutionary Military Council* "at the last Red Army exhibition received the greatest number of positive comments from the visitors." And yet, he complained, "this painting was passed over for the prize, and prizes were awarded to paintings that received a smaller number of good comments."[22] The union representative, I. E. Khvoinik, then inquired "why Brodsky was not awarded a prize at the tenth AKhR exhibition for his painting *Meeting of the Revolutionary Military Council* if it had received the greatest number of votes from 2,000 questionnaires." According to the protocol, "the representatives of AKhR explain that RVSR [Revolutionary Military Council of the Republic] awarded the prizes and the jury was not made up of artists. In the ensuing dispute AKhR hastened to defend Brodsky."[23] In other words, during the mid-1920s, comments from questionnaires and possibly also comment books played a significant role in discussions within the artist community.

In 1929 GlavIskusstvo's State Commission for the Purchase of Visual Art experimented with a new form of acquiring Soviet art for the Soviet state. At a special exhibition by several artist organizations (including AKhR and OSt) groups of viewers, selected from different social backgrounds that were meticulously listed in percentages and tabular form, received questionnaires for judging the paintings on the walls. Among other things, the commission concluded that "the distribution of positive and negative comments is about the same for the different social categories"; that "almost all grades given are not explained, but where they are, one can observe the following: in the category 'white-collar workers,' the criteria 'reality,' 'naturalness' are most frequent, in the category 'workers' the criteria 'beauty' or 'ugliness of colors' prevail."[24] The commission decided not to recommend this method of selecting paintings, because, if organized on a large scale, it would create enormous logistical problems. Masses of viewers, who were representative of the different social groups, would have to be channeled past a large number of paintings, all of which would have to be exhibited in one place at the same time.

The experiment with the new method of the acquisition of artwork was apparently a sign of the renewed radicalism of the First Five-Year Plan (1928–1932) and was forced upon the artist unions by GlavIskusstvo.[25] At least, representatives of the artist organizations wrote a collective letter in which they defended themselves against an article attacking them in the newspaper

Komsomol'skaia Pravda, and in so doing revealed further details of how they had surveyed viewer opinions. Among other things, they emphasized that the exhibition had been sufficiently publicized and that the opinions had been collected anonymously.[26]

The 1934 exhibition "Young Artists" featured a questionnaire sheet (*oprosnyi listok*). It read as follows: "Questionnaire. Write down your opinion about the exhibition and its artwork. Underline: worker, white-collar worker, student, peasant, officer, Red Army soldier. Put the completed questionnaire into the box."[27] V. G. Tsybulin, who classified himself as a "student" and "peasant," commented on a picture entitled *After Work* by a certain Nevezhin: "This work is but a shadow of the French school in our socialist reality. This piece is artificial. Where is the horse's behind? This work is bad in that it does not show the real life, and the technique is weak."[28]

Later during the 1930s, artists used the comments to further their own standing or lessen that of their colleagues. During a 1937 discussion in the Committee for Arts Affairs regarding the selection of sculptures for the annual MOSSKh sculpture exhibition, one functionary argued that the negative comments at last year's sculpture exhibition had not been taken seriously enough. "90–95 percent of the comments in the three visitor comment books," he claimed, "were negative, clearly negative. . . . But at the discussion . . . they tried to downplay this by saying that the visitors to the exhibition were just a 'strolling public' (*flaniruiushchaia publika*). It seems to me that one must not say this kind of thing about Soviet citizens who come to an exhibition. This was possible before the Revolution, then there was a *flaniruiushchaia publika.*"[29] The functionary, Zhukov, continued: "To demonstrate more clearly . . . how the spectator judges this exhibition, I translated all comments into the numerical idiom. . . . When the viewer says that 'this is the best of all, I like this piece the most' or if he says that this is the best work of the exhibition, or if he says that it is very good, I . . . gave a 5. When viewers said that something is simply good, I put down the number 4, and when it is satisfactory—3, and when they curse, I gave a 2 or 1. And so, 25 comments on Merkurov are almost all 4s or 5s." "Comrades," he concluded, "I believe that our greatest kind of criticism is mass criticism, not the criticism of art historians."[30] Thus at the very moment they were largely being turned into a Potemkin village, the comment books began to be represented as signs of truly democratic art production—as opposed to prerevolutionary art for the few, for the *flaniruiushchaia publika.*[31]

There were more, and there was more to, representations of Soviet democratic art production. Aleksandr Gerasimov, in a discussion of Katsman's one-man exhibition at the Academy of Fine Arts on 26 June 1950, offered an excursus on Katsman's *Visitors with Kalinin* (1927) (Plate 18). The picture itself depicts a

pseudo-participatory practice—petitioners to the Soviet Union's elderly grand-father, Old Bolshevik and President of the USSR Mikhail Kalinin. Gerasimov in his discussion mentions that the peasant petitioners so much identified with the painting that they traveled from far away and made actual gestures of reverence. Thus Katsman achieved a remarkable doubling of representation: the *narod* votes with its feet and overcomes obstacles on its way to a painting that depicts the *narod* voting with its feet and coming to the incarnation of Soviet power:

> M. I. Kalinin, depicted by Katsman, is standing and reading a petition, which the farmers who have come to him have given him. Next to him stands a farm woman, with yet another paper that she wants to hand Kalinin. Then there stands a secretary and a group of farmers. No doubt this is no longer only a collective portrait but already a thematic composition with a certain theme, the theme of showing the relationship of the Soviet people with its new popular power—the All-Russian elder (*starosta*) . . . , to show a new type of statesman, who is unusually close to the people, whom these farmers consider entirely one of their own, who came to him with their needs. . . . I cannot forget the impression that this painting made on the farmers who came to look at it. They came into the room and looked at the painting for 3–5 minutes, then bowed deeply to E. A. [Katsman], said "thank you," and left. At first the people came from 10 kilometers away to look at this picture, then from 20 kilometers. So this picture received widespread popularity without any advertisements or posters.[32]

One leading artist, Boris Ioganson, in a similar vein said of Aleksandr Gerasimov's own *Hymn to October:* "When I was at the Tretyakov Gallery and stood in front of the painting, I was very interested in the opinion of the people who were looking at this painting. The painting is much liked, it evokes interest. I think that the compositional aspect of the painting is very interestingly done, in the sense that the spectator seemingly is present in the room, seemingly takes part in a big meeting, where he can hear the words of his beloved leader, Comrade Stalin, where he can see the government, where he can see representatives of the sciences and the arts."[33] Both Gerasimov in his discussion of Katsman's *Visitors with Kalinin* and Ioganson in his discussion of Gerasimov's *Hymn to October* in effect are crediting the painter with creating a participatory effect himself: the painting now is as if life-giving and allows for the spectator to partake in sacral processes. This comes close to iconic perception, as in Russian Orthodox icon painting, where the image transmits sacral charge into the world.

Artists took the comments in comment books very seriously. At the 1939 exhibition "Stalin and the People of the Soviet Land" one artist wrote to the director of the Tretyakov Gallery: "Is the exhibition well-frequented? Do you have a visitor comment book and do they criticize me a lot there?"[34] The comments

were also used in the press for the public shaming of artists, at artists' union and organization meetings, and in attacks on individual artists by colleagues. Artists themselves could retain the all-important image of modesty and still praise their very own pictures by mentioning positive comments about them.[35]

Artists also received letters from people who had visited a museum and gone on a guided tour. These people related what the tour guide had said about the artist's work and the artist, in turn, at least in one case tried to protest to the director of the museum, demanding that the treatment of his painting by the tour guide change. Thus Isaak Brodsky wrote to the direction of the Tretyakov Gallery that he regularly received letters from his aficionados in which they complained that certain pictures of his had been treated unfairly by the tour guide. One letter claimed that a tour guide had commented on Brodsky's classic, *Lenin at the Smolny* (Plate 1), as follows: "Brodsky was the first of the artists to side with the Revolution, but his art has turned bad (*iskhalturilos'*). Look only at the portrait of *Lenin at the Smolny*. Everything is delineated scrupulously—the covers of the chairs, the floor—only Lenin does not look like himself. You cannot feel the restlessness of the time, Lenin is too calm, there is no sense that the blaze of the revolution is burning close by." Brodsky was not amused: "I am astonished that tour guides are allowed to say such nonsense about a painting that has received general recognition here and abroad. As is well known, the second version of the painting is at the Lenin Museum and I doubt that the painting gets subjected to such ignorant attacks there." As if to emphasize the seriousness and authenticity of his source, Brodsky cited the letter writer's name and address.[36]

As far as the comments themselves are concerned, it is noteworthy that these were extremely codified and positive at exhibitions of Stalin cult art—and thus at the sacral center of the Soviet Union. The following comment on the 1949 exhibition on the occasion of Stalin's seventieth birthday is typical: "The exhibition 'The Image of Stalin in the Arts' has touched us deeply. The guided tour of Comrade M. M. Epshtein managed to show graphically and clearly what the artists and sculptors of the Stalin epoch want to express in their works. We are grateful to Comrade Stalin that he created wonderful conditions for the blossoming of our art. [Signed] The 8th grade students of School 407, Pervomaisky Raion, 24 December 1949."[37] Other comments were more detailed: "By and large the exhibition creates a strong, radiant impression. The picture *Hymn to October* by Aleksandr Gerasimov is particularly uplifting. Shurpin's *Morning of Our Motherland* [Plate 8] is excellent. In [this picture] there is so much light, so much air! You want to take a deep breath when you look at it. The huge fields on which the first tractors are already plowing, this light, blue-green spring sky—together they serve as a wonderful background for the most important figure on the canvas—the figure of Comrade Stalin. It was he, the leader of

peoples, who defended the blossoming expanses of our motherland against the enemy, thanks to his wise leadership the sun will never be extinguished above our country."[38] Consider also a particularly lengthy comment by Moscow art students, which began by noting their enthusiasm:

> We looked at the exhibition "Comrade Stalin in the Visual Arts" with great excitement. Among the many good pictures, we very much liked Oreshnikov's picture, *Lenin and Stalin in the Petrograd Defense Headquarters*, to which the guides pay little attention, despite the fact that this picture is painted with great skill. Granted, it does not impress with bright colors, but the space and tense atmosphere of those years are well expressed in it. At the exhibition there is also a large painting by the artist Khmelko which bears the title *To the Great Russian People*. They say that there is a lot of light in it, but in truth there is no light in it and the illumination even seems weak, which lends a somewhat sad look to the Georgievsky Hall. Moreover, if you pay attention to Kaganovich's face and the figure to the right of Kaganovich (apparently Zhdanov), one could imagine that the artist wanted to show a different content of the picture and not the content it is supposed to have. Brodsky's portraits in oil and pencil are very good, and we all like Yar-Kravchenko's pencil portraits of Stalin a lot. By the way, Brodsky's Stalin is the one with the most verisimilitude at the entire exhibition. And we wish that these portraits and Oreshnikov's picture *Stalin and Lenin in Petrograd* would stay at the Tretyakov Gallery, because we are afraid that they will be removed at the end of the exhibition. We also very much liked Shurpin's picture *The Morning of Our Motherland*. The Students of MSKhSh [Moscow Secondary Art School].[39]

Critical comments at Stalin exhibitions were exceedingly rare. This was because of the sacral status of representations of Stalin, which were to be revered rather than examined, but also because a museum guard controlled the comment book and because some of the few-and-far-between critical comments that were entered were then removed. A critical comment (by a student) at the 1937–38 exhibition "Art of the Georgian SSR" ran as follows:

> The general impression of the exhibition of Georgian art is overwhelming. It is a great pleasure to be able to follow the lives of our leaders—from many years ago to the Great Constitution that bears the beloved name of Stalin. For us, the youth of the land of socialism, this is a wonderful gift. Thanks to Comrade Beria, the initiator of these outstanding works of art! It is all the more saddening to see among these fantastic pictures the work *Reception of the Georgian Delegation at the Kremlin* by one Krotkov. The faces of Comrades Kaganovich and Yezhov are so distorted that they are hardly recognizable. The face of Comrade Voroshilov has a strange, untypical expression. It is annoying that the Commission which has organized this fantastic exhibition let in this painting—a painting that elicits unanimous displeasure and anger among the visitors.[40]

Many of these comments were hardly distinguishable from professional art criticism in Stalin's time. Indeed, one of the totalizing ambitions of socialist

realist art was to erase all boundaries, including those between lay art apprecia-
tion and professional art criticism, ultimately between art and criticism.[41] So-
cialist realism was not quite successful in erasing these boundaries, as the self-
referential logic of differentiating professional, specialized discourses proved
overpowering. Stalinist art criticism did develop its own voice, but its borders
remained porous. Professional art critics continually pillaged comment books
for ideas expressed in "the voice of the people" to buttress their specialized,
Hegel-saturated rhetoric. This was one of the abiding functions of the comment
book, besides its role in furnishing ammunition for debates within the artist
community.

During the 1920s the comment book also had the function of providing gen-
uine sociological information on visitor reactions. It could change the art that
was being produced, or readjust the ways in which it was presented in exhibi-
tions and museums (the hanging and surroundings, including the guided tours,
noise level, and lighting). It could teach museum-goers the expected repertoires
of reception, and, quite simply, to teach them how to behave as cultured view-
ers. By contrast, during the 1930s—this is especially true for Stalin portraits—
the comment book turned into a symbolic, pseudodemocratic practice. Its main
purpose became to show to the Soviet Union and to the world that Soviet art
was produced by the people and for the people, and hence was "popular" in
both senses of the word. Reception turned into performance.

THE CELEBRITY EVENING: MEETING THE
MAN WHO PLAYED STALIN

In the wake of the new Stalinist emphasis on heroes and the individual (*lich-
nost'*), Soviet screen and stage actors began to be revered no less than Holly-
wood stars. From Liubov Orlova during the 1930s to Andrei Mironov during
the 1960s and 1970s, actors set beauty standards, were emulated by countless
teenagers, and were consulted on questions entirely unrelated to their profes-
sion. In the absence of a commercialized fan culture, Soviet actors communi-
cated with their audience through different channels. Famous actors received
fan mail, to be sure, but in answering this mail they took care to point out that
their relationship to their audience was a socialist one. Just as the painters em-
phasized how indebted they were to the popular masses, actors also stressed
that they were "of the people" and produced art "for the people."

Aleksei Denisovich Diky (1889–1955) was one of Moscow's best-known
stage actors during the 1930s (Fig. 6.1).[42] His career took an abrupt turn when
"he was arrested (on criminal charges, it seems) at the end of the 1930s and
later set free."[43] During the 1940s Diky attained new fame as a movie actor, at
first in the lead role of Marshal Kutuzov in *Kutuzov* (1944) and later as Stalin
in three movies, *Private Aleksandr Matrosov (1947)*, *The Third Blow* (1948),

Figure 6.1. Actor Aleksei Diky at a make-up session for his role as Stalin in the movie *The Battle of Stalingrad* (1949). Source: RGALI, f. 2376, op. 1, d. 82, l. 8. © RGALI.

and *The Battle of Stalingrad* (1949).[44] Diky's performance as Stalin, in which the *vozhd'* was stripped of his Georgian accent and at times wildly gesticulated with his hands, was widely perceived as incongruous with the established film iconography. After Semyon Goldshtab had played Stalin early on in the movies *Lenin in October* (1937) and *Man With a Rifle* (1938), Mikhail Gelovani, a Georgian actor, had done more than any other for the canonical film image of the leader: Gelovani's Stalin spoke with a thick Georgian accent and moved hardly at all (Plate 19). In the perception of Soviet moviegoers, Gelovani's Stalin was *the* celluloid Stalin, and Diky's version therefore was a shock to many. Diky's Stalin was also perceived as contributing to the "russification" of Stalin during a time when the battle against "cosmopolitanism" was in full swing.[45] While Diky's tenure as Stalin was relatively short-lived, it still exhibited the characteristics of Soviet stardom: Diky not only received a Stalin Prize and was celebrated in the highest echelons of the world of culture, he also cultivated a special relationship with his audience, whose letters from home and questions on scrap paper, passed to the stage at the celebrity evening, he occasionally answered with round-robin letters.

In 1948 Diky thus introduced a radio address tellingly entitled "An Open Letter by A. D. Diky about His Work on the Image of J. V. Stalin in the Movie *The Third Blow*" as follows: "While looking through my papers, I found your

request to recount how I worked on the making of Admiral Nakhimov's image. It is only now that I found your letter to me. Time has gone by, but the anguish over this annoying misunderstanding has remained, and I hasten to get in touch with you and make up for my small fault. The movie *The Third Blow,* in which I participated in the role of Comrade Stalin, has just appeared. Many are writing to me with the request to tell how I worked on the making of the image of the man of genius who is our leader." Diky closed by invoking the advantage of the medium of radio in reaching across large distances: "It is my pleasure to do this primarily for you, our faraway kin."[46] The modern mass media allowed Diky to answer letters and queries en masse and to create an impression of particular closeness to even the most remote of his fans.

A thoroughly typical fan letter was the one that young Yevgenia Bocharovaia sent to Aleksei Diky on Victory Day (May 9) 1949:

> Dear Comrade Diky!
> This little letter will be a surprising mystery for you. First, where is it from? Second, who wrote it? Yes, indeed, a girl you do not know by the name of Zhenia is writing this little letter. From the industrial town of Kramatorsk in the Donets Basin, a student learning to become a master craftsman. . . . Dear comrade, I cannot express my happiness, my enthusiasm about today, about the day of 9 May 1949. They showed the new movie *The Battle of Stalingrad* in Kramatorsk, in which you participated in the role of J. V. Stalin. Our entire group of students was absolutely delighted. And we want to wish you the greatest success for your further work. We wish you lots of good health for many years. Please forgive what might be a somewhat forward step on my part, but I am hoping to receive a tiny letter back from you. So write and we will be happy to receive a letter from you. Our address: Kramatorsk, Ordzhonikidze Factory OTO. Bocharovaia Ye. Iv. Stay well.[47]

A postcard from an elderly man, who was clearly more educated, addressed the famous actor as "Dear, esteemed Comrade Diky" and continued in a tone that suggested an equality between the actor and the writer in terms of age, education, and worldview: "Forgive an unknown person for writing to you, but I want to express my gratitude for the creation of the image of Comrade Stalin in the movie *The Third Blow.* You have depicted Joseph Vissarionovich the way everyone knows him, that is, as a politician, a military man, and a statesman of enormous talent. Therefore I felt great satisfaction when I saw your name in the list of the new Stalin Prize laureates. Please allow me to sincerely congratulate you and to wish you new, great successes. Respectfully yours, A. Gaidaryov."[48] Aleksei Grigorievich Shabanov, from a village in the Primorie region, began a letter by telling how difficult it had been to find out Diky's address and by saying that he was his greatest fan. He continued: "For a while I knew that a new film, *The Battle of Stalingrad,* had come out, but I did not have a chance to watch it and I racked my brains over how to get to watch this movie [since] I

knew that Diky played the role of Comrade Stalin there." After returning from a trip to Voronezh oblast, Shabanov finally got a chance to watch the long-awaited movie: "And when I found out that they were going to show the movie *The Battle of Stalingrad* in the evening I grew sick with waiting for the evening. And here I am sitting with my old lady, my mother, and she sees the living Stalin for the first time. She sees how Comrade Stalin calmly works in his office on the making of a plan, she sees how Comrade Stalin calmly leads, without agitation and confusion gives orders to our generals for the defeat of the Hitlerites at Stalingrad. On the screen she sees for the first time what war means, she couldn't remain seated on her bench and decided to leave, but I made her finish watching the first part after all. Dear Diky, many thanks for masterfully creating the image of Comrade Stalin."[49]

After receiving a Stalin prize, Diky indeed became the veritable object of a small personality cult, albeit in the sphere of entertainment rather than politics, and thus outside the definition of personality cult in this book. Though he had been so recently a prisoner in Stalin's labor camps, Diky, as a cult object, invariably received requests for patronage. The two social processes of personality cult and patronage were inextricably linked, as we saw in Chapter 4.[50]

The typical and more direct form of connection between the actor and his audience was, however, not the epistolary genre but the live celebrity evening, at which the audience jotted down—mostly anonymous—notes on pieces of scrap paper and passed them forward to the stage (Plates 20, 21). One such note is strictly congratulatory: "To A. D. Diky, the performer of the role of Comrade Stalin. In the name of soldiers from Gorky allow me to express sincere affection to you for the beloved image of our leader, which you have performed in the movie *The Third Blow.* We are sending you and your colleagues wishes for good health and further productive work in the sphere of art. With greetings, L. A. Zaikov, private in Army Unit 41491."[51] But most simply wondered, "How was the image of Comrade Stalin created? What materials did you use for the creation of this image?"[52] They also wanted to know if Diky had received personal instructions from Stalin, if he had met with Stalin, and if he had "met, then please tell about it."[53]

Many spoke of the different Stalin images of the actors Gelovani and Diky with astonishing openness: "We just watched the movie and the deep shock that we felt over first seeing the true portrayal of our leader has yet to subside! We were used to seeing Comrade Stalin performed by M. G. Gelovani, and all acting possibilities were limited to likeness in appearance. Gelovani was good at that, and only that! In your performance the viewer for the first time saw the man and leader in the way in which he lives in the soul and consciousness of every one of us. Words are powerless, especially in this moment. It seems that this is the peak that cannot be topped by anything. But knowing your un-

limited creative potential we believe that we will again see you on the screen, where you will further perfect the image of the beloved leader." The writer signed anonymously as "a viewer" and requested "that comrade chairman," the master of ceremonies at the celebrity evening, "publicize this letter."[54] Another writer asked "why Comrade Gelovani no longer stars in the role of Stalin?"[55] Yet another even inquired: "Tell us why you speak without the characteristic accent, when you play J. V. Stalin" (Plate 21).[56] And "because we want to know Comrade Stalin, we want to know him in detail down to his accent."[57] Presumably in reply to Diky's statement that an actor need not portray the leader mimetically, but rather must represent his essential psychological traits, one person asked, "in that case, why did Shchukin, the best actor in the role of V. I. Lenin, take into consideration the peculiarities of Lenin's manner of speaking," probably referring to Lenin's habit of burring.[58] Yet other notes gave concrete advice on how the writers wanted Diky to change his portrayal of Stalin: "I love you very much as an actor and would like you very much to do a lot more as a revolutionary and stormy petrel (*burevestnik*) in the role of Stalin. Think about this. I think this is a shortcoming."[59] Finally, one person complained about Diky's insincerity: "By not answering the questions about meeting Comrade Stalin you are being evasive, like Mikhail Illarionovich Kutuzov."[60]

It is unclear whether this advice was heeded or whether, in general, the audience's input had any consequences whatsoever in the artistic production of movies. The integrative effect, however, of creating a bond between artist and audience and the impression among the people that their opinion mattered, that they were truly involved in the creative process, should not be underestimated. In one of the last Stalin movies, *The Fall of Berlin* (1949), Mikhail Gelovani returned to his habitual role as the *vozhd'* (Plate 19)—at the will of the people or the whim of Stalin?

This brings us back to the vexed question of reception. Let us begin by asking about the intended audience of the Stalin cult products, especially the Stalin portraits and Stalin films treated in this chapter. Clearly, the products were meant for the "masses"—for the entire population. There was no differentiation into elite and popular products, into products for women or men, into products for children or adults, into products for Caucasus mountaineers or Ivanovo textile workers, into products for Soviet citizens of Muslim background or those of Russian Orthodox heritage, and if some products—such as oil-painted copies of celebrated, publicly exhibited Stalin oil portraits—were restricted to the privileged few of the Stalinist elite, this did not change their expressive registry, which continued to be tailored to the totality of the population. True, this totality was still restricted to the Soviet populace, as the cult products were not targeted at a global audience. Even during the post-1945 expansion of the Soviet sphere of influence, first in Eastern Europe, then during the Cold War in the

developing world, it is questionable if this ever became the case. In this respect Stalin cult production differed fundamentally from capitalist cultural production. The Hollywood film industry, from the 1920s onward, was directed at an international audience.[61]

The perceived taste of the Soviet totality was an important factor in dictating the ways in which the leader was portrayed. Cult producers deemed legibility to be of prime importance and strove to create uniform and uniformly legible cult products—which they then expected to be read uniformly by the audience. Because audience tastes seemed nebulous after the Revolution, during NEP questionnaires and comment books (as well as other forms of audience research in different sectors of the arts) played a significant role in trying to ascertain the Soviet population's repertoires of reception. At the same time, during the first postrevolutionary decade, the comment book already served educational purposes—with the page as late as 1933 divided into two columns, one for comments, the other reserved for reactions to these comments. It is possible that the results of the NEP and First Five-Year Plan–era sociological audience research bolstered the general turn from abstractionism to realism. This turn was also a result of the dictator's and his henchmen's taste, and other factors.

Coeval with the onset of the full-blown Stalin cult in the early 1930s, the comment book mutated into a largely performative instrument. Its overriding purpose became to demonstrate to the Soviet populace (and perhaps to the West) that Soviet art—including that of the Stalin cult—was for the people and from the people.[62] Was it successful in this representational effort? We cannot know, but we can know some of the ways in which the comment book was supposed to, and indeed did, "work" during the existence of the Stalin cult. One function of the comment book was to suggest to the population that it participated in a feedback cycle, in the making of art that was made for it. The population was presented to itself as both the object and the author of art. True, this function played hardly any role with Stalin portraits, where irreverent comments were considered out of place and were indeed physically censored. But through the publication of visitor comments in the newspapers and through the public shaming of some artists via these comments, the act of commenting in a comment book was generally endowed with the meaning of participation or even empowerment. It is likely that some of this aura was transferred to the act of leaving a comment on a Stalin portrait. At the celebrity evening, a similar act was writing comments on scrap paper, which were passed forward to the stage and received a reaction by the celebrity, say, a response spoken in the microphone. Such "participatory practices" proffered by the regime were likely perceived by many not as "pseudo," but as genuinely effective participation in the arts. Pierre Bourdieu's insights about opinion polls in democratic societies are pertinent here: "The opinion poll is, at the present time, an instrument of politi-

cal action; its most important function is perhaps to impose the illusion that a public opinion exists."[63] What amplified the illusionary effect of participation in Stalin's Russia was that the contemporaneous alternatives of participation were portrayed as utterly unattractive: on the one hand there was total dictatorship in Nazi Germany, Fascist Italy, and other authoritarian states, on the other hand there was conflict-ridden, ineffective participation—"democracy" in quotation marks—in the United States, Britain, and France.

Further functions of comment books were to teach museum-goers to acquire "culture" (*kulturnost'*), and to let museum-goers help each other acquire "culture"—by creating a shared communicative space, in which one viewer read the comments of another. In this way comment books also created community and served integrative purposes, bringing together people from all walks of life in a single, and from the 1930s onward increasingly sacrally charged, space (signified by the shift toward expensive, colored leather-bound comment books). The final goal of comment books was the total mobilization of the population. As for the actual comments, they surely taught museum-goers to "speak Bolshevik" in the sphere of the visual arts, that is, to acquire the official discourse about the paintings they were seeing.[64] For example, *Pravda* published similar reactions by moviegoers after the premiere of a new film, thus prestructuring its further reception.[65] In fact, many of these comments were beamed to the larger population via the mass media, so that they had influence on people beyond the community of writers of entries in exhibition or museum comment books. Through reading in the press that certain comments had, in an extreme case, cut off an artist from the community of artists, writers of comments were given a sense of empowerment. Indeed, and unbeknownst to the writers, in nonpublic communication within the artists' community comments were mobilized to raise or lower the standing of artists. Artists were very anxious about the comments they received.

After Stalin's death the comment book resumed some of the genuinely consultative NEP-era functions it had lost during the 1930s. Thus in July 1954 Aleksandr Gerasimov wrote to Petr Pospelov at the Central Committee and complained that the recently closed exhibition of his artwork from trips to India and Egypt had garnered negative comments. Enthusiastic comments made by Indians or Egyptians might have been due to "diplomatic politeness," as Gerasimov explained with ostentatious modesty—but there were also "evil ad hominem attacks and even terrorist threats, examples of which I am enclosing." The cultural newspaper *Sovetskaia Kul'tura,* the successor to *Sovetskoe Iskusstvo,* had failed to follow Gerasimov's demand to write critically about the attacks and threats.[66] Clearly, a year and a half after Stalin's death and in the midst of creeping, silent de-Stalinization, Gerasimov's star was sinking. At the same time a new atmosphere of openness was gradually settling in, as

can be seen from some of the negative comments Gerasimov attached. "We still know how to make bombs from tin cans," one anonymous writer threatened.[67] Another directly fought back: "Muscovites are embarrassed by the dirt and settling of personal scores, which these pages are full of. And we think it is a shame that those who write such things hide their last names," wrote three women (with legible last names).[68] A fellow artist likewise bemoaned the cowardice of the writers of "hooligan attacks" and surmised that the few legible last names were in fact pseudonyms.[69]

Under Khrushchev the comment book became but one of several consultative institutions, the new "complaint book" (*kniga zhalob*) in stores and government offices constituting another.[70] The comment book indeed became considerably more democratic and the artist acquired more agency in deploying it. Thus the sculptor Stepan Erzia set out a comment book in his studio in order to collect comments testifying to the bad conditions there.[71] By 1980, when a book on the artist Ilia Glazunov appeared, five-sixths of it were comments—positive and negative—from a 1979 exhibition in Leningrad's Manezh. They ranged from "Thank you for your pure art. Encountering it, one gets spiritually cleaner and brighter" to "A triumph of tastelessness!" and "Comrade Glazunov! Not only are you a plagiarizer, you lack basic taste and humanity."[72]

Conclusion

STALIN DIED ONE real and several symbolic deaths. Many people experienced his physical death on 5 March 1953 as a loss of truly existential proportions. With the passing of the leader, the force that held their lives together suddenly was no more. There was a logic to the fact that his demise brought about their own deaths—from heart attacks or as a result of being trampled in the crowds moving forward to see his lifeless body. For those who managed to catch a glimpse of his corpse as it lay in state in the Hall of Columns of the House of Unions there would be no closure. His cult and its alchemy of power had made him seem larger than life, so that now embalming his dead remains, dressing them in the white generalissimo's uniform, and placing them next to Lenin could not suffice. Not even removal from the Mausoleum and burial at the Kremlin wall brought an end to this story. Stalin's corpse kept rising from the grave, like that of the fictitious dictator Varlam Aravidze in Tengiz Abuladze's 1986 movie *Repentance*.[1]

Khrushchev's secret speech of February 1956 was followed by a massive iconoclastic campaign that sought to remove every trace of Stalin's image and name from Soviet public space. The state-sponsored iconoclasm of 1956 and 1961 (the year of the Twenty-Second Party Congress which made de-Stalinization official policy) was preceded by iconoclastic initiatives from below, for there had always been cases of people defiling the leader's public image, writing anti-Stalin ditties, telling anti-Stalin jokes, and celebrating the day of Stalin's death.[2] These initiatives from below made sense, since Stalin had become a symbol—a concentrated site of meaning—and as a symbol he stood for more than Stalin the person: for Soviet-style communism, for Soviet nationality policy, for Soviet religious policy, and much more. Yet neither these popular responses nor the state's iconoclastic efforts could bring a sense of closure.

Stalin had to die again and again—most recently in 1989/1991. Indeed, he is still alive, as a spate of post-Soviet Staliniana (books, movies) and public approval ratings of 50-plus percent at the beginning of the third millennium go to show. It seems that the Stalin-era slogan "Stalin will live eternally!" (*Stalin—vechno zhiv!*) has as much relevance today as it did in the past. Why this is the case will occupy scholars for a long time. Perhaps, as some have suggested, it has to do with the absence of regime change at the time of his death, a circumstance that contrasts markedly with "initial scenes of death and their sequencing with respect to regime end" in such cases as those of Italy's Mussolini ("hanging and humiliation"), Germany's Hitler ("suicide and silence"), Japan's Hirohito ("desacralization and confident state funeral"), and Romania's Nicolae and Elena Ceauşescu ("execution and 'secretive' public burial").[3]

The sources of the Stalin cult was the first issue this book has tried to resolve. Rather than viewing the cult as the outgrowth of eternal Russian Byzantine authoritarianism, a simple product of Stalin's psychopathology, an inescapable feature of totalitarian regimes, or a concession to the premodern mentality of the peasants who entered the Party during the Great Break, I have viewed the Stalin cult as an example of the modern personality cult more generally. Modern personality cults in the sphere of politics share five features that set them apart from their predecessors. They are secular, that is, they reject a metaphysical source of legitimacy (as with divine right) and instead are anchored in popular sovereignty; their cult objects are all male; they address the entire population, not merely an elite; they use mass media and uniform, mass-produced cult products; and they are limited to closed societies, in which the mass media are sufficiently controlled to prohibit the introduction of rival cults. The move to modern personality cults was of course nonlinear, yet the trend can easily be traced. Napoleon III was the first politician with a modern personality cult. Later stages included World War I, during which the mass base of personality cults expanded further and the cults themselves became entangled. If, for example, during Louis XIV's reign monarchy was the undisputed form of political rule, the post-1918 leaders embodied radically different worldviews that vied for global hegemony—Mussolini stood for fascism, Stalin for communism, Churchill and Roosevelt for capitalism. The cult representations of these leaders also became entangled. Stalin's calm oratorical style and body language, for example, were juxtaposed to Hitler's wild gesturing and rhetoric. Despite many discomforting commonalities, a comparison of the symbolic politics of Stalin, Hitler, and the like with Roosevelt (or Charles de Gaulle or Ronald Reagan) shows that the differences are more important.

We have noted there were at least three more influences on the complex path to the Stalin cult. There was the "tsarist carryover," the tradition of the cult of the tsar which weighed heavily upon the Bolsheviks, no matter how much they

tried to distance themselves from it after the October Revolution. There was the tradition of personality cults on the Left, no matter how impossible to reconcile with the collectivist ideology of Marxism. And there was the tradition of the radical intelligentsia circles, whose members glorified circle leaders with cult products. All the leading Bolsheviks were socialized in these circles, and once they usurped power in 1917 the formative experience of the circle began to shine through, no matter the disdain they heaped on personality cults.

Just how the symbolic dimension of Stalin became all-important—how his cult was made—and how the resulting cult products circulated and how people made sense of them, has been the main subject of this book. The newspaper *Pravda* was an important instrument that Stalin portraitists used to navigate through the rugged terrain of Party politics. It was the country's premier news medium, and also a microcosm of the Stalin cult. It is an ideal case with which to study the way the cult's visual registry developed over time. After the cult's take-off in mid-1933, *Pravda* was preoccupied with establishing Stalin as number one in the collective imaginary—distinguishing him visually from his comrades-in-arms. After this task had been achieved (by 1939, Stalin's sixtieth birthday), Stalin's appearances were restricted to Soviet holidays. The war brought a hiatus in depictions, and then a major shift in the way Stalin was portrayed: as of late 1943 he was shown as a military commander and elder statesman. Toward the end of his life, Stalin began to appear in "absent" representations—for example, the faces of listeners gathered around a radio receiver. These absent representations were a kind of preparation for his death, a foreshadowing of his absence. When he finally did die, his piecemeal disappearance from *Pravda* propelled and at the same time indexed the slow (and initially silent) process of de-Stalinization.

If *Pravda* is a window on the pictorial evolution of the cult, Aleksandr Gerasimov's 1938 painting, *Stalin and Voroshilov in the Kremlin,* arguably the most famous Stalin portrait, lends itself to a hermeneutics of a (indeed, *the*) socialist realist leader portrait. A mirror of Soviet power, this painting is organized around Stalin in concentric circles. These concentric circles became the dominant form of spatial organization in portraits of Stalin. Depictions of Lenin differed markedly: they were organized in linear fashion, with Lenin's body or arm directed toward a focal point in the picture. They expressed the dynamic forward movement of the Revolution, whereas depictions of Stalin were meant to convey a sense of arrival after the building of socialism during the First Five-Year Plan.

In the fabrication of his visual image Stalin's role was crucial. He masterminded his own cult, often acting as the ultimate filter of its products before they were released for social circulation. Because Marxism was fundamentally incompatible with the very idea of a personality cult, his role was kept secret.

Stalin bridged the gap between what was (his cult) and what ought to have been (collective leadership) by resuscitating a culturally virulent pattern that I have called "immodest modesty"—feigning public disapproval and grudging tolerance of the cult out of democratic conviction while all along clandestinely controlling it. Other Party bosses were instrumental in managing the cult in the different spheres of artistic production. Kliment Voroshilov was responsible for the case most prominently discussed in this book—oil portraiture. He became a patron of socialist painters; in fact, an entire system of informal patronage developed in which high-ranking Party figures oversaw one or other sector of the arts. For example, Yenukidze and, after his death, Molotov were patrons of the theater, Kaganovich of architecture. Within the Soviets' highly planned system of art production, it may at first seem paradoxical that personal patronage became so influential. When one considers that the ultimate aim was to manufacture a patricentric cult of the leader—a supremely personalized form of power—this seems less perplexing. Specifically, Voroshilov visited painters in their studios and corrected their portraits of Stalin, but also engendered a sizable cult of his own by sitting for his own portrait. Voroshilov's cult standing probably saved his life during the Great Terror and after he bungled the Winter War in 1940. The effort to disentangle him from Stalin in public symbolic politics would have been mind-boggling indeed. Symbolic power in Stalinist Russia became a question of life and death.

Every Stalin portrait has a biography enmeshed in a complex set of events. Its life began with a competition, followed by an exhibit. Announced in the cultural newspaper, or in letters to selected artists, the competition set the parameters of the portrait: its subject matter, its painterly technique and size, and the technical strictures that attendant mechanical reproduction imposed on the original. The organizing institution of the Stalin portrait competition then provided (original or retouched) photographic or cinematic templates. It was an open secret that many painters then engaged a model to sit as Stalin—after all, Stalin himself was not available! As the artists began painting, colleagues or art patrons from the upper ranks of the Party who made the rounds of the studios gave informal critiques. Official, but not public criticism came from the competition's jury (or the khudsovet if the portrait emerged outside the context of a competition). Just before an exhibition's opening a Party boss walked through the rooms and removed one or two portraits, made changes in the order of hanging, or demanded that, at the eleventh hour, specific corrections be made to a given painting—retouch a cigarette here, correct Stalin's nose there. Once opened, the exhibition garnered reviews and, after a time lag, became an object of art critical discussion in published form. Painters took much of this criticism to heart as they began their next Stalin portrait.

The next stage in the portrait's biography was reproduction. The most individualized and elite form of reproduction was copying in oil.[4] Sometimes even star painters produced copies of their successful pictures, but most copying artists were painters further down the hierarchy. Mechanical reproduction involved a multitude of media—from postcards to posters. In the process, most portraits were retouched. A painting passed through many filters of inspection before it was released into mass circulation. These ranged from the official censor at a press to Stalin's secretariat—and, most likely, Stalin personally. Sometimes these filters, especially Stalin himself, went into action only after the portrait had been released into circulation. As a result, it sometimes occurred that all unsold copies of, for example, a book with Stalin portraits as illustrations were taken off bookstore shelves. While the Stalin cult had no all-controlling agency—a "Stalin cult commission" or a "ministry of propaganda"—it did refer to Stalin's secretariat and Stalin himself as an Archimedean point.

It is difficult to say much about the ways in which the cult products were received, for this is an issue that raises numerous methodological problems. This book, however, has offered a way out of the conceptual cul-de-sac of reception by retracing the mechanisms whereby reactions to cult products were gathered, and by identifying the various kinds of logic that governed these mechanisms. After the Civil War, theater and other sectors of the arts began "measuring" cultural consumption. These efforts were expanded to include the visual arts and they accelerated during the Great Break, when some suggested that all state art acquisition should be based on the study of viewer opinions. After the Great Break and in concert with the expansion of the Stalin cult, these utopian, scientific approaches gave way to more symbolic approaches. The visitor comment book placed at art exhibits became a kind of performance. Its primary function was to demonstrate, both to those who entered comments and to the outside world, that Soviet art was intended for the masses—that it was unlike Western, "bourgeois" art, which was meant only for a few. For some who entered comments (and for some who passed comments on scrap paper to Stalin actor Aleksei Diky on stage at a celebrity evening), the act of performing these participatory rituals provided a real sense of participation.

Just how many resources the Stalin cult mobilized and how it captivated the bodies, feelings, and dreams of people in the Soviet Union and sympathizers abroad remains puzzling to this day. The poet Joseph Brodsky was named after Stalin and slept under a photograph of Stalin in his childhood Leningrad communal apartment room of sixteen square meters, which he shared with his parents. The founder of the Moscow-Tartu school of semiotics, Yuri Lotman, supplemented his student stipend by painting Stalin portraits for factory wall

newspapers. The peasant Andrei Arzhilovsky recorded a dream in his diary less than a year before he was executed during the Great Terror in August 1937:

> Someone told me I could see Stalin. A historic figure, it would be interesting to get to see him. And so . . . A small room, simple and ordinary. Stalin is drunk as a skunk, as they say. There are only men in the room, and just two of us peasants, me and one other guy with a black beard. Without a word, Vissarionovich knocks the guy with the black beard down, covers him with a sheet and rapes him brutally. "I'm next," I think in despair, recalling the way he used to carry on in Tbilisi, and I'm thinking, how can I escape, but after his session Stalin seems to come to his senses somewhat, and he starts up a conversation, "Why were you so eager to see me personally?" "Well, why wouldn't I be? Portraits are just portraits, but a living man, and a great one at that, is something else altogether," said I. Overall, things worked out fairly well for me and they even gave me some dinner . . .

After Stalin's death the mother of the future dissident émigré Aleksandr Zino-viev cut a portrait of Stalin from the newspaper and placed it in the Bible, explaining to her son that "Stalin took on his soul everybody else's sins, that everyone is going to criticize him now and that someone has to pray for him." And Molotov, asked in the mid-1970s if he ever dreamed of Stalin, confessed, "Sometimes. In extraordinary situations. . . . In a destroyed city . . . I can't find a way out, and I meet him. In a word, very strange, confusing dreams."[5]

Why do many authors throw up their hands and describe the effects of the Stalin cult as "hysteria," "mass psychosis," and other terms indicating that they understand that they do not understand? Why did Anna Akhmatova speak of the tears people shed over Stalin as an "anesthetic" that "is wearing off?"[6] How did the human person, the creature whom Ernst Cassirer once termed a *zoon symbolikon*, a "symbolic being," frame the person at the top of that pyramid of power?[7]

A study in the alchemy of power, this book has offered an analysis of how the Stalin cult was made. It has reconstructed the processes through which the various elements of the cult were chosen, combined, and interacted. Key to the alchemical process is the assumption that the end result is a sum that amounts to more than its parts. In other words, a surplus. Stalin's elevation, his larger-than-life presence, is precisely this kind of surplus. And yet this surplus is of a different order. Ultimately we end up with a surplus of the unknowable. It, too, belongs inextricably to the alchemy of power; it is a surplus that remains beyond books.

Appendix
The Statistics of Visual Representations
of Stalin in *Pravda*

A few technical words on the quantification of Stalin representations in *Pravda* are in order before we turn to the actual numbers. I defined "visual representations" as photographs, reproductions of paintings, depictions on book covers, and portrayals in plays or movies. I counted the number of these visual representations—by month, by year, and for the entire twenty-four-year span. In addition, I made the following distinctions: Stalin on the first page or on other pages of the paper; Stalin shown alone or with others;[1] Stalin in the foreground ("direct" or "primary" representations) or in the background ("indirect" or "secondary" representations, as in a portrait on the wall, as a plaster bust, as a large, full-body sculpture, on a poster, or on a portrait carried by demonstrators).

The quantitative evolution of Stalin's image in *Pravda* looks as follows. The public Stalin cult began when Stalin turned fifty. On 21 December 1929 the entire issue of *Pravda* was devoted to Stalin's birthday. There was no slow buildup to 21 December—merely four pictures of Stalin were spread throughout the year, compared to fifteen visual depictions of Lenin in 1929. Prior to December 1929, the glorification of Stalin had always been second to that of other Bolshevik leaders such as Lenin, Trotsky, and Kalinin. Between 1930 and mid-1933 Stalin was shown rarely; when Stalin did appear, this was still registered. As Aleksandr Soloviev noted in his diary about the 1931 May Day celebrations in Moscow, "I was on Red Square. . . . On the Mausoleum there were Comrade Stalin and the members of the Politburo. . . . The demonstrators are carrying a few portraits of Comrade Stalin. Earlier it wasn't like this."[2] As for images in *Pravda*, there was a steady increase from 1931 onward (Graph App.1). He was shown 8 times in 1931, 20 times in 1932, 32 times in 1933, 68 times in 1934, and 89 times in 1935 (including both direct and indirect representations). This number dropped to 77 in 1936. In the two subsequent years it expanded greatly and reached an all-time high of 142 representations in 1939, the year of Stalin's sixtieth birthday. Still, even at this high point his image did not appear every day, as one might have expected. Nor did Stalin agree

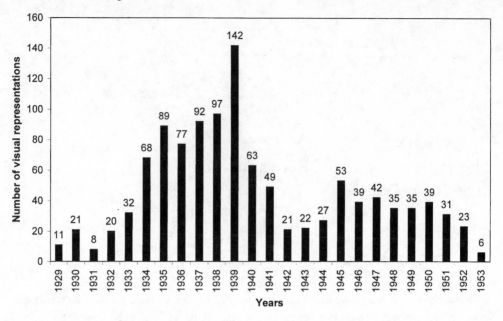

Graph App.1. Visual representations per year.

to every request to rename a mountain, town, factory, or kindergarten in his honor. Rather there was a process of distinction, of raising Stalin's value through scarcity and selective diffusion.

By Stalin's seventieth birthday in 1949, the overall number of representations of him was down to 35 images, a drop that can be explained by the move away from photography and pictures of birthday celebrations toward other media such as film and sculpture. This drop came after a period of expansion following low wartime levels (21 representations in 1942, 22 in 1943, and 27 in 1944). To illustrate the magnitude of the wartime recession, during the three years of war the combined number of depictions of Stalin (70) was less than in any single year at the high point in the second half of the 1930s. During the eight postwar years, 1945–1952, Stalin was shown on average 37.1 times per year, with numbers varying between a high of 53 in 1945 and a low of 23 in 1952. This was less than half the median number of 82.5 depictions per year during the eight years before the war, 1933–1940, even though figures oscillated between 32 in 1933 and 142 in 1939. Several things account for the lower plateau of postwar Stalin representations. On the one hand *Pravda* no longer had to take part in the making of Stalin's cult, since a canon of Stalin images had been firmly established between 1933 and the German attack on the Soviet Union in June 1941. By the end of the war Stalin was almost everywhere, not just in *Pravda*. It had become practically impossible to move through Soviet space in the course of a single day and not encounter a representation of Stalin— hence the decline in *Pravda*'s importance in diffusing such representations. But the representations of Stalin themselves changed, too. They became increasingly indirect and figurative, showing, for example, not Stalin, but a group of people with

shining faces gathered around a radio receiver, clearly engaged by listening to their leader.

In summary, the larger statistical picture shows increasing numbers after mid-1933, culminating in 1939 surrounding the celebrations of Stalin's sixtieth birthday. These years of the expansion, canonization, and diffusion of Stalin's image were followed by three years of war, during which Stalin appeared rarely in *Pravda*— likely because the war had top priority, because for so long victory was uncertain, and because linking Stalin with defeats was deemed undesirable. Conversely, giving credit to Stalin for victory was considered extremely desirable. Therefore in 1945 the number of visual representations of Stalin made a huge leap, to almost double what it had been in 1944. From then on until his death, this number hovered around 40 a year, almost half of what it had been in the mid- and late 1930s. Stalin's apotheosis had been completed, *Pravda* was but one of many media in which he was glorified, and indirect representations became increasingly important.

These statistical trends change if we differentiate between direct representations of Stalin and background representations. Again, visual background representations include painted Stalin portraits, Stalin busts (usually in plaster), colossal full-body sculptures, posters, and handicrafts such as the Stalin portrait woven into a Kirgiz carpet or the vase from a Leningrad porcelain factory. (Verbal background representations included banners with Stalin quotes; airplanes with "STALIN" painted on their wings; and airplanes formations making the name "S-T-A-L-I-N.") The all-time high of direct representations was in 1935, when Stalin appeared 80 times on the pages of *Pravda*, but there were only 9 indirect representations (Graph App.2).

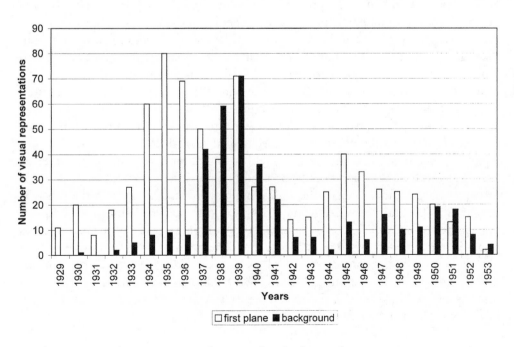

Graph App.2. Visual representations: foreground vs. background.

In his birthday year 1939, the second most saturated year, he was shown 71 times directly and 71 times indirectly. This was only logical: even if the makers of *Pravda* had wanted to show more, say, Stalin portraits on the walls of kolkhoz chairmen or factory directors, in 1935 the private and public realms of Soviet life were not suffused enough with Stalin cult products to achieve this effect. The dynamics of background representations of Stalin were as follows during the two and a half decades studied: between 1929 and 1936 hardly any background representations of Stalin appeared—an average of 4.1 per year, to be precise—because *Pravda* was primarily occupied with establishing Stalin as the Soviet leader. Between 1937 and 1941 there were many background representations of Stalin—46 per year. Sometimes indirect outweighed direct representations, partly because after the cult production drives of the mid-1930s, such as the Stalin portrait competitions we examined in Chapter 5, there were enough Stalin cult products to be placed in backgrounds. Other reasons for the increase in indirect representation were that the process of establishing Stalin as number one leader in the collective imagination had been completed, and most likely also that it was considered unsuitable to link direct representations of Stalin with the cataclysms of the purges.

During the war years there were few background representations because so many photographs and pictures were from the front lines—open spaces like fields or woods without a place to put Stalin pictures. New Stalin representations were tailored to the extraordinary circumstances of the war. In the postwar period, primary representations again outweighed secondary ones. Between 1945 and 1953 there was a total of 198 primary representations and 105 secondary representations. Between 1937 and 1941, by contrast, there had been a total of 230 secondary representations and 213 primary representations. This postwar change was due to the new monumentalism of Stalin's generalissimo image. Overall, Stalin was shown less often, but when he did appear, he did so in direct representations, on the front page, and all by himself. A scarcity of secondary representations was no longer the issue. Instead, the appearance of Stalin's image had become highly ritualized and was limited to the holidays of the annual Soviet cycle. In fact, one could argue that the greater the number of Stalin representations circulating in society, the more limited his appearance in *Pravda* had to become. There was an intrinsic connection between the potential for mechanical reproduction of a leader's countenance in the modern world and the deliberate limitation of his social presence. The more Stalin a medium could potentially supply, the greater the value of his infrequent appearance—hence the rather limited *Pravda* exposure in the postwar period. The less Stalin a medium could supply, the greater the value of his frequent appearance—hence the expansive *Pravda* exposure in 1933–1939. Cult producers themselves explicated this logic of supply and demand, of scarcity and value—much like their capitalist counterparts in Hollywood. Consider the East German Communist and editor of the journal *Ost und West*, Alfred Kantorowicz, who noted in his diary events surrounding the December 1949 celebration of Stalin's seventieth birthday in the just-founded GDR:

In the first place we are supposed to celebrate Stalin's seventieth birthday. All desks are already being flooded by Party Bureau and Kulturbund materials, three weeks before the event. We have been offered numerous celebratory articles. They are useless in their effusiveness and the epithets they employ, which incidentally only detract from the intended glorification and diminish the value of the one who is extolled. One doesn't speak of the "ingenious" Goethe, the "sublime" Marx, the "great" Beethoven, the "universal" Michelangelo. Mentioning their names is enough. But try and explain this to the courtiers and careerists. Each shouts louder than the other; their language is out of all bounds, it merely screeches, howls and shrieks, and turns somersaults.[3]

This logic is homologous not only to Stalin's "immodest modesty" but also to the logic that governed the field of "personality" in the early twentieth century, which Warren Susman has described as an "essentially antinomian vision" that placed a premium on self-expression while at the same time shunning selfishness.[4] "But the ultimate irony of that vision of personality," Simonetta Falasca-Zamponi explicates, "was actually the idea of being liked and likable, of appealing to the multitudes and attracting them, while being different from them."[5]

The statistical trends for visual representations of Stalin alone or with others are quite similar to those of primary vs. secondary representations (Graph App.3). At the outset of the cult in 1929 a scissors opened: representations with others by far outweighed those in which he was shown by himself. This scissors gradually

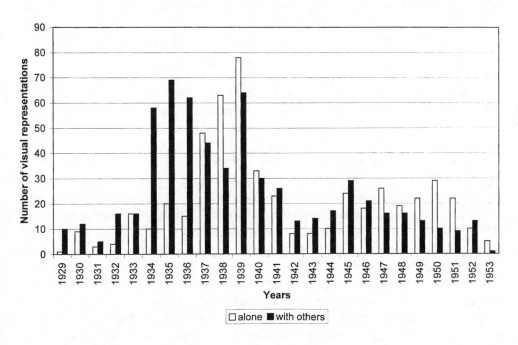

Graph App.3. Visual representations: alone vs. with others.

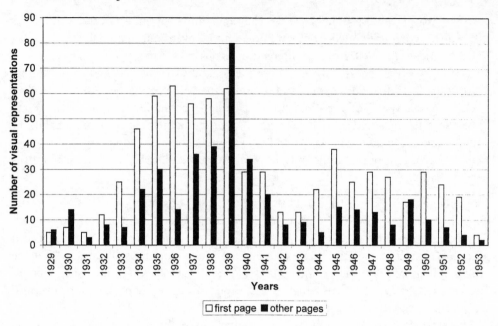

Graph App.4. Visual representations: front page vs. other pages.

closed during the years of Stalin's establishment at the top of the hierarchy, so that in 1937 for the first time ever, solitary representations prevailed over those with others. In 1938 there was an all-time high of 63 Stalin representations by himself compared with thirty-four representations with others. Stalin had become the undisputed single leader.

During the war Stalin was rarely shown, and if he was shown at all it was most often with other people like generals, diplomats, and foreign dignitaries. The postwar period, however, signaled a return to the prewar trend and in conjunction with the new, reigning monumentalism of the generalissimo image, he was shown more often by himself than with others.

The presentation of Stalin on the front page or other pages of *Pravda* shows an overwhelming preponderance of front-page representations over those on other pages (Graph App.4). Exceptions were 1929, 1930, 1939, 1940, and 1949, though for different reasons. In 1929–1930 the cult was in its fledgling period and Stalin's position was too fragile to secure for him the most sacral place, the front page of the paper. In the birthday years 1939–1940 and in 1949 there was an overflow of representations in general, and these had to be spread throughout the entire paper. To illustrate, in 1939 Stalin appeared in 80 visual representations in the body of the newspaper, as well as in 62 front-page representations.

Such is the numerical evolution of Stalin's visual image in *Pravda*. An exercise in quantitative history presupposes, of course, that one cares about the statistical side of the pictorial Stalin cult. There are serious reasons not to care. There is the consideration of actually how representative were the images? Why does this in-

quiry focus on visual rather than text-based representations? After all, *Pravda* was a newspaper, not a tabloid or a glossy magazine. Why consider images rather than text, audio (radio), or audiovisual (film) representations in general? And why does this research examine a single newspaper, which mediated but a minute fraction of the signs through which Stalin's image was projected to the public?

Then consider the issue of an image's context. Stalin might appear in a single issue of *Pravda* twice but Molotov, in conjunction with a foreign policy event, four times. In another issue Stalin might appear only once but all by himself. Statistically the former example outweighs the latter. Placement and paratext are further aspects of the larger question of context. In one issue, a majestic Stalin photograph may take up a quarter of the front-page, while in another he is shown on page four as a barely discernible plaster bust in the background of a picture of a polling station at a kolkhoz election campaign. In one issue the caption may prestructure the audience's reception of the picture, while in another there is no caption and the unrelated text of an article placed next to the picture creates unexpected meanings.

Finally, there is the issue of how the image is perceived. As reader-response theorists have been telling us since the 1970s, meanings are neither fixed nor intrinsic to signs but arise from a communicative process between sign and reader, spectator, or listener.[6] What used to be called "the receiving end" actually plays a dominant role in the construction of meaning. Hence it would make little sense to count the number of Stalin images in an issue of *Pravda* published on a sunny Saturday in May. Context tells us that the paper was left unread because most *Pravda* readers were too busy planting potatoes at their dachas—May 9 is the traditional starting day of the planting season. Similarly East Germans, faced with the public Stalin cult on the occasion of his seventieth birthday in 1949, might ascribe not the intended meanings but the meanings attached to Stalin's effigy in Nazi propaganda, seeing not the wise and benevolent "father of peoples," but the swarthy embodiment of "Judeo-Asiatic Bolshevism." As should be clear by now, there is meaning to pictures beyond numbers. This is what the book that precedes this appendix has been about.

Abbreviations and Glossary
of Frequently Used Terms

Academy of Arts of the USSR. Members appointed by the Communist Party, established in 1947.

Agitprop. Agitation and propaganda, positive term akin to "enlightenment." The Agitprop Department at the Central Committee of the Bolshevik Party was responsible for cultural affairs, including the visual arts.

AKhR. Association of Artists of the Revolution, name as from 1928 of the Association of Artists of Revolutionary Russia (AKhRR), founded in 1922. Merged with the regional bodies (e.g. MOSSKh) of the Artists' Union in 1932.

Comintern. Communist International. Founded in Moscow to promote the spread of worldwide communism, existed 1919–1943.

Committee for Arts Affairs. State body founded in 1936. Its Khudfond section took over responsibility for *kontraktatsiia* from VseKoKhudozhnik.

Cult product(ion). This book's collective designation for (the making of) Stalin portraits, posters, drawings, statues, busts, films, plays, poems, and songs.

d. delo (file) (archive).

f. fond (collection) (archive).

g. god (year).

GlavIskusstvo. Narkompros division engaged in financing visual arts production, founded in 1928.

Glavlit. Main censorship agency responsible mostly for texts and visual products, founded in 1922.

Great Break. Period of forced industrialization and collectivization of agriculture, 1928–1932. Taken from Stalin's November 1929 *Pravda* article "Year of the Great Break: On the Twelfth Anniversary of the October Revolution."

Gulag. Literally Main Administration for Corrective Labor Camps, figuratively the Soviet system of prisons and forced labor.

GTG. State Tretyakov Gallery, Moscow.

GUM. Main State Department Store, Moscow.

Ikonografiia. Iconography or sum of canonical visual representations of Stalin. The term was stripped of its Russian Orthodox religious connotations and no longer signified icon painting.

IMEL. Marx-Engels-Lenin Institute, archive of papers of key Marxists and institute for Party ideology.

Iskusstvo. Visual Arts Publishing House.

Iskusstvo. Highbrow thick journal for the visual arts, launched in 1933.

Izo. Visual Arts Department of Narkompros. The main distributor of limited state resources for painters during the 1920s.

IZOGIZ. Visual Arts Publishing House. Subordinate to GlavIskusstvo.

Izokombinat. Visual art factory, responsible for the industrial production of Stalin statues, busts, portraits, etc. Visual art factories were first established in the 1930s.

Khudfond. Art Fund, part of Committee for Arts Affairs, founded in 1936. Took over responsibility for *kontraktatsiia* from VseKoKhudozhnik.

Khudsovet. Art soviet. Jury-like collective body for judging art in various organizations.

Kniga otzyvov. Visitors' comment book at exhibitions.

Kolkhoz. Collective farm.

Komsomol. Communist Youth League.

Kontraktatsiia. System of commissioning and paying for visual art.

Kruzhok, kruzhki. Intelligentsia circle(s) of students, artists, Bolsheviks, etc.

Kulak. Rich peasant.

l., ll. list, listy (folio, folios) (archive).

Lenin Museum. Moscow museum of the life and work of Lenin that also housed Stalin art.

LOSSKh. Leningrad Section of the Union of Soviet Artists, subsumed under unified Artists' Union in 1957.

Lubok. Popular print. Cheap print medium in prerevolutionary Russia.

Maslovka. Artist housing and studio complex on Upper Maslovka Street in Northern Moscow, opened in 1930.

M Br I. I. Brodsky Apartment Museum, Scientific Research Museum of the Russian Academy of Arts, St. Petersburg (archive).

MOSSKh. Moscow Section of the Union of Soviet Artists, founded in 1932, renamed Moscow Union of Soviet Artists (MSSKh) in 1938, subsumed under unified Artists' Union in 1957.

Mossovet. Moscow City Soviet.

Museum of the Revolution. Moscow museum, housed Stalin art.

Narkompros. People's Commissariat of Enlightenment, in charge of education and culture.

Naturshchik. Sitter for portraits, substituting for the actual person.

NEP. New Economic Policy, 1921–1928. Period of partial return to a market economy following the Civil War; often used as a general term for the period in Soviet history between the Civil War and the Great Break.

NKVD. People's Commissariat of Internal Affairs, name of the ministry in charge, among other areas, of the Soviet secret police, 1934–1946; often used as a general name for the secret police.

ob. oborot (verso) (archive).

Oblast. Administrative unit roughly equivalent to a province.

Obraz(y). Stock image(s) for portraying Stalin, e.g. "father of peoples," "generalissimo" or "coryphaeus of science." The term was stripped of its Russian Orthodox religious connotations.

Old Bolshevik. Person who had been a member of the Bolshevik Party before the October Revolution.

op. opis' (inventory) (archive).

OR GTG. Manuscript Division, State Tretyakov Gallery, Moscow (archive).

OSt. Society of Easel Painters, nonfigurative artist movement, 1925–1931.

Palace of Soviets. Tall building in central Moscow for which Cathedral of Christ the Redeemer was destroyed. Never built.

Peredvizhniki. Wanderers, a group of prerevolutionary realist artists named after the itinerant exhibitions around which they coalesced in the 1870s. They existed until 1923, when they joined AKhRR.

Politburo. Governing body, part of the Central Committee.

Proletkult. Proletarian Culture movement (founded on 20 January 1918 and subsumed in the Party in November 1922).

Pushkin Fine Arts Museum. Moscow museum housing Western art.

RABIS. Union of Art Workers. Disbursed "soft benefits," such as vacations.

Repin Institute. Renamed Leningrad Academy of Arts (founded in 1932, renamed in 1944). Included art university (Art VUZ), art history institute, museum, library, and laboratories. Subsumed under the USSR Academy of Arts in 1947.

RGALI. Russian State Archive of Literature and Art, Moscow (archive).

RGANI. Russian State Archive of Contemporary History, Moscow (archive).

RGASPI. Russian State Archive for Social and Political History, Moscow (archive).

ROSTA. Russian Telegraph Agency. News agency of the RSFSR, 1918–1935. Responsible for "ROSTA Windows" posters.

RSDRP. Russian Socialist Democratic Workers' Party.

RSFSR. Russian Soviet Federative Socialist Republic.

Russian Museum. Leningrad art museum.

RVSR. Also Revvoensovet. Revolutionary Military Council of the Republic. Supreme military authority, 1918–1934. Headed by Voroshilov 1925–1934.

Secretariat. Stalin's main office, as part of his General Secretary post of the Bolshevik Party. Formally a special section of the Central Committee, de facto one of the most powerful institutions in the USSR.

Shtiglits Art College. Leningrad institution of undergraduate art education.

Sovetskoe Iskusstvo. Culture newspaper for visual artists. Appeared twice a week for most of its existence from 1931 onward.

Sovnarkom. Council of People's Commissars. Governing body.

Stakhanovism. Productivity-raising measures to overfulfill the plan, implemented in 1935, named after a coal miner. Closely linked with shock work and socialist competition.

Stroganov Art College. Moscow institution of undergraduate art education.

Surikov Institute. Moscow Art Institute (renamed as such in 1948, opened in 1936 as the Moscow Institute of Visual Art and called the Moscow State Art Institute 1940–1948).

TASS. Soviet News agency.

Thick journal. Journal dealing with political, social, and cultural affairs—"thick" in the sense of "lengthy." Such journals have been an important intellectual forum for Russian intelligentsia since the nineteenth century.

TsDRI. Central House of Art Workers, Moscow. A club-like establishment for members of the artistic intelligentsia, especially artists and actors.

TsIK. Central Executive Committee. Highest governing body of Soviet state (not Party), 1922–1938.

TsK VKP(b). Central Committee of the Bolshevik Party.

Tvorchestvo. Visual arts thick journal, more heavily illustrated than Iskusstvo and geared toward a wider artist audience, including amateur painters. Launched in 1933.

VKP(b). All-Union Communist Party (Bolsheviks). Name of the Soviet Communist Party 1925–1952.

Vozhd', vozhdi. Leader(s), a term reminiscent of the Italian Duce or the German Führer. Applied not just to Stalin, but also to other high-ranking Bolsheviks.

VseKoKhudozhnik. All-Russian Cooperative Comradeship "Artist." Subordinate to GlavIskusstvo.

Notes

INTRODUCTION

1. Iurii Borev, *Staliniada: Memuary po chuzhim vospominaniiam s istoricheskimi prichtami i razmyshleniiami avtora* (Moscow: Kniga, 1991), 226. For another version see Vasily Grossman, *Life and Fate* (New York: New York Review Books, 2006), 765–766. On Kavtaradze's Gulag sentence see Robert Conquest, *The Great Terror: A Reassessment* (New York: Oxford University Press, 1990), 68.

2. Simon Sebag Montefiore, *Stalin: The Court of the Red Tsar* (London: Weidenfeld and Nicolson, 2003), 4. For another version see Evgeny Dobrenko, "Mezhdu istoriei i proshlym: Pisatel' Stalin i literaturnye istoki sovetskogo istoricheskogo diskursa," in *Sotsrealisticheskii kanon,* ed. Evgeny Dobrenko and Hans Günther (St. Petersburg: Gumanitarnoe agenstvo 'Akademicheskii proekt,' 2000), 651.

3. The story about the Moscow students is recounted by Zdeněk Mlynář, a major player in the Prague Spring: Zdenek Mlynarzh, *Moroz udaril iz Kremlia* (Moscow: "Republika," 1992), 18–19 (I am grateful to Elena Zubkova for reminding me of this source); on Kahlo see Patrick Marnham, *Dreaming with His Eyes Open: A Life of Diego Rivera* (New York: Knopf, 1998), 310; on Pasternak see diarist Kornei Chukovsky quoted in Irina Paperno, "Intimacy with Power: Soviet Memoirists Remember Stalin," in *Personality Cults in Stalinism—Personenkulte im Stalinismus,* ed. Klaus Heller and Jan Plamper (Göttingen: Vandenhoeck & Ruprecht unipress, 2004), 332; Bukovsky's nightmare is in Vladimir Bukovsky, *To Build a Castle: My Life as a Dissenter* (New York: Viking, 1978), 81–83; for heart attacks: a week after Stalin's death a group of women from Kuibyshev oblast wrote to Molotov, "The day that I. V. Stalin was buried, there was such grief that many of us were brought to emergency rooms with heart attacks." RGASPI, f. 82, op. 2, d. 1465, l. 82. Dated 13 March 1953. Eugenia Ginzburg recounted heart attacks even among Gulag internees. See Eugenia Ginzburg, *Within the Whirlwind,* trans. Ian Boland (New York: Harcourt Brace Jovanovich, 1981), 358.

4. Clifford Geertz, "Centers, Kings, and Charisma: Reflections on the Symbolics of Power," in *Local Knowledge* (New York: Basic, 1983), 124.

5. Several authors share a similar practice-oriented approach to Soviet culture— grounded in archival work and exhibiting a range of theoretical influences, among them Pierre Bourdieu's praxeological sociology, New Historicist literary criticism, historiography in the vein of Michel de Certeau, and social history of art à la Michael Baxandall. See es-

pecially Thomas Lahusen, *How Life Writes the Book: Real Socialism and Socialist Realism in Stalin's Russia* (Ithaca: Cornell University Press, 1997), but also Maria Gough, *The Artist as Producer: Russian Constructivism in Revolution* (Berkeley: University of California Press, 2005); Galina Iankovskaia, *Iskusstvo, den'gi i politika: Khudozhnik v gody pozdnego stalinizma* (Perm: Perm'skii gosudarstvennyi universitet 2007); Oliver Johnson, "Aleksandr Laktionov: A Soviet Artist" (D.Phil. diss., University of Sheffield, 2008); Catriona Kelly and David Shepherd, eds., *Russian Cultural Studies: An Introduction* (New York: Oxford University Press, 1998); Christina Kiaer, *Imagine No Possessions: The Socialist Objects of Russian Constructivism* (Cambridge, Mass.: MIT Press, 2005); Valerie A. Kivelson and Joan Neuberger, eds., *Picturing Russia: Explorations in Visual Culture* (New Haven: Yale University Press, 2008); Susan E. Reid, "All Stalin's Women: Gender and Power in Soviet Art of the 1930s," *Slavic Review* 57, no. 1 (1998): 133–173; and Kirill Tomoff, *Creative Union: The Professional Organization of Soviet Composers, 1939–1953* (Ithaca: Cornell University Press, 2006). For a landmark study of the sociology of art see Howard Becker, *Art Worlds* (Berkeley: University of California Press, 1982).

6. See Benno Ennker, "Politische Herrschaft und Stalinkult 1929–1939," in *Stalinismus: Neue Forschungen und Konzepte,* ed. Stefan Plaggenborg (Berlin: Arno Spitz, 1998), 166; Ennker, "'Struggling for Stalin's Soul': The Leader Cult and the Balance of Power in Stalin's Inner Circle," in *Personality Cults in Stalinism,* ed. Heller and Plamper, 165–166; James L. Heizer, "The Cult of Stalin, 1929–1939" (Ph.D. diss., University of Kentucky, 1977), 80, 99, 138. For the thesis that intra-Party opposition to Stalin's single leadership first had to be quelled and that "After the Central Committee plenum in January 1933, there was an extraordinary intensification of Stalin worship," see Roy Medvedev, *Let History Judge: The Origins and Consequences of Stalinism,* ed. and trans. George Shriver (New York: Columbia University Press, 1989), 315.

7. On the aftermath and dismantling of the Stalin cult see the work of Polly Jones, e.g., "Strategies of De-Mythologisation in Post-Stalinism and Post-Communism: A Comparison of De-Stalinisation and De-Leninisation" (D.Phil. diss., University of Oxford, 2002).

8. Understanding how the visual Stalin cult worked in other parts of the multiethnic Soviet Union will depend on the completion of local studies. In particular, one hopes that future research will flesh out the specifics of Stalin's depiction in the Muslim parts of the Soviet empire where the Islamic prohibition on the depiction of human beings held sway.

9. Males and females above the age of seven years. See *The Soviet Union: Facts, Descriptions, Statistics* (Washington, D.C.: Soviet Union Information Bureau, 1929), 208.

10. I owe this point to a conversation with Hans Günther in Berkeley, 1998. Also see Rolf Hellebust, "Reflections of an Absence: Novelistic Portraits of Stalin before 1953," in *Socialist Realism Revisited: Selected Papers from the McMaster Conference,* ed. Nina Kolesnikoff and Walter Smyrniw (Hamilton, Ont.: McMaster University, 1994), 111–120. On the socialist realist novel as bildungsroman see Katerina Clark, *The Soviet Novel: History as Ritual* (Chicago: University of Chicago Press, 1981), 16–17, 57.

11. There are exceptions. Kazimir Lisovskii, *V Turukhanskoi ssylke* (Novosibirsk: Novosibgiz, 1947), deals with Stalin's escape from his Siberian place of exile. Many Stalinist novels include the hero's trip from the periphery to the center, i.e. to Stalin in Moscow. See Rosalind Marsh, *Images of Dictatorship: Portraits of Stalin in Literature* (London: Routledge & Kegan Paul, 1989), 39.

12. On Marianne see Maurice Agulhon, *Marianne au combat: L'imagerie et la symbolique républicaines de 1789 à 1880* (Paris: Flammarion, 1979); Agulhon, *Marianne au pouvoir: L'imagerie et la symbolique républicaines de 1880 à 1914* (Paris: Flammarion, 1989). On German Hermann see Andreas Dörner, *Politischer Mythos und symbolische Politik: Sinnstiftung durch symbolische Formen am Beispiel des Hermannsmythos* (Opladen: Westdeutscher Verlag, 1995); on German Michel see Tomasz Szarota, *Der deutsche Michel: Die Geschichte eines nationalen Symbols und Autostereotyps* (Osnabrück: fibre, 1998).

13. Edward Shils, *Center and Periphery: Essays in Macrosociology* (Chicago: University of Chicago Press, 1975), 3. Shils goes on to specify the universality of "the sacred" by claiming that "every society has an 'official' religion, even when that society or its exponents and interpreters, conceive of it, more or less correctly, as a secular, pluralistic, and tolerant society."

14. Ibid., 5. Clifford Geertz reiterates the axiom of "the inherent sacredness of central authority" and adds his own, "the ingenerate tendency of men to anthropomorphize power." Geertz, "Centers, Kings, and Charisma," 146, 124.

15. Philippe Burrin has also criticized the axiomatic approach to sacrality and convincingly argued that it is "important to avoid speaking of a 'transfer' or 'displacement' of the sacred, as if the sacred were a fixed substance that attaches itself to different objects in different epochs." See Philippe Burrin, "Political Religion: The Relevance of a Concept," *History and Memory* 9, nos. 1–2 (1997): 345 n. 16.

16. On "charisma" and "charismatic authority" see Max Weber, *Economy and Society: An Outline of Interpretive Sociology,* ed. Guenther Roth and Claus Wittich, vol. 3 (New York: Bedminster Press, 1968), 1111–1156. On further problems of Weber's "charisma" concept see Jan Plamper, "Introduction: Modern Personality Cults," in *Personality Cults in Stalinism,* ed. Heller and Plamper, 34–37. For an application of the charisma concept to Soviet leader cults, see Carsten Goehrke, "Lenin, Stalin, Gorbatschow—Charisma und Sowjetherrschaft," in *Charisma: Revolutionäre Macht im individuellen und kollektiven Erleben,* ed. Walter Jacob (Zurich: Chronos, 1999), 117–137.

17. For a deployment of Turner's "communitas" that describes an antistructure sociability that can turn into structure, see Barbara Walker's *Maximilian Voloshin and the Russian Literary Circle: Culture and Survival in Revolutionary Times* (Bloomington: Indiana University Press, 2005). For an exploration of the similarities and differences between Weber's "charisma" and Turner's "communitas" see Winfried Gebhardt, *Charisma als Lebensform: Zur Soziologie des alternativen Lebens* (Berlin: Dietrich Reimer, 1994), 182–187.

18. This approach has recently been most dominant and is represented by Michael Burleigh, Emilio Gentile, Philippe Burrin, and Klaus Vondung, who are indebted not only to Durkheim and Voegelin, but also to Karl Löwith, Carl Schmitt, and Jacob Talmon. Its main forum is the journal *Totalitarian Movements and Political Religions,* founded in 2000. For an overview of this literature, see David D. Roberts, "'Political Religion' and the Totalitarian Departures of Inter-war Europe: On the Uses and Disadvantages of an Analytical Category," *Contemporary European History* 18, no. 4 (2009): 381–414.

19. For a like-minded plea to situate the Soviet Union in a wider modern context while not losing sight of its particularities, see Michael David-Fox, "Multiple Modernities vs. Neo-Traditionalism: On Recent Debates in Russian and Soviet History," *Jahrbücher für Geschichte Osteuropas* 55, no. 4 (2006): 535–555.

20. There is a considerable historiography on the ripple effects of the Enlightenment's and the French Revolution's attack on monarchic sacrality. Those who have argued for the rationalization and secularization of society and the desacralization of monarchy go back to Michael Walzer, *Regicide and Revolution: Speeches at the Trial of Louis XVI* (Cambridge: Cambridge University Press, 1974). Those who have posited the "transfer" or rechanneling of sacral aura to alternative spheres favor an approach to modern ideologies of "political religion" or "political theology" (see above, note 15).

21. See Claude Lefort, "The Image of the Body and Totalitarianism," in Lefort, *The Political Forms of Modern Society* (Cambridge, Mass.: MIT Press, 1986), 292–306. George Mosse has also noted that from approximately the beginning of the nineteenth century, national myths and symbols coalesced into a secular religion that "attempted to draw the people into active participation in the national mystique through rites and festivals, myths and symbols which gave a concrete expression to the general will. . . . The new politics provided an objectification of the general will; it transformed political action into a drama

supposedly shared by the people themselves." See George L. Mosse, *The Nationalization of the Masses: Political Symbolism and Mass Movements in Germany from the Napoleonic Wars Through the Third Reich* (New York: H. Fertig, 1975), 1–2.

22. See the classical study by Ernst Kantorowicz, *The King's Two Bodies: A Study in Medieval Political Theology* (Princeton: Princeton University Press, 1957). More generally see David G. Hale, "Analogy of the Body Politic," in *Dictionary of the History of Ideas*, ed. Philip P. Wiener, vol. 1 (New York: Scribner, 1973), 67–70. For an application of Kantorowicz to the Lenin and Stalin cults see Victoria Bonnell, *Iconography of Power: Soviet Political Posters Under Lenin and Stalin* (Berkeley: University of California Press, 1997), chap. 4.

23. I borrow "patricentric" from John Borneman, "Introduction: Theorizing Regime Ends," in *Death of the Father: An Anthropology of the End in Political Authority*, ed. John Borneman (New York: Berghahn, 2004), 3.

24. The cult of Argentina's Evita Perón, which comes closest to qualifying, was mostly posthumous and surrounded someone who did not come to power as a politician but as a politician's spouse.

25. For the first archivally based study of this commission, see Benno Ennker, *Die Anfänge des Leninkults in der Sowjetunion* (Cologne: Böhlau, 1997).

CHAPTER 1. PATHS TO THE STALIN CULT

1. L. Trotskii, "Stalinskaia biurokratiia i ubiistvo Kirova: Otvet amerikanskim druz'iam," *Biulleten' Oppozitsii (bol'shevikov-lenintsev)* 7, no. 41 (January 1935): 7 (reprinted as *Biulleten' Oppozitsii*, vol. 3 [New York: Monad Press, 1973]).

2. For exceptions see, for example, David Brandenberger, "Stalin as Symbol: A Case Study of the Personality Cult and Its Construction," in *Stalin: A New History*, ed. Sarah Davies and James Harris (Cambridge: Cambridge University Press, 2005), 249–270.

3. As Moshe Lewin, one of the foremost "revisionist" historians of Soviet Russia, wrote: "Not much effort is needed to relate the 'Stalin cult' to this broader strategy of 'sanctifying' the state. The Stalin cult became a linchpin in this revamped secular orthodoxy. Sermons, vows, adulation, and panegyrics contributed a peculiar 'Byzantine' flavor to the neo-autocracy." Moshe Lewin, *The Making of the Soviet System: Essays in the Social History of Interwar Russia* (New York: Pantheon, 1985), 306. Also consider Richard Stites: "Stalin's utopia of the 1930s, with all its military and industrial achievement, its welfare infrastructure, and its mass education, was in part an archaic throwback to pre-modern forms of myth. And at the center of this archaic myth system was the cult of Stalin." Richard Stites, "Stalin: Utopian or Antiutopian? An Indirect Look at the Cult of Personality," in *The Cult of Power: Dictators in the Twentieth Century*, ed. Joseph Held (Boulder: East European Monographs, 1983), 86; Eric Hobsbawm: "In turning himself into something like a secular Tsar, defender of the secular Orthodox faith, the body of whose founder, transformed into a secular saint, awaited the pilgrims outside the Kremlin, Stalin showed a sound sense of public relations. For a collection of peasant and animal-herding peoples mentally living in the Western equivalent of the eleventh century, this was almost certainly the most effective way of establishing the legitimacy of the new regime." Eric Hobsbawm, *The Age of Extremes: The Short Twentieth Century, 1914–1991* (New York: Penguin, 1994), 390; Tony Judt after quoting a 1951 Latvian Stalin poem: "This obsequious neo-Byzantine anointing of the despot, the attribution to him of near-magical powers . . ." *Postwar: A History of Europe since 1945* (New York: Penguin, 2005), 175.

4. See, for example, Robert C. Tucker, *Stalin in Power: The Revolution from Above, 1928–1941* (New York: W. W. Norton, 1990), chap. 7. "Extreme self-idealizing such as that seen in Stalin inescapably leads to conflict—within the person and with others. Being at best humanly limited and fallible, such an individual is bound in practice, in his actual self and his performance, to fall short of the ideal self's standards of perfection and supremely

ambitious goals of achievement and glory. He will make mistakes, very likely all the greater because of his need to score only spectacular triumphs. For all this he will unconsciously accuse, berate, condemn, and despise himself—unconsciously because he can admit into awareness only those aspects of himself and his life that are, or appear to be, in keeping with his ideal self or that can be rationalized comfortably with its dictates" (p. 162). "So it was that the inner needs of a self-glorifying and vengeful leader were being institutionalized in public life and the workings of the governmental system" (p. 171).

5. See, for example, Benno Ennker, "The Stalin Cult, Bolshevik Rule, and Kremlin Interaction in the 1930s," in *The Leader Cult in Communist Dictatorships: Stalin and the Eastern Bloc*, ed. Balázs Apor et al. (Basingstoke: Palgrave, 2004), 83–101.

6. See, for example, Graeme Gill, "The Soviet Leader Cult: Reflections on the Structure of Leadership in the Soviet Union," *British Journal of Political Science* 10, no. 2 (1980): 167–186; Gill, "Personality Cult, Political Culture and Party Structure," *Studies in Comparative Communism* 17, no. 2 (1984): 111–121; Gill, *The Origins of the Stalinist Political System* (Cambridge: Cambridge University Press, 1990); Christel Lane, *The Rites of Rulers* (Cambridge: Cambridge University Press, 1981), esp. 204–221, 277–278; Jeremy T. Paltiel, "The Cult of Personality: Some Comparative Reflections on Political Culture in Leninist Regimes," *Studies in Comparative Communism* 16, nos. 1–2 (1983): 49–64. For contemporary public relations or branding approaches, see Lorraine E. Gayer, "Power, Purchase and Persuasion. Stalin: The Creation of an Image" (M.A. thesis, California State University, Dominguez Hills, 2004); Steven Heller, *Iron Fists: Branding the 20th-Century Totalitarian State* (London: Phaidon, 2008), esp. 152–169.

7. See, for example, Reinhard Löhmann, *Der Stalinmythos: Studien zur Geschichte des Personenkultes in der Sowjetunion (1929–1935)* (Münster: Lit, 1990). On the *vydvizhentsy* and upward mobility more generally see Sheila Fitzpatrick's *Education and Social Mobility in the Soviet Union, 1921–1934* (Cambridge: Cambridge University Press, 1979). The "social integration" explanation ultimately goes back to Ferdinand Tönnies, *Community and Association* (London: Routledge and Paul, 1955), originally published in German in 1926, and Richard Sennett, *The Fall of Public Man* (New York: Knopf, 1976). It is also at the root of defining socialist realism as kitsch or the aesthetic manifestation of middlebrow, petty bourgeois taste, as in Vera Dunham, *In Stalin's Time: Middleclass Values in Soviet Fiction*, enlarged and updated edition (Durham, N.C.: Duke University Press, 1990), which is usually traced back to Clement Greenberg, "Avant-Garde and Kitsch," *Partisan Review* 5, no. 5 (1939): 34–49. Greenberg later disavowed this essay as "too simplistic." Saul Ostrow, "'Avant-Garde and Kitsch,' Fifty Years Later: A Conversation with Clement Greenberg on the Fiftieth Anniversary of His Seminal Essay," *Arts Magazine* 64 (December 1989): 56.

8. Carl Friedrich and Zbigniew Brzezinski called the cult of the leader one of the six characteristics of a totalitarian state. See Carl J. Friedrich and Zbigniew K. Brzezinski, *Totalitarian Dictatorship and Autocracy* (Cambridge, Mass.: Harvard University Press, 1956). Consider also Hannah Arendt's well-known formulation: "In the center of the movement, as the motor that swings it into motion, sits the Leader. He is separated from the elite formation by an inner circle of the initiated who spread around him an aura of impenetrable mystery which corresponds to his 'intangible preponderance.' His position within this intimate circle depends upon his ability to spin intrigues among its members and upon his skill in constantly changing its personnel. He owes his rise to leadership to an extreme ability to handle inner-party struggles for power rather than to demagogic or bureaucratic-organizational qualities. . . . The totalitarian movements have been called 'secret societies established in broad daylight.' . . . Perhaps the most striking similarity between the secret societies and the totalitarian movements lies in the role of the ritual. The marches around Red Square in Moscow are in this respect no less characteristic than the pompous formalities of the Nuremberg party days. . . . These similarities are not, of course, accidental; they cannot

simply be explained by the fact that both Hitler and Stalin had been members of modern secret societies before they became totalitarian leaders—Hitler in the secret service of the Reichswehr and Stalin in the conspiratorial section of the Bolshevik party. They are to some extent the natural outcome of the conspiracy fiction of totalitarianism whose organizations supposedly have been founded to counteract secret societies—the secret society of the Jews or the conspiratory society of the Trotskyites." Hannah Arendt, *The Origins of Totalitarianism* (New York: Harcourt, Brace and Company, 1951), 361–365.

9. See especially Bernice Glatzer Rosenthal, *New Myth, New World: From Nietzsche to Stalinism* (University Park: Pennsylvania State University Press, 2002), 238–243, 360, 364, 372–394, 424–425; Vladimir Papernyi, *Kul'tura "Dva"* (Moscow: Novoe literaturnoe obozrenie, 1996), 119–121, 134–135, 156, 185–186.

10. For examples see the classic by Nikolai Berdyaev, *The Origin of Russian Communism,* trans. R. M. French (London: Centenary Press, 1937) and the work of Klaus-Georg Riegel, e.g. "Marxism-Leninism as a Political Religion," *Totalitarian Movements and Political Religions* 6, no. 1 (2005): 97–126.

11. See also Benno Ennker and Heidi Hein-Kircher, eds., *Der Führer im Europa des 20. Jahrhunderts* (Marburg: Herder-Institut, 2010), which comprises articles on Fascist (Mussolini, Franco, Dollfuß), Nazi (Hitler, Koch, Pavelić), Soviet (Stalin, Iaroslavsky, Brezhnev), but also Baltic (Smetona), East-Central European (Tiso, Ceauşescu) and Balkan (Tito, Hoxha) leader cults. The volume was published after I finished working on this book.

12. On the influence of Napoleon III's image on the presentation of Alexander II see Richard Wortman, *Scenarios of Power: Myth and Ceremony in Russian Monarchy,* vol. 2 (Princeton: Princeton University Press, 2000), 24–25.

13. Matthew Truesdell, *Spectacular Politics: Louis-Napoleon Bonaparte and the* Fête Impériale, *1849–1870* (New York: Oxford University Press, 1997), vii.

14. Ibid., 164.

15. Ibid.

16. Ibid., 27, chap. 6, 59.

17. Ibid., 53, 58.

18. Ibid., 67, 79–80.

19. Ibid., 35. Truesdell explains the downfall of the Republic partly as the result of symbolic dilemma, for the republicans had not managed "to create republican forms of festivity that were viable alternatives to the monarchical forms that gave central symbolic place to one man." And unlike the monarchists, the republicans were deeply divided among themselves, giving Louis-Napoleon ample opportunity to present himself as being above political divisions altogether. See ibid., 33.

20. Ibid., 75–76.

21. Ibid., 96, 152, 166.

22. Ibid., 78.

23. Ibid., 36–37.

24. Ibid., 10, 22, 51–52. Chap. 9 documents "rituals of opposition" to Napoleon III's symbolic politics, consisting either of the subversion of Imperial spectacles or of the staging of alternative spectacles.

25. On this see Pierre Bourdieu, "The Production and Reproduction of Legitimate Language," in *Language and Symbolic Power,* trans. Gino Raymond and Matthew Adamson (Cambridge, Mass.: Harvard University Press, 1991), 43–65; Marshall McLuhan, *Understanding Media: The Extensions of Man* (Cambridge, Mass.: MIT Press, 1996), 14; Benedict Anderson, *Imagined Communities: Reflections on the Origin and Spread of Nationalism* (London: Verso, 1983); Eugene Weber, *Peasants into Frenchmen: The Modernization of Rural France* (Stanford: Stanford University Press, 1979).

26. See Peter Burke, *The Fabrication of Louis XIV* (New Haven: Yale University Press, 1992).

27. A study on the resilience of premodern monarchic ritual in the German states well into the nineteenth century lends support to this chronology and definition of the modern personality cult. See Hubertus Büschel, *Untertanenliebe: Der Kult um deutsche Monarchen 1770–1830* (Göttingen: Vandenhoeck & Ruprecht, 2006).

28. Wortman, *Scenarios of Power*, vol. 2, 211.

29. The familial image was, however, different from Nicholas I's domestic scenario in that Alexander III's family members functioned not as independent subjects in monarchic representations, but as objects of the tsar's affection. Not the tsar's family, but the tsar's family life, apart from public ceremonies, assumed a sacred character. Thus Alexander III was the first tsar to adhere to the Western middle-class ideal of separate private vs. public lives. See ibid., 278–279.

30. Ibid.

31. Ibid., 183, 214, 221, 230–231.

32. Ibid., 383.

33. Ibid., 344. At the coronation, the national element of monarchic representations had also been expanded, with the tsar and his wife changing—as the first royal couple since Peter I—from Western dress to Russian dress at the ball. See ibid., 378.

34. Ibid., 366.

35. Ibid., 421 (emphasis in original).

36. The numbers of printed verbal and visual depictions of the tsar increased tremendously and spread throughout the countryside through the network of outlets of Ivan Sytin's publishing house. See ibid., 488.

37. Ibid., 501.

38. For another study of the rupture of the bond between the tsar and his subjects between 1861 and 1917, much of it based on an analysis of petitions to the special Chancellery of His Imperial Highness for the Receipt of Petitions, see G. V. Lobacheva, *Samoderzhets i Rossiia: Obraz tsaria v massovom soznanii rossiian (konets XIX–nachalo XX vekov)* (Saratov: Saratovskii Tekhnicheskii Universitet, 1999).

39. The phrase "royal carryover" is in Truesdell, *Spectacular Politics,* 18.

40. Quoted in D. L. Brandenberger and A. M. Dubrovsky, "'The People Need a Tsar': The Emergence of National Bolshevism as Stalinist Ideology, 1931–1941," *Europe-Asia Studies* 50, no. 5 (1998): 873 (and for a careful attribution of the source 884 n. 4). Brandenberger and Dubrovsky interpret the quote as testifying to Stalin's étatism rather than his tolerance of Bolshevik personality cult inspired by a tsar cult.

41. Thanks to John G. Ackerman for coining the phrase "the revenge of Muscovy" in a 13 November 2004 letter. Boris Souvarine spoke of the Stalin cult as "historic atavism of ancient Muscovy." Boris Souvarine, *Stalin: A Critical Survey of Bolshevism,* trans. C. L. R. James (New York: Alliance, 1939), 510.

42. See Daniel Field, *Rebels in the Name of the Tsar* (Boston: Houghton Mifflin, 1976), 1–26.

43. On Russia and mass society in the wake of the Great War see Stephen Kotkin, "Modern Times: The Soviet Union and the Interwar Conjuncture," *Kritika: Explorations in Russian and Eurasian History* 2, no. 1 (2001): 111–164, esp. 127–137, and David L. Hoffmann, *Cultivating the Masses: Modern State Practices and Soviet Socialism, [1914–1939]* (Ithaca: Cornell University Press, 2011).

44. Warren Susman's argument about the rise of individual personality as a value in mass society is elaborated in Simonetta Falasca-Zamponi, "The 'Culture' of Personality: Mussolini and the Cinematic Imagination," in *Personality Cults in Stalinism,* ed. Heller and Plamper, 83–107.

45. Quoted in Orlando Figes, *A People's Tragedy: The Russian Revolution 1891–1924* (London: PIMLICO, 1997), 350.

46. Ibid., 351.

47. On the Kerensky cult see ibid., 338, 437–438, 448–449. Further see A. G. Golikov, "Fenomen Kerenskogo," *Otechestvennaia istoriia*, no. 5 (1992): 60–73; Orlando Figes and Boris Kolonitskii, *Interpreting the Russian Revolution: The Language and Symbols of 1917* (New Haven: Yale University Press, 1999), chap. 3; Boris Kolonitskii, *Simvoly vlasti i bor'ba za vlast': K izucheniiu politicheskoi kul'tury rossiiskoi revoliutsii 1917 goda* (St. Petersburg: Dmitrii Bulanin, 2001); Kolonitskii, "'Democracy' in the Political Consciousness of the February Revolution," *Slavic Review* 57, no. 1 (1998): 95–106, esp. 105; Kolonitskii, "K izucheniiu mekhanizma desakralizatsii monarkhii (Slukhi i 'politicheskaia pornografiia' v gody Pervoi mirovoi voiny)," in *Istorik i revoliutsiia: Sbornik statei k 70-letiiu so dnia rozhdeniia Olega Nikolaevicha Znamenskogo*, ed. N. N. Smirnov, B. I. Kolonitskii, and V. Iu. Cherniaev (St. Petersburg: Dmitrii Bulanin, 1999), 72–86; Kolonitskii, "'We' and 'I': Alexander Kerensky in His Speeches," in *Autobiographical Practices in Russia—Autobiographische Praktiken in Russland*, ed. Jochen Hellbeck and Klaus Heller (Göttingen: Vandenhoeck & Ruprecht unipress, 2004), 179–196.

48. Figes, *A People's Tragedy*, 442–443.

49. Kolonitskii also emphasizes the interrelatedness of all Bolshevik cults—of Trotsky, Lenin, and those of Red Civil War field commanders. Boris Kolonitskii, 8 September 2009 and 16 August 2010 email communications.

50. Mussolini's cult rule was preceded by Gabriele D'Annunzio's rule in Fiume during 1919–1920, in which the poet tried to overcome the specter of parliamentary democratic politics with harmonizing, unifying aesthetics, spectacle, symbols, oratory, and crowd hypnosis. On D'Annunzio's cult see Michael A. Ledeen, *The First Duce: D'Annunzio at Fiume* (Baltimore: Johns Hopkins University Press, 1977); Charles S. Maier, *Recasting Bourgeois Europe: Stabilization in France, Germany, and Italy in the Decade after World War I* (Princeton: Princeton University Press, 1975), 114–134.

51. Mussolini quoted in Simonetta Falasca-Zamponi, *Fascist Spectacle: The Aesthetics of Power in Mussolini's Italy* (Berkeley: University of California Press, 1997), 33. On Mussolini's cult also see R. J. B. Bosworth, *The Italian Dictatorship: Problems and Perspectives in the Interpretation of Mussolini and Fascism* (London: Edward Arnold, 1998); "Charisma and the Cult of Personality in Modern Italy," special issue, *Modern Italy* 3, no. 2 (1998). On public spectacles, including those involving the Mussolini cult, see Mabel Berezin, *Making the Fascist Self: The Political Culture of Interwar Italy* (Ithaca: Cornell University Press, 1997). For a review of literature on Italian Fascist culture, symbols, myths, rituals, and cults see Roger Griffin, "The Primacy of Culture: The Current Growth (or Manufacture) of Consensus within Fascist Studies," *Journal of Contemporary History* 37, no. 1 (2002): 21–43.

52. There was also a strong tradition of Russian Le Bonism, and it may have helped lay the intellectual foundation for the Stalin cult. See, for example, N. A. Ukhach-Ogovorich, *Psikhologiia tolpy i armiia* (Kiev: Tipografiia S. V. Kul'zhenko, 1911), 18–24.

53. See Emilio Gentile, *The Sacralization of Politics in Fascist Italy* (Cambridge, Mass.: Harvard University Press, 1996). Falasca-Zamponi has argued that the "political religion" approach of Gentile cannot capture the cultural specificity of the Mussolini cult. See her *Fascist Spectacle*, 7–8, 187–188.

54. On this rivalry see Burke, *The Fabrication of Louis XIV*, and Maria Goloubeva, *The Glorification of Emperor Leopold I in Image, Spectacle and Text* (Mainz: Philipp von Zabern, 2000).

55. See Ludolf Herbst, "Der Fall Hitler—Inszenierungskunst und Charismapolitik," in *Virtuosen der Macht: Herrschaft und Charisma von Perikles bis Mao*, ed. Wilfried Nippel (Munich: C. H. Beck, 2000), 183; Herbst, *Hitlers Charisma: Die Erfindung eines deutschen Messias* (Frankfurt/Main: S. Fischer, 2010).

56. See David-Fox, "Multiple Modernities vs. Neo-Traditionalism"; Michael David-Fox, "The Intelligentsia, the Masses, and the West: Particularities of Russian-Soviet Modernity," in David-Fox, *Crossing Borders: Modernity, Ideology, and Culture in Soviet Russia* (Pitts-

burgh: University of Pittsburgh Press, forthcoming). For a similar emphasis on "comparisons," "affinities," and "areas of convergence," while stressing that "to compare is not to equate," see Wolfgang Schivelbusch, *Three New Deals: Reflections on Roosevelt's America, Mussolini's Italy, and Hitler's Germany, 1933–1939* (New York: Metropolitan, 2006), 10–11, 13, 15.

57. See Hans-Ulrich Wehler, *Deutsche Gesellschaftsgeschichte: Vom Beginn des Ersten Weltkriegs bis zur Gründung der beiden deutschen Staaten,* vol. 4 (Munich: C. H. Beck, 2003), 551–563. Despite countless books on Hitler there is no study of the Hitler cult (Ian Kershaw's *The "Hitler Myth": Image and Reality in the Third Reich* [New York: Oxford University Press, 1987] is on popular reactions to Hitler and his politics as recorded in surveillance reports). For the first overview of the literature on symbolic politics in the Third Reich see Henning Bühmann, "Der Hitlerkult: Ein Forschungsbericht," in *Personality Cults in Stalinism,* ed. Heller and Plamper, 109–157.

58. On the Piłsudski cult see Heidi Hein, *Der Piłsudski-Kult und seine Bedeutung für den polnischen Staat: 1926–1939* (Marburg: Herder-Institut, 2002).

59. This account is based on Ulrich Keller, "Franklin D. Roosevelts Bildpropaganda im historischen und systematischen Vergleich," in *Führerbilder: Hitler, Mussolini, Roosevelt, Stalin in Fotografie und Film,* ed. Martin Loiperdinger et al. (Munich: Piper, 1995), 135–165; David Culbert, "Franklin D. Roosevelt: Das Image des 'demokratischen' Führers in Wochenschau und Radio," ibid., 166–188. Also see Patrick J. Maney, *The Roosevelt Presence: A Biography of Franklin Delano Roosevelt* (New York: Macmillan International, 1992).

60. Keller, "Franklin D. Roosevelts Bildpropaganda," 144–145.

61. Goebbels quoted in Sabine Behrenbeck, "'Der Führer': Die Einführung eines politischen Markenartikels," in *Propaganda in Deutschland: Zur Geschichte der politischen Massenbeeinflussung im 20. Jahrhundert,* ed. Gerald Diesener and Rainer Gries (Darmstadt: Wissenschaftliche Buchgesellschaft, 1996), 51.

62. The canonization thesis is in Culbert, "Franklin D. Roosevelt," 170.

63. Term from Keller, "Franklin D. Roosevelts Bildpropaganda," 148.

64. Ibid., 149.

65. Ibid., 152. In the Soviet Union, by contrast, "agitation and propaganda" were positive terms connoting enlightenment rather than manipulation. See Matthew Lenoe, *Closer to the Masses: Stalinist Culture, Social Revolution, and Soviet Newspapers* (Cambridge, Mass.: Harvard University Press, 2004), 7, 249.

66. Timothy Garton Ash quoted in Truesdell, *Spectacular Politics,* 10.

67. Keller, "Franklin D. Roosevelts Bildpropaganda," 161.

68. On Kleinbort see Mark Steinberg: "Indeed, in the view of one astute contemporary observer of working-class attitudes in Russia [Kleinbort], a fully developed *kul't lichnosti* . . . or *kul't cheloveka* . . . existed in the discourse of activist Russian workers," and "A comparable expression had been used earlier by Emile Durkheim. . . . Although Kleinbort employs 'kul't cheloveka' in quotation marks, he mentions no source." Mark Steinberg, "The Injured and Insurgent Self: The Moral Imagination of Russia's Lower-Class Writers," in *Workers and Intelligentsia in Late Imperial Russia: Realities, Representations, Reflections,* ed. Reginald E. Zelnik (Berkeley: International and Area Studies, 1999), 310, 325 n. 2. For Plekhanov see George Plekhanov, "On the Role of the Individual in History," in *Russian Philosophy,* ed. James M. Edie et al., vol. 3 (Chicago: Quadrangle, 1965), 368–370.

69. The voluntarist Nietzschean element in Lenin's personality, for instance, was perceived as un-Russian and very effective at the same time. See Figes, *A People's Tragedy,* 392. Also see Bernice Glatzer Rosenthal, ed., *Nietzsche and Soviet Culture: Ally and Adversary* (Cambridge: Cambridge University Press, 1994); Hans Günther, *Der sozialistische Übermensch: M. Gor'kij und der sowjetische Heldenmythos* (Stuttgart: J. B. Metzler, 1993).

70. As Figes has written, "Much of Lenin's success in 1917 was no doubt explained by his towering domination over the party. No other political party had ever been so closely

tied to the personality of a single man. Lenin was the first modern party leader to achieve the status of a god: Stalin, Mussolini, Hitler and Mao Zedong were all his successors in this sense. Being a Bolshevik had come to imply an oath of allegiance to Lenin as both the 'leader' and 'teacher' of the party. It was this, above all, which distinguished the Bolsheviks from the Mensheviks (who had no clear leader of their own)." Figes, *A People's Tragedy*, 391.

71. See Walker, *Maximilian Voloshin and the Russian Literary Circle;* Walker, "Kruzhkovaia kul'tura i stanovlenie sovetskoi intelligentsii: Na primere Maksimiliana Voloshina i Maksima Gor'kogo," *Novoe literaturnoe obozrenie* 40, no. 6 (1999): 210–222; Walker, "On Reading Soviet Memoirs: A History of the 'Contemporaries' Genre as an Institution of Russian Intelligentsia Culture from the 1790s to the 1970s," *Russian Review* 59, no. 3 (2000): 327–352; Walker, "*Kruzhok* Culture and the Meaning of Patronage in the Early Soviet Literary World," *Contemporary European History* 11, no. 1 (2002): 107–123. Formal university education introduced circle-like seminars in the late nineteenth century. Often these seminars were taught at home, and often university teachers were held in esteem by their students in ways reminiscent of the reverence accorded to circle leaders. See Andy Byford, "Initiation to Scholarship: The University Seminar in Late Imperial Russia," *Russian Review* 64, no. 2 (2005): 299–323.

72. Quoted from Yuri Slezkine, *The Jewish Century* (Princeton: Princeton University Press, 2004), 144.

73. Anna Ostroumova-Lebedeva quoted in Walker, *Maximilian Voloshin and the Russian Literary Circle*, 182. On the cult-building around Voloshin after his death in 1932, especially during Khrushchev's Thaw, see ibid., 189–190, 193–196.

74. On the relationship between ruler and poet as manifest, for example, in odes to the three eighteenth-century empresses, see Harsha Ram, *The Imperial Sublime: A Russian Poetics of Empire* (Madison: University of Wisconsin Press, 2003), esp. chap. 2.

75. Andrei Turgenev and his Friendly Literary Society of 1801 likely was the first, Nikolai Stankevich and his circle of Russian Hegelians of the 1830s was the most famous.

76. For a historical sketch of Russian circles from the late eighteenth century onward see Walker, *Maximilian Voloshin and the Russian Literary Circle*, 8–9, 13–15.

77. See, for example, Ram, *The Imperial Sublime*, 126–127.

78. Alexander Zholkovsky, "The Obverse of Stalinism: Akhmatova's Self-Serving Charisma of Selflessness," in *Self and Story in Russian History*, ed. Laura Engelstein and Stephanie Sandler (Ithaca: Cornell University Press, 2000), 68.

79. Robert Service, *Lenin: A Biography* (London: Macmillan, 2000), 71. John Markovic found that at least 190 revolutionaries were socialized in *kruzhki*. His findings are based on a working sample of 1,144 biographies of revolutionaries in the first and third editions of the *Great Soviet Encyclopedia*, with data on circle activity missing for 954 individuals. See John Markovic, "Socialization and Radicalization in Russia, 1861–1917: An Analysis of the Personal Backgrounds of Russian Revolutionaries" (Ph.D. diss., Bowling Green State University, 1990), 104–105.

80. Amy Knight, *Beria: Stalin's First Lieutenant* (Princeton: Princeton University Press, 1993), 16; Sergo Beriia, *Moi otets Beriia: V koridorakh stalinskoi vlasti,* trans. from French by N. M. Stambulian (Moscow: OLMA-PRESS, 2002), 16.

81. Stepan A. Mikoian, *Vospominaniia voennogo letchika-ispytatelia* (Moscow: Izdatel'skii Dom "Tekhnika—Molodezhi," 2002), 8.

82. *Bol'shaia sovetskaia entsiklopediia,* 2nd ed., vol. 31 (Moscow: Gosudarstvennoe Nauchnoe Izdatel'stvo "Bol'shaia Sovetskaia Entsiklopediia," 1955), 171; Oleg V. Khlevniuk, *In Stalin's Shadow: The Career of "Sergo" Ordzhonikidze,* trans. David J. Nordlander, ed. Donald Raleigh (Armonk: M. E. Sharpe, 1995), 10.

83. See Sandra Dahlke, *Individuum und Herrschaft im Stalinismus: Emel'jan Jaroslavskij (1878–1943)* (Munich: Oldenbourg, 2010), 38.

84. *Bol'shaia sovetskaia entsiklopediia*, 2nd ed., vol. 28 (Moscow: Gosudarstvennoe Nauchnoe Izdatel'stvo "Bol'shaia Sovetskaia Entsiklopediia," 1954), 152.

85. Kliment E. Voroshilov, *Rasskazy o zhizni (Vospominaniia)*, vol. 1 (Moscow: Politizdat, 1968), 69, 90.

86. Ibid., 139–141.

87. Quoted from Robert McNeal, *Stalin: Man and Ruler* (New York: New York University Press, 1988), 9.

88. Robert C. Tucker, *Stalin as Revolutionary, 1879–1929: A Study in History and Personality* (New York: W. W. Norton, 1973), 85. As always with Stalin's early years, the source for this is the only extant account of Stalin's youth by his former friend and later émigré: Joseph Iremaschwili, *Stalin und die Tragödie Georgiens: Erinnerungen* (Berlin: n.p., 1932). For a review of the first Stalin biographies see Christoph Mick, "Frühe Stalin-Biographien 1928–1932," *Jahrbücher für Geschichte Osteuropas* 36, no. 3 (1988): 403–423.

89. See James von Geldern, *Bolshevik Festivals, 1917–1925* (Berkeley: University of California Press, 1993), 82–84; Richard Stites, *Revolutionary Dreams: Utopian Vision and Experimental Life in the Russian Revolution* (New York: Oxford University Press, 1989), 65, 88–93.

90. For the argument of Fedorovian continuity see Nina Tumarkin, *Lenin Lives! The Lenin Cult in Soviet Russia* (Cambridge, Mass.: Harvard University Press, 1983). For the ad hoc thesis see Ennker, *Die Anfänge des Leninkults in der Sowjetunion*. For the Lenin cult as political religion see L. A. Andreeva, *Religiia i vlast' v Rossii: Religioznye i kvazireligioznye doktriny kak sposob legitimizatsii politicheskoi vlasti v Rossii* (Moscow: Ladomir, 2001). For the public reception of Lenin as related in surveillance reports see Olga Velikanova, *The Public Perception of the Cult of Lenin Based on Archival Materials* (Lewiston: Edwin Mellen Press, 2001); Velikanova, *Making of an Idol: On Uses of Lenin* (Göttingen: Muster-Schmidt, 1996). On the Lenin museums as part of the Lenin cult see Velikanova, "Der Lenin-Kult in sowjetischen Museen," *Osteuropa* 43, no. 10 (1993): 929–938. Further see Claudio Sergio Ingerflom and Tamara Kondratieva, "Pourquoi la Russie s'agite-t-elle autour de Lénine?" in *La Mort du Roi: Autour de François Miterrand. Essai d'ethnographie politique comparée*, ed. Jacques Julliard (Paris: Gallimard, 1999), 261–292; François-Xavier Coquin, "L'image de Lénine dans l'iconographie révolutionnaire et postrévolutionnaire," *Annales: Économies, Sociétés, Civilisations* 44, no. 2 (1989): 223–249.

91. See Ennker, *Die Anfänge des Leninkults in der Sowjetunion*, 120–228.

92. See ibid., 267–270.

93. Both quoted ibid., 268.

94. Walter Benjamin, "Moskau," in *Denkbilder* (Frankfurt/Main: Suhrkamp, 1974), 48.

95. Both Robert Tucker and Nina Tumarkin supported the thesis that Stalin orchestrated the Lenin cult. Ultimately this thesis goes back to Nikolai Valentinov and has been convincingly proven baseless by Ennker, *Die Anfänge des Leninkults in der Sowjetunion*, 315–319.

96. Mikhail Yampolsky stressed this point in an interview in Oksana Bulgakowa, Frieda Grabe, and Enno Patalas, *Stalin—Eine Mosfilmproduktion* (Westdeutscher Rundfunk documentary film in color, 90 minutes, 1993).

CHAPTER 2. STALIN'S IMAGE IN TIME

1. The same held true for *Izvestia* where a drawing by Evgeny Katsman, the newspaper's preferred artist, was on the front page. See *Izvestia*, 21 December 1929, 1. Later there even appeared a theoretical justification of the leader cult by K. Popov, "Partiia i rol' vozhdia," *Partiinoe stroitel'stvo* 1, no. 3 (1930): 5–9.

2. James Heizer was first to infer "that the information for all papers was being provided by one office, perhaps in the Kremlin." Heizer, "The Cult of Stalin, 1929–1939" (Ph.D.

diss., University of Kentucky, 1977), 62. After the opening of the archives Benno Ennker was able to actually demonstrate the Politburo's concerted preparation of these celebrations. See "'Struggling for Stalin's Soul': The Leader Cult and the Balance of Power in Stalin's Inner Circle," in *Personality Cults in Stalinism—Personenkulte im Stalinismus*, ed. Klaus Heller and Jan Plamper (Göttingen: Vandenhoeck & Ruprecht unipress, 2004), 163–165.

3. As Heizer has aptly summarized, "It would have been possible for him to have had his name in *Pravda* daily if he had wished. This low profile was obviously by his own choice. No one could have appeared more modest." Heizer, "The Cult of Stalin, 1929–1939," 55.

4. The exceptions, totaling twenty-one missing issues between 1 January 1929 and 31 December 1953, are as follows. 1940: 8 November; 1943: 2 March, 9 March, 16 March, 23 March, 30 March, 6 April, 13 April, 20 April, 27 April, 4 May, 11 May, 16 May, 18 May, 25 May, 1 June, 8 June, 15 June, 23 June, 29 June, 14 September. On these days either the paper did not appear for war-related reasons or I was unable to obtain a copy at the libraries I accessed—the library of the Institut für Osteuropäische Geschichte und Landeskunde, Tübingen (which holds a nearly complete run of original hard copies); the library of RGASPI, Moscow (hard copy originals); the Universitätsbibliothek Tübingen (microfilms); German interlibrary loan (microfilms); Doe Library, University of California, Berkeley (microfilms).

5. For a first attempt at a quantitative analysis of references to Stalin in Pravda, see G. Alekseev, "Kolichestvennye parametry kul'ta lichnosti," *SSSR v protivorechiiakh* 6 (1982): 5–11.

6. This was the 28 January 1938 publication of the "Muddle Instead of Music" article in *Pravda*. RGALI, f. 962, op. 6, d. 42, l. 6.

7. See Rosalinde Sartorti, *Pressefotografie und Industrialisierung in der Sowjetunion: Die Pravda 1925–1933* (Wiesbaden: Harrassowitz, 1981); Julie Kay Mueller, "Staffing Newspapers and Training Journalists in Early Soviet Russia," *Journal of Social History* 31, no. 4 (1998): 851–873; Alex Inkeles, *Public Opinion in Soviet Russia: A Study in Mass Persuasion* (Cambridge, Mass.: Harvard University Press, 1958); Peter Kenez, *The Birth of the Propaganda State: Soviet Methods of Mass Mobilization, 1917–1929* (Cambridge: Cambridge University Press, 1985).

8. Matthew Lenoe, *Closer to the Masses: Stalinist Culture, Social Revolution, and Soviet Newspapers* (Cambridge, Mass.: Harvard University Press, 2004), 17.

9. See Jeffrey Brooks, *Thank You, Comrade Stalin! Soviet Public Culture from Revolution to Cold War* (Princeton: Princeton University Press, 2000), 19–20.

10. A 1924 protocol of a Politburo meeting bemoaned that "1. Recently in the local press (in journals and newspapers) information was published that gave away the itineraries from the center, the stops, events (congresses, conferences, demonstrations), place of medical treatment, and the return itineraries of the members of the USSR and RSFSR government as well as the Central Committee of the RKP(b). 2. Some editors sent without the knowledge of the OGPU not only reporters but also photographers who made entire photo shootings of the places which the comrades mentioned in 1. came to. 3. The appearance of this information in the press facilitated the work of all kinds of spies and impeded the protection of the government members." Therefore it suggested concealing the travel plans outside Moscow of the Party and state leadership and stipulated that all journalists carry OGPU licenses. Note in this document: the still prominent role of the OGPU; the lack of control over the use of leaders' photos in the provinces; and the degree to which in 1924 the Politburo still considered it necessary to explain why it was tightening control. See "Proekt tsirkuliara OGPU organam pechati o svedeniiakh, davaemykh v pechati o chlenakh pravitel'stva" as part of Politburo protocol no. 5, 1924, published in *Kommersant" Vlast'*, 21 June 2004, 62.

11. See Lenoe, *Closer to the Masses*, 20.

12. Ibid., 19. To be sure, censorship constituted another filter. The day before Stalin's fiftieth birthday, central Glavlit issued a circular exhorting local censorship boards "to watch

out that Stalin's photograph be printed *exclusively* from templates supplied by the ROSTA" press agency. A. V. Blium, *Za kulisami "ministerstva pravdy": Tainaia istoriia sovetskoi tsenzury, 1917–1929* (St. Petersburg: Gumanitarnoe agenstvo 'Akademicheskii proekt,' 1994), 128 (emphasis in original). For more on Stalin's image and censorship during High Stalinism see Blium, *Sovetskaia tsenzura v epokhu total'nogo terrora, 1929–1953* (St. Petersburg: Gumanitarnoe agenstvo 'Akademicheskii proekt,' 2000), esp. 237–242.

13. On the informal power of Stalin's secretariat see Oleg Khlevniuk, *Politbiuro: Mekhanizmy politicheskoi vlasti v 30-e gody* (Moscow: ROSSPEN, 1996), 65–69, 117–118; Niels Erik Rosenfeldt, *Knowledge and Power: The Role of Stalin's Secret Chancellery in the Soviet System of Government* (Copenhagen: Rosenkilde & Bagger, 1978); Robert C. Tucker, *Stalin in Power: The Revolution from Above, 1928–1941* (New York: W. W. Norton, 1990), 123–125.

14. RGASPI, f. 558, op. 11, d. 1499, ll. 2–20b.

15. RGASPI, f. 558, op. 11, d. 1499, l. 39.

16. RGASPI, f. 558, op. 11, d. 1475, l. 3 (the original photograph of Stalin's head is on l. 4, the letter from the journal informing Poskryobyshev that it is now enclosing the retouched version on l. 5, and the retouched photo finally on l. 6). The postwar continuation, ending in 1952, of this kind of correspondence is in RGASPI, f. 558, op. 11, d. 1476.

17. RGASPI, f. 558, op. 11, d. 1475, ll. 35–36.

18. RGASPI, f. 558, op. 11, d. 1475, l. 40 (5 January 1945 letter by V. Boitekhov, editor in chief of the journal *Smena*).

19. RGASPI, f. 558, op. 11, d. 1475, l. 7 (the photograph of Ordzhonikidze and Stalin is on l. 8).

20. RGASPI, f. 558, op. 11, d. 1475, l. 13.

21. See the 270-page post-birthday collection *Stalin: Sbornik statei k piatidesiatiletiiu so dnia rozhdeniia*, which contained 495 greetings. Heizer, "The Cult of Stalin," 65–68.

22. *Pravda*, 4 January 1930, 4.

23. Ibid., 2 January 1930, 2; 6 January 1930, 1. Also see the ad for Stalin's "Dizzy with Success" speech ibid., 3 March 1930, 6. Note that these examples of ads are spread throughout the entire newspaper, from the front page to the back page.

24. Ibid., 10 May 1930, 5.

25. See Heizer, "The Cult of Stalin," 61, 80.

26. *Pravda*, 6 March 1931, 5.

27. For the Avilov picture see ibid., 13 August 1933, 3, 24 October 1934, 2, and 19 November 1934, 2; for the Gerasimov picture: 10 April 1934, 1.

28. Ibid., 24 January 1934, 3. Later aviators were termed "Stalin falcons" (*stalinskie sokoly*) and outstanding students at Moscow State University "Stalin fellows" (*stalinskie stipendiaty*). See ibid., 30 June 1938, 1; 3 July 1940, 4.

29. Ibid., 19 August 1933, 1.

30. Ibid., 13 June 1933, 1. For the first airplane formation spelling out the word "S-T-A-L-I-N" see ibid., 1 July 1935, 1.

31. Ibid., 20 January 1934, 4.

32. See ibid., 9 August 1930, 4, and 17 November 1930, 5.

33. See ibid., 4 January 1935, 1. Furthermore, in a photograph of a memorial meeting for Lenin, Stalin was shown as very much standing out, even though he was in the second row of attendants. See ibid., 22 January 1935, 1. The deliberate centering of Stalin is also seen in pencil drawings in 1931 and 1935 by Gustav Klutsis, which served as the basis for his posters. See Plate 22 and Fig. 138 in Margarita Tupitsyn, *The Soviet Photograph, 1924–1937* (New Haven: Yale University Press, 1996).

34. See *Pravda*, 8 February 1934, 1. Also see 7 February 1934, 1; 21 March 1939, 2.

35. See ibid., 13 July 1937, 1.

36. See ibid., 22 July 1940, 1.

37. See ibid., 24 February 1935, 1; 12 February 1934, 1. Stalin was for the first time shown with his hand holding a headphone to his ear and hence touching his face in *Pravda* on 16 February 1936, 1.

38. On the gaze and eyes in sixteenth and seventeenth-century art see Alfred Neumeyer, *Der Blick aus dem Bilde* (Berlin: Gebr. Mann, 1964). Also see Norman Bryson, *Vision and Painting: The Logic of the Gaze* (New Haven: Yale University Press, 1983), esp. chap. 5. Curiously, nineteenth-century ruler portraits rarely employ this visual strategy. See Rainer Schoch, *Das Herrscherbild in der Malerei des 19. Jahrhunderts* (Munich: Prestel, 1975). Thanks to Sergiusz Michalski for directing me to Neumeyer and Schoch.

39. For a reproduction of this 1915 photograph see *Pravda*, 5 January 1940, 3.

40. On 22 January 1930, for example, *Pravda*'s second page carried a picture of Stalin sitting second from the right among a total of six high Party bosses, yet in the caption he was mentioned first. On 4 May 1933 the caption underneath a photograph of the presidium on a tribune mentioned Stalin first, even though he was in the second row and in order of standing neither first from the right nor from the left; on 19 May 1933 a photograph depicted, from left to right, Kaganovich, Stalin, and Molotov, while the caption placed Stalin ahead of Molotov and Kaganovich; on 15 May 1935 *Pravda* again listed Stalin ahead of Kaganovich, Molotov, Voroshilov, and others, even though he was not seated first from left or right.

41. See e.g. ibid., 15 January 1938, 1, and 19 March 1938, 1.

42. See e.g. Stalin's full-page article "O rabote v derevne: Rech' tov. Stalina," *Pravda*, 17 January 1933, 1.

43. See the speech by Kalinin, ibid., 18 May 1933, 2.

44. See e.g. the article "Proizvedeniia I. V. Stalina na 75 iazykakh," ibid., 5 November 1935, 6.

45. On this see John MacCannon, *Red Arctic: Polar Exploration and the Myth of the North in the Soviet Union, 1932–1939* (New York: Oxford University Press, 1998).

46. See the entire issue of *Pravda*, 6 June 1934.

47. For the ticker tape parade see ibid., 11 August 1936, 6; for Stalin kissing Chkalov and Baidukov respectively see ibid., 11 August 1936, 1, 4; for the article, "Eto Stalin vospital takikh khrabretsov," see ibid., 24 July 1936, 3. For a first picture of Chkalov and Stalin see ibid., 22 July 1936, 1.

48. See ibid., 14 September 1936, 1.

49. See ibid., 25 May 1937, 1.

50. See ibid., 4 May 1935, 3.

51. See ibid., 3 March 1936, 1.

52. Joan Neuberger has called this "the double whammy cult of Pushkin and the cult of Stalin." Joan Neuberger, *Hooliganism: Crime, Culture, and Power in St. Petersburg, 1900–1914* (Berkeley: University of California Press, 1993), 282 n. 12. For the cult of Taras Shevchenko in *Pravda* see 1 April 1935, 6; for the Lomonosov cult see the article, "Genial'nyi syn russkogo naroda," ibid., 18 November 1936, 1. For linkages between the cults of Lenin and Pushkin see Rainer Grübel, "Gabe, Aufgabe, Selbstaufgabe: Dichter-Tod als Opferhabitus. Zur Genese des sowjetischen Personenkultes aus Dichtertod, Lenin- und Puškingedenken," in *Welt hinter dem Spiegel: Zum Status des Autors in der russischen Literatur der 1920er bis 1950er Jahre,* ed. Klaus Städtke (Berlin: Akademie, 1998), 139–204. On the celebration of the centenary of Pushkin's death in 1937, particularly the politics and iconography of the Pushkin memorials, see Iurii Molok, *Pushkin v 1937 godu: Materialy i issledovaniia po ikonografii* (Moscow: Novoe literaturnoe obozrenie, 2000). On the 1937 Pushkin centennial in literature, especially as it related to Russian Nietzscheanism, see Irina Paperno, "Nietzscheanism and the Return of Pushkin in Twentieth-Century Russian culture (1899–1937)," in *Nietzsche and Soviet Culture: Ally and Adversary,* ed. Bernice Glatzer Rosenthal

(Cambridge: Cambridge University Press, 1994), 211–232. On the mutual reinforcement of Dostoevsky's and Pushkin's symbolic power as writers see Marcus C. Levitt, *Russian Literary Politics and the Pushkin Celebration of 1880* (Ithaca: Cornell University Press, 1989). On the celebration surrounding the hundredth anniversary of Pushkin's birth see Levitt, "Pushkin in 1899," in *Cultural Mythologies of Russian Modernism: From the Golden Age to the Silver Age,* ed. Boris Gasparov, Robert P. Hughes, and Irina Paperno (Berkeley: University of California Press, 1992), 183–203.

53. *Pravda,* 13 February 1937, 3. The transfer of specific markers of the iconography of the leaders to other cultural figures was generally widespread.

54. See Stephen Moeller-Sally, *Gogol's Afterlife: The Evolution of a Classic in Imperial and Soviet Russia* (Evanston: Northwestern University Press, 2002), 159.

55. *Pravda,* 4 December 1938, 4.

56. See e.g. ibid., 1 May 1941, 1.

57. See ibid., 14 July 1932, 1 (photograph); 8 July 1934, 1 (drawing).

58. Prior to the Kirov murder Stalin was shown in *Pravda* as a pallbearer at the funerals of Sen Katayama, 10 November 1933, 2; Clara Zetkin, 23 June 1933, 1–2; and Viacheslav Menzhinsky, 14 May 1934, 1; and dressed in white at the funeral of Valerian Dovgalevsky, 23 July 1934, 1. After the Kirov funeral Stalin appeared as a pallbearer at the funerals of Kuibyshev, 28 January 1935, 1; the geologist Aleksandr Karpinsky, 18 July 1936, 1; Ordzhonikidze, 21 February 1937, 3 (with Voroshilov); Maria Ulianova, 15 June 1937, 1; Marshal Shaposhnikov, who had died 26 March 1945 (with Molotov), 29 March 1945, 1; Aleksandr Shcherbakov, 13 May 1945, 1; Kalinin, 6 June 1946, 3; and Vasily Vakhrushev, 16 January 1947, 1. It seems that Stalin is mostly placed to the right of the coffin, probably because of his chronically stiff left elbow. In the postwar period other leaders—not so much Stalin—increasingly appeared walking alongside an open coffin carried by a car.

59. A high point was attained a year later when an Aleksandr Gerasimov painting of Stalin, Voroshilov, and other military figures occupied the entire width and one-third of the front page of *Pravda,* 17 April 1936, 1.

60. For the newborn see ibid., 7 November 1935, 7.

61. The "blossoming generation" and the Pioneer article are ibid., 1 July 1935, 2.

62. See Katerina Clark, *The Soviet Novel: History as Ritual* (Chicago: University of Chicago Press, 1981), 99, 105.

63. See *Pravda,* 10 November 1935, 1. For another example of the new Stalin, smiling and at ease, see ibid., 23 February 1936, 1.

64. "Zhit' stalo trudnee i grustnee (Ot londonskogo korrespondenta 'Pravdy')," ibid., 27 December 1935, 7.

65. On this and the "friendship of peoples" see Terry Martin, *The Affirmative Action Empire: Nations and Nationalism in the Soviet Union, 1929–1939* (Ithaca: Cornell University Press, 2001), 432–461.

66. Rogers Brubaker, "Nationhood and the National Question in the Soviet Union and Post-Soviet Eurasia," *Theory and Society* 23, no. 1 (1994): 47–78. For more on the ethnic dimension of Stalin's portrayal see David L. Hoffmann, *Stalinist Values: The Cultural Norms of Soviet Modernity, 1917–1941* (Ithaca: Cornell University Press, 2003), 157–158; Jan Plamper, "Georgian Koba or Soviet 'Father of Peoples'? The Stalin Cult and Ethnicity," in *The Leader Cult in Communist Dictatorships: Stalin and the Eastern Bloc,* ed. Balázs Apor et al. (Basingstoke: Palgrave, 2004), 123–140.

67. RGASPI, f. 558, op. 11, d. 1122, l. 164. Quoted from V. A. Nevezhin, ed., *Zastol'nye rechi Stalina: Dokumenty i materialy* (Moscow: AIRO-XX, 2003), 158.

68. RGALI, f. 652, op. 8, d. 11, l. 18. By G. I. Fomin, typewritten copy dated 17 March 1938.

69. Several pages of an issue devoted to the "reception of the delegation from Soviet Georgia" showed no ethnic link whatsoever between Stalin and his personal co-nationals.

See *Pravda,* 21 March 1936, 1–3. Also see the reproduction of Irakly Toidze's painting "Tovarishch Stalin na Riongese" and the article "Opening of the Exhibition of Artists of Georgia," ibid., 31 July 1936, 1.

70. For an Uzbekicized Stalin portrait in the background on the wall of the Stalin kolkhoz laboratory in Namanganskii raion, Uzbek SSR, see *Pravda,* 13 January 1940, 4.

71. On the "oriental despot" from Montesquieu to Wittfogel see Harsha Ram, *The Imperial Sublime: A Russian Poetics of Empire* (Madison: University of Wisconsin Press, 2003), 250 n. 39.

72. "Narod odobriaet stalinskuiu konstitutsiiu" was the title of an article published in *Pravda,* 13 July 1936, 1.

73. See ibid., 18 October 1936, 6: "J. V. Stalin Room at the Kharkov Palace of Pioneers. Kharkov, 17 Oct. (TASS). While familiarizing himself with the work of the P. P. Postyshev Palace of Pioneers and Young Octobrists, Kharkov obkom secretary Comrade S. A. Kudriavtsev suggested opening I. V. Stalin rooms at the palace. The idea of creating rooms that will showcase materials on the youth, life, and struggle of the wise leader and beloved friend of children, Iosif Vissarionovich Stalin, was enthusiastically greeted by thousands of Kharkov Pioneers and schoolchildren." On a projected "Stalin Museum of the Defense of Tsaritsyn" in Stalingrad see ibid., 19 October 1936, 4.

74. "Berech' i okhranit' svoikh vozhdei, kak boevoe znamia," ibid., 16 August 1936, 3; "Berech' i okhranit' tov. Stalina," ibid., 17 August 1936, 5.

75. See e.g. the article "Schastlivye deti stalinskoi epokhi," ibid., 23 September 1937, 1.

76. Ibid., 30 December 1937, 3.

77. See e.g. ibid., 24 August 1939, 1; 1 September 1939, 1; 29 September 1939, 1, where he was shown somewhat standoffishly in the background.

78. For a still of Gelovani starring as Stalin in *The Vyborg Side* see ibid., 28 November 1938, 4.

79. See the respective images ibid., 22 January 1941, 1 ("old" Stalin), and 15 February 1941, 1 ("young" Stalin).

80. To be sure, Party comrades and others sent Stalin letters and telegrams on every birthday, not just the decennial ones. For examples see congratulatory telegrams and letters from individuals (e.g. Kaganovich) and organizations (e.g. school no. 72, Moscow) for Stalin's sixty-third birthday in RGASPI, f. 558, op. 11, d. 1359; or Poskryobyshev's letter to Stalin congratulating him on his sixty-eighth birthday in RGASPI, f. 558, op. 11, d. 786, l. 130 (dated 21 December 1947).

81. See the 19 December 1934 Politburo decision to "honor Comrade Stalin's request to forbid all festivities or celebrations or publications in the press or in meetings on the occasion of his fifty-fifth birthday on 21 December." RGASPI, f. 558, op. 11, d. 1353, l. 8. Also see Sarah Davies, "Stalin and the Making of the Leader Cult in the 1930s," in *The Leader Cult in Communist Dictatorships,* ed. Apor et al., 38–39, 45 n. 56.

82. See the entire issue of *Pravda,* 4 February 1941.

83. Ibid., 23 June 1941, 1.

84. See ibid., 15 February 1942, 2.

85. See ibid., 23 February 1942, 1.

86. See ibid., 28 March 1942, 2.

87. Caricatures of the Nazis had much in common with caricatures of Americans in times when relations with the United States were strained. On this see Kevin J. McKenna, *All the Views Fit to Print: Changing Images of the U.S. in "Pravda" Political Cartoons, 1917–1991* (New York: Peter Lang, 2001), 10, 56, 76.

88. *Pravda,* 10 April 1942, 2.

89. Caption: "Zapadnyi front: Pervomaiskii miting v Nevskoi gvardeiskoi chasti. Vystupaet batal'onnyi kommisar G. A. Khanchevskii," ibid., 3 May 1943, 1.

90. See e.g. ibid., 23 February 1944, 1.

91. For a Stalin portrait on a flag at a workers' rally at Airplane Factory no. 292 see ibid., 13 June 1942, 2; for a photo of Stalin between Churchill and Harriman see ibid., 18 August 1942, 1.

92. Italo Calvino, "Il Duce's Portraits: Living with Mussolini," *The New Yorker,* 6 January 2003, 35. Thanks to Ilya Vinkovetsky for this source.

93. *Pravda,* 14 December 1942, 1.

94. Ibid., 12 March 1945, 2. Also see 8 April 1945, 2; 18 April 1945, 3.

95. I was unable to determine whether the original was a painting or drawing.

96. Here, too, I was unable to determine whether the original was a painting or drawing.

97. *Pravda,* 13 May 1945, 1.

98. Elena Zubkova quoted from David Hoffmann, ed., *Stalinism: The Essential Readings* (Malden/Oxford: Blackwell 2003), 292.

99. This does not mean his prewar image disappeared entirely. At a Komsomol meeting in the Dynamo Stadium a large Stalin portrait adorns the tribune. In this portrait his hair is jet black. See *Pravda,* 18 June 1945, 1.

100. See ibid., 1 August 1945, 1.

101. See ibid., 25 July 1945, 1; 3 August 1945, 1–2.

102. See ibid., 13 August 1945, 1.

103. See, for example, "VI sessiia Verkhovnogo Soveta RSFSR 1-go sozyva: Zasedanie 5 iunia 1945 goda," ibid., 6 June 1945, 1; "Torzhestvenno-traurnoe zasedanie v Bol'shom zale Kremlevskogo dvortsa, posviashchennoe 22-i godovshchine so dnia smerti V. I. Lenina," ibid., 22 January 1946, 1; "Na sovmestnom zasedanii Soveta Soiuza i Soveta Natsional'nostei 19 marta," ibid., 20 March 1946, 1.

104. On the tribune were standing from left to right Merkulov, Vyshinsky, Gorkin, Shkiriatov, Mikoian, Molotov, Malenkov, Beria, Vasilevsky, Antonov, Bulganin, Budyonny, Kaganovich, Voznesensky, Andreev, Popov, Shvernik, and Kosygin. If anyone stood out, it was probably Molotov, who was in the center of the left half of the picture. See ibid., 8 November 1945, 1. True, Stalin perhaps compensated for his absence on 8 November with a front-page photo in the white generalissimo's uniform, filling three-quarters of the right-hand page, on 7 November 1945. For Stalin's last appearance on Revolution Day see *Pravda,* 8 November 1952, 1.

105. A series of smaller advertisements announced the film until on 8 August it received a full-page notice, featuring a still image of Stalin swearing his oath to Lenin, a long article by Chiaureli himself on the "Making of the Great Image," reactions of moviegoers from around the country, and several statistics of attendance in selected towns. See ibid., 8 August 1946, 2. According to André Bazin's famous interpretation of the scene, in which Stalin comes to a park bench directly from Lenin's deathbed in Gorki, the dead leader's power is transferred to Stalin by way of two metaphors: on the one hand Lenin's empty place on the park bench alludes to a widely known photograph showing the two leaders seated together on this very bench. On the other, Stalin looks at the sky and "through the fir tree branches a sunbeam penetrates and illuminates the forehead of the new Moses." See Andre Bazen [André Bazin], "Mif Stalina v sovetskom kino," *Kinovedcheskie zapiski,* no. 1 (1991): 167 (original: "Le cinéma soviétique et le mythe de Staline," *Esprit,* no. 8 [1950]: 210–235). On the park bench scene in Vertov's *Tri pesni o Lenine* (1934) and Chiuareli's *Kliatva* also see Hans Günther, "Mudryi otets Stalin i ego sem'ia (na materiale kartin D. Vertova i M. Chiuareli)," *Russian Literature,* no. 43 (1998): 205–220.

106. See Jan C. Behrends, *Die erfundene Freundschaft: Propaganda für die Sowjetunion in Polen und der DDR* (Cologne: Böhlau, 2006), 249.

107. See Schoch, *Das Herrscherbild in der Malerei des 19. Jahrhunderts,* 11–12.

108. A poem by Vas. Lebedev-Kumach, "Golos vozhdia," appeared in *Pravda,* 11 February 1946, 4.

109. Ibid., 1 January 1947, 1.

110. On festivals structuring Soviet time see Malte Rolf, "Constructing a Soviet Time: Bolshevik Festivals and Their Rivals During the First Five-Year Plan. A Study of the Central Black Earth Region," *Kritika: Explorations in Russian and Eurasian History* 1, no. 3 (2000): 447–473; Rolf, *Das sowjetische Massenfest (1917–1941)* (Hamburg: Hamburger Edition, 2006). On Soviet festivals and holidays see also Matthias Braun, "Sowjetische und traditionelle Festkulturen im Vorkriegsstalinismus: Das Beispiel der zentrumsfernen Region Rjazan', 1927–1941" (M.A. thesis, University of Leipzig, 2004); Karen Petrone, *Life Has Become More Joyous, Comrades: Celebrations in the Time of Stalin* (Bloomington: Indiana University Press, 2000); Joy Chatterjee, *Celebrating Women: Gender, Festival Culture, and Bolshevik Ideology, 1910–1939* (Pittsburgh: University of Pittsburgh Press, 2002).

111. In 1947 there were four Stalin pictures before 21 January, all on the front page and involving one regularly recurring event, a workers' gathering, and two of a kind that occurred only occasionally. On 4 January a Stalin poster with a reproduction of a painting of Stalin in his generalissimo's uniform with medals was clearly montaged into a photograph of female textile workers, who had gathered on the shop floor for a meeting. On 11 January there was a large photo of Stalin and the British Field Marshal Montgomery on the occasion of their meeting, on 15 and 16 January there were pictures of Stalin at the funeral of the minister of the coal industry V. V. Vakhrushev.

112. Stalin's pockmarks and a cigarette in his left hand were later retouched out. For the original picture see Edvard Radzinskii, *Stalin* (Moscow: Vagrius, 1997), pictorial insert 160–161. For the retouched version see Tucker, *Stalin as Revolutionary*, pictorial insert 266–267.

113. In other Lenin-Stalin photographs, "Gender attributes reinforce the construction of Lenin as the feminized dreamer of the *vita contemplativa*, while Stalin embodies the *vita activa* as an aggressive, powerful man of action who is capable of realizing these visions." Erika Maria Wolf, "*USSR in Construction:* From Avant-Garde to Socialist Realist Practice" (Ph.D. diss., University of Michigan, 1999), 198. The photograph under discussion is a montage ("The Current is Switched On") from a 1932 Dneprostroi cycle in *USSR in Construction*.

114. "To znamia, chto nad nami podnial Lenin,/Ne poshatnut ni gody, ni veka./Kak dobryi kon', stupaet tverdo vremia,/Idut goda, i my idem vpered./Po tem putiam, chto zaveshchal nam Lenin,/Rodnoi tovarishch Stalin nas vedet."

115. I. Riabov, "Velikoe sodruzhestvo," *Pravda*, 21 January 1947, 2.

116. For such a "new," previously unpublished Lenin letter to Stalin, dated 19 May 1922, about the "development of radio technology" see ibid., 21 January 1949, 1–2.

117. Between 22 January and 23 February Stalin was shown five times (twice on 10 February, once on 12 February, once on 16 February, and once on 21 February) in conjunction with the elections to the Supreme Soviets of the USSR and the union republics, once while dropping his ballot in the box. The Red Army was founded by a decree of 15 January 1918. The Day of the Red Army was first celebrated in 1918 on 10 February and from 1919 onward on 23 February. See Victor Topolyansky, "Three Riddles of an Old Holiday (observed as Red Army Day in the Past)," *New Times* (April 2001): 54–60. Thanks to Malte Rolf for this source.

118. *Pravda*, 23 February 1947, 1.

119. Ibid., 1 May 1947, 1.

120. On paratext in Stalinist publishing see Brian Kassof, "A Book of Socialism: Stalinist Culture and the First Edition of the *Bol'shaia sovetskaia entsiklopediia*," *Kritika: Explorations in Russian and Eurasian History* 6, no. 1 (2005): 55–95, esp. 59–60.

121. An airplane formation at the Tushino aerodrome in 1948 formed the words "SLAVA STALINU." See *Pravda*, 26 July 1948, 2.

122. See ibid., 4 May 1940, 1.

123. Victory Day was celebrated in *Pravda* every single year of the period under discussion, 1945–1952. In 1951 and 1952, however, the newspaper did not carry Stalin pictures. This finding contradicts the thesis that 9 May was discontinued as a holiday soon after the war because the regime deemed it too unruly; see Rolf, *Das sowjetische Massenfest,* 328. I am grateful to Malte Rolf for alerting me to these larger implications.

124. Stalin received the Gold Star medal on his sixtieth birthday in December 1939 after having been awarded the title Hero of Socialist Labor earlier that year. See http://www .soviet-awards.com/titles1.htm (last consulted 1 June 2005).

125. For an in-depth analysis of the 1944 Physical Culture parade see Pat Simpson, "Parading Myths: Imaging the New Soviet Woman on *Fizkul'turnik*'s Day, July 1944," *Russian Review* 63, no. 2 (2004): 187–211.

126. Characteristically, whenever a new standard work on postwar Stalinist politics touches on the question of succession, it centers on Stalin's efforts to maintain an equilibrium among his lieutenants, not on grooming an heir. See Yoram Gorlizki and Oleg Khlevniuk, *Cold Peace: Stalin and the Soviet Ruling Circle, 1945–1953* (New York: Oxford University Press, 2004), 10, 72, 101–108, 148–151.

127. The catch phrase "Soviet patriotism" emerged in 1936. It is seen as Russocentric nationalism packaged as multiethnic identity by, among others, David Brandenberger, *National Bolshevism: Stalinist Mass Culture and the Formation of Modern Russian National Identity* (Cambridge, Mass.: Harvard University Press, 2002); Alan Bullock, *Hitler and Stalin: Parallel Lives* (London: HarperCollins, 1991), 2.

128. *Pravda,* 27 July 1947, 1.

129. Ibid., 28 July 1947, 1.

130. Thus in 1946 the Day of the Soviet Air Force was celebrated on 18 August. See the photo of the Party elite in Tushino one day later in ibid., 19 August 1946, 1.

131. "Den' Vozdushnogo flota v Moskve: Prazdnik na Tushinskom aerodrome," ibid., 4 August 1947, 1.

132. Thus Stalin was both the metaphor and the synecdoche of Lenin. See Hayden White, *Metahistory: The Historical Imagination in Nineteenth-Century Europe* (Baltimore: Johns Hopkins University Press, 1973), 31–38.

133. In 1946, for example, 24 November marked another second-tier military holiday, the Day of Soviet Artillery.

134. *Pravda,* 4 December 1949, 1.

135. E.g. ibid., 7 December 1949, 1.

136. Both ibid., 8 December 1949, 2–3. The exhibition opened on 22 December 1949 (see Evgenii Gromov, *Stalin: Vlast' i iskusstvo* [Moscow: Respublika, 1998], 413).

137. On the exhibition see the text of a guided tour in RGASPI, f. 558, op. 11, d. 1434, ll. 1–114. For photographs of the gifts see RGASPI, f. 558, d. 1421–1423. On the exhibition more generally see Nikolai Ssorin-Chaikov and Olga Sosnina, "The Faculty of Useless Things: Gifts to Soviet Leaders," in *Personality Cults in Stalinism,* ed. Heller and Plamper, 277–300; Nikolai Ssorin-Chaikov, "Heterochronia of Modernity and Birthday Gifts to Stalin, 1949," *Journal of the Royal Anthropological Institute* 12, no. 2 (2006): 355–375; Olga Sosnina and Nikolai Ssorin-Chaikov, eds., *Dary vozhdiam—Gifts to Soviet Leaders* (Moscow: Pinakoteka, 2006).

138. RGASPI, f. 558, op. 11, d. 1419, l. 141.

139. RGASPI, f. 558, op. 11, d. 1419, ll. 131–1310b.

140. RGASPI, f. 558, op. 11, d. 1419, l. 130.

141. RGASPI, f. 558, op. 11, d. 1419, l. 112.

142. RGASPI, f. 558, op. 11, d. 1419, l. 250b.

143. The "transmediality" or blurring of boundaries between various media, as in the visualization of text or the textualization of the visual, has been identified as a hallmark of socialist realist culture. See Jurij Murašov and Georg Witte, eds., *Die Musen der Macht:*

Medien in der sowjetischen Kultur der 20er und 30er Jahre (Munich: Wilhelm Fink, 2003), 24, 173–186.

144. *Pravda*, 17 December 1949, 1, 3.

145. The 7 November 1941 Stalin photo is ibid., 21 December 1949, 8.

146. See ibid., 22 December 1949, 4.

147. The last rubric appeared ibid., 9 October 1951, 2.

148. See ibid., 25 January 1950, 3.

149. See ibid., 13 March 1950, 1, 3.

150. See ibid., 15 March 1950, 1.

151. Ibid., 4 May 1950, 1. Likewise there was a Stalin portrait in the background of a photo of Ukrainian miners collecting signatures for the Stockholm appeal against nuclear weapons. See ibid., 4 July 1950, 1.

152. For the Baku photo see ibid., 25 December 1950, 1. Stalin also appeared in an article on the inauguration ceremony of the fifty-meter high Stalin sculpture in Erevan, dedicated to the Armenian Republic's thirtieth anniversary. See ibid., 21 December 1950, 3.

153. P. Pavlenko, "Spasibo vozhdiu," ibid., 24 September 1950, 2.

154. See ibid., 8 November 1950, 1–2.

155. See ibid., 22 January 1951, 1.

156. See ibid., 1 May 1951, 1; 2 May 1951, 1, 3.

157. Ibid., 3 May 1951, 1.

158. "Shestidesiatiletie Matiasa Rakoshi: Torzhestvennoe zasedanie v Budapeshte," ibid., 9 March 1952, 5; "Shestidesiatiletie Prezidenta Pol'skoi Respubliki Boleslava Beruta," ibid., 19 April 1952, 3.

159. Ibid., 3 May 1952, 1.

160. See ibid., 6 October 1952, 1.

161. See ibid., 15 October 1952, 1.

162. See ibid., 8 November 1952, 1; 10 November 1952, 1.

163. See ibid., 5 December 1952, 1; 21 January 1953, 2.

164. See ibid., 20 July 1953, 4; 27 July 1953, 1.

165. See ibid., 24 August 1953, 3.

166. See ibid., 9 November 1953, 2.

CHAPTER 3. STALIN'S IMAGE IN SPACE

1. V. V. Sadoven', "Metodicheskaia razrabotka ekskursii po GTG na temu: 'Obrazy Lenina i Stalina v sovetskom izobrazitel'nom iskusstve'" (1947). See OR GTG, f. 8.III, d. 926, ll. 1–2.

2. OR GTG, f. 8.III, d. 926, ll. 14, 16.

3. OR GTG, f. 8.III, d. 926, ll. 16–17.

4. Here I follow Edward Shils, *Center and Periphery: Essays in Macrosociology* (Chicago: University of Chicago Press, 1975), 3, 5.

5. Katerina Clark, *Petersburg: Crucible of Cultural Revolution* (Cambridge, Mass.: Harvard University Press, 1995), 278. On Moscow as the sacral center of Soviet Russia in the 1930s see also Hans Günther, "Das Massenlied als Ausdruck des Mutterarchetypus in der sowjetischen Kultur," *Wiener Slawistischer Almanach*, no. 44 (1997): 348.

6. *Istoriia vsesoiuznoi kommunisticheskoi partii (bol'shevikov): Kratkii kurs* (1945; reprint, Moscow: Pisatel', 1997), 3.

7. Ibid., 17.

8. Ibid., 18.

9. Ibid., 31.

10. Rainer Schoch, *Das Herrscherbild in der Malerei des 19. Jahrhunderts* (Munich: Prestel, 1975).

11. Henri Barbusse, quoted in *Stalin: K shestidesiatiletiiu so dnia rozhdeniia* (Moscow: Pravda, n.d. [1939 or 1940]), 75. The Barbusse quote on Stalin was disseminated widely and was reprinted in *Pravda,* 7 November 1935, 2.

12. RGASPI, f. 74, op. 1, d. 292, ll. 92–920b. Dated 15 July 1933.

13. Signed by "M. M. Gromov, A. B. Iumashev, S. A. Danilin, Negoreloe-Moskva, 23 August 1937." *Pravda,* 24 August 1937, 2.

14. Mount Stalin (*pik Stalina*) was renamed Mount Communism (*pik Kommunizma*) in 1962 after the second wave of de-Stalinization and in 1998 Mount Ismail Samani in independent Tadzhikistan.

15. *Pravda,* 17 September 1937, 6. For the story on the ascent of Mount Lenin see ibid., 7 September 1937, 6.

16. Ibid., 5 October 1935, 6.

17. This flag was clearly retouched into the photograph. See ibid., 1 February 1940, 1.

18. In his collection of panegyric court poetry from the 1650s to 1670s Simeon Polotsky frequently compared tsars, such as Fedor Alekseevich, to the sun: "I dare to call Russia heaven/For I find planets in it./You [O Tsar] are the sun; the moon is Tsaritsa Mariia;/and Tsarevich Aleksei is the bright morning star" ("Nebom Rossiiu nareshchi derzaiu/Ibo planety v onei obretaiu./Ty solntse; luna—Mariia tsaritsa;/Aleksei svetla tsarevich denitsa.") See Harsha Ram, *The Imperial Sublime: A Russian Poetics of Empire* (Madison: University of Wisconsin Press, 2003), 35 (translation by Ram).

19. See Evgenii Gromov, *Stalin: Vlast' i iskusstvo* (Moscow: Respublika, 1998), 44–45.

20. On Soviet folklore, sometimes called fakelore, see Frank Miller, *Folklore for Stalin: Russian Folklore and Pseudofolklore in the Stalin Era* (Armonk: M. E. Sharpe, 1990); Felix Oinas, *Essays on Russian Folklore and Mythology* (Columbus: Slavica, 1985). Alma Kunanbaeva and Izaly Zemtsovsky have insisted on the falsification of Soviet folklore and the often violent pressure exerted on such pre-Soviet folklore performers as Dzhambul to take on new Stalinist roles; this pressure is rarely documented and only transpires from oral sources. See their "Communism and Folklore" and the discussion surrounding it in *Folklore and Traditional Music in the Former Soviet Union and Eastern Europe,* ed. James Porter (Los Angeles: Department of Ethnomusicology, UCLA, 1997), 3–44. Also see Ursula Justus, "Vozvrashchenie v rai: Sotsrealizm i fol'klor," in *Sotsrealisticheskii kanon,* ed. Evgeny Dobrenko and Hans Günther (St. Petersburg: Gumanitarnoe agenstvo 'Akademicheskii proekt,' 2000), 70–86; Justus, "Vtoraia smert' Lenina: Funktsiia placha v period perekhoda ot kul'ta Lenina k kul'tu Stalina," ibid., 926–952.

21. See Levon A. Abramian, "Tainaia politsiia kak tainoe obshchestvo: Strakh i vera v SSSR," *Etnograficheskoe obozrenie,* no. 5 (1993): 38.

22. "Stalin, solntse moe, ia ponial v Moskve:/Serdtse mudrogo Lenina b'etsia v tebe./V den' siiaiushchii, kak biriuza,/Byl v Kremle ia v krugu druzei./Uvidali moi glaza/Velichaishego iz liudei./Ty, ch'e imia dostiglo zvezd/Slavoi pervogo mudretsa,/Byl vnimatelen, laskov prost/I rodnei rodnogo ottsa./Za radushnyi, ottsovskii priem v Kremle,/Stalin, solntse moe, spasibo tebe." Quoted in Abramian, "Tainaia politsiia," 38.

23. "A esli u nashei liubimoi zastavy/Poiaviatsic polchishcha liutykh vragov,/My grianem desantom neslykhannoi slavy/Po cherepu vrazh'ikh fashistskikh polkov.//My tam proletim, gde do nas ne letali./My vse sovershim, chto svershit' my dolzhny.//Da zdravstvuet solntse! Da zdravstvuet Stalin!/Da zdravstvuet liudy sovetskoi strany! (2 raza) A. Bezymenskii." *Pravda,* 6 November 1935, 4.

24. "STALIN—SOLNTSE ZOLOTOE NASHE (Iz materialov dlia toma 'Narodnoe tvorchestvo,' prislannykh v redaktsiiu 'Dvukh piatiletok')/ Stalin—solntse zolotoe nashe./Dlia vragov smertel'no slovo—/'Stalin.'/Grozovye tuchi razognavshi,/Ty otkryl nam solnechnye dali.//. . . //Posredi boitsov, pered srazhen'em,/Bogatyrski velichav i stroen,/Boevym sverkaet snariarzhen'em/Voroshilov—znamenitsy voin./Nikogda v boiakh ne pobezhdennyi,/On odet v broniu krepchaishei/stali,/Smelyi voin, solntsem/osveshchennyi . . . /Eto solntse

zolotoe—Stalin. . . . " *Pravda,* 10 September 1936, 10. Also see an "uncredited poem by a child published soon after Stalin's death [that] was marked as a child's work by metrical irregularities that would not have been forgiven a mature poet": "Little bird, take to the Kremlin/My warm greetings./To the sun of the world, the capital,/To dear Moscow,/To Stalin, my friend and my father!" "Ptitsa, v Kreml' otnesi/Moi goriachii privet./Solntsu mira, v stolitsu,/V rodnuiu Moskvu,/Stalinu—drugu—ottsu moemu!" Catriona Kelly, "Riding the Magic Carpet: Children and Leader Cult in the Stalin Era," *Slavic and East European Journal* 49, no. 2 (2005): 199–224.

25. See "Shein is das Leb'n," in G. von Poehl and M. Agthe, *Das Judentum: Das wahre Gesicht der Sowjets* (Berlin: Otto Stollberg, 1943), 83. The transliterated original stanza reads: "Er hat die groijße scheine Sunn/Op der Erd' arofgebracht,/a bliehendik'n Garten/Fun unser Land gemacht." This Soviet Yiddish Stalin folklore is from a Nazi propaganda publication, eager to prove the alleged "Judeo-Bolshevik" connection. For the Nazi volume, Yiddish ditties (*chastushki*) dedicated to Stalin were extracted from Dobruzhin, *Jiddische Volkslieder weg'n Stalinen* (Moscow: Der Emes, 1940). I am grateful to Frank Grüner for sharing this source with me.

26. RGASPI, f. 558, op. 11, d. 717, l. 102. Letter by V. I. Vitkevich. N.d. but stamped "received 31 January 1945."

27. RGASPI, f. 558, op. 11, d. 1377, l. 114.

28. RGALI, f. 2368, op. 2, d. 36, l. 16.

29. Hans Blumenberg and Martin Jay, among others, have identified as typical for modern discourse the privileging of the sense of vision and the frequency of luminary metaphors. See Hans Blumenberg, "Light as a Metaphor for Truth," in *Modernity and the Hegemony of Vision,* ed. David Levin (Berkeley: University of California Press, 1993), 30–62; Martin Jay, *Downcast Eyes: The Denigration of Vision in Twentieth-Century French Thought* (Berkeley: University of California Press, 1993).

30. See Poehl and Agthe, *Das Judentum,* 85–86.

31. David Freedberg, *The Power of Images: Studies in the History and Theory of Response* (Chicago: University of Chicago Press, 1989), 62.

32. Katerina Clark is among the many scholars to have noted Stalin's immobility; in her words, Stalin "was also of a different temporal order—of being, rather than becoming—and so was depicted in film and art as static and vertical or, if moving at all, doing so at an exaggeratedly slow and deliberate, monument-like pace." Clark, *Petersburg,* 302.

33. For the vitality of "gender codes" in "naturalizing" power relations, see Joan Wallach Scott, *Gender and the Politics of History* (New York: Columbia University Press, 1988), 48.

34. Ironically, in real life Stalin apparently used expensive British pipes. In 1948 Ivan Maisky, the Soviet ambassador in London, sent Stalin pipes as complimentary gifts from two British pipe-making companies. Earlier the British ambassador in Moscow, Sir Archibald Clark Kerr, had given Stalin a pipe, a fact that was publicized in the British press. See RGASPI, f. 558, op. 11, d. 775, l. 110. Letter by Ivan Maisky from Moscow, dated 18 August 1948.

35. Consider postmodernist writer Viktor Pelevin's novel *Generation "P,"* in which the main hero Tatarsky composes a new television ad spot: "He had a new idea. He picked up his pencil again and wrote under his first caption: advertisement/poster for 'Sony Black Trinitron.' A close-up of uniform cuffs. Fingers are breaking 'Gertsegovina Flor' and rummaging the table. A voice [with a Georgian accent]: 'Did you see my pipe (*trubka*), Comrade Gorky?' 'I threw it away, Comrade Stalin.' 'Why is that?' 'Because, Comrade Stalin, the leader of the world proletariat can only have a "Trinitron-Plus" television tube (*trubka*).'" Viktor Pelevin, *Generation "P"* (Moscow: Vagrius, 1999), 111. This quote is not in Andrew Bromfield's English translation *Homo Zapiens* (New York: Penguin, 2003).

36. For the long history of the "female" disease of hysteria see e.g. the literature cited in Sander L. Gilman et al., *Hysteria beyond Freud* (Berkeley: University of California Press,

1993), xviii–xxiv. Trotsky, too, was portrayed as hysterical and effeminate. For example, in the screenplay of V. V. Vishnevsky's *Unforgettable 1919,* Stalin's calm but realistically sober evaluation of the situation of the Reds in the Russian Civil War is presented as the ideal golden mean between, on the one hand, overly optimistic reports (*igra v spokoist-vie*) and, on the other hand, the "hysterical fits of Trotsky." See "Rol' I. V. Stalina iz p'esy V. V. Vishnevskogo 'Nezabyvaemyi 1919-i,' sygrannoi A. D. Dikim v Malom teatre: Mash. s pometkami A. D. Dikogo [1949]," RGALI, f. 2376, op. 1, d. 16, l. 1.

37. Henri Barbusse, *Stalin: A New World Seen Through One Man,* quoted in Philip Boobyer, *The Stalin Era* (New York: Routledge, 2000), 109. Stalin's unpretentious rhetorical style was seen as a strength rather than a weakness and taken as a sign of his modesty. Galina Shtange, a professor's wife and member of the intelligentsia, in 1937 noted in her diary about a radio address by Stalin: "Stalin speaks very slowly and distinctly—extremely simply, so simply that each word penetrates into your consciousness and I think the man cannot be found who would not be able to understand what he says. I really love that, I don't like highfaluting, bombastic speeches that are aimed at creating an acoustic effect." Véronique Garros, Natalia Korenevskaya, and Thomas Lahusen, eds., *Intimacy and Terror: Soviet Diaries of the 1930s* (New York: New Press, 1995), 205.

38. Heinrich Hoffmann, *Hitler Was My Friend* (London: Burke, 1955), 114.

39. Joachim C. Fest, *Hitler: Eine Biographie* (Frankfurt/Main: Ullstein, 1973), 709–710.

40. RGALI, f. 2932, op. 1, d. 344, l. 11. Gerasimov gave this speech on the occasion of Stalin's seventieth birthday at the Central House of Art Workers during an evening devoted to "The Image of Iosif Vissarionovich Stalin in Works of Art."

41. RGALI, f. 2932, op. 1, d. 344, l. 11.

42. Katerina Clark noted that "The spatial hierarchy was articulated in a series of concentric circles, somewhat like a national *matrioshka* doll: the outer rim was the country at large (the periphery), the first inner circle was Moscow, and then came the Kremlin. There was also an innermost inner, Stalin's study in the Kremlin, but it was generally considered too sacred to be actually represented; it could be seen only as 'the light in the window.' In its stead, commonly either St. George's Hall, the place of public ceremonial and investiture, or a tower of the Kremlin functioned as that solid, innermost doll of the *matrioshka*." Katerina Clark, "Socialist Realism and the Sacralizing of Space," in *The Landscape of Stalinism: The Art and Ideology of Soviet Space,* ed. Evgeny Dobrenko and Eric Naiman (Seattle: University of Washington Press, 2003), 11.

43. The painting was not only Stalinist Russia's most famous. Ekaterina Voroshilova, Kliment Voroshilov's wife, in 1955 noted in her diary: "A. M. [Gerasimov] at various times painted a number of paintings of K. E. [Voroshilov], of which I don't like a single one, with the exception of the group portrait *I. V. Stalin and K. E. Voroshilov in the Kremlin.*" RGASPI, f. 74, op. 1, d. 439, l. 76. Entry dated 17 November 1955.

44. At a 1938 meeting at the Central House of Art Workers, Gerasimov was asked, "The landscape for the portrait *Stalin and Voroshilov* is completely painted from life or changed?" He answered, "It is painted from life, but for the composition I had to move closer two characteristic houses (*dlia kompozitsii mne prishlos' dva kharakternykh domika priblizit'*)." See RGALI, f. 2932, op. 1, d. 701, l. 33.

45. See Mikhail Yampolsky, "In the Shadow of Monuments: Notes on Iconoclasm and Time," in *Soviet Hieroglyphics: Visual Culture in Late Twentieth-Century Russia,* ed. Nancy Condee (Bloomington: Indiana University Press, 1995), 93. According to Yampolsky, one of the reasons that the Kremlin has had no anthropomorphic monuments "may be connected with the fact that its cathedrals have absorbed such a concentration of history that a monument, which denies history's progression, could not withstand the powerful weight of historical evidence. By their historical gravity, the cathedrals would destroy the pathos of any anthropomorphic monument." Ibid., 96.

46. True, the Lenin Mausoleum on Red Square, right outside the Kremlin walls, can be regarded as an anthropomorphic monument. As Lenin's successor, celebrated as "Lenin today" from the late 1920s to the mid-1930s, Stalin drew legitimizing power from the presence of the dead leader in the mausoleum.

47. Interestingly, the Soviet star on Voroshilov's belt can be seen as being linked through a diagonal axis with the red star on the Kremlin tower.

48. The leader, however, is always in the center, and the masses remain in the periphery; see Clark, *Petersburg,* 306.

49. See I. S. Rabinovich's introductory article to *Stalin i liudy sovetskoi strany v izobrazitel'nom iskusstve: Katalog vystavki* (Moscow: Izdanie Gosudarstvennoi Tret'iakovskoi Gallerei, 1939), 7.

50. See Timothy J. Colton, *Moscow: Governing the Socialist Metropolis* (Cambridge, Mass.: Belknap Press of Harvard University Press, 1995), 259–262, 331–334, 365–367; Sona Stephan Hoisington, "'Ever Higher': The Evolution of the Project for the Palace of Soviets," *Slavic Review* 62, no. 1 (2003): 41–68; Dmitrii Khmel'nitskii, *Zodchii Stalin* (Moscow: Novoe literaturnoe obozrenie, 2007), 42–100.

51. Hoisington, "'Ever Higher,'" 62.

52. *Pravda,* 20 February 1934, 2 (from the original "Postanovlenie Soveta Stroitel'stva Dvortsa Sovetov pri Prezidiume TsIK Soiuza SSR 19 Fevralia 1934 goda").

53. On Soviet-style communism as eschatology see Igal Halfin, *From Darkness to Light: Class, Consciousness, and Salvation in Revolutionary Russia* (Pittsburgh: University of Pittsburgh Press, 2000).

54. Katharina Kucher, "Raum(ge)schichten: Der Gor'kij-Park im frühen Stalinismus," *Osteuropa* 55, no. 3 (2005): 157. Also see Kucher, *Der Gorki-Park: Freizeitkultur im Stalinismus 1928–1941* (Cologne: Böhlau, 2007).

55. Kucher, "Raum(ge)schichten," 160–161.

56. Begicheva closed by proposing two more projects, the implementation of a Stalin medal and the removal of Lenin from money bills, because Lenin "did not like money. He did not like gold with its dark power over people. Tsars and despots were shown on coins, but they acknowledged the omnipotence of money; I don't want LENIN's image, the purest of images, to be crumpled by (often dirty) hands." RGASPI, f. 82, op. 2, d. 506, ll. 142–145. Dated 12 September 1945.

57. TsDRI was the result of a 1935 merger of the RABIS (Union of Art Workers)–initiated and Lunacharsky-supported Club of Theater Workers (founded on 25 February 1930) and the Club of Moscow Artists (founded on 16 July 1932) into a Club of Art Masters. On 26 December 1937 this Club of Art Masters was renamed Central House of Art Workers. See the CD-ROM by N. B. Volkova and Klaus Waschik, eds., *Russian State Archive of Literature and Art: The Complete Archive Guide* (Munich: K. G. Saur, 1996), synopsis of TsDRI. f. 2932. According to another source, the Club of Art Masters was located on Staropimenovskii pereulok until it moved to Pushechnaia ulitsa in 1939 and was renamed Central House of Art Workers. See Vigdariia Khazanova, *Klubnaia zhizn' i arkhitektura kluba 1917–1941* (Moscow: "Zhiraf," 2000), 94–95 n. 74.

58. The meetings at TsDRI involved a question-and-answer period, at which criticism from the audience might be voiced. Following our meeting, someone asked: "Honestly, isn't your painting *Stalin at the Sixteenth Party Congress* weak? Your last painting, *Stalin and Voroshilov,* is more interesting." Gerasimov replied: "At the exhibition I received praise for this picture not because I am Gerasimov. Therefore it was not weak among the paintings exhibited there. In comparison to the picture *Stalin and Voroshilov* it is, of course, weaker." RGALI, f. 2932, op. 1, d. 701, l. 31.

59. RGALI, f. 2932, op. 1, d. 701, l. 25. The painting was first exhibited at the 1938 "Twenty Years of the Red Army" exhibition (see OR GTG, f. 8.II, d. 994, l. 59).

60. For a photograph of Gerasimov during the actual painting of *Stalin and Voroshilov in the Kremlin* see V. S. Manin, *Iskusstvo v rezervatsii: Khudozhestvennaia zhizn' Rossii 1917–1941gg.* (Moscow: Editorial URSS, 1999), 217.

61. RGALI, f. 2020, op. 2, d. 6, l. 4. It appears that two rival publishing houses, IZOGIZ and Iskusstvo, conducted Stalin portrait competitions during the same year, 1937, on the occasion of the twentieth anniversary of the October Revolution. Both were closed competitions, in which only selected artists were invited to participate; open competitions were publicized widely and garnered more entries. The IZOGIZ competition was financially even more rewarding than that of Iskusstvo: a first prize received twenty thousand rubles, whereas Iskusstvo paid fifteen thousand. For Iskusstvo's competition, see RGALI, f. 652, op. 8, d. 112.

62. RGALI, f. 2020, op. 8, d. 6, l. 3.

63. RGALI, f. 2020, op. 8, d. 6, l. 3. To be sure, the participants also had "the right to suggest their own theme to the publishing house, as long as it [did] not diverge from the purpose of the competition." See RGALI, f. 2020, op. 8, d. 6, l. 4.

64. RGALI, f. 2020, op. 8, d. 6, l. 4.

65. RGALI, f. 2932, op. 1, d. 701, ll. 26–27.

66. RGALI, f. 2932, op. 1, d. 776, l. 5. An *Iskusstvo* article about Stalin Prize winners ("Prazdnik sotsialisticheskoi kul'tury," *Iskusstvo*, no. 2 [1941]: 6), published shortly before the German attack on the Soviet Union in World War II, claimed that the title *Na strazhe mira* was in fact not Gerasimov's invention but of popular origin: "Not surprisingly, the viewer gave the group portrait *I. V. Stalin and K. E. Voroshilov in the Kremlin* a different name: *Guarding Peace (Na strazhe mira)*."

67. OR GTG, f. 8.III, d. 926, ll. 16. Sadoven further echoed Gerasimov: "The picture was painted for the twentieth anniversary of the Red Army and had a different title—*Guarding Peace (Na strazhe mira)*. It is a vivid example of the evolution from portrait subjects in Soviet art to historical subjects, executed in the monumental style. The painting conveys the spirit of the epoch of Stalin's prewar Five-Year Plans, which pushed the country forward on the Leninist path. Our reception of this painting is particularly emotional in our days, when our Motherland, after the victorious Great Patriotic War, under the leadership of Stalin has resumed creative, constructive labor." OR GTG, f. 8.III, d. 926, ll. 17–18.

68. *Dva vozhdia posle dozhdia*, a piece of oral lore, was told to me by Gábor Rittersporn, whom I wish to thank. It is confirmed by Mariia Chegodaeva, *Dva lika vremeni (1939: Odin god stalinskoi epokhi)* (Moscow: Agraf, 2001), 40.

69. RGALI, f. 2932, op. 1, d. 344, l. 9.

70. Also see V. I. Vikhtinskii et al., *Vo imia mira (Podpisanie dogovora mezhdu Sovetskim Soiuzom i Kitaiskoi Narodnoi Respublikoi)*, illustration in Hubertus Gassner and Alisa Liubimova, eds., *Agitatsiia za schast'e: Sovetskoe iskusstvo stalinskoi epokhi* (Bremen: Edition Temmen, 1994), 107; D. A. Nalbandian's Dlia schast'ia naroda: *Zasedanie Politbiuro TsK VKP(b)*, illustration ibid., 100.

71. Significantly, in Shegal's picture of 1937, Lenin is still larger than life: he appears in the background as a statue about three times bigger than Stalin. In Nalbandian's *Dlia schast'ia naroda* (see note 70), Lenin appears only in a small picture on a wall at back; Stalin himself had become so much the center that he no longer needed any sort of legitimacy from the older leader, Lenin.

72. See illustration 276 in Matthew Cullerne Bown, *Socialist Realist Painting* (New Haven: Yale University Press, 1998), 253.

73. See illustration ibid., 104. The same could be said of Gorky in Anatoly Iar-Kravchenko's *A. M. Gor'ky Reads to Stalin* (*A. M. Gor'kii chitaet Stalinu;* see illustration ibid., 106). Gorky is reading to Stalin, Voroshilov, and Molotov, but here the axis Gorky-Stalin is so strong as to break through the circular spatial arrangement—the presence of the country's sacral center, Stalin, is literally overpowering.

74. The competing metaphor here is that of Stalin the gardener. For Stalin's applications of this metaphor to himself, see Jochen Hellbeck, "Laboratories of the Soviet Self: Diaries of the Stalin Era" (Ph.D. diss., Columbia University, 1998), 64–66. On the change from machine to garden metaphors for Soviet society see Katerina Clark, *The Soviet Novel: History as Ritual* (Chicago: University of Chicago Press, 1981), chap. 4. On the related metaphor of the gardening state see also Zygmunt Bauman, *Modernity and the Holocaust* (Ithaca: Cornell University Press, 1989), 13, 71, 91–92; Amir Weiner, *Making Sense of War: The Second World War and the Fate of the Bolshevik Revolution* (Princeton: Princeton University Press, 2001), 27–31.

75. *Sovetskoe Iskusstvo*, no. 7 (14 February 1947): 1.

76. See ibid., no. 6 (20 January 1951): 1.

77. Different folk arts, it should be noted, were gendered differently. Embroidery was considered a typically female art form.

78. Zamoshkin then turned to the process of production and stressed the time-consuming manual creation of the portrait, which Tselman worked on "over the course of one-and-a-half years." Time-consuming manual labor, the paragon of conscious deceleration, is seen as possessing great value—against the backdrop of fast industrial production in the modern age. Unsurprisingly, in line with this evocation of the personalized nature of preindustrial artistic production, the embroideress personally delivered her portrait as a gift to Stalin: "Comrade Tselman gave her work as a gift to Comrade J. V. Stalin. The portrait, as a piece of artwork, is currently being shown in the State Tretyakov Gallery." But in this reliquary of Stalin art it only ended up after both a number of painters, representing a high art as opposed to Tselman's folk art, and an institution, the Institute of Art Industry, had given their approval: "Prominent Soviet artists examined her portrait: the USSR People's Artist A. Gerasimov, the RSFSR People's Artist V. Iakovlev, the Stalin Prize laureate V. Efanov, the artist P. Vasilev, creator of many works dedicated to V. I. Lenin and I. V. Stalin. They all unanimously noted the great artistic merit of this work. The Institute of Art Industry also gave a first-class appraisal of Comrade Tselman's work, noting that her portrait has great artistic value and is executed with high technical mastery and great subtlety in color tones." *Pravda*, 9 June 1946, 2.

79. Albert Boime, *The Magisterial Gaze: Manifest Destiny and American Landscape Painting c. 1830–1865* (Washington: Smithsonian Institution Press, 1991), 1.

80. Ibid., 21–22.

81. Ibid., 9–10. In his 1836 "Essay on American Scenery," Thomas Cole wrote: "Where the wolf roams, the plough shall glisten; on the gray crag shall rise temple and tower—mighty deeds shall be done in the now pathless wilderness" (quote Boime, *The Magisterial Gaze,* 53). Boime comments on this passage: "Here is the textual delineation of his graphic rendition of the idea of futurity and the overcoming of the human and material obstacles to this progress. It is this challenge to the Euro-Americans that makes the civilizing process so basic to their idea of advance—carried out with the sense of a God-ordained mission" (ibid.).

82. One could claim that *Morning of Our Motherland* cannot be compared with the American paintings since Cole, for example, belongs to the genre of landscape painting, and Shurpin to portraiture. Yet the dividing line between these genres is in fact quite blurred, and both paintings feature a mixture of portrait and landscape components. More importantly, Stalinist landscape painting from the 1930s onward, as Mark Bassin has observed, differed from American landscape painting in its attempted reconciliation of the innate elementalism (*stikhiinost'*) of nature and the Soviet people's mastery over precisely this elementalism—witness the hydroelectric plants and the industrial construction sites. "The result," writes Bassin, "was an entire category of artistic production, the individual examples of which were all united by the deliberate effort to demonstrate how Soviet reality was actually achieving the utopian goal of preserving the unique elemental splendour of the natural world at the

very time that it was transforming this same world into something completely different and incalculably superior." Mark Bassin, "'I Object to Rain that Is Cheerless': Landscape Art and the Stalinist Aesthetic Imagination," *Ecumene* 7, no. 3 (2000): 334.

83. Boime, *The Magisterial Gaze,* 75–76.

84. RGALI, f. 2932, op. 1, d. 344, l. 11. Also see Samokhvalov's 1940 Lenin picture, which at first sight suggests a spatial arrangement in circular motion, but actually is quite different; here, Lenin also moves forward, quite literally out of the picture, in the direction of the viewer (see illustration in Gassner and Liubimova, *Agitatsiia za schast'e,* 97).

85. RGALI, f. 2942, op. 1, d. 133, l. 430b. The occasion was a 4 March 1939 meeting of the Moscow Sculptors' Union dedicated to the subject of "the image of V. I. Lenin and J. V. Stalin in sculpture."

86. "PORTRET VOZHDIA/Znakomy mne vsekh morshinok cherty,/Vse iskorki v pristal'nom vzore;/V nem stol'ko prekrasnoi, rodnoi/Prostoty!/V nem volia naroda, v nem nashi mechty,/V nem myslei bezbrezhnoe more.//I kazhdaia tonkaia skladka na lbu/Rasska-zhet pro trudnye gody./Pro t'iur'my Sibiri, s vragami bor'bu,/Pro to, kak pobedno v ogne i dymu/Shagali rabochie vzvody.//Pro to, kak zavody v pustyniakh rosli,/Kak v tundre tsvety rastsvetali,/Pro to, kak my golod i stuzhu proshli,/Proshli i bogatymi stali./Znakomaia vsem nam, rodnaia shinel',/Dymok serebristyi ot trubki . . . /I vizhu ia khleb ukrainskikh stepei,/Kavkazskuiu neft', zhar donbasskikh uglei,/Linkorov vysokie rubki./Ia vizhu, kak sotni geroev truda,/Tvoeiu zabotoi sogrety,/Vozvodiat zavody, dvortsy, goroda . . . /Tvoriat vdokhnovenno poety./Piloty—geroi vozdushnykh morei—/Tumany i mrak pobezhdaiut,/I tysiachi nashikh sovetskikh detei/Imia vozhdia proslavliaiut. ALEKSANDR KARACHUNSKII. 16 let. g. Aleksandriia, Kirovogradskaia obl." *Pravda,* 1 May 1941, 5.

87. "Lunacharski," writes Matthew Cullerne Bown, "in his book *The Great Turning* (*Velikii Povorot,* 1919), provided an extended, passionate description of his [Lenin's] head." Bown, *Socialist Realist Painting,* 56.

88. RGALI, f. 2368, op. 2, d. 36, l. 12. This statement is by Evgeny Katsman.

89. RGALI, f. 2368, op. 2, d. 36, l. 16.

90. RGALI, f. 2932, op. 1, d. 344, l. 21. The fixation on eyes had a long cultural heritage. Suffice it to recall Romanticism's eyes as "windows of the soul" or the differing depiction of men's and women's eyes in French Impressionism (see Stephen Kern, *The Gaze in English and French Paintings and Novels, 1840–1900* [London: Reaktion, 1996]). For Russia Richard Wortman describes the cultural significance of the tsar's eyes as expressing his character more than any other part of his body. He cites a number of contemporary memoiristic impressions of Alexander II's weak gaze, in comparison with the domineering eyes of his father, Nicholas I. See Richard Wortman, *Scenarios of Power: Myth and Ceremony in Russian Monarchy,* vol. 2 (Princeton: Princeton University Press, 2000), 22–23.

91. RGALI, f. 2932, op. 1, d. 344, ll. 21–22.

92. On the heroes of socialist realist novels acquiring this ability see Clark, *The Soviet Novel,* 141–145; Abram Tertz [Andrei Siniavsky], *The Trial Begins and On Socialist Realism,* trans. Max Hayward and George Dennis (Berkeley: University of California Press, 1982), 149.

93. From the magazine of the Union of Soviet Writers of the Lithuanian SSR, *Pergale,* no. 4 (1950): 52, quoted in Czeslaw Milosz, *The Captive Mind,* trans. Jane Zielonko (New York: Knopf, 1953), 231. Thanks to Malte Rolf for this source.

94. For illustration see *Sovetskoe Iskusstvo,* no. 21 (22 May 1948): 1.

95. For illustration see Gleb Prokhorov, *Art under Socialist Realism: Soviet Painting 1930–1950* (Roeville East: Craftsman House, 1995), 101, 48.

96. Diana Leslie Cheren comes close to such an exegesis in her study of a painting of Deneika, occupying the border zone between avant-garde and socialist realism, "Recovering Uncertainty: An Interpretation of Aleksandr Deineka's 'The Defense of Petrograd,'" (M.A. thesis, University of California Berkeley, 1995). So does Christina Kiaer in her own work

on Aleksandr Deineka: see, for example, Christina Kiaer, "Was Socialist Realism Forced Labour? The Case of Aleksandr Deineka in the 1930s," *Oxford Art Journal* 28, no. 3 (2005): 321–345. Typically, however, these studies are on a stylistically ambiguous painter, not on a full-fledged socialist realist like Aleksandr Gerasimov or Dmitry Nalbandian.

97. Boris Groys, "The Art of Totality," in *The Landscape of Stalinism,* ed. Dobrenko and Naiman, 98–99.

98. On this see Schoch, *Das Herrscherbild in der Malerei des 19. Jahrhunderts,* 9, 25.

99. Quoted from A. Schmarsow and B. Klemm, eds., *W. Bürgers Kunstkritik,* vol. 2 (Leipzig: Klinkhardt & Biermann, 1909), 317.

CHAPTER 4. THE POLITICAL IS PERSONAL, ART IS POLITICAL

1. "Vdrug iz 'PRAVDY' rezko-zvonnaia/Treskotnia telefonnaia:/—'Dem'ian!'/—'Ia ne slyshu! Oglokh!' /—'Bros' shutit'!'/—'Nu, ne budu!'/—'V redaktsii perepolokh:/Telegrammy—gruda na grudu!/ . . . /Po sluchaiu polustoletiia Stalina!/Pust' tam Stalin, kak khochet,/Serditsia, grokhochet,/No 'PRAVDE' nel'zia uzhe dal'she/Molchat'./Pishi o Staline bezotlagatel'no./Stalinskii nomer sdaetsia v pechat'/Dvatsatogo dekabria obiazatel'no!' . . ." *Pravda,* 21 December 1929, 4. Thanks to Evgenii Bershtein for help with the translation.

2. See Claus Scharf, "Tradition—Usurpation—Legitimation: Das herrscherliche Selbstverständnis Katharinas II.," in *Rußland zur Zeit Katharinas II.: Absolutismus—Aufklärung—Pragmatismus,* ed. Eckhard Hübner, Jan Kusber, and Peter Nitsche (Cologne: Böhlau, 1998), 98–99. On the continuity between Lomonosov's panegyric odes and Stalin poetry see Joachim Klein, "18. Jahrhundert," in *Russische Literaturgeschichte,* ed. Klaus Städtke (Stuttgart: J. B. Metzler, 2002), 84–85. Thanks to Ingrid Schierle for directing me to these publications.

3. True to sentimentalism, writers representing Nicholas I are overwhelmed by their feelings so that they cannot truly express what they intend to express. "This results in the frequent resort to aporia, the confession of the artist's inability to express or describe what he wishes." Richard Wortman, *Scenarios of Power,* vol. 1, 285.

4. *Stalin: K shestidesiatiletiiu so dnia rozhdeniia* (Moscow: Pravda, n.d. [1939 or 1940]), 58.

5. In the same book, Stalin was quoted as saying of Lenin: "the simplicity (*prostota*) and modesty (*skromnost'*) of Lenin, is his urge to remain unnoticed or, at least, not to stand out and emphasize his high position." Ibid., 74.

6. Ibid., 159.

7. Vladimir F. Alliluev, *Khronika odnoi sem'i: Alliluevy, Stalin* (Moscow: Molodaia gvardiia, 1995), 201. Quoted in Evgenii Gromov, *Stalin: Vlast' i iskusstvo* (Moscow: Respublika, 1998), 411.

8. Lion Feuchtwanger, *Moscow 1937: My Visit Described for My Friends* (New York: Viking, 1937), 76–77. Quoted in Robert C. Tucker, *Stalin in Power: The Revolution from Above, 1928–1941* (New York: W. W. Norton, 1990), 407.

9. Emil Ludwig, *Stalin* (Zurich: Carl Posen, 1945), 188, 190.

10. See Peter Kenez, *Cinema and Soviet Society, 1917–1953* (Cambridge: Cambridge University Press, 1992), 245–246 n. 3, quoting Ervin Sinkó, *Egy Regény Regénye: Moszkvai Naplójegyzetek, 1935–1937,* 3rd ed. (Újvidék, Serbia: Forum Könyvkiadó, 1988), 540.

11. For more reviews of the sources regarding Stalin's "modesty" see Leonid Maksimenkov, "Kul't: Zametki o slovakh-simvolakh v sovetskoi politicheskoi kul'ture," *Svobodnaia mysl',* no. 10 (1993): 26–31; Erik van Ree, *The Political Thought of Joseph Stalin: A Study in Twentieth-Century Revolutionary Patriotism* (London: RoutledgeCurzon, 2002), 164–165. For a review of the sources including Stalin's personal archive at RGASPI, f. 558, op. 11, which became available in 2000, see Sarah Davies, "Stalin and the Making of the Leader Cult in the 1930s," in *Stalin and the Eastern Bloc: The Leader Cult in Communist*

Dictatorships:, ed. Balázs Apor et al. (Basingstoke: Palgrave, 2004), 29–46. Also see Aleksander M. Etkind, "Psychological Culture," in *Russian Culture at the Crossroads: Paradoxes of Postcommunist Consciousness,* ed. Dmitri N. Shalin (Boulder: Westview Press, 1996), 112–113: "Contrary to the 'cult of personality' thesis, Soviet power was not vested in a person; it derived from the state and the party, whose comrades had to exude modesty and reticence and act as conduits for its collective wisdom. Trotsky showed too much personal ambition, which violated the Bolsheviks' personal beliefs. . . . Stalin, by comparison, was a paragon of modesty and collegiality. His demonstratively noncompetitive style in public suited the spirit of the time well."

12. RGASPI, f. 558, op. 1, d. 5088, l. 1210b.

13. RGASPI, f. 558, op. 11, d. 203, ll. 22–23. 20 April 1933 letter by I. Ionov, deputy director of publishing house Stary Bolshevik, with appended dedication by Bibineishvili.

14. RGASPI, f. 558, op. 11, d. 203, l. 21. Copy of Stalin's reply letter to I. Ionov, 21 April 1933.

15. RGASPI, f. 17, op. 163, d. 1020, l. 12. Original: "TsK VKP(b) Politbiuro, Protokol No. 6, Punkt 6 ot 4.V.1934g. Slushali: o stroitel'stve Instituta Stalina v Tiflise. (t.t. Stalin, Beria). Postanovili: (1) Priniat' predlozhenie t. Stalina ob otmene resheniia Zakpromkoma o postroike v Tiflise Instituta Stalina. (b) Reorganizovat' stroiushchegosia v Tiflise Institut v filial Instituta Marksa-Engel'sa-Lenina."

16. Yaroslavsky's 1 August 1935 letter indicated that only Stalin's fiat would open to him the doors of the archive at the Marx-Engels-Lenin Institute (IMEL): "C[omrade] Stalin! Sergo [Ordzhonikidze] called me today before his departure and told me that he talked to you about my planned book 'Stalin.' The exceptional obstacles in this affair that he told you about can only be removed by you: it is indispensable that you or Comrade Poskryobyshev order IMEL or AOR [Archive of the October Revolution] that they allow the use of all available materials and documents. Without this they will not give me a chance to use them." RGASPI, f. 558, op. 1, d. 5089, l. 1. Stalin was also always the ultimate arbiter of what constituted sycophancy and what did not. In answer to a 1940 letter by Yaroslavsky, he wrote: "The painting 'Stalin visits the sick Voroshilov' by the artist Shapiro is the outgrowth of a misunderstanding, since there was no 'Stalin visit to the sick Voroshilov' either in 1907 or 1908. . . . False merits should be attributed neither to me nor to Comrade Voroshilov—we have enough true merits and real authority. But obviously some of the careerist authors of 'memoirs' and the authors of several suspect articles 'about the leaders' need this. They want to advance their careers through excessive and sickening praise of the leaders of Party and state. Do we have the right to cultivate in our people such feelings of servility and toadyism? Clearly we do not. More than that: it is our duty to eradicate these disgraceful and slavish feelings." RGASPI, f. 558, op. 11, d. 842, ll. 45, 49–50 (original of 29 April 1940 letter by Stalin to Yaroslavsky in answer to Yaroslavsky's questions).

17. Quoted in Leonid Maksimenkov, *Sumbur vmesto muzyki: Stalinskaia kul'turnaia revoliutsiia 1936–1938* (Moscow: Iuridicheskaia kniga, 1997), 292–293.

18. See Vance Kepley, *In the Service of the State: The Cinema of A. Dovzhenko* (Madison: University of Wisconsin Press, 1986), 494, quoted in Kenez, *Cinema and Soviet Society,* 148 (155 n. 23 for source). The original document is in RGASPI, f. 71, op. 10, d. 127, ll. 188–189. Published in Andrei Artizov and Oleg Naumov, eds., *Vlast' i khudozhestvennaia intelligentsiia: Dokumenty TsK RKP(b)-VKP(b), VChK-OGPU-NKVD o kul'turnoi politike. 1917–1953 gg.* (Moscow: Mezhdunarodnyi fond "Demokratiia," 1999), 350–351. (Cited as first published in: Anatolii Latyshev, "Stalin i kino," in *Surovaia drama naroda: Uchenye i publitsisty o prirode stalinizma,* ed. Iu. P. Senokosov and Iu. G. Burtin [Moscow: Politizdat, 1989], 494–495.)

19. Quoted from V. A. Nevezhin, ed., *Zastol'nye rechi Stalina: Dokumenty i materialy* (Moscow: AIRO-XX, 2003), 154–155. Original file entitled, "Rechi Stalina I. V. za sentiabr'-noiabr' 1938 goda, ne voshedshie v Sobranie Sochinenii," in RGASPI, f. 558, op. 11, d.

1122, ll. 161–162. Table talk recorded by R. Khmelnitsky and incorrectly dated 7 November 1938 (rather than 1937).

20. RGASPI, f. 558, op. 11, d. 1121, l. 24. This particular file is entitled, "Doklady, rechi, stat'i, interv'iu Stalina I. V., ne voshedshie v Sobranie Sochinenii. Rechi, pis'ma Stalina I. V. na ianvar'–mart 1938 goda, ne voshedshie v Sobranie Sochinenii." Later in 1938 Stalin wrote the comment "a sycophantic piece (*podkhalimskaia shtuka*)" across a *Poem About a Flower* by the Persian poet Lakhuti, translated from Farsi into Russian and dedicated to "The Leader. The Comrade. Stalin." RGASPI, f. 558, op. 11, d. 760, l. 25. The poem is dated 31 December 1938.

21. The function as signal of the Stalin comments on Smirnova's book can be gleaned from the Institute of Marxism-Leninism director M. A. Savelev's 1938 letter to the journal *Molodaia gvardiia*. In the context of a ban on a new work on Lenin he alluded to Stalin's comments: "I strongly recommend to the editorial board to familiarize yourselves with the comment Stalin wrote regarding the depiction of his childhood (you have this comment at your own publishing house *Molodaia gvardiia*)." In late 1953, Stalin's comment was made famous when the leading Soviet history journal, *Voprosy istorii*, mustered it as support for its indictment of the cult of personality (though not yet of Stalin's person). For the posthumous quoting of the comment see the publication (without archival attribution) in P. N. Pospelov, "Piat'desiat let kommunisticheskoi partii Sovetskogo Soiuza," *Voprosy istorii,* no. 11 (1953): 21. Pospelov's article was based on a 19 October 1953 talk given at the Academy of Sciences.

22. RGASPI, f. 558, op. 11, d. 167, ll. 102–103. Stalin's corrections are dated 23 May 1940.

23. On the transfer of the modesty ethos from sainthood—via the sons of priests—to the left intelligentsia see Laurie Manchester, "Harbingers of Modernity, Bearers of Tradition: Popovichi as a Model Intelligentsia Self in Revolutionary Russia," *Jahrbücher für Geschichte Osteuropas* 50, no. 3 (2002): 343; Manchester, *Holy Fathers, Secular Sons: Clergy, Intelligentsia, and the Modern Self in Revolutionary Russia* (DeKalb: Northern Illinois University Press, 2008), 74.

24. RGASPI, f. 81, op. 3, d. 255, l. 159, ll. 118–1180b. Tovstukha's note bears a handwritten "7/VII" date without a year, except a "192" (with a blank space for the specific year in the 1920s) letterhead (of the Tsentral'nyi Komitet R.K.P [B-ov] Moskva).

25. RGASPI, f. 558, op. 11, d. 801, l. 17. Letter to Stalin by M. Rafailov dated 21 August 1924.

26. RGASPI, f. 558, op. 11, d. 801, l. 18. Letter to Mekhlis by M. Rafailov dated 21 August 1924.

27. This history of fond 558 is based on a 25 September 2005 email communication by Oleg Khlevniuk, to whom I am very grateful.

28. For many of Stalin's most important decisions there is no documentation at all. His penchant for the telephone is legendary and goes back at least to his behind-the-scenes dealings against the opposition during the 1920s, when a special telephone system allowed him to eavesdrop on his opponents, if the Soviet defector Boris Bazhanov is to be believed. See Boris Bazhanov, *Vospominaniia byvshego sekretaria Stalina* (N.p.: SP 'Sofinta' Informatsionno-reklamnyi tsentr 'Infodizain,' 1990), 55–60.

29. Oleg Khlevniuk, *Politbiuro: Mekhanizmy politicheskoi vlasti v 30-e gody* (Moscow: ROSSPEN, 1996), 15–16.

30. On this see Jan Plamper, "Archival Revolution or Illusion? Historicizing the Russian Archives and Our Work in Them," *Jahrbücher für Geschichte Osteuropas* 51, no. 1 (2003): esp. 62–69.

31. It also bears noting that the records of the Party's Politburo and Central Committee give little indication that these highest institutions of Soviet power discussed issues pertaining to the Stalin cult: there are almost no decisions as to celebrations of his birthdays or

anything else. A thorough reading of the Central Committee depository of Orgburo and Politburo agendas for the period of 1929–1952 (f. 17, op. 113) furnished such items as "2.0 About the celebration of the tenth anniversary of the Comintern. Resolution of the Central Committee of 22 February 1929" (RGASPI, f. 17, op. 113, d. 705), but only two resolutions regarding the Stalin cult. The first was a resolution "about the placing of an AKhRR [*Assotsiatsiia Khudozhnikov Revoliutsionnoi Rossii*] popular print *Stalin Among the Female Delegates* in issue no. 1 of the journal *Iskusstvo.*" This resolution, almost exactly six months before the first manifestation of the cult, Stalin's fiftieth birthday celebration, is a sign that the cult was in planning from early 1929 onward and that the Party played a role in this planning that it did not want to hide at that point. RGASPI, f. 17, op. 113, d. 731. See protocol no. 121 of the Central Committee Orgbiuro meeting of 24 May 1929, item "84.0 O pomeshchenii v No. 1 zhurnala 'Iskusstvo' lubka AKhRR'a 'Stalin sredi delegatok.'" The second resolution involving the Stalin cult was the already mentioned 19 December 1934 Politburo decision to "honor Comrade Stalin's request to forbid all festivities or celebrations or publications in the press or in meetings on the occasion of his fifty-fifth birthday on 21 December." RGASPI, f. 558, op. 11, d. 1353, l. 8.

32. Tucker, *Stalin in Power,* 147. Also see Robert McNeal, *Stalin: Man and Ruler* (New York: New York University Press, 1988), 107, 146–153, 234–235.

33. See Konstantin Simonov's 1965 interview with Marshal Konev, quoted in Konstantin Simonov, *Glazami cheloveka moego pokoleniia: Razmyshleniia o I. V. Staline* (Moscow: Kniga, 1990), 358.

34. Dmitrii Volkogonov, *Triumf i tragediia: Politicheskii portret I. V. Stalina,* vol. 1 (Barnaul: Altaiskoe knizhnoe izdatel'stvo, 1990), 315.

35. More generally, he was a legendary bureaucrat with a record of processing and controlling a phenomenal quantity of cultural products down to the smallest detail, as has become evident since the opening of the archives. Katerina Clark, among others, has remarked on the extent and breadth of Stalin's filtering of cultural products in her "The Cult of Literature and Nikolai Ostrovskii's 'How the Steel was Tempered,'" in *Personality Cults in Stalinism—Personenkulte im Stalinismus,* ed. Klaus Heller and Jan Plamper (Göttingen: Vandenhoeck & Ruprecht unipress, 2004), 415.

36. RGASPI, f. 558, op. 11, d. 760, l. 163. Copy of Central Committee protocol no. 120, 17 May 1929.

37. RGASPI, f. 558, op. 11, d. 760, l. 162. Letter by Lunacharsky to Central Committee, 18 May 1929.

38. RGASPI, f. 558, op. 11, d. 781, l. 126. Letter by Maria Osten dated 23 February 1935.

39. RGASPI, f. 74, op. 2, d. 41, l. 6. Not dated, but filed under correspondence, 14–21 April 1930.

40. RGASPI, f. 74, op. 1, d. 292, l. 135. The painting had a longer history. A year earlier, Modorov had first written to Voroshilov about this very picture. Modorov had expanded upon his intended message ("with this picture I wanted to express that the existing membership of the Politburo is the author of the First Five-Year Plan") and then asked Voroshilov "to look at my work and give directions for complementing and correcting several places where I might not have succeeded. The critical place is the portrait of Comrade L. M. Kaganovich, who is standing next to you." The picture showed the Politburo at a construction site in the Urals, "where thousands of workers and the entire Obkom, headed by Comrade Kabakov, looked at the picture. The reactions were fabulous. Comrade Kabakov devoted particular attention to the picture at hand and wishes to have a large canvas for his auditorium. His recommendations for changes were very minor: (a) make Kirov a little older, (b) take another look at Comrade Ordzhonikidze, and (c) at Comrade Andreev. They like everything else. Without exception they particularly like the portrait of Comrade Stalin, your portrait, as well as that of Comrades Kalinin and Molotov in the center of the picture.

They did not say anything about Comrade Kaganovich, but I feel myself that he did not quite turn out well. That is why I am appealing for the help of you, the favorite comrade and friend of the artists, who understands art. . . . " Modorov closed by explaining where and when Voroshilov could inspect the painting. Voroshilov noted on Modorov's letter: "Tomorrow we will have to stop by Comrade Modorov's studio." RGASPI, f. 74, op. 1, d. 295, ll. 18–19. Dated 22 March 1933.

41. RGASPI, f. 74, op. 1, d. 281, l. 15.

42. RGALI, f. 652, op. 8, d. 157, l. 33. Poskryobyshev did not specify which portrait needed retouching. Likewise in 1933 IZOGIZ inquired of Voroshilov, in a fashion that had by then become routine, if he would release for mass printing a certain picture of him on a horse (attached as a photograph). Voroshilov returned the letter with the following comment: "I saw the picture and even though I do not quite like it, I do not object to its publication." RGASPI, f. 74, op. 1, d. 292, l. 13. Voroshilov's reply is dated 13 January 1933. The original letter was by Osip Beskin and the picture in question was *Comrade Voroshilov at the Cavalry Parade* by the artist Denisovsky. For a further (undated) example with a picture of a Voroshilov portrait by A. Bystriakov attached see RGASPI, f. 74, op. 1, d. 292, l. 15.

43. RGASPI, f. 558, op. 11, d. 1477, l. 7 (l. 8 for Stalin portrait). Letter by D. Vadimov dated 18 March 1943.

44. RGASPI, f. 558, op. 11, d. 1477, l. 17. Letter by the director of the N. Sundukov, "Direktor Izdatel'stva Akademii pedagogicheskikh nauk RSFSR." Neutolimov's Lenin woodcut is on l. 18, the Stalin woodcut on l. 19.

45. Across the top of Sundukov's letter there is a remark in handwriting: "to Comrade Shepilov." See RGASPI, f. 558, op. 11, d. 1477, l. 17.

46. RGASPI, f. 558, op. 11, d. 1477, l. 20. Letter dated 30 October 1947.

47. RGASPI, f. 558, op. 11, d. 1477, l. 21. Letter dated 14 November 1947.

48. RGASPI, f. 558, op. 11, d. 1477, l. 28. Letter dated 12 December 1947 to the Central Committee Special Sector's Fifth Section, which since World War II had been responsible for processing letters written to Stalin and delegating them to the responsible institutions, which would then act upon them.

49. RGASPI, f. 558, op. 11, d. 1477, l. 22. Letter by Glavrepertkom chief M. Dobrynin dated 14 November 1947. Toidze's Stalin portrait is on l. 23. Thus despite all the regularization and formalization of approval procedures of cult art, the leader's fiat remained decisive.

50. RGASPI, f. 558, op. 11, d. 1477, l. 24. Letter dated 17 November 1947.

51. RGASPI, f. 558, op. 11, d. 1477, l. 25. Letter dated 17 November 1947 by Agitprop deputy chairman Lebedev to the Central Committee Special Sector.

52. RGASPI, f. 558, op. 11, d. 1477, l. 26. Not dated.

53. See RGASPI, f. 558, op. 11, d. 1478. The letter, from Iskusstvo director Kukharkov about artist A. Kruchin, is not dated.

54. For an outright rejection consider the following case. The journal *Vokrug sveta* asked Poskryobyshev whether it could publish an etching of Stalin by V. A. Favorsky. The editorial board must have had its own doubts about the etching, for it considered "it necessary to let you know that the artist is prepared to change the shoulder straps of the figure next to Comrade Stalin, likely Marshal Vasilevsky, in order to make him appear like a staff officer, or to completely drop this figure. The artist is also prepared to make in his etching whatever other changes he is ordered to make." RGASPI, f. 558, op. 11, d. 1477, l. 30. Letter by I. Inozemtsev, editor of *Vokrug sveta*, dated 21 November 1947. The Favorsky etching is on l. 31. Poskryobyshev must have delegated the case to the Agitprop Department because the next piece of correspondence is a laconic letter by Agitprop deputy chairman Lebedev to the Central Committee Special Sector: "The etching of artist Favorsky incorrectly depicts Comrade Stalin's looks (*vneshnost'*), which is why its publication in the journal would be inappropriate. The journal's editorial board has been informed about this." RGASPI, f. 558,

op. 11, d. 1477, l. 29. Letter dated 12 December 1947 to the Central Committee Special Sector's Fifth Section.

55. RGASPI, f. 558, op. 11, d. 1477, l. 16. Letter dated 2 August 1947. The Central Committee Agitprop Department between August 1939 and July 1948 was called Administration of Propaganda and Agitation, *Upravlenie propagandy i agitatsii* (UPA). See T. M. Goriaeva et al., eds., *Instituty upravleniia kul'turoi v period stanovleniia: 1917–1930-e gg. Partiinoe rukovodstvo; Gosudarstvennye organy upravleniia; Skhemy* (Moscow: ROSSPEN, 2004), 57.

56. However, it is unclear how representative this sample is. See RGALI, f. 2305, op. 1, d. 128, ll. 6, 10, 12, 14, 17–18, 21–22, 25–26, 28, 30, 32, 35–36, 39, 41, 47, 49.

57. Examples include Lavrenty Beria (RGALI, f. 2305, op. 1, d. 128, l. 24), Lazar Kaganovich (RGALI, f. 652, op. 8, d. 144, l. 126; RGALI, f. 652, op. 8, d. 147, l. 75), Mikhail Kalinin (RGALI, f. 652, op. 8, d. 144, l. 33), Valery Mezhlauk (RGALI, f. 652, op. 8, d. 157, l. 7), Anastas Mikoian (RGALI, f. 652, op. 8, d. 144, l. 68), and Viacheslav Molotov (RGALI, f. 2305, op. 1, d. 128, l. 13).

58. Though offering no evidence, Volkogonov already noted the participation of Stalin's secretaries and Stalin himself in the cult: "And therefore Tovstukha, Dvinsky, Kanner, Mekhlis, and then Poskryobyshev on a daily basis inspected and approved (*vizirovali*) all more or less important materials about him [Stalin] and the photographs set aside for the press. They showed the most important ones to him, the General Secretary. Not infrequently his pencil added a word or two, which illuminated even more prominently the 'extraordinariness,' 'acumen,' 'decisiveness,' 'care,' 'courage,' and 'wisdom' of 'Comrade Stalin.'" Volkogonov, *Triumf i tragediia,* vol. 1, 321; also see 436.

59. See RGALI, f. 2305, op. 1, d. 135, l. 6.

60. See RGALI, f. 2305, op. 1, d. 128, l. 37.

61. The exact date when a secure telephone connection to the southern vacation spots was established is still unknown. It is, however, a fact that the ciphered telegrams stopped in 1936. See Khlevniuk, *Politbiuro,* 14–15. More recently, it has become clear that a "closed (high-frequency) telephone connection ('VCh') between Moscow and the government dachas in the south was established, it seems, in 1935. From that time on Stalin and his comrades-in-arms also began exchanging telephonograms. . . ." Oleg Khlevniuk et al., eds., *Stalin i Kaganovich: Perepiska, 1931–1936gg.* (Moscow: ROSSPEN, 2001), 8. The other, slower communication channel was via NKVD couriers who took two to three days to carry letters between the southern spas and Moscow. See ibid., 6.

62. RGASPI, f. 558, op. 11, d. 88, ll. 21–22. Original of ciphered telegram by Stalin to Kaganovich, Yezhov, and Molotov from Sochi, 17 August 1935.

63. For Stalin's control of TASS texts see RGASPI, f. 558, op. 11, d. 207 ("Soobshcheniia TASS: Soobshcheniia, biulleteni i vestniki TASS s rezoliutsiiami, pravkami i pometkami Stalina I. V. i zapiski ob opublikovanii ikh v pechati"). Some of the press releases in this file have such comments in Stalin's hand as "not worth publishing." For his ban on eulogistic newspaper articles see e.g. RGASPI, f. 558, op. 11, d. 293, ll. 148–149.

64. Original: "<u>Che-pu-kha</u> St." RGASPI, f. 558, op. 11, d. 1494, l. 6. Lev Mekhlis, at the time editor of *Pravda,* had sent this article on 13 August 1934 to Stalin for permission to publish. Stalin then left his comment and on 1 September 1934 the following note was made on the article: "Mekhlis has been informed."

65. The acting director of Gospolitizdat had first contacted Pospelov who allowed going ahead with the book. "Now it is ready as proofs," in the words of P. Chagin, acting director of Gospolitizdat in his 24 September 1940 letter to Poskryobyshev. Nonetheless, Stalin simply wrote to Zhdanov and Pospelov: "I ask you to forbid the Russian-language publication of Gamsakhurdia's book." RGASPI, f. 558, op. 11, d. 730, l. 190.

66. RGASPI, f. 558, op. 11, d. 699, l. 61. Letter dated 8 December 1932.

67. Stalin changed paragraphs, cut pages, changed words, and added sentences in the 1939 OGIZ version of his biography. See RGASPI, f. 558, op. 11, d. 1281 ("<u>O biografii</u>

Stalina I. V. Kratkaia biografiia 'Iosif Vissarionovich Stalin,' ispravlennaia i dopolnennaia Stalinym I. V.") For the 1947 version see RGASPI, f. 558, op. 11, d. 1282 ("O biografii Stalina I. V. Maket knigi 'Iosif Vissarionovich Stalin: Kratkaia biografiia.' Vtoroe izdanie, ispravlennoe i dopolnennoe. Sostaviteli: Aleksandrov G. F., Galaktionov M. R., Kruzhkov V. S., Mitich M. B., Mochalov V. D., Pospelov P. N.") For more on Barbusse's Stalin biography beginning in 1935 with comments by Stalin, including on a screenplay by Barbusse for a Stalin film, see RGASPI, f. 558, op. 11, d. 700. For background and details see David Brandenberger, "Sostavlenie i publikatsiia ofitsial'noi biografii vozhdia—katekhizisa stalinizma," *Voprosy istorii*, no. 12 (1997): 141–150; Brandenberger, "Stalin as Symbol: A Case Study of the Personality Cult and Its Construction," in *Stalin: A New History*, ed. Sarah Davies and James Harris (Cambridge: Cambridge University Press, 2005), 249–270. Khrushchev, incidentally, in 1956 shrewdly manipulated the traces of Stalin's editing of his biography and left out any evidence that contradicted his assertion of Stalin's megalomania. On this see Maksimenkov, "Kul't," 31–33.

68. For Stalin's comments on the screenplay of Dovzhenko's *Shchors* and a Dovzhenko letter to Stalin see RGASPI, f. 558, op. 11, d. 164.

69. RGASPI, f. 558, op. 11, d. 166, l. 142. "Fil'm *Pervaia Konnaia*, Stsenarii Vs. Vishnevskogo, variant dlia rezhiserskogo tsenariia, V. Vishnevskogo, E. Dzigan. 1939." Title of file: "Kinostsenarii 'Pervaia Konnaia.' Stsenarii kinokartiny Vishnevskogo V. 'Pervaia Konnaia' s pravkami Stalina I. V. (poslednii variant)."

70. RGASPI, f. 558, op. 11, d. 163, ll. 1–20b., 94. "Stsenarii kinokartiny Kaplera A. i T. 'Lenin v 1918 godu' ('Pokushenie na Lenina') s rezoliutsiei i zamechaniiami Stalina I. V." According to a note on the screenplay, he watched the movie on 18 January (year?) between 3:00 and 5:15 A.M., testifying to his well-known habit of watching movies in the Kremlin late at night. His handwritten remarks were typed out.

71. Oleg V. Khlevniuk, *In Stalin's Shadow: The Career of "Sergo" Ordzhonikidze,* trans. David J. Nordlander, ed. Donald Raleigh (Armonk: M. E. Sharpe, 1995), 110. The book was Mamia Orakhelashvili's *Sergo Ordzhonikidze: Biograficheskii ocherk.*

72. For examples see Sheila Fitzpatrick, *Everyday Stalinism: Ordinary Life in Extraordinary Times. Soviet Russia in the 1930s* (New York: Oxford University Press, 1999), 30–31, 113, 195–197.

73. RGASPI, f. 81, op. 3, d. 256, l. 48. Dated 7 December 1932.

74. See Zholkovsky, "The Obverse of Stalinism: Akhmatova's Self-Serving Charisma of Selflessness," in *Self and Story in Russian History,* ed. Laura Engelstein and Stephanie Sandler (Ithaca: Cornell University Press, 2000, 46–68); Irene Masing-Delic, "Purges and Patronage: Gor'kii's Promotion of Socialist Culture," in *Personality Cults in Stalinism,* ed. Heller and Plamper, 443–468; on Gerasimov: Tat'iana Khvostenko, *Vechera na Maslovke bliz "Dinamo": Vospominaniia,* vol. 2: *Za fasadom proletarskogo iskusstva* (Moscow: Olimpiia Press, 2003), 12.

75. A description of Stalin's visit is in RGALI, f. 2368, op. 2, d. 38, l. 37 (the 1928 date for this episode is from an autobiographical vignette in RGALI, f. 2368, op. 1, d. 4, l. 2). Katsman recounted the same visit at much greater length and more formulaically in 1949. See RGALI, f. 2368, op. 2, d. 36, ll. 6–8. For the founding documents and theoretical treatises of the various modernist and realist groups see I. Matsa et al., eds., *Sovetskoe iskusstvo za 15 let: Materialy i dokumentatsiia* (Moscow: OGIZ-IZOGIZ, 1933); Hubertus Gassner and Eckhart Gillen, *Zwischen Revolutionskunst und sozialistischem Realismus: Dokumente und Kommentare. Kunstdebatten in der Sowjetunion zwischen 1917 und 1934* (Cologne: DuMont, 1979).

76. On the Peredvizhniki see Elizabeth Valkenier, *Russian Realist Art: The State and Society. The Peredvizhniki and Their Tradition* (Ann Arbor: Ardis, 1977); Valkenier, *Ilya Repin and the World of Russian Art* (New York: Columbia University Press, 1990); Valkenier, *The Wanderers: Masters of 19th-Century Painting: An Exhibition from the Soviet Union* (Fort Worth: Dallas Museum of Art, 1990).

77. In his 1969 obituary for Voroshilov, Katsman recounted how he had come to share the Kremlin studio: "The daughter of the famous critic V. V. Stasov, who was responsible for the management of the Kremlin, got me a studio at the Kremlin with Voroshilov's agreement, where I worked for fifteen years and produced many portraits of Lenin's comrades-in-arms [In 1969, in the wake of de-Stalinization, Katsman could no longer mention Stalin and had to resort to the code word 'Lenin's comrades-in-arms']. Voroshilov personally made a list of the comrades I portrayed. Together with me worked Unshlikht's wife S. A. and Pavel Radimov. Voroshilov allowed Radimov and me to come to his office without ringing the bell." RGALI, f. 2368, op. 2, d. 33, l. 8. I. S. Unshlikht's wife was an artist (see Tat'iana Khvostenko, *Vechera na Maslovke bliz "Dinamo": Vospominaniia,* vol. 1: *Zabytye imena* [Moscow: Olimpiia Press, 2003], 32). In an earlier (1949) version, Katsman did not mention Unshlikht or his wife, likely because the former was repressed as a Pole in fall 1937 and therefore became persona non grata for the remainder of the Stalin era. See RGALI, f. 2368, op. 2, d. 36, l. 6. According to Tat'iana Khvostenko Unshlikht was shot in 1938 (see Khvostenko, *Vechera na Maslovke bliz "Dinamo,"* vol. 2, 12). According to Robert Conquest he was arrested in late 1937 (see Conquest, *The Great Terror,* 244). Hard to believe, but the abstract painter David Shterenberg, founding chairman of the Society of Easel Painters (1924–1932), purportedly shared the same studio with Katsman and Radimov. See Khvostenko, *Vechera na Maslovke bliz "Dinamo,"* vol. 1, 28.

78. RGALI, f. 2932, op. 1, d. 344, l. 17. Likewise the director of *The Fall of Berlin,* Mikhail Chiaureli, asked Aleksandr Nikolaevich [Poskryobyshev?] to be allowed to look at Stalin's office "for its correct depiction in the film." He was granted his request. See RGASPI, f. 558, op. 11, d. 825, l. 19.

79. RGALI, f. 2368, op. 2, d. 36, l. 11.

80. Katsman states that Stalin visited the exhibition together with other Politburo members on 30 June 1933, though he is not entirely sure of that date. See RGALI, f. 2368, op. 2, d. 36, l. 11. The other exhibition he visited was the tenth AKhR exhibition in 1928. See Gromov, *Stalin: Vlast' i iskusstvo,* 59–60.

81. RGALI, f. 2368, op. 2, d. 36, ll. 12–13.

82. RGALI, f. 2932, op. 1, d. 344, l. 6. The context here was the July 1933 meeting of Brodsky, Gerasimov, and Katsman with Stalin and Voroshilov at Stalin's dacha.

83. Interestingly, Politburo sessions were off-limits to artists, photographers, or anyone else interested in recording the session. Brodsky apparently had permission to paint the Politburo in session until his patrons at the Politburo reneged (through the editor of *Komosmol'skaia Pravda*): "Yesterday I talked to Comrade Yenukidze. He asked me to tell you precisely the following: tell him that, in spite of L. M. [Kaganovich's] comment on the letter 'I do not object' and in spite of Voroshilov's personal intervention, it is absolutely prohibited to admit anyone to the Politburo—not artists, photo journalists, or cameramen. He must not get offended at us. We very much wanted to do this for Brodsky ourselves, but this is the rule." RGALI, f. 2020, op. 2, d. 6, l. 1. Letter dated 25 January 1934. Does this support the thesis of several scholars that the Bolsheviks carried their self-understanding of a conspirational group across the revolutionary divide? See Gabor Rittersporn, "The Omnipresent Conspiracy: On Soviet Imagery of Politics and Social Relations in the 1930s," in *Stalinism: Its Nature and Aftermath: Essays in Honour of Moshe Lewin,* ed. Nick Lampert and Gabor Rittersporn (Armonk: M. E. Sharpe, 1992), 101–120; Stephen Kotkin, *Magnetic Mountain: Stalinism as a Civilization* (Berkeley: University of California Press, 1995), 351, 353.

84. Katsman took "32 sessions, in the course of approximately two months" for a full-size painting of Voroshilov, commissioned for the 1933 exhibition "Fifteen Years of the Red Army." See his 25 April 1933 postcard to Brodskii in RGALI, f. 2020, op. 1, d. 181, l. 15. Elsewhere Katsman wrote about this 1933 painting: "He [Voroshilov] posed 32 days for me at the Revolutionary War Soviet" (RGALI, f. 2368, op. 2, d. 34, l. 9.) Perhaps it was only natural that Voroshilov, as main patron of the arts, actually took the time to pose for

artists—unlike other high Party members. There are letters from Katsman in which he asked that Voroshilov visit him in his Kremlin studio, for "it would be very good to finish <u>at least your eyes</u> in the commenced portrait!" RGASPI, f. 74, op. 1, d. 292, l. 67.

85. OR GTG, f. 8.II, d. 993, l. 28ob.

86. RGASPI, f. 81, op. 3, d. 423, ll. 71–72. Letter by Sergei Lobanov from Moscow, dated 11 October 1931 (or 1934?).

87. One of these was the medical profession. As one of Stalin's physicians remembered, "During my final visit in 1930, Stalin asked me how he could thank me for healing him. I asked him to help me change my apartment, which was a former merchant's horse stable. He smiled after this conversation." I. B. Chernomaz, "Vrach i ego patsient: Vospominaniia I. A. Valedinskogo o I. V. Staline," in *Golosa istorii: Muzei revoliutsii. Sbornik nauchnykh trudov,* no. 23, book 2 (Moscow: n.p., 1992), 123.

88. This did not only apply to artists as well. Consider the sculptor I. V. Tomsky's description of the 1939 Party congress: "I remember that Comrade Grizodubova was supposed to give the opening speech, to do a short welcome address. How nervous she was. She said that her legs were shaking out of nervousness, that she would much more easily do an incredible flight than say a few words at this moment. But as soon as Comrade Stalin appeared, as soon as she saw his gentle face, her entire false fear completely went away." RGALI, f. 2932, op. 1, d. 344, l. 20. Dated 1949. When photographing Stalin in April 1932, the American photographer James Abbe repeated many of the same tropes as the painters. See James E. Abbe, *I Photograph Russia* (London: George G. Harrap, 1935), 57–75; and Pasha Angelina, the tractor-driving Stakhanovite, during a 1935 Kremlin congress with Stalin present "walked to the podium feeling totally numb. There was a lump in my throat, and I could not utter a sound. I just stood there silently, looking at Stalin. He understood my nervousness and said softly, so that only I could hear: 'Be brave, Pasha, be brave . . .' Those words became the guiding light of my whole life." Quoted from Sheila Fitzpatrick and Yuri Slezkine, eds., *In the Shadow of Revolution: Life Stories of Russian Women* (Princeton: Princeton University Press, 2000), 316.

89. RGALI, f. 2932, op. 1, d. 344, l. 6. This is a stenogram of "an evening, dedicated to the theme: 'The Image of Iosif Vissarionovich Stalin in Works of Art'" at the Central House of Art Workers (TsDRI), 23 December 1949.

90. RGALI, f. 2368, op. 2, d. 36, ll. 20–21.

91. RGALI, f. 2368, op. 2, d. 36, l. 5.

92. See introduction by I. S. Rabinovich to *Stalin i liudy sovetskoi strany v izobrazitel'nom iskusstve,* 4. The drawing was also mentioned in the 1947 pamphlet for guides in the Tretyakov Gallery. See "Metodicheskaia razrabotka ekskursii po GTG na temu: 'Obrazy Lenina i Stalina v sovetskom izobrazitel'nom iskusstve,'" 1947, by V. V. Sadoven, in OR GTG, f. 8.III, d. 926, l. 3, where the portrait is listed as "N. Andreev—*Portret I. V. Stalina* 1922g. /pastel'/." Indeed, the visitors were to stop at this drawing and the guide was to say: "One of the few portraits of Comrade Stalin of the time, drawn from life. The portrait conveys the features of Comrade Stalin with great directness and precision. Executed in pastels, softly yet firmly, the portrait is an artistic document of great value. The autograph of Comrade Stalin on the portrait shows that Comrade Stalin likes this portrait." OR GTG, f. 8.III, d. 926, l. 24.

93. Hitler also censored his physical imperfections. For Hitler banning photographs showing him with spectacles or a reading glass see Heinrich Hoffmann, *Hitler Was My Friend* (London: Burke, 1955), verso of pictorial insert between 176 and 177.

94. The following is based on B. A. Bessonov, "'Menia vstretil chelovek srednego rosta . . .': Iz vospominanii skul'ptora M. D. Ryndziunskoi o rabote nad biustom I. V. Stalina v 1926g." in *Golosa istorii,* no. 23, book 2, 111–118. For the Rykov detail, see 112. Ryndziunskaia's memoirs were published, at least partially, in 1939 on Stalin's sixtieth birthday: "Interv'iu s M. Ryndziunskoi," *Dekada moskovskikh zrelishch,* no. 36 (21 December 1939): 16–17. Quoted in Gromov, *Stalin: Vlast' i iskusstvo,* 61–62 (459 nn. 37–40).

95. Bessonov, "'Menia vstretil chelovek srednego rosta . . . ,'" 113.

96. Ibid., 115.

97. Ibid., 116.

98. Ibid.

99. Ibid., 117.

100. Ibid.

101. Ibid., 113. Ryndziunskaia was asked to report any artwork on Stalin for the 1939 anniversary exhibition "J. V. Stalin and the People of the Soviet Land in the Fine Arts." She spoke of a "1933 portrait in wood" and "an unfinished work, still in clay (portrait), without any contract and not earmarked for any organization." She finished: "I would also very much like to do a portrait of Comrade Stalin in 1902." OR GTG, f. 8.II, d. 992, l. 5. Letter dated 12 April 1939. However, the exhibition catalogue only lists a plaster sculpture by People's Artist V. I. Kachalov and one by Mamlakat, no Stalin portrait by Ryndziunskaia. See *Stalin i liudy sovetskoi strany v izobrazitel'nom iskusstve,* 40.

102. Author's interview with Vladilen Aleksandrovich Shabelnikov, A. M. Gerasimov's son-in-law, Moscow, 28 April 2000. However, Brodsky's son Evgeny claimed that his father never did a life portrait of Stalin: "Voroshilov tried to convince Stalin to pose for my father. He ordered my father to Moscow twice because it looked like Stalin agreed to pose. Both times my father returned with nothing." He concluded, "Neither my father nor any other artist managed to paint Stalin in person." M Br, "Vospominaniia syna I. I. Brodskogo, E. I. Brodskogo," typescript, 1982, 47.

103. Matthew Cullerne Bown, *Art under Stalin* (New York: Oxford University Press, 1991), 61. The source for this (235 n. 38) is Roi Medvedev, "O Staline i stalinizme," *Znamia,* no. 3 (1989): 156. Bown also claims that Stalin during the 1930s ended up unhappy with his portrayal "by the sculptor, Boris Iakovlev" (116). But there was no sculptor by the name of Boris Yakovlev, only a painter Boris Yakovlev, and the more famous painter, Vasily Yakovlev. (Even in Bown's own *Socialist Realist Painting* [New Haven: Yale University Press, 1998], 118, Boris Yakovlev is called a painter, and several of his landscape paintings are reproduced. Bown's *A Dictionary of Twentieth-Century Russian and Soviet Painters, 1900–1980s* [London: Izomar, 1998] lists the painter brothers Boris Nikolaevich Yakovlev [1890–1972] and Vasilii Nikolaevich Yakovlev [1893–1953], 352–353).

104. Bown, *Socialist Realist Painting,* 234. For variations of the Mukhina story see Bown, *Art under Stalin,* 222–223. Nowhere does Bown cite the source for this story.

105. Interview with Shabelnikov, Moscow, 28 April 2000. Likewise Isaak Brodsky's son Evgeny claims to have posed as Voroshilov for the painting *The People's Commisar for Defense K. E. Voroshilov Out Skiing,* 1937. See M Br, "Vospominaniia syna I. I. Brodskogo, E. I. Brodskogo," 52.

106. In 1941 the Central Committee discussed sanctions in the case of a lawyer by the name of I. A. Slavkin and several other sitters who had modeled as Lenin. See RGASPI, f. 17, op. 125, d. 70, ll. 17–41 (for photographs of Slavkin); Sergei Konstantinov, "Nesostoiavshii-sia uchastnik Leniniany: Kak iurist Slavkin rabotal vozhdem mirovogo proletariata," *Neza-visimaia gazeta,* 30 September 2000, 10 (thanks to Uta Gerlant for this newspaper article).

107. RGALI, f. 2368, op. 2, d. 36, l. 11. Katsman further mentioned painting Ordzhoni-kidze at a political meeting: "I saw Comrade Ordzhonikidze for the last time at the Eighth Extraordinary Congress of Soviets at the Kremlin. In the course of ten days I saw him every day. I sat in the fifth row and clearly saw and carefully studied the dear faces of our leaders, among them Comrade Ordzhonikidze. For some reason he always sat with Comrade L. M. Kaganovich at the edge. For the most part, he worked, wrote something and signed the papers that his secretary kept bringing. And when he did not work, he tilted his head, rested it on the palm of his hand, and looked into the room, at us. I drew him in this position." RGALI, f. 2368, op. 2, d. 34, l. 2.

108. RGALI, f. 2368, op. 2, d. 36, l. 14. Katsman also recounted painting Stalin at the 1936 Congress of Kolkhoz Farmers at the Bolshoi: "In 1936 I made a pencil drawing of

Comrade Stalin, giving a speech at the Bolshoi Theater at the Congress of Kolkhoz Farmers. The Tretyakov Gallery acquired this drawing." RGALI, f. 2368, op. 2, d. 36, l. 10.

109. "[Fedor] Modorov and [Vasily] Svarog were supposed to come with us, but the former was gone, the latter ill." RGALI, f. 2368, op. 2, d. 36, l. 20.

110. RGALI, f. 2020, op. 1, d. 181, ll. 16–160b.

111. Bown, *Socialist Realist Painting*, 184.

112. RGALI, f. 2368, op. 1, d. 50, l. 40b.

113. RGALI, f. 2020, op. 1, d. 181, l. 300b.

114. RGALI, f. 2020, op. 1, d. 181, l. 31.

115. RGALI, f. 2932, op. 1, d. 701, l. 22.

116. RGALI, f. 2020, op. 1, d. 181, l. 520b.

117. RGALI, f. 2368, op. 2, d. 48, ll. 1–10b. Date not further specified.

118. RGALI, f. 2368, op. 2, d. 48, l. 4. Date not further specified.

119. RGALI, f. 2368, op. 2, d. 36, l. 11.

120. Khvostenko, *Vechera na Maslovke bliz "Dinamo,"* vol. 1, 131, 317.

121. RGALI, f. 2368, op. 2, d. 48, ll. 7–8. Katsman's letter to Voroshilov is dated 7 November 1953. He was probably referring to the July 1933 meeting of Isaak Brodsky, Aleksandr Gerasimov, and himself with Voroshilov and Stalin at Stalin's dacha.

122. This and the following biographical information are from A. D. Chernev, *229 Kremlevskikh vozhdei: Politbiuro, Orgbiuro, Sekretariat TsK Kommunisticheskoi partii v litsakh i tsifrakh. Spravochnik* (Moscow: Redaktsiia zhurnala "Rodina," Nauchnyi tsentr "Russika," 1996), 119; Michael T. Florinsky, *McGraw-Hill Encyclopedia of Russia and the Soviet Union* (New York: McGraw-Hill, 1961); V. I. Ivkin, *Gosudarstvennaia vlast' SSSR: Vysshie organy vlasti i upravleniia i ikh rukovoditeli, 1923–1991gg.: Istoriko-bibliograficheskii spravochnik* (Moscow: ROSSPEN, 1999), 258–259; *Bol'shaia Sovetskaia Entsiklopediia,* 2nd ed., vol. 9 (Moscow: Gosudarstvennoe nauchnoe izdatel'stvo "Bol'shaia Sovetskaia Entsiklopediia," 1951), 128–130; Joseph L. Wieczynski, *The Modern Encyclopedia of Russian and Soviet History,* vol. 43 (Gulf Breeze: Academic International Press, 1986), 67–70. For a detailed chronology of Voroshilov's professional life see V. Akshinskii, *Kliment Efremovich Voroshilov: Biograficheskii ocherk* (Moscow: Politizdat, 1974), 261–283.

123. Lugansk was a frequent topos in correspondence with the artists. Quite typically, once a Bolshevik reached the highest ranks of the Party, requests for patronage came from his hometown or birthplace. They could also, however, come from places named after the Party leader. Thus Lazar Kaganovich in July 1945 wrote to Nikita Khrushchev, asking that the Ukrainian leader expedite the rebuilding of a school destroyed during the war in the village Kaganovich of Kaganovich Raion in Kiev oblast after his "fellow villagers had appealed to [him] with a letter." RGASPI, f. 81, op. 3, d. 426, l. 10.

124. *Bol'shaia Sovetskaia Entsiklopediia,* vol. 9, 129.

125. Typically, a Voroshilov biography first enumerated the sectors of the arts the Sovmin Bureau of Culture was responsible for, which did not include the visual arts. In the following paragraph the biography recounted his "personal portfolio"—and the visual arts figured prominently: "Kliment Yefremovich was personal friends with many writers, artists, composers, actors, movie people, as well as publishing, radio, and television workers. And not only from our country, but also of other states." See Akshinskii, *Kliment Efremovich Voroshilov,* 235.

126. "We happily learned that the USSR put you in charge of culture and art. We, the old guard of artists have been working under your leadership for more than a quarter century...." RGALI, f. 2368, op. 2, d. 48, l. 5. Dated 1946.

127. Kliment E. Voroshilov, *Rasskazy o zhizni (Vospominaniia),* vol. 1 (Moscow: Politizdat, 1968), 53. In Russian a slide projector was called a *svetoskop.*

128. See ibid., 75–80. For the Grabar and Grekov pictures see *Kliment Efremovich Voroshilov: Zhizn' i deiatel'nost' v fotografiiakh i dokumentakh* (Moscow: Izdatel'stvo "Plakat," 1978), 45.

129. See Akshinskii, *Kliment Efremovich Voroshilov,* 252. In 1931 Isaak Brodsky and another Leningrad artist, in honor of Voroshilov's fiftieth birthday, even proposed the creation of a "Voroshilov Art Gallery," "where all the pictures and works of art connected with the heroic feats, the life, and work of the Red Army should be concentrated." RGALI, f. 2020, op. 1, d. 14, l. 16.

130. RGASPI, f. 74, op. 1, d. 429, l. 18. Voroshilova recorded 26 February 1947 as her first working day at the Lenin Museum.

131. RGASPI, f. 74, op. 1, d. 429, ll. 28–30. This is a 16 January 1949 letter from Voroshilova to her grandson that she entered into this file.

132. See e.g. RGASPI, f. 74, op. 1, ll. 75–76. Entry of 17 November 1955.

133. See, for example, the 1966 photograph of Voroshilov and Strobl and the accompanying caption: "K. E. Voroshilov and his friend, the famous Hungarian sculptor Zhigmond Kishfaludi Shtrobl." *Kliment Efremovich Voroshilov,* 91; Akshinskii, *Kliment Efremovich Voroshilov,* 235.

134. Sheila Fitzpatrick was first to note this. See her *Everyday Stalinism,* 110–114. Also see M. N. Afanas'ev, *Klientilizm i rossiiskaia gosudarstvennost': Issledovanie klientarnykh otnoshenii,* 2nd ed. (Moscow: Tsentr konstitutsionnykh issledovanii Moskovskogo obshchestvennogo nauchnogo fonda, 2000); Sheila Fitzpatrick, "Patronage and the Intelligentsia in Stalin's Russia," in *Challenging Traditional Views of Russian History,* ed. Stephen G. Wheatcroft (Basingstoke: Palgrave, 2002), 92–111; and the following articles in *Contemporary European History* 11, no. 1 (2002): Maruška Svašek, "Contacts: Social Dynamics in the Czechoslovak State-Socialist Art World," 67–86; Kiril Tomoff, "'Most Respected Comrade . . .': Patrons, Clients, Brokers and Unofficial Networks in the Stalinist Music World," 33–65; Barbara Walker, "*Kruzhok* Culture and the Meaning of Patronage in the Early Soviet Literary World," 107–123; Vera Tolz, "'Cultural Bosses' as Patrons and Clients: The Functioning of the Soviet Creative Unions in the Postwar Period," 87–105.

135. Gerald Easter has argued that many personal networks extended back to the pre-revolutionary Russian Marxist underground. The Civil War, then, was a time when old networks were fortified and new ones forged. A whole elite of provincial *komitetchiki* thus emerged, who, according to Easter, maintained their local networks (the Transcaucasian Party officials were particularly adept at this) and ultimately acted as a constraint on central power until the Great Terror. See Gerald Easter, *Reconstructing the State: Personal Networks and Elite Identity in Soviet Russia* (Cambridge: Cambridge University Press, 2000).

136. On the commission's judging of art see Benno Ennker, *Die Anfänge des Leninkults in der Sowjetunion* (Cologne: Böhlau, 1997), 268–290.

137. In the fall of 1924, for example, Voroshilov received two posters from TsIK (Tsentral'nyi Ispolnitel'nyi Komitet) with the request to approve them. Voroshilov returned them with a note that read: "I have nothing against the printing of the posters, even though the depiction of V. I. [Lenin] is not quite successful." RGASPI, f. 74, op. 1, d. 94, l. 5.

138. For a different interpretation witness Molotov, who claimed that Voroshilov's close association with the painters was, in Stalin's eyes, a liability rather than an asset. "Of course, I would say that Stalin never completely trusted [Voroshilov]," Molotov told Felix Chuev. He went on, "Voroshilov started to behave like gentry. He enjoyed mixing with artists and actors, he loved theater and especially painters. He would often entertain them at his place. . . . Voroshilov clung more to the painters, and they were nonparty people for the most part. . . . Voroshilov rather loved to pose as something of a patron of the arts. And the artists, for their part, tried to the utmost to reciprocate. Alexander Gerasimov, a very talented artist, painted Voroshilov on horseback, Voroshilov skiing. Their association appeared to be one of mutual back-scratching. Stalin was correct in his criticisms, for all artists are big-mouths. They are essentially harmless, of course, but they are constantly surrounded by ne'er-do-wells of every sort. And such connections were used to approach Voroshilov's aides and his

domestics." Albert Resis, ed., *Molotov Remembers: Inside Kremlin Politics. Conversations with Felix Chuev* (Chicago: Ivan R. Dee, 1993), 225.

139. Sheila Fitzpatrick, "Introduction," in *Stalinism: New Directions,* ed. Sheila Fitzpatrick (New York: Routledge, 2000), 11.

140. See Fitzpatrick, *Everyday Stalinism,* 62–66.

141. For more on embodiment and impersonation in Stalinism, including its etymology in Russian, see Sheila Fitzpatrick, "Making a Self for the Times: Impersonation and Imposture in 20th-Century Russia," *Kritika: Explorations in Russian and Eurasian History* 2, no. 3 (2001): 472 n. 9.

142. Jochen Hellbeck, *Revolution on My Mind: Writing a Diary under Stalin* (Cambridge, Mass.: Harvard University Press, 2006), 327.

143. Boris Groys, *The Total Art of Stalinism: Avant-Garde, Aesthetic Dictatorship, and Beyond,* trans. Charles Rougle (Princeton: Princeton University Press, 1992), 35–36.

144. Thus the sculptor I. D. Shadr, in a typical petition letter to Voroshilov in 1937, at first enumerated all his finished sculptures, then described the project he was currently working on, and finally asked that Voroshilov improve his "exceptionally difficult conditions." He had no studio of his own and his family was living in "two small rooms." RGASPI, f. 74, op. 1, d. 295, l. 33. The letter is dated 21 March 1937. Voroshilov then corresponded with his secretary who initiated a change in Shadr's living space. This was a typical exertion of pressure from the top on the lowest levers of power, including the housing organizations. It is interesting to note how little this situation had changed a quarter of a century later. In 1961, the artist and graphic designer Nikolai Atabekov attached his original cover design for Voroshilov's 1927 book, *The Defense of the USSR,* together with physical proof that Voroshilov had used it (the remark "a little lighter" written in Voroshilov's hand) to a letter emphasizing how much this token of a connection to Voroshilov meant to him and then asking if Voroshilov could help him move into a more spacious apartment. The exact living conditions were always described in great detail, because the letter writers knew that their letters would serve as the basis for the patron's correspondence with the relevant authorities at a lower level. RGASPI, f. 74, op. 1, d. 292, ll. 6–7. The letter is dated 21 June 1961.

145. For an example see the 28 January 1935 letter by the relatives of N. I. Mikhailov, who had made a drawing of Kirov's funeral that was interpreted ambiguously: spots in the background created the impression of a ghost attacking Stalin. RGASPI, f. 74, op. 1, d. 292, ll. 123–124.

146. Gerasimov, for instance, in 1934 managed to add a trip to Turkey to a three-month stay in Paris and Rome by appealing to Voroshilov, whom he addressed, in this petition letter, as "kind, dear Kliment Efremovich." See RGASPI, f. 74, op. 1, d. 295, l. 5. And like so many others, the caricaturist Deni ended up being personally indebted to Stalin, to whom he thought it necessary to address his request for a three-month vacation because of chronic fatigue and illness. See RGASPI, f. 558, op. 11, d. 726, ll. 15–150b. Letter by Deni to Stalin dated 23 April 1932.

147. RGASPI, f. 74, op. 1, d. 292, l. 17.

148. RGASPI, f. 74, op. 1, d. 292, l. 18.

149. See M Br, "Vospominaniia syna I. I. Brodskogo, E. I. Brodskogo," 37.

150. Sheila Fitzpatrick has called these intermediaries "brokers." See her *Everyday Stalinism,* 112.

151. RGASPI, f. 74, op. 1, d. 292, l. 72. Letter dated 27 December 1934. In a 1931 letter, also transmitted by Katsman, Yakovlev wrote that he had heard that Voroshilov was unhappy with his work. Yakovlev then defended himself by listing numerous works in progress and citing the approval of colleagues closer to Voroshilov, such as Brodsky, as well as of political leaders like Yenukidze. He next asked Voroshilov to come and visit his studio

and continued by describing his difficult housing and working situation, only to end with a petition for Voroshilov's intervention in this regard. See RGASPI, f. 74, op. 1, d. 292, ll. 183–184.

152. The contested issue was likely remuneration for a Brodsky painting or reproduction: "If, by chance, you see or call K. E. Voroshilov, mention the letter that Kirov wrote to him in this regard and say a couple of warm words for my rescue, I really need to be saved from those scoundrels that want to swallow me alive. Only Voroshilov can get me out of this mess. . . . Evgeny Aleksandrovich [Katsman], you and I are on good terms." RGASPI, f. 74, op. 1, d. 294, ll. 10–10ob. Letter dated 16 November 1926. Later, in 1935, Brodsky apparently telegraphed Beria (at that time head of the Transcaucasian Party committee) to ask if he could do a painting of Stalin, likely connected with Stalin's youth in Georgia. Beria signed a letter from the Moscow office of the Transcaucasian Party committee to Brodsky in Leningrad: "Comrade Stalin is against the painting of the picture you telegraphed me about." RGALI, f. 2020, op. 2, d. 13, l. 1. Dated 27 November 1935.

153. In another instance that took place in 1926, Kirov wrote to Voroshilov, saying that Brodsky had appealed to him for help. At issue was a bankrupt publishing house in the Urals that owed Brodsky money. Upon Kirov's letter, Voroshilov contacted the secretary of the Perm Obkom in the Urals and asked him to help Brodsky recoup his losses. This case shows that the local Party boss who at the same time belonged to the central Party elite— Kirov, in Brodsky's case—could act as a broker of patronage, too. See RGASPI, f. 74, op. 2, d. 42, ll. 76–77ob.; RGASPI, f. 74, op. 1, d. 295, l. 4. A patron's secretary usually also acted as a significant intermediary. Gerasimov, for example, was keenly aware of the secretary's importance and asked Voroshilov's secretary, whom he addressed with the familiar *ty*, to hand over a certain letter with a negative message separately from "congratulations and other pictures so as not to mix happy things with sad things. . . . I am entirely counting on your tactfulness." RGASPI, f. 74, op. 1, d. 295, ll. 4–4ob.

154. RGASPI, f. 74, op. 1, d. 295, ll. 14–14ob. Dated 21 January 1930.

155. RGASPI, f. 558, op. 11, d. 726, ll. 17–17ob. Letter by Deni to Mekhlis dated 15 June 1933.

156. RGASPI, f. 17, op. 125, d. 466, l. 93. Dated 15 May 1946.

157. RGASPI, f. 17, op. 125, d. 466, ll. 94, 96.

158. RGASPI, f. 74, op. 1, d. 292, l. 46. Dated 3 February 1937.

159. RGASPI, f. 74, op. 1, d. 292, l. 48. Dated 27 June 1937. Similarly, an unknown artist in 1934 sent a photograph of a painting of Voroshilov on a horse and explained: "I painted [the portrait] from photographs and those impressions that stayed in my visual memory from the moments when I saw him. It is very important to me . . . to find out from people close to Comrade Voroshilov what they think of the portrait, what they like about it and what does not satisfy them; this is all the more important to me since this portrait is a preparatory one for a planned large portrait. . . . " RGASPI, f. 74, op. 1, d. 292, l. 15.

160. See Fitzpatrick, "Patronage and the Intelligentsia," 99. On the strengthening of personal ties, including patronage relations, along ethnic lines in the wartime and postwar Vinnitsia elite see Amir Weiner, *Making Sense of War: The Second World War and the Fate of the Bolshevik Revolution* (Princeton: Princeton University Press, 2001), 58–70.

161. Interviews with Shabelnikov, Moscow, 28 April and 10 May 2000.

162. *Sovetskoe Iskusstvo*, no. 5 (26 January 1933): 4. The article "Nakanune XV-letiia Krasnoi Armii" celebrated the tenth anniversary of RABIS's *shefstvo* over the Red Army.

163. *Sovetskoe Iskusstvo*, no. 9 (20 February 1933): 1. Voroshilov further credited RABIS with increasing amateur cultural activity (*samodeiatel'nost'*) among Red Army soldiers.

164. RGASPI, f. 74, op. 1, d. 292, l. 165.

165. Thus in 1955 Ekaterina Voroshilova in her diary summed up her husband's friendship with Aleksandr Gerasimov, whose star had fallen under Khrushchev, "A. M. Gerasimov is a great friend of K. E. [Voroshilov's]. He often visits us at home and sees K. E. much more

often than any of the Soviet artists." RGASPI, f. 74, op. 1, d. 439, l. 76. Entry dated 17 November 1955.

166. RGASPI, f. 74, op. 1, d. 295, l. 19. Forty years after the formation of AKhR under Voroshilov's protection, one of its co-founders, Pavel Radimov, still thought it necessary to apologize to Voroshilov for not visiting him on a certain day. "I sincerely repent, but I have an excuse," wrote Radimov in 1961. His son had married unexpectedly, without ceremony, and he hoped that Voroshilov, whom Radimov had known since 1922 and who had held Radimov's son on his lap when he was a child, would be able to attend the marriage festivities. RGASPI, f. 74, op. 1, d. 292, ll. 146–147. 20 October 1961 letter by Radimov to Voroshilov. And in October 1956 Aleksandr Gerasimov, after his status had worsened in the wake of Khrushchev's de-Stalinization, asked his patron of three decades to intervene on his behalf, even if only to increase press coverage of his exhibition: "Despite the fact that [the exhibition] is successful with the visitors, there is not a word about it in such newspapers as *Pravda, Sovetskaia kul'tura, Literaturnaia gazeta, Vecherniaia Moskva*—I am giving up in despair. I wrote about this to Nikita Sergeevich [Khrushchev]. I have no hope that he, who is so busy with state affairs, will visit the exhibition. I am asking you, if there is an occasion, to relate to him your impression of my paintings." RGASPI, f. 74, op. 1, d. 295, l. 13. Dated 27 October 1956.

167. RGASPI, f. 74, op. 1, d. 294, l. 9. Letter dated 8 November 1926.

168. RGASPI, f. 74, op. 1, d. 292, l. 11. Not dated.

169. RGASPI, f. 74, op. 1, d. 294, l. 12. Dated 22 July 1928.

170. RGASPI, f. 74, op. 1, d. 292, l. 71. Dated 16 November 1934.

171. The following was prompted by a conversation in 2001 with Jochen Hellbeck, whom I wish to thank.

172. RGASPI, f. 81, op. 3, d. 426, l. 58. Dated 19 February 1935.

173. The language of female letter writers differed only slightly from that of men. In fact, only men could use terms like "I kiss you affectionately (*krepko Vas tseluiu*)" (Brodskii) and "I always love you" (Katsman). In women's letters, the rhetoric of affection was more subdued, since it faced the danger of being interpreted as romance. Thus a certain Mata Vazhadze from Moscow wrote to Voroshilov: "Your photograph with your dedication reminds me of the brightest and most cheerful days of my life, when I had a chance to look so closely at the great Stalin and all of his closest comrades-in-arms." RGASPI, f. 74, op. 1, d. 298, l. 21. Dated 13 March 1937.

174. RGASPI, f. 74, op. 1, d. 301, ll. 6–10ob. Dated 17 [December—because of the mention of the funeral, which was most likely Kirov's] 1934. Note that almost all of Voroshilov's correspondence was typed out by his secretary, whereas these letters are preserved in the original only. Probably Voroshilov thought they were too sensitive to entrust to a secretary for copying.

175. See Jan Plamper, "Georgian Koba or Soviet 'Father of Peoples'? The Stalin Cult and Ethnicity," in *The Leader Cult in Communist Dictatorships*, ed. Apor et al., 135.

176. Khvostenko, *Vechera na Maslovke bliz "Dinamo,"* vol. 1, 28, 245. Khvostenko's two-volume memoirs are not based on a diary. They include numerous reproductions of paintings, facsimiles of letters, and previously unpublished photographs (collected by her husband, the photojournalist Viliam Mendeleev). See ibid., 93, 470. There is also a documentary film *Dom na Maslovke* that I have not been able to obtain.

177. Ibid., 122, 391–396, 432.

178. Ibid., 28, 32. An account of the initiative for the complex in a *Sovetskoe Iskusstvo* article differed in details, in failing to mention the participation of modernist painters in the mid-1920s, and in its narrative mode of bildungsroman-like overcoming of hurdles thanks to the heroic Party: "Everything began quite modestly. In 1928 the AKhR artists E. Katsman, V. Perelman, and P. Radimov had the idea of building the first House of Moscow Artists and appealed to Sovnarkom in this regard. The artists could not really imagine

exactly how much the state would have to pay for the realization of such an idea and asked for only 200,000 rubles. At Sovnarkom Comrade Peterson spoke about this question. He declared: 'It is pointless to spend 200,000 on the construction for a house of artists . . .' The authors of the project exchanged disappointed looks. Comrade Peterson made a long pause . . . 'for this enterprise we must release 800,000 to the artists.'" Samuil Margolin, "Dom na Maslovke," *Sovetskoe Iskusstvo,* no. 51–52 (5 November 1934): 3. With a drawing by Karachentsov.

179. Margolin, "Dom na Maslovke," 3.

180. Ibid.

181. Khvostenko, *Vechera na Maslovke bliz "Dinamo,"* vol. 1, 66.

182. Ibid., 8, 58, 176, 253.

183. Ibid., 8, 11, 49–52.

184. Margolin, "Dom na Maslovke," 3. A follow-up 1934 article, entitled "Sculpture Studios," added: "The Mossovet transferred the buildings of two former churches, Trinity on Sretenka and Pokrovka on Bakunin Street, to the Moscow Oblast Union of Soviet Sculptors. The union is converting the churches into sculpture studios. About twenty Moscow sculptors are getting a chance to design in the new studios buildings, squares, and parks in Moscow and other towns." *Sovetskoe Iskusstvo,* no. 46 (5 October 1934): 2.

185. As Sheila Fitzpatrick aptly put it, "writers and artists were urged to cultivate a sense of 'socialist realism'—seeing life as it was becoming, rather than life as it was—rather than a literal or 'naturalistic' realism. But socialist realism was also a Stalinist mentalité, not just an artistic style. Ordinary citizens also developed the ability to see things as they were becoming and ought to be, rather than as they were. An empty ditch was a canal in the making; a vacant lot where old houses or a church had been torn down, littered with rubbish and weeds, was a future park." Fitzpatrick, *Everyday Stalinism,* 8–9.

186. See RGALI, f. 2470, op. 2, d. 18, l. 63. "Protocol no. 22 of external session of the art soviet for painting in the Maslovka artist studios," dated 22 September 1949. For more on the khudsovet, see pp. 184–192.

187. Or at least to the closest provincial center, since the center-periphery dynamics played out in the provinces as well, as Galina Iankovskaia has shown using the example of Perm and Ekaterinburg (in Soviet times, Molotov and Sverdlovsk respectively). See G. A. Iankovskaia, *Iskusstvo, den'gi i politika: Khudozhnik v gody pozdnego stalinizma* (Perm: Perm'skii gosudarstvennyi universitet, 2007), 192–193.

188. Khvostenko, *Vechera na Maslovke bliz "Dinamo,"* vol. 1, 253.

189. See Susan E. Reid, "The Soviet Art World in the Early Thaw," *Third Text: Critical Perspectives on Contemporary Art and Culture* 20, no. 2 (2006): 161.

190. RGASPI, f. 558, op. 11, d. 711, l. 188.

191. RGASPI, f. 558, op. 11, d. 711, l. 191. Letter to M. N. Blokhin dated 3 September 1924. Similarly but already foreshadowing the later immodest modesty paradigm, in 1925 Stalin countered an initiative by the Tsaritsyn Party Committee to rename their city on the Volga "Stalingrad" by disclaiming any involvement in the renaming initiative, saying, in his own words, that "I strive neither for glory nor esteem and do not want the contrary impression to be created," yet conceding: "If you've already trumpeted too loudly about Stalingrad and now have difficulties giving up what you have started, do not drag me into this story. . . . " From 1925 until 1961 Tsaritsyn bore the name of Stalingrad. Maksim Leushin, "'Ia ne dobivalsia i ne dobivaius' pereimenovaniia Tsaritsyna v Stalingrad': Iz lichnogo arkhiva I. V. Stalina," *Istochnik,* no. 3 (2003): 54–55. Stalin's letter to the secretary of the Tsaritsyn Gubkom, B. P. Sheboldaev, is dated 25 January 1925. It is preserved in RGASPI, f. 558, op. 11, d. 831, l. 44.

192. In 1933, for instance, Katsman attempted to entice Kaganovich as a patron. As usual, he banked on his Kremlin studio—which granted physical proximity to the leaders—as a resource. "Dear Lazar Moiseevich!," he wrote on 16 January 1933, "Did you receive my

preliminary project of your idea of large pictures from the October Revolution?" leaving his address and telephone number. He added in a postscript: "I produced a small picture— Lenin, Marx, and Stalin. I would very much like to show it to you and get your advice—is it good and does it fit, can (and should) I circulate it to the masses (*mozhno li puskat' v massy [i nuzhno li?]*)? I would be very happy if you stopped by my studio (in the Kremlin)." RGASPI, f. 81, op. 3, d. 421, l. 82.

193. Yenukidze held the post of secretary of the TsIK Presidium from 1922 to 1935, when he was demoted. He was finally arrested and shot in 1937. See Ivkin, *Gosudarstvennaia vlast' SSSR*, 301–302. For Kaganovich's role as patron of architecture, see his involvement in the construction of prestige objects like the Moscow metro and the planning of the Palace of Soviets. This involvement is reflected in correspondence in his personal archive (RGASPI, f. 81). For Molotov and the theater see RGASPI, f. 82.

CHAPTER 5. HOW TO PAINT THE LEADER?

1. The legal footing for MOSSKh's founding was the summary abolition of all independent artist organizations in the 23 April Party Central Committee decree "On the Reorganization of Literary and Artistic Organizations."

2. Of the 24,000 self-defined artists 5,000 worked in Moscow (the figures are approximations). By comparison, in Nazi Germany in 1936 there were about 42,000 artists, in the United States in 1940 about 62,000. See Galina Yankovskaya, "The Economic Dimensions of Art in the Stalinist Era: Artists' Cooperatives in the Grip of Ideology and the Plan," *Slavic Review* 65, no. 4 (2006): 779, 783.

3. This and the following are based on G. A. Iankovskaia, *Iskusstvo, den'gi i politika: Khudozhnik v gody pozdnego stalinizma* (Perm': Perm'skii gosudartvennyi universitet, 2007); Matthew Cullerne Bown, *Socialist Realist Painting* (New Haven: Yale University Press, 1998); Bown, *Art under Stalin* (New York: Oxford University Press, 1991); Bown, "Aleksandr Gerasimov," in *Art of the Soviets: Painting, Sculpture, and Architecture in a One-Party State, 1917–1992*, ed. Bown and Brandon Taylor (Manchester: Manchester University Press, 1993), 121–139; Mariia Chegodaeva, *Dva lika vremeni (1939: Odin god stalinskoi epokhi)* (Moscow: Agraf, 2001); Brandon Taylor, "On AKhRR," in *Art of the Soviets*, ed. Bown and Taylor, 51–72; V. S. Manin, *Iskusstvo v rezervatsii: Khudozhestvennaia zhizn' Rossii 1917–1941gg.* (Moscow: Editorial URSS, 1999); T. M. Goriaeva et al., eds., *Instituty upravleniia kul'turoi v period stanovleniia: 1917–1930-e gg. Partiinoe rukovodstvo; gosudarstvennye organy upravleniia; Skhemy* (Moscow: ROSSPEN, 2004); Vern G. Swanson, *Soviet Impressionism* (Woodbridge: Antique Collectors' Club, 2001).

4. See Bown, *Socialist Realist Painting*, 56–59.

5. These private collectors also bought artwork left in the studios of deceased artists, whose families were at a loss as to where to store this art since the studios reverted to the state. See M. P. Lazarev, "'Garmoniia i algebra'" (unpublished typescript, commissioned by L. S. Shishkin, Moscow art gallerist), 10. The artist Fridrikh Lekht called the Old Bolshevik Sergei Mitskevich a "Soviet *metsenat*" of the 1920s. See Tat'iana Khvostenko, *Vechera na Maslovke bliz "Dinamo": Vospominaniia*, vol. 2: *Za fasadom proletarskogo iskusstva* (Moscow: Olimpiia Press, 2003), 61. To get an inkling of the astonishing dimensions private collecting assumed in post-Stalin Russia see the Museum of Private Collections (Muzei lichnykh kollektsii), a part of Moscow's Pushkin Fine Arts Museum.

6. Diary entry (17 March 1925), quoted in Khvostenko, *Vechera na Maslovke bliz "Dinamo,"* vol. 2, 71.

7. Grigoriev, like Radimov a graduate of the influential prerevolutionary Kazan art school, in the early 1920s had worked in the Soviet museum administration under Trotsky's wife. He was purged during the Terror and mention of him disappeared from accounts of the trip to Repin. See Bown, *Socialist Realist Painting*, 72, 82, 202.

8. Thus in 1919 Aleksandr Gerasimov contributed a Lenin portrait and Katsman a portrait of Marx to the 1 May celebrations on Moscow's Red Square. See Katsman's diary account, retold in Khvostenko, *Vechera na Maslovke bliz "Dinamo,"* vol. 2, 66.

9. For examples of these late paintings see Ingrid Brugger and Joseph Kiblitsky, eds., *Kasimir Malewitsch* (Bad Breisig: Palace Editions, 2001). It should be mentioned that dating Malevich's paintings is tricky, because he was notorious for backdating.

10. See Khvostenko, *Vechera na Maslovke bliz "Dinamo,"* vol. 2, 156–162.

11. To delve into a little more detail, the first phase of the First Five-Year Plan was characterized by a renewed revolutionary zealousness that engulfed the visual arts, too. A new modernist association named Oktiabr' (October) was founded in 1928. Several events in art institution-building foreshadowed unification and centralization in 1932: the Federation of Organizations of Soviet Artists was founded on 18 June 1930 and in May 1931 came the creation of the Russian Association of Proletarian Artists, which drew on the leftist nucleus of Oktiabr', AKhR, and others. In other words, unification in 1932 was the culmination of a process initiated some three to four years earlier. On this see also John Barber, "The Establishment of Intellectual Orthodoxy in the U.S.S.R., 1928–1934," *Past and Present,* no. 83 (1979): 141–164.

12. Narkompros was subordinate to the Council of People's Commissars, Sovnarkom, renamed Sovmin, Council of Ministers in March 1946.

13. GlavIskusstvo is not to be confused with the much smaller successor to Izo Narkompros, Glaviskusstvo, which was founded in early 1921 and which was subordinate to Glavnauka within Narkompros.

14. Apart from the various Narkompros organizations and their successor, the Committee for Arts Affairs, there was another disbursor of "soft benefits" such as vacations and other leisuretime outlets for tired artists: the Union of Art Workers (RABIS, Profsoiuz Rabotnikov Iskusstv). Besides vacation resorts, it ran the Central House of Art Workers.

15. For an Iskusstvo letter to Kaganovich's secretariat, asking, on behalf of the painter Anatolii Iar-Kravchenko, for "at least temporary usage of the newest photographs in your possession and approved by Comrade Kaganovich," see RGALI, f. 652, op. 8, d. 157, l. 89. Dated 22 August 1937. For a letter by IZOGIZ's deputy editor to "Boris Zakharovich" (Shumiatsky? Head of the Soviet film industry), asking that two editors get access to documentary film and be allowed to "watch the movies in which Comrade Stalin took part" from 1934 to 1936 for "a unique album, 'Stalin,'" see RGALI, f. 652, op. 8, d. 97, l. 46.

16. In June 1938 the publishing house Selkhozgiz, which had published Aleksandr Gerasimov's portrait of the botanist Ivan Michurin, transferred its expired rights to the portrait to the publisher Iskusstvo. For his agreement to this transfer Iskusstvo wired money to Gerasimov's bank account. For the correspondence, see RGALI, f. 652, op. 8, d. 144, ll. 21–24.

17. See above, p. 30, and Chapter 2, note 6.

18. *Sovetskoe iskusstvo* was targeted at visual artists and theater people. Writers and cinema artists had their own newspapers. *Sovetskoe iskusstvo* succeeded the newspaper *Rabochii i iskusstvo* and was published from 1931 until June 1953, when it was followed by the newspaper *Sovetskaia kul'tura.* During World War II between January 1942 and 1944 *Sovetskoe iskusstvo* temporarily merged with *Literaturnaia gazeta* and was called *Literatura i iskusstvo.*

19. *Iskusstvo* did not appear between 1942 and 1946 while publication of *Tvorchestvo* was suspended between July 1941 and December 1945, and from 1948 to 1956.

20. On amateur painters see S. Iu. Rumiantsev and A. P. Shul'pin, eds., *Samodeiatel'noe khudozhestvennoe tvorchestvo v SSSR: Ocherki istorii, 1930–1950gg.,* vol. 1 (Moscow: Gosudarstvennyi institut iskusstvoznaniia, 1995).

21. "Of the AKhRR membership," writes Bown, "Fedor Bogorodski was the best-known *chekist,* although how active he was in this field in the 1920s is hard to tell." Bown, *Socialist Realist Painting,* 76.

22. Witness, for example, the case of N. I. Mikhailov, whose sketch of Kirov's funeral had a few stains that created the impression of a "ghost or skeleton, seemingly grabbing Comrade Stalin." RGASPI, f. 74, op. 1, d. 292, ll. 123. Mikhailov's letter to Voroshilov is dated 28 January 1935 and was not signed because of his arrest by the NKVD during the night of 25–26 January, as a note by his wife and parents explained.

23. "Nakanune iubileinoi vystavki 'Khudozhniki RSFSR za piatnadtsat' let,'" *Sovetskoe Iskusstvo*, no. 21 (8 May 1933): 1.

24. Ibid., no. 24 (27 May 1933): 4.

25. RGALI, f. 652, op. 8, d. 112, ll. 15–16, 67.

26. RGALI, f. 652, op. 8, d. 112, l. 50.

27. RGALI, f. 652, op. 8, d. 112, l. 72.

28. RGALI, f. 652, op. 8, d. 112, l. 25.

29. RGALI, f. 652, op. 8, d. 112, l. 1.

30. RGALI, f. 652, op. 8, d. 112, l. 2.

31. RGALI, f. 2020, op. 2, d. 6, l. 3. Ekaterina Degot' has argued that the original socialist painting was but a template for technical reproduction. Traditional realist painterly qualities—in fact, technical craftsmanship—were reduced to the capability of creating a perfect template. Consequently reproductions acquired greater aura than originals. See her "Sichtbarkeit des Unsichtbaren: Die transmediale Utopie der russischen Avantgarde und des sozialistischen Realismus," in *Musen der Macht: Medien in der sowjetischen Kultur der 20er und 30er Jahre*, ed. Jurij Murašov and Georg Witte (Munich: Wilhelm Fink, 2003), 145–147. Yet at the same time official culture elaborately staged the authenticity of the original. Consider the following *Pravda* article: "The Narkompros USSR Museum Department bought in Kharkov from the widow of the artist Kozlov a drawing of Lenin, which had been unknown so far. The artist Kozlov made his pastel drawing at the Kremlin in Moscow on 29 May 1921. It shows Vladimir Ilyich listening to the Italian deputy Lazzari's comments. Vladimir Ilyich's autograph is on the drawing: 'V. I. Ulianov (Lenin).'" *Pravda*, 19 December 1935, 6.

32. RGALI, f. 2020, op. 2, d. 6, l. 4.

33. "Industry of Socialism" has been dubbed "arguably the most important artistic event of the 1930s, both in defining the stylistic and iconographic parameters of socialist realism at a particular historical moment, and in implementing, on an unprecedented scale, the planned production of art under state patronage, in line with the centralized control of industry and agriculture." Susan E. Reid, "Socialist Realism in the Stalinist Terror: The *Industry of Socialism* Art Exhibition, 1935–41," *Russian Review* 60, no. 2 (April 2001): 153.

34. Nevertheless, as late as 1944 competitions for leader portraits still seem to have been an occasional part of the repertoire of Soviet art politics. Early that year the Moscow Artists' Union was reprimanded for not following through on its decision to start a competition for a Stalin portrait (the decision "remained on paper only," as the stenographic record critically noted). RGASPI, f. 74, op. 1, d. 427, l. 3.

35. A. Gushchin, "Lenin i Stalin v narodnom izobrazitel'nom iskusstve," *Iskusstvo* 7, no. 3 (May–June 1939): 76.

36. Susan Reid writes that "MOSSKh announced a competition in November 1938 for commissions for work dedicated to the image of Lenin and Stalin (RGALI, f. 2943, op. 1, ed. khr. 227, l. 11)." See Reid, "Socialist Realism in the Stalinist Terror," 168 n. 63. There is a slight chance that this competition was connected with the 1939 exhibition.

37. OR GTG, f. 8.II, d. 992, ll. 16, 21.

38. In fact, the deadline of Stalin's birthday was so pressing that the organizers asked the trade union to which the scholarly personnel and the various workers who equipped the rooms belonged to agree to extend the eight-hour workday. See OR GTG, f. 8.II, d. 994, l. 88.

39. OR GTG, f. 8.II, d. 992, ll. 5, 29.

40. "It needs to be pointed out as a gratifying fact that different artistic institutions are competing for the right to run this exhibition." OR GTG, f. 8.II, d. 993, l. 50b.

41. OR GTG, f. 8.II, d. 993, l. 7.

42. OR GTG, f. 8.II, d. 993, l. 8.

43. OR GTG, f. 8.II, d. 993, ll. 21–210b. Stenographic record of the "meeting for the preparation of the exhibition" of 7 October 1939.

44. It bears noting that artwork from the periphery was always judged in the center, if an exhibition took place in Moscow. In the exhibition "Achievements of Soviet Realist Art," for example, the chairman of the Moscow jury, Boris Ioganson, explained that "in Leningrad, in Kiev, in Minsk, in Kharkov, in Tbilisi, in Baku, in Tashkent, in Erevan and other places assisting commissions have been formed, that is commissions that select the best artwork on location according to their judgment and send it to Moscow for final discussion and selection by our jury here." The judging then proceeded by majority vote (with the painter, if present in the jury, abstaining from voting). Thus Vasily Efanov's *Girl with a Jug* was accepted with twenty-two favorable votes and one negative vote. OR GTG, f. 18, d. 183, ll. 3, 8. Stenographic record dated 1 October 1940.

45. OR GTG, f. 8.II, d. 993, l. 8. About Central Asia the same functionary, Veimark, said: "The art in the Central Asian Republics is more random. So far we do not see the kind of great activity as in Georgia, Armenia, and Azerbaijan, where artists were mobilized for Stalin themes. . . . In Turkmenia we have the portrait carpet. . . . In Kazakhstan and Kirgiziia we also have something: Kazakh tapestries with portraits. . . . In Tadzhikistan we have murals. . . . In Buriat-Mongolia, I believe, there should also be something fitting. . . . I think that we could thus get a minimum of 100 pieces of artwork out of the national republics for this exhibition, even if we select rigorously." OR GTG, f. 8.II, d. 993, ll. 11–12.

46. OR GTG, f. 8.II, d. 994, l. 3.

47. OR GTG, f. 8.II, d. 994, l. 115.

48. OR GTG, f. 8.II, d. 993, l. 220b.

49. OR GTG, f. 8.II, d. 993, l. 23.

50. See, for example, the Leningrad artist Vladimir Kuznetsov's letter in OR GTG, f. 8.II, d. 993, l. 62.

51. See the protocols of the jury in OR GTG, f. 8.II, d. 993, ll. 89–92, 94–99, 105–107, 142–152.

52. For telegrams of individual artists or local artist unions saying that their contributions were going to be late see OR GTG, f. 8.II, d. 993, ll. 119–122.

53. OR GTG, f. 8.II, d. 994, l. 59. Letter dated 4 November 1939. Voroshilov gave his agreement on 14 November.

54. OR GTG, f. 8.II, d. 993, l. 25.

55. OR GTG, f. 8.II, d. 993, l. 26.

56. OR GTG, f. 8.II, d. 993, ll. 280b.–29.

57. OR GTG, f. 8.II, d. 993, l. 260b.

58. OR GTG, f. 8.II, d. 993, l. 28.

59. On the Georgian exhibition and Beria's involvement see Judith Devlin, "Beria and the Development of the Stalin Cult," in *Stalin: His Time and Ours,* ed. Geoffrey Roberts (N.p.: Irish Association for Russian and East European Studies, 2005), 25–46.

60. OR GTG, f. 8.II, d. 763. l. 3.

61. OR GTG, f. 8.II, d. 993, ll. 191–192.

62. In 1938–1939, for example, a "mobile exhibition Lenin-Stalin in the Fine Arts," consisting mostly of reproductions and plaster casts of existing artwork, was prepared by the Tretyakov Gallery for travel through the Soviet Union. See OR GTG, f. 8.II, d. 888. In 1949, the Irkutsk art museum organized an exhibition entitled "Stalin and the Stalin Era in Works of Art." The exhibition showed artwork from the museum's collection, especially paintings focusing on Stalin's experience of Siberian exile, and several masterpieces acquired from

Moscow painters; however, there were also painted copies of famous paintings. See the catalogue, *Vystavka: Stalin i Stalinskaia epokha v proizvedeniiakh izobrazitel'nogo iskusstva* (Irkutsk: Izdanie Irkutskogo oblastnogo khudozhestvennogo muzeia, 1949). In Kursk an exhibition of Stalin art from all over the Soviet Union ("Stalin and the Stalin Epoch in the Works of Soviet Graphic Artists") opened shortly after Stalin's sixtieth birthday. See *Pravda*, 22 January 1940, 6.

63. OR GTG, f. 8.II, d. 994, l. 203.

64. At a discussion in the organizing committee about how to increase the recently opened "Industry of Socialism"'s attractiveness to visitors, one participant suggested that "Iosif Vissarionovich Stalin should find time to visit the exhibition. Will his judgment not be a stimulus for the toiling masses to visit this exhibition? The visit of Comrade Stalin and the Politburo members will be our greatest reward, this is what we ought to strive for and then there will be no more obstruction, the artwork will be evaluated properly, and we will occupy an appropriate place." OR GTG, f. 18, d. 136, ll. 28–29. Stenographic record dated 14 April 1939.

65. OR GTG, f. 8.II, d. 994, ll. 211–214. Quote on l. 212.

66. See M. P. Lazarev, "Problemy tsenoobrazovaniia na proizvedeniia izobrazitel'nogo iskusstva v SSSR: Popytka analiza" (unpublished typescript, commissioned by L. S. Shishkin, Moscow art gallerist), 3.

67. Some commissions were produced directly for the Art Fund, which then could take paintings out of storage for sale or exhibition.

68. Lazarev, "Problemy tsenoobrazovaniia," 14.

69. Lazarev, "'Garmoniia i algebra,'" 22. Dugladze continued, "But I have to say that there were also honoraria of five thousand rubles, which they paid for a small landscape painting. This is how much prices differed!"

70. Lazarev, "Problemy tsenoobrazovaniia," 16.

71. Lazarev, "'Garmoniia i algebra,'" 31.

72. Lazarev, "Problemy tsenoobrazovaniia," 18; Yankovskaya, "The Economic Dimensions of Art in the Stalinist Era," 788.

73. For an example of a painter being paid directly by the publisher, consider S. V. Gerasimov, who received 5 percent of the rated value (*nominal*) of an album of wall paintings, in which his painting *V. I. Lenin at the Second Congress of Soviets* was included. See RGALI, f. 652, op. 8, d. 157, l. 14. On the Bureau for the Protection of Authors' Rights, see RGALI, f. 652, op. 8, d. 144, l. 11.

74. As the Leningrad artist G. Vereisky in October 1937 wrote to his Moscow publisher Iskusstvo from Sukhumi, the subtropical Black Sea port, "I am very interested to find out when I can get the money Iskusstvo owes me for prints of my portraits." He continued, stressing the hope he placed in the personal influence of his addressee, one Tamara Mikhailovna, "I write to you with the earnest request that you push this matter; without this the publisher does not hurry to pay back its debts (I speak from experience)." RGALI, f. 652, op. 8, d. 157, ll. 26–26ob.

75. RGALI, f. 652, op. 8, d. 144, l. 3. Dated 15 July 1938.

76. See the *akty* and *protokoly* of the commissions in charge of retouched Stalin portraits by Gerasimov in 1938 in RGALI, f. 652, op. 8, d. 144, ll. 14–15, 17.

77. It also reflects a more general ambivalence toward the photograph in Stalinist Russia, whose claim to authenticity was exploited while its power to produce less filtered representations was feared. On this, see Leah Dickerman, "Camera Obscura: Socialist Realism in the Shadow of Photography," *October*, no. 93 (2000): 139–153.

78. RGALI, f. 652, op. 8, d. 97, l. 10. N.d., but file from 1940.

79. RGALI, f. 652, op. 8, d. 144, l. 103. Dated 9 March 1938.

80. RGALI, f. 652, op. 8, d. 147, l. 28. Dated 13 May 1938.

81. See, for example, RGALI, f. 652, op. 8, d. 157, l. 47.

82. See Jan Plamper, "Abolishing Ambiguity: Soviet Censorship Practices in the 1930s," *Russian Review* 60, no. 4 (2001): 531.

83. 1938 art soviet protocols of the "MOSSKh manufacturing bureau" (no place given) of the Art Fund "sculpture department" commented, for example, on a "composition *Stalin with a Child* by G. Lavrov, plaster, 2.5 meters in height, for reproduction": "Suggest working on the portrait likeness of J. V. Stalin's head. Find the right proportions of J. V. Stalin's hands and head, of the girl's head relative to J. V. Stalin's head." RGALI, f. 2942, op. 2, d. 2, l. 14 (dated 29 August 1938). In 1940 we learn of a sculpture factory in Mytishchi in Moscow oblast, which offered fifty-seven ready sculptures ranging in subject from Chernyshevsky to Henri Barbusse to Stalin to a Pioneer with a drum to a little bear, priced from ten rubles to three thousand rubles (the Stalin statue cost two thousand rubles). See RGALI, f. 2942, op. 2, d. 12, ll. 47–48.

84. *Sovetskoe Iskusstvo*, no. 22 (11 May 1935): 4.

85. Ibid., no. 48 (17 October 1937): 6.

86. This was the Mytishchi sculpture factory. See RGALI, f. 2942, op. 2, d. 12, l. 87.

87. In the early 1980s, this factory merged with the Russian Visual Propaganda (Rosizopropaganda, located on Petrovka 28, Moscow) organization and was known as the Vuchetich All-Union Artistic-Manufacturing Association (Vsesoiuznoe Khudozhestvenno-Proizvodstvennoe Ob"edinenie im. Vucheticha). Today it is still on Profsoiuznaia 76, Moscow, and is still abbreviated VKhPO, even if it has turned into a corporate business and its acronym is now deciphered as All-Russian Artistic Manufacturing Association (Vserossiiskoe Khudozhestvenno-Proizvodstvennoe Ob"edinenie im. Vucheticha).

88. For one such case see RGALI, f. 2470, op. 2, d. 18, l. 63.

89. See a Glavizo Komitet letter in RGALI, f. 2470, op. 2, d. 18, l. 2.

90. RGALI, f. 2470, op. 2, d. 18, ll. 46–46ob.

91. RGALI, f. 2470, op. 2, d. 18, l. 7. The meeting was on 8 February 1949. Also consider a 22 February 1949 meeting, at which 302 sketches of paintings submitted for a competition (leading up to Stalin's seventieth birthday exhibition?) were judged anonymously. Of these, 43 were accepted and 259 turned down. Of the 43 accepted, one got a first prize, two a second prize, three a third prize, and four a fourth prize. Thirty-three were ordered to be turned in as finished paintings. See RGALI, f. 2470, op. 2, d. 18, ll. 11–18ob. A typical interior visual factory inventory for the year of 1949 listed artists alphabetically, with number and date of contract, the sum paid according to contract, and, interestingly, a fee for "social insurance and production costs" (*sotsstrakh, proizvodstvennye raskhody*), which, in the case of artist F. V. Antonov amounted to 1,296.74 rubles of a total of 13,026.69 rubles (9.96 percent). RGALI, f. 2470, op. 2, d. 67, l. 32.

92. Author's interview with Vladilen Aleksandrovich Shabelnikov, A. M. Gerasimov's son-in-law, Moscow, 28 April 2000.

93. At least in the case of the Moscow Painting-Sculpture Factory's art soviet and the Moscow Artists' Association, the governing board of the association seems to have been superior to the art soviet. In one case the art soviet wrote to the governing board asking that it approve its stenographic protocol so that it could act upon the protocol and definitively draw up contracts for those paintings that had been approved and turn down those that had been rejected. See RGALI, f. 2470, op. 2, d. 18, l. 5.

94. The art soviet, however, declined to criticize the sketch in depth and demanded that the artist first produce more elaborate sketches. Apparently the larger issue was whether the art soviet would recommend funding by the association for a future painting. See RGALI, f. 2470, op. 2, d. 20, ll. 29–30.

95. If absent, the artist was expected to read the stenographic record of the discussion. When the art soviet discussed, for example, A. S. Stavrovsky's painting *Harvesting the Grain* on 29 August 1949, the chairperson asked: "But how are we going to speak in the absence of the painter?" One art soviet member answered: "What do we need the painter

for? If there are going to be suggestions for change, he will look at the stenogram." RGALI, f. 2470, op. 2, d. 21, l. 47. Likewise, in order to refresh their memory, artists could reread the stenogram. At least they were told to do so if their resubmissions failed to show the changes recommended at the relevant session of the art soviet. See, for example, RGALI, f. 2470, op. 2, d. 21, l. 183: "The remarks at the last art soviet were correct and the painter should carefully read the stenogram."

96. RGALI, f. 2470, op. 2, d. 21, l. 166.

97. See RGALI, f. 2470, op. 2, d. 21, l. 63.

98. It is also possible that Yerushev's painting was planned long before the 1946 release of the film, *The Oath*, and that he had the misfortune of now, after the appearance of the film, being held to the images canonized by the film. The art soviet in fact reproached Yerushev for failing to appreciate the canonical moment of *The Oath*: the transfer of legitimacy from one leader to another. A pivotal moment did not receive its proper treatment by the artist—perhaps quite simply (and unfortunately for Yerushev) because of bad timing.

99. It was precisely through implementation that socialist realism was actually fleshed out, as Erika Wolf has argued: "Socialist Realism took shape only through the development of a working practice and this required a period of adaptation and experimentation." Wolf, "*USSR in Construction*: From Avant-Garde to Socialist Realist Practice" (Ph.D. diss., University of Michigan, 1999), 271–272. Studies of socialist realism in the visual arts (in addition to those previously cited) include Antoine Baudin, *Le réalisme socialiste soviétique de la période jdanovienne (1947–1953): Les arts plastiques et leurs institutions*, vol. 1 (Bern: Peter Lang, 1997); Baudin and Leonid Heller, *Le réalisme socialiste soviétique de la période jdanovienne (1947–1953): Usages à l'intérieur, image à exporter*, vol. 2 (Bern: Peter Lang, 1998); Mariia Chegodaeva, *Sotsrealizm: Mify i real'nost'* (Moscow: Zakharov, 2003); Thomas Christ, *Der Sozialistische Realismus: Betrachtungen zum Sozialistischen Realismus in der Sowjetzeit* (Basel: Wiese Verlag, 1999); Ekaterina Degot', *Terroristicheskii naturalizm* (Moscow: Ad Marginem, 1998); Degot', *Russkoe iskusstvo XX veka* (Moscow: Trilistnik, 2000); Igor Golomstock, *Totalitarian Art in the Soviet Union, the Third Reich, Fascist Italy, and the People's Republic of China* (New York: IconEditions, 1990); Jørn Guldberg, "Socialist Realism as Institutional Practice: Observations on the Interpretation of the Works of Art of the Stalin Period," in *The Culture of the Stalin Period*, ed. Hans Günther (London: St. Martin's, 1990), 149–177; Aleksandr Morozov, *Konets utopii: Iz istorii iskusstva v SSSR 1930-kh godov* (Moscow: Galart, 1995); Morozov, *Sotsrealizm i realizm* (Moscow: Galart, 2007); *Mif i real'nost': Kul'tura i iskusstvo strany Sovetov (1920–1950-e gody): Nauchnaia konferentsiia. Materialy i issledovaniia* (Kirov: Promizdat, 2002). For further titles see the review article by Oliver Johnson, "Alternative Histories of Soviet Visual Culture," *Kritika: Explorations in Russian and Eurasian History* 11, no. 3 (2010): 581–608.

100. Katerina Clark has characterized High Stalinist culture as neo-Platonist: empirical knowledge is no longer telling, inner truths count more than outward appearances. See her *The Soviet Novel: History as Ritual* (Chicago: University of Chicago Press, 1981), 141.

101. RGALI, f. 2470, op. 2, d. 20, ll. 540b.–570b.

102. RGALI, f. 2470, op. 2, d. 21, ll. 62–65.

103. RGALI, f. 2470, op. 2, d. 20, ll. 570b.–58.

104. RGALI, f. 2470, op. 2, d. 20, l. 98.

105. RGALI, f. 2470, op. 2, d. 20, ll. 125–126.

106. RGALI, f. 2470, op. 2, d. 22, l. 84.

107. Interview with Shabelnikov, Moscow, 28 April 2000.

108. RGALI, f. 2470, op. 2, d. 21, l. 65.

109. The exigency here probably was the demand of the Kalinin Museum to single out four delegates and to display them prominently in the form of portraits *en miniature*. In other words, local heroes were to be emphasized, whereas the art soviet recommended a group portrait. See RGALI, f. 2470, op. 2, d. 21, ll. 65–66.

110. RGALI, f. 2470, op. 2, d. 21, ll. 121–122.

111. RGALI, f. 2470, op. 2, d. 22, l. 287.

112. RGALI, f. 2470, op. 2, d. 22, l. 179.

113. RGALI, f. 2470, op. 2, d. 21, l. 123.

114. RGALI, f. 2470, op. 2, d. 21, l. 6. In the same painting, the books on Lenin's table were criticized by Fedor Shurpin, who "associated [them] with religious books." RGALI, f. 2470, op. 2, d. 21, l. 7.

115. For an introduction to Western Marxist and Soviet art criticism see Margaret A. Rose, *Marx's Lost Aesthetic: Karl Marx and the Visual Arts* (New York: Cambridge University Press, 1984). On the beginnings of art criticism in Russia also see Andrei Makhrov, "The Pioneers of Russian Art Criticism: Between State and Public Opinion, 1804–1855," *Slavonic and East European Review* 81, no. 4 (2003): 614–633.

116. For an alternative view that landscape painting constituted a central genre in Stalinist art, that "the depiction of nature was a major preoccupation of Socialist Realism," see Mark Bassin, "'I Object to Rain that Is Cheerless': Landscape Art and the Stalinist Aesthetic Imagination," *Ecumene* 7, no. 3 (2000): 313.

117. Bown, *Socialist Realist Painting*, 101.

118. Ibid.

119. On the shift from Sergei Eisenstein's and Dziga Vertov's *tipazhnost'* to *lichnost'* and Liubov Orlova's star cult, see Oksana Bulgakowa, "Der erste sowjetische Filmstar," in *Personality Cults in Stalinism—Personenkulte im Stalinismus,* ed. Klaus Heller and Jan Plamper (Göttingen: Vandenhoeck & Ruprecht unipress, 2004), 365–389.

120. RGALI, f. 2368, op. 2, d. 38, ll. 11–12.

121. See K. Sitnik, "O populiarnoi monografii," *Iskusstvo,* no. 1 (1947), 78–80.

122. Pictures that did not fit into this taxonomy often ended up in the storage rooms of the Art Fund as *nelikvidy.* See Lazarev, "'Garmoniia i algebra,'" 17.

123. Particularly after the postwar resurrection of the Academy of Arts, many painters and sculptors produced both a work of art and a written comment on their work—a "dissertation." Together, these two elements bestowed upon the artist the Russian equivalent of a Ph.D. in art history, *kandidat iskusstvovedeniia.*

124. A. V. Protopopov, "I. V. Stalin (skul'ptura)" (avtoreferat dissertatsii na soiskanie uchenoi stepeni kandidata iskusstvovedeniia, Akademiia khudozhestv SSSR, Institut zhivopisi, skul'ptury i arkhitektury im. I. E. Repina, Leningrad, 1953), 6–7.

125. V. L. Rybalko, "I. V. Stalin v molodye gody (skul'ptura)" (avtoreferat dissertatsii na soiskanie uchenoi stepeni kandidata iskusstvovedeniia, Akademiia khudozhestv SSSR, Institut zhivopisi, skul'ptury i arkhitektury im. I. E. Repina, Leningrad, 1950), 6.

126. Unidentified author, *Avtoreferat dissertatsii Instituta im. I. E. Repina, Akademii Khudozhestv SSSR,* Leningrad, 1 June 1950, 5.

127. V. G. Val'tsev, "I. V. Stalin sredi rybakov Eniseia (zhivopis')" (avtoreferat dissertatsii na soiskanie uchenoi stepeni kandidata iskusstvovedeniia, Akademiia khudozhestv SSSR, Institut zhivopisi, skul'ptury i arkhitektury im. I. E. Repina, Leningrad, 1953), 7.

128. "Prazdnik sotsialisticheskoi kul'tury," *Iskusstvo,* no. 2 (1941): 6.

129. On the nineteenth-century roots of socialist realism see Irina Gutkin, *The Cultural Origins of the Socialist Realist Aesthetic, 1890–1934* (Evanston: Northwestern University Press, 1999).

130. RGASPI, f. 74, op. 1, d. 295, l. 23. The letter to Stetsky is dated 1 April 1933, the copy to Voroshilov used here has a date of 2 April 1933. Photography was a constant point of reference in this art criticism. Also in 1933, one critic wrote: "The photographic naturalism (*naturalistichnost'*) of some portraits at the exhibition probably does not need to be emphasized. It would be ridiculous to take away from artists an auxiliary tool as powerful as photography, which nowadays almost all of the Western European masters use. Photography undoubtedly has more advantages over quick, impressionistic sketches from life, but

the artist must turn the photograph into a true work of art, not a poor copy of the photo-graph." See Sergei Romov, "Krasnaia armiia v zhivopisi: Iubileinaia vystavka 15 let RKKA,'" *Iskusstvo*, no. 4 (1933): 27.

131. Romov, "Krasnaia armiia v zhivopisi,'" 25–26.

132. S. Razumovskaia, "Sergei Gerasimov," *Iskusstvo*, no. 2 (1934): 65. A reproduction of Sergei Gerasimov's 1932 oil painting *Stalin among the Cadets* is on p. 60.

133. Ibid., no. 53 (17 November 1935): 4.

134. L. Gutman, "O portretakh vozhdei," *Iskusstvo*, no. 1 (1935): 5.

135. In Gutman's words: "Through the generalization and synthesis of reality—extracting the content of depicted images from the real world—the artist creates portraits that are also convincing with regard to their form; and in the development of the portrait genre there already emerges a bounded, vital, and dialectical unity of form and content that cannot be reached in any other way." Ibid., 10.

136. Ibid.

137. Ibid., 11.

138. See Mark Neiman, "Novye portrety tovarishcha Stalina," *Iskusstvo*, no. 6 (1937): 61. As also manifest in this 1937 article, once narratives of Stalin's life appeared in print af-ter the mid-1930s, they became a second important source (apart from visual iconography) on which art criticism drew in analyzing a Stalin portrait's "intertextuality." At the Tretya-kov's Georgian exhibition (1937–1938), the pictorial representation of Stalin's childhood and his later activities in the Caucasus was clearly based on such verbal accounts as Henri Barbusse's Stalin biography (which had appeared in Russian in early 1936) and Lavrenty Beria's memoirs. See the article on the exhibition by Evg. Kriger, "Istoriia, voploshchennaia v zhivopisi," ibid., no. 1 (1938): 3–20.

139. OR GTG, f. 18, d. 173, ll. 86–87. "Rukopis' F. S. Mal'tseva: Individual'nyi portret i tipicheskii obraz v sovetskom iskusstve" (1940).

140. B. Keller, "Skul'ptura na vystavke," *Iskusstvo*, no. 2 (1941): 45–47.

141. Osip Beskin, "O kartine, naturalizme i realizme (v sviazi s rabotami Leningradskikh molodykh khudozhnikov)," ibid., no. 4 (1939): 12.

142. The term signified the established representations of a person (rarely an object). For a use of the term with respect to someone other than Stalin see e.g. I. S. Rabinovich, "Kist'iu druzei i vragov: Khudozhestvennaia ikonografiia Marksa," *Sovetskoe Iskusstvo*, no. 13 (14 March 1933): 1.

143. Consider the example of Brodsky, who refused to do a commissioned group portrait after the start of the Great Terror in 1937: "I will paint the painting and then one of the persons turns out to be an enemy of the people, and again they will prohibit the painting! I won't do this painting." M Br, "Vospominaniia syna I. I. Brodskogo, E. I. Brodskogo," 25. Or consider the example of Gerasimov, who was painting a group portrait of political leaders in 1937. As this was the height of the Great Terror, he kept receiving calls from the Party's Central Committee, announcing that "unfortunately, Comrade X also turned out to be an enemy of the people." At first Gerasimov painted over individual figures, adding a palm leaf or a column here and there. When the number of "enemies of the people" became unmanageable Gerasimov simply covered the entire picture with lilacs, lest he be accused of making propaganda for the condemned enemies of the Soviet Union. Interviews with Shabelnikov, Moscow, 28 April and 10 May 2000.

144. RGANI, f. 5, op. 17, d. 543, ll. 181–181ob. Denisov's letter is dated 11 May 1955.

145. RGANI, f. 5, op. 17, d. 543, l. 180. Lepeshinskaia's letter is dated 3 June 1954.

146. RGANI, f. 5, op. 17, d. 543, l. 180. Dated 7 April 1955.

147. RGANI, f. 5, op. 17, d. 543, l. 181.

148. RGANI, f. 5, op. 17, d. 543, l. 181ob. The term *trafaretchik* (from *trafaret*, stencil) was taken from the reproduction of Soviet posters. Beginning in the early 1920s the press agency ROSTA sent stencils to provincial ROSTA outlets, which artists painted or airbrushed

one after another onto paper stock until a "ROSTA Window"—a multicolored poster with a schematic touch—emerged. For an illustration of this process, see Klaus Waschik and Nina Baburina, *Werben für die Utopie: Russische Plakatkunst des 20. Jahrhunderts* (Bietigheim-Bissingen: edition tertium, 2003), 202. For an illustration of the related technique of copying and magnifying visual art using numbered squares, in this case a 1927 Lenin poster, see Svetlana Malysheva, *Sovetskaia prazdnichnaia kul'tura v provintsii: Prostranstvo, simvoly, istoricheskie mify (1917–1927)* (Kazan: Ruten, 2005), 322.

149. RGANI, f. 5, op. 17, d. 543, l. 178. In this Central Committee note Denisov is identified as a *khudozhnik-kopiist,* "born in 1890, Party member since 1907, without higher education, has been working at the Moscow division of the Khudozhestvennyi Fond since 1946."

150. RGANI, f. 5, op. 33, d. 27, ll. 183–184. Letter dated 28 October 1957.

151. RGANI, f. 5, op. 17, d. 543, ll. 186–187ob.

152. Interview with Professor Yuri Romakov, program *Namedni* on NTV, 21 December 1999.

153. See *Pravda,* 14 November 1935, 2.

154. Her letter was dated 9 December 1934 and was inspired by Kirov's murder on 1 December: "The death of Comrade Kirov has led me to a thought that I want to share with you. The problem is that Comrade Kirov's death mask does not give a full impression of the living Comrade Kirov. Unfortunately, this problem cannot be rectified in the case of Comrade Kirov. But we have many other dear and beloved leaders, whose image we would like to preserve for posterity exactly the way it is." RGASPI, f. 74, op. 1, d. 292, l. 179. *Pravda* repeatedly showed plaster death masks of Party leaders, such as that of Ordzhonikidze (done by Merkurov). See *Pravda,* 21 February 1937, 2.

155. RGASPI, f. 74, op. 1, d. 292, l. 180. Voroshilov's remark is dated 5 January 1935.

CHAPTER 6. THE AUDIENCE AS CULT PRODUCER

1. For discussions of the *svodki* see Paul Corner, ed., *Popular Opinion in Totalitarian Regimes: Fascism, Nazism, Communism* (New York: Oxford University Press, 2009).

2. For like-minded conceptions of reception see Jochen Hellbeck, "Speaking Out: Languages of Affirmation and Dissent in Stalinist Russia," *Kritika: Explorations in Russian and Eurasian History* 1, no. 1 (2000): 71–96; Lynne Viola, "Introduction" and "Popular Resistance in the Stalinist 1930s: Soliloquy of a Devil's Advocate," in *Contending with Stalinism: Soviet Power and Popular Resistance in the 1930s,* ed. Viola (Ithaca: Cornell University Press, 2002), 2, 43, 18. For more on the specificity of Stalin-era subject construction see Jochen Hellbeck, *Revolution on My Mind: Writing a Diary under Stalin* (Cambridge, Mass.: Harvard University Press, 2006).

3. See Jean-Jacques Becker, *The Great War and the French People,* trans. Arnold Pomerans (Dover, N.H.: Berg, 1985), 97.

4. See Evgeny Dobrenko, *The Making of the State Reader: Social and Aesthetic Contexts of the Reception of Soviet Literature,* trans. Jesse Savage (Stanford: Stanford University Press, 1997).

5. See Peter Kenez, *Cinema and Soviet Society, 1917–1953* (Cambridge: Cambridge University Press, 1992), 82, 86, 90–91; Yuri Tsivian, *Early Cinema in Russia and Its Cultural Reception,* ed. Richard Taylor, trans. Alan Bodger (Chicago: University of Chicago Press, 1998); Denise Youngblood, *Movies for the Masses: Popular Cinema and Soviet Society in the 1920s* (Cambridge: Cambridge University Press, 1992); Youngblood, *Soviet Cinema in the Silent Era, 1918–1935* (Ann Arbor: UMI Research Press, 1985).

6. RGALI, f. 645, op. 1, d. 113, l. 5.

7. RGALI, f. 645, op. 1, d. 113, l. 36.

8. RGALI, f. 645, op. 1, d. 312, l. 1.

9. On surveys of the success of Soviet advertisements among consumers, and the German and American models for such surveys, see Randi Barnes Cox, "The Creation of the Socialist Consumer: Advertising, Citizenship and NEP" (Ph.D. diss., Indiana University, 2000), 303–311. I am grateful to Randi Cox for directing me to these pages.

10. On comment books in the Soviet Union see the literature cited in Susan E. Reid, "In the Name of the People: The Manège Affair Revisited," *Kritika: Explorations in Russian and Eurasian History* 6, no. 4 (2005): 676 n. 10; Oliver Johnson, "Assailing the Monolith: Popular Responses to the 1952 All-Union Art Exibition," *Meno istorija ir kritika/Art History and Criticism*, no. 3 (special issue "Art and Politics: Case-Studies from Eastern Europe") (Kaunas: Vytautas Magnus University, 2007): 45–51; G. A. Iankovskaia, *Iskusstvo, den'gi i politika: Khudozhnik v gody pozdnego stalinizma* (Perm: Perm'skii gosudartvennyi universitet, 2007), 221–223. In addition, on comment books cited in an official publication of the 1939 Industry of Socialism exhibition see Susan E. Reid, "All Stalin's Women: Gender and Power in Soviet Art of the 1930s," *Slavic Review* 57, no. 1 (1998): esp. 152 n. 59; on a comment book at a 1929 exhibition of a porcelain sculptor, see Karen L. Kettering, "Natalia Dan'ko and the Lomonosov State Porcelain Factory, 1917–1942" (Ph.D. diss., Northwestern University, 1998), 152–153; on comment books at the 1934 exhibition of the model of the Palace of Soviets by Boris Iofan et al. in the Pushkin Fine Arts Museum, see Stephan Hoisington, "'Ever Higher': The Evolution of the Project for the Palace of Soviets," *Slavic Review* 62, no. 1 (2003): 62; on comment books at ethnographic exhibitions see Francine Hirsch, *Empire of Nations: Ethnographic Knowledge and the Making of the Soviet Union* (Ithaca: Cornell University Press, 2005), 211–215. On post-Stalin comment books see Aleksei Fominykh, "'Kartinki s vystavki': Knigi otzyvov Amerikanskoi vystavki v Moskve 1959 goda—vozvrashchenie istochnika," *Ab Imperio* no. 2 (2010): 151–170; Susan E. Reid, "The Exhibition *Art of Socialist Countries*, Moscow 1958–9, and the Contemporary Style of Painting," in *Style and Socialism: Modernity and Material Culture in Post-War Eastern Europe*, ed. Susan E. Reid and David Crowley (Oxford: Berg, 2000), 101–132.

11. Interviews with Aleksandr Morozov, professor of art history, Moscow, 24 February 2000, and Mikhail Lazarev, art historian, Moscow, 1 March 2000. Elizabeth Valkenier makes no mention of comment books in her studies of the Peredvizhniki; see Valkenier, *Russian Realist Art: The State and Society. The Peredvizhniki and Their Tradition* (Ann Arbor: Ardis, 1977); Valkenier, *Ilya Repin and the World of Russian Art* (New York: Columbia University Press, 1990). On Western comment books see Reid, "In the Name of the People," 677, n14.

12. Interview with Natalia Masalina, senior research associate OR GTG, Moscow, 30 March 2000.

13. See, for example, OR GTG, f. 8.II, d. 513 ("Artists of the RSFSR over the Past Fifteen Years" exhibition, 1933).

14. Interview with Masalina.

15. RGASPI, f. 74, op. 1, d. 429, ll. 110ob.–111. Entry dated 3 May 1949.

16. Interview with Masalina.

17. See "Dve vystavki. 1. 'Khudozhniki RSFSR za 15 let.'—2. '15 let Krasnoi Armii,'" *Sovetskoe Iskusstvo*, no. 27 (14 June 1933): 1.

18. See ibid., no. 41 (8 September 1933): 1.

19. For example: "The anniversary exhibition 'Artists of the RSFSR over the Past Fifteen Years' in its first 13 days drew 42,581 visitors. Of these, 33,000 visited the painting section, 8,000 the sculpture section, and 1,581 the poster section." See ibid., no. 32 (14 July 1933): 1.

20. About this exhibition, which opened on 19 March 1923, Katsman observed in his diary: "They laid out a book for visitor opinions. From these recorded opinions it was clear that the exhibition was successful, that it amazed many. Trotsky wrote: 'Good, but I am prohibiting the painting of generals for the next five years.' Indeed, there was one big

drawback—we painted too few ordinary heroes—but this was the fault of the Revolutionary War Soviet, which gave us commissions." Evgeny Katsman, diary entry (17 March 1925), quoted in Khvostenko, *Vechera na Maslovke bliz "Dinamo": Vospominaniia*, vol. 2: *Za fasadom proletarskogo iskusstva* (Moscow: Olimpiia Press, 2003), 76.

21. RGALI, f. 645, op. 1, d. 432, ll. 69–69ob. The letter by I. I. Abramov, "instructor at Ural oblast political education," is dated 13 April 1925 and part of a file about the 1928 exclusion proceedings of Isaak Brodsky from AKhRR. Presumably, Brodsky produced this letter in his own defense. The reasons for Brodsky's temporary ouster lay in AKhRR's turn toward a less mimetic style of representation during the Cultural Revolution. See Valkenier, *Russian Realist Art*, 158–159; Matthew Cullerne Bown, *Socialist Realist Painting* (New Haven: Yale University Press, 1998), 115–116.

22. RGALI, f. 645, op. 1, d. 432, l. 4.

23. RGALI, f. 645, op. 1, d. 432, l. 210b.

24. RGALI, f. 645, op. 1, d. 485, l. 31.

25. On the didactic approach to museums during the First Five-Year Plan, which overburdened pictures with surrounding explanations and preceded the early 1930s turn to a more iconophilic stance, which treated pictures as objects to be revered rather than explained, see Adam Jolles, "Stalin's Talking Museums," *Oxford Art Journal* 28, no. 3 (2005): 429–455.

26. RGALI, f. 645, op. 1, d. 485, ll. 34–350b. The collective letter is not dated.

27. RGALI, f. 642, op. 1, d. 38, l. 1.

28. RGALI, f. 642, op. 1, d. 38, l. 1.

29. RGALI, f. 962, op. 6, d. 85, l. 18.

30. RGALI, f. 962, op. 6, d. 85, ll. 21–22.

31. For a public Soviet representation of the comment book as standing for a shift from bourgeois art for a few to socialist art for the masses, consider the words of one newspaper commentator: "The relationship between our viewer and our artist is entirely different; there is a different creative collaboration. The Soviet artist paints and creates for his proletarian viewer, he puts his art in the service of these masses of toilers and . . . listens very carefully to their voice, judgment, praise, and critical remarks." Val. V., "Na vystavke kartin 'Vsekokhudozhnika': Zritel' u poloten," *Stalinskii rabochii*, 8 August 1935.

32. RGALI, f. 2368, op. 2, d. 38, ll. 16–17.

33. See "Stenogramma zasedaniia VIII plenuma Orgkomiteta Soiuza Sovetskikh Khudkov 1-yi den': Vystuplenie B. V. Iogansona 'Sovetskaia zhivopis' v period Otechestvennoi voiny,'" OR GTG, f. 18, d. 396, ll. 22–23. Dated 3 June 1943.

34. OR GTG, f. 8.II, d. 993, l. 191.

35. For example, to prevent the closing of an outdoor exhibition of his sculptures outside Yalta, the wood sculptor Bezrukov in 1967 deftly instrumentalized popular enthusiasm. The mythical *narod*, the sculptor claimed, "not only expressed its enthusiasm verbally but also left behind twenty books of comments with tens of thousands of expressions of gratitude." See Bezrukov's petition letter to Voroshilov in RGASPI, f. 74, op. 1, d. 311, l. 90.

36. RGALI, f. 2020, op. 1, d. 114, ll. 1–10b. The letter is not dated.

37. OR GTG, f. 8.II, d. 23, l. 1.

38. OR GTG, f. 8.II, d. 23, l. 1.

39. OR GTG, f. 8.II, d. 23, l. 2. "Otzyvy zritelia o vystavke 'I. V. Stalin v izobrazitel'nom iskusstve'" (1949–1950).

40. OR GTG, f. 8.II, d. 771, ll. 1–10b.

41. See pp. 114–116.

42. Diky was born on 25 February 1889 in Ekaterinoslav into a family of Ukrainian theater artists and died in Moscow on 1 October 1955.

43. Evgenii Gromov, *Stalin: Vlast' i iskusstvo* (Moscow: Respublika, 1998), 233. An encyclopedia of the Moscow Arts Theater laconically notes about Diky's arrest: "He was

subject to repressions, but Nemirovich-Danchenko did a lot to save him." See A. M. Sme-lianskii, *Moskovskii Khudozhestvennyi Teatr: Sto let*, vol. 2: *Imena i dokumenty* (Moscow: Izdatel'stvo "Moskovskii Khudozhestvennyi teatr," 1998), 64. According to a biographical dictionary, "Diky was arrested and spent five years in a correctional labor camp." V. A. Torchinov and A. M. Leontiuk, eds., *Vokrug Stalina: Istoriko-biograficheskii spravochnik* (St. Petersburg: Filologicheskii fakul'tet Sankt-Peterburgskogo gosudarstvennogo univer-siteta, 2000), 195.

44. Diky also played Stalin in the following plays at the State Malyi Theater: *Southern Knot* and *Unforgettable 1919*. Oddly, the movie *Aleksandr Matrosov* is listed neither in the standard filmography, A. V. Machereta, ed., *Sovetskie khudozhestvennye fil'my: Annotiro-vannyi katalog*, vol. 2: *Zvukovye fil'my, 1930–1957* (Moscow: Iskusstvo, 1961), nor in such histories as Jay Leyda's *Kino: A History of the Russian and Soviet Film,* 3rd ed. (Boston: George Allen and Unwin, 1983). And yet, Diky himself repeatedly mentioned the movie, recounting, for example, in a 1949 radio address: "At the same time as my work in the the-ater [of 1947], I starred in the role of Comrade Stalin in the movie *Aleksandr Matrosov.*" RGALI, f. 2376, op. 1, d. 128, l. 3. "A. D. Diky. Vystupleniia po radio i o rabote nad obra-zom I. V. Stalina v kinofil'makh i spektakliakh Malogo teatra" (1949).

45. Incidentally, it is not true that Semyon Goldshtab, a Jew, was banned forever from the role of Stalin after the Hitler-Stalin Pact, as is widely assumed. Goldshtab played Stalin, for example, in *Aleksandr Parkhomenko* (1942).

46. RGALI, f. 2376, op. 1, d. 109, l. 1.

47. RGALI, f. 2376, op. 1, d. 197, ll. 1–10b.

48. RGALI, f. 2376, op. 1, d. 197, l. 2. Dated 14 May 1949.

49. RGALI, f. 2376, op. 1, d. 197, ll. 16–160b. Dated 2 July 1949.

50. Witness the following letter from Nina Gerasimova, a student at Vladimir's machine-building vocational college, who first congratulated Diky on his Stalin Prizes and then asked him to help her out of the following situation: "Because of difficult family relations, I cannot receive an education, despite my great desire to obtain one." RGALI, f. 2376, op. 1, d. 197, l. 5. Dated 3 June 1949.

51. RGALI, f. 2376, op. 1, d. 197, ll. 7–70b.

52. RGALI, f. 2376, op. 1, d. 197, l. 46. Also see RGALI, f. 2376, op. 1, d. 197, ll. 26–27, 37, 39–40.

53. RGALI, f. 2376, op. 1, d. 197, l. 32.

54. RGALI, f. 2376, op. 1, d. 197, l. 20. However, the Stalin acting of Diky cannot have been as distinctive as we might like to believe, for a group of four soldiers congratulated Diky on his performance as Stalin in *The Oath*, where in actuality Mikhail Gelovani played the role. RGALI, f. 2376, op. 1, d. 197, l. 12.

55. RGALI, f. 2376, op. 1, d. 197, l. 28.

56. RGALI, f. 2376, op. 1, d. 197, l. 34.

57. RGALI, f. 2376, op. 1, d. 197, l. 33.

58. RGALI, f. 2376, op. 1, d. 197, l. 43.

59. RGALI, f. 2376, op. 1, d. 197, l. 18.

60. RGALI, f. 2376, op. 1, d. 197, l. 45.

61. Personal communication by Vinzenz Hediger, Bochum, 26 February 2005. On Hollywood's early measuring of the reception of its films from the 1920s onward in general and on the tailoring of Hollywood films to international audiences in particular see Susan Ohmer, "Measuring Desire: George Gallup and Audience Research in Hollywood," *Journal of Film and Video* 43, nos. 1–2 (1991): 3–28; Lea A. Handel, *Hollywood Looks at Its Audi-ence* (Urbana: University of Illinois Press, 1950). I am grateful to Vinzenz Hediger for these references.

62. In another example of performed participation in a mass medium, *Pravda* presented the building in 1937 in Kiev of a monument in honor of just-deceased Sergo Ordzhonikidze

as an outgrowth of a democratic workers' wish—"the workers of the Lenin Forge factory voiced their wish to have a monument build for unforgotten Sergo." *Pravda,* 6 July 1937, 6.

63. Pierre Bourdieu, "Public Opinion Does Not Exist," in *Communication and Class Struggle,* ed. Armand Mattelart and Seth Siegelaub, vol. 1 (New York: International General, 1979), 125.

64. Ibid., 681–682. "Speaking Bolshevik" is from Stephen Kotkin, *Magnetic Mountain: Stalinism as a Civilization* (Berkeley: University of California Press, 1995), 198–237.

65. See the reactions to *Valerii Chkalov* in *Pravda,* 21 March 1941, 4.

66. RGANI, f. 5, op. 17, d. 499, l. 99. Letter dated 24 July 1954.

67. RGANI, f. 5, op. 17, d. 499, l. 100.

68. RGANI, f. 5, op. 17, d. 499, l. 100.

69. RGANI, f. 5, op. 17, d. 499, l. 101.

70. On complaint books see Reid, "In the Name of the People," 683 n. 36.

71. The Central Committee archives contain a petition letter by an editor of the journal *Ogonek,* which had featured a story on Erzia by Boris Polevoi, asking for a new studio and adducing entries from the comment book ranging from those of art students to those of such well-known sculptor colleagues as Vadim Sidur. RGANI, f. 5, op. 17, d. 499, ll. 13–32. The letter from *Ogonek* to Petr Pospelov at the Central Committee is on l. 13 and dated 3 March 1954.

72. *Khudozhnik i Rossiia* (Düsseldorf: Grad Kitezh, 1980), 157–159.

CONCLUSION

1. On Stalin's death, funeral, and eventual burial see B. S. Ilizarov, "Stalin: Bolezni, smert' i 'bessmertie,'" *Novaia i noveishaia istoriia,* no. 6 (2000): 125–145.

2. For examples see Sarah Davies, *Popular Opinion in Stalin's Russia: Terror, Propaganda, and Dissent, 1934–1941* (Cambridge: Cambridge University Press, 1997), 168–182; for iconoclastic belletristic attacks on the Stalin cult during and after Stalin's reign see Rosalind Marsh, "Literary Representations of Stalin and Stalinism as Demonic," in *Russian Literature and Its Demons,* ed. Pamela Davidson (New York: Berghahn, 2000), 473–511; for an account of annual celebrations of Stalin's passing by Gulag returnees in Moscow see Barbara Honigmann, *Ein Kapitel aus meinem Leben* (Munich: Hanser, 2004), 67.

3. John Borneman, "Introduction: Theorizing Regime Ends," in *Death of the Father: An Anthropology of the End in Political Authority,* ed. John Borneman (New York: Berghahn, 2004), 2. Also see John S. Schoeberlein, "Doubtful Dead Fathers and Musical Corpses: What to Do with the Dead Stalin, Lenin, and Tsar Nicholas," ibid., 201–219.

4. There was a general awareness that possession of an original or oil copy was a mark of belonging to the elite. In 1947 young Andrei Sakharov was invited to the office of Igor Kurchatov, the father of the Soviet atomic bomb and one of the most powerful figures in the science establishment: "As we talked, Kurchatov stroked his bushy black beard, his expressive brown eyes gleaming. On the wall facing me hung a larger-than-life oil portrait of Stalin with his pipe and the Kremlin in the background. The painting, clearly by one of the 'court' artists, symbolized Kurchatov's high standing in the state hierarchy; it remained in place for some time even after the Twentieth Party Congress." Andrei Sakharov, *Memoirs,* trans. Richard Lourie (New York: Knopf, 1990), 93.

5. On Brodsky see Lev Losev, *Iosif Brodskii: Opyt literaturnoi biografii* (Moscow: Molodaia Gvardiia, 2006), 19; on Lotman see Catriona Kelly, "'A Laboratory for the Manufacture of Proletarian Writers': The *Stengazeta* (Wall Newspaper), *Kulturnost'* and the Language of Politics in the Early Soviet Period," *Europe-Asia Studies* 54, no. 4 (2002): 590; for Arzhilovsky see Véronique Garros, Natalia Korenevskaya, and Thomas Lahusen, eds., *Intimacy and Terror: Soviet Diaries of the 1930s* (New York: New Press, 1995), 132–133; Aleksandr Zinov'ev, *Ispoved' otshchepentsa* (Moscow: Vagrius, 2005), 247 (thanks to

Nikolai Mitrokhin for this reference); for Molotov see Albert Resis, ed., *Molotov Remembers: Inside Kremlin Politics. Conversations with Felix Chuev* (Chicago: Ivan R. Dee, 1993), 198.

6. Anna Akhmatova as quoted from Lidiia Chukovskaia's diaries and cited in Irina Paperno, *Stories of the Soviet Experience: Memoirs, Diaries, Dreams* (Ithaca: Cornell University Press, 2009), 102.

7. Ernst Cassirer, *Versuch über den Menschen: Einführung in eine Philosophie der Kultur* (Hamburg: Felix Meiner, 1996), 43.

APPENDIX

1. In the borderline case of three photographs next to each other—Stalin all by himself on the left, in the middle a coffin and wreathes at the funeral for aviators of the crashed Maxim Gorky airplane, Molotov alone on the right—I counted as "Stalin with others." For the pictures see *Pravda*, 21 May 1935, 1.

2. Quoted from *Moskovskie novosti*, 5 May 1996, 28.

3. Entry of 30 November 1949, quoted in Jan C. Behrends, *Die erfundene Freundschaft: Propaganda für die Sowjetunion in Polen und der DDR* (Cologne: Böhlau, 2006), 203–204.

4. Susman quoted in Simonetta Falasca-Zamponi, "The 'Culture' of Personality: Mussolini and the Cinematic Imagination," in *Personality Cults in Stalinism—Personenkulte im Stalinismus*, ed. Klaus Heller and Jan Plamper (Göttingen: Vandenhoeck & Ruprecht unipress, 2004), 88.

5. Ibid.

6. For reception theory in art history see Wolfgang Kemp, *Der Betrachter ist im Bild: Kunstwissenschaft und Rezeptionsästhetik* (Berlin: Reimer, 1992). Foundational texts of reception studies in literary scholarship are Wolfgang Iser, *The Act of Reading: A Theory of Aesthetic Response* (Baltimore: Johns Hopkins University Press, 1980); Hans Robert Jauss, *Toward an Aesthetic of Reception* (Minneapolis: University of Minnesota Press, 1982).

Index